The So

Pacific Ocean

Solomon Islands

Santa Cruz

Vanuatu

Fiji

New Caledonia

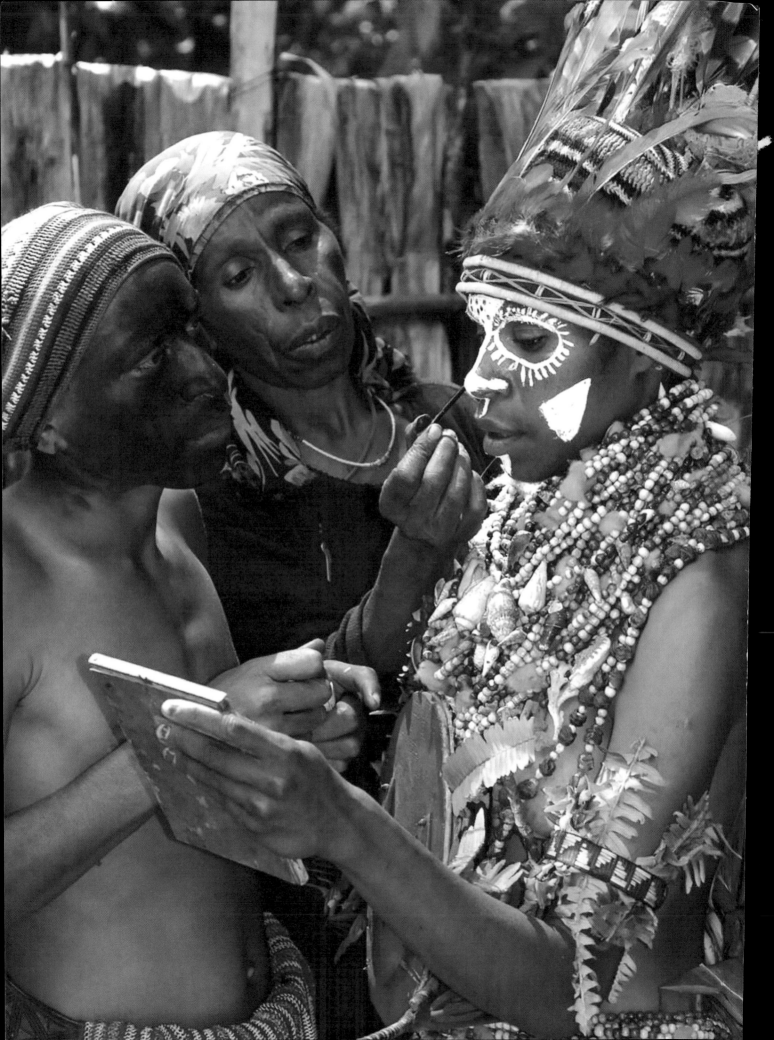

ADORNED
by nature

Adornment, exchange & myth in the South Seas

WOLFGANG GRULKE

Designed by et al design consultants
Printed in Czech Republic by Finidr
Published in the United Kingdom by
At One Communications, AtOne.org
ISBN 978-1-9160394-4-5

FRONT COVER IMAGE: A young boy
adorned for celebration. He is wearing
a splendid headpiece of green beetle
carapaces and cuscus fur, a necklace made
of bamboo and threaded yellow orchid
stems, and a dramatic *Turbo* shell neck
adornment. Jairus from Nukunt village,
Simbai, Madang Province, Papua New
Guinea. Photo: Olga Fontanellaz 2015

PREVIOUS PAGE: Preparing the natural
adornments for a women's Sing-sing.
Wahgi Valley, New Guinea Highlands.
Photo: WG 2002

RIGHT: A Melpa woman adorned with
a natural fibre *bilum* bag, a natural fibre
nosepiece and a necklace made of Job's
Tears seeds. Wahgi Valley, near Mount
Hagen, New Guinea Highlands.
Photo: WG 2002

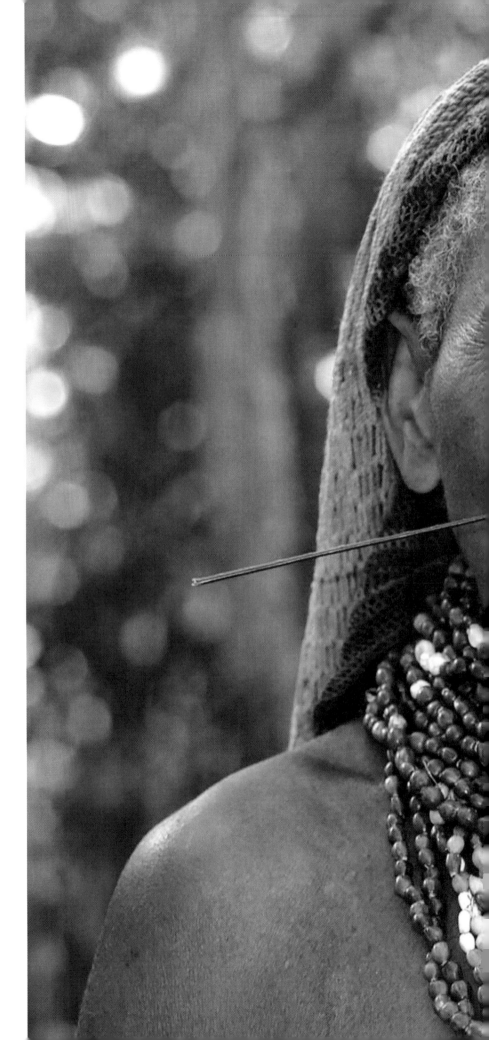

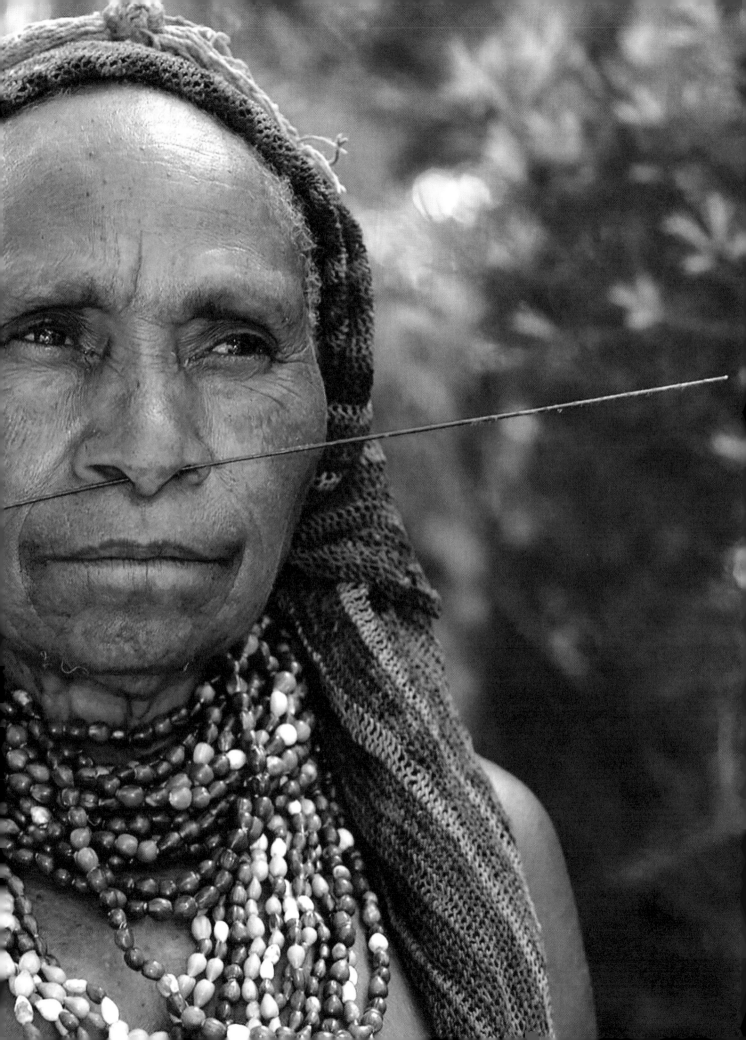

ADORNED
by nature

Adornment, exchange & myth in the South Seas

A personal journey through their material
culture and the magic

South Seas islanders had little access to metals or
precious stones, so they crafted superlative and
fabled adornments from nature

They created currencies and ground-breaking
trading networks that nurtured relationships
and redefined value

This is their story

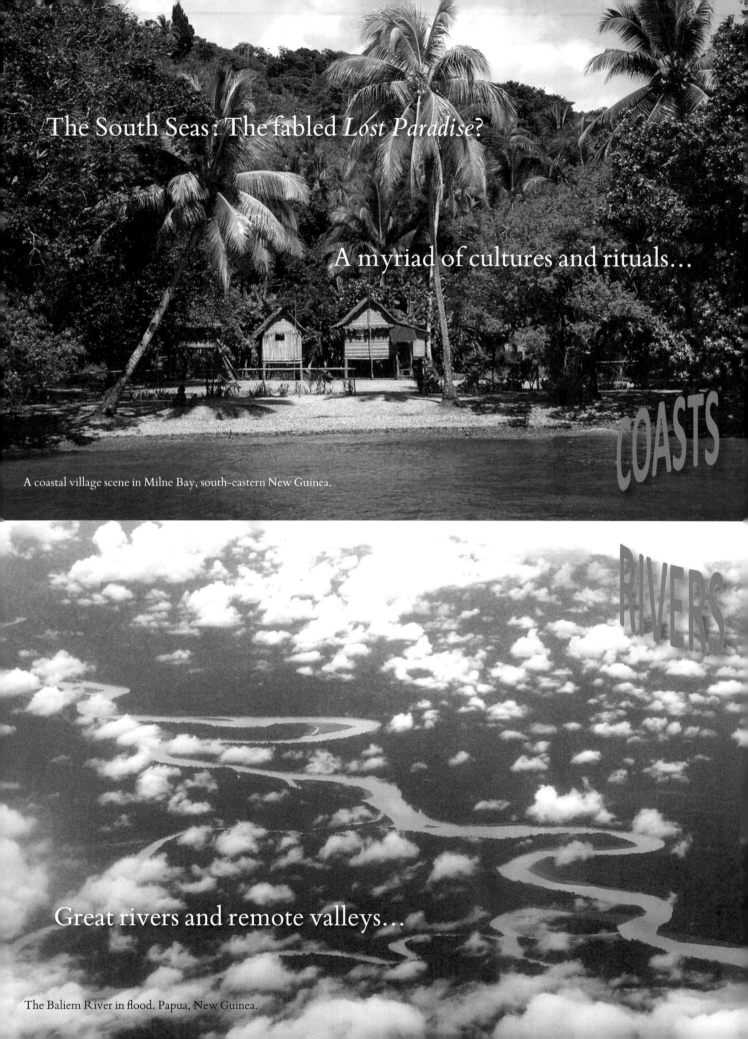

The South Seas: The fabled *Lost Paradise?*

A myriad of cultures and rituals…

COASTS

A coastal village scene in Milne Bay, south-eastern New Guinea.

RIVERS

Great rivers and remote valleys…

The Baliem River in flood. Papua, New Guinea.

Highlands with snow-capped mountains...

HIGHLANDS

A traditional Highlands home in the shade of Angels' Trumpet trees grown for their potent psychedelic and medicinal properties.

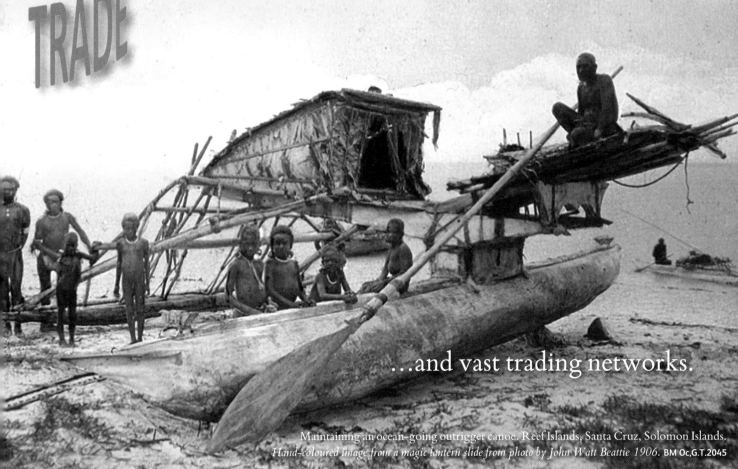

TRADE

...and vast trading networks.

Maintaining an ocean-going outrigger canoe. Reef Islands, Santa Cruz, Solomon Islands.
Hand-coloured image from a magic lantern slide from photo by John Watt Beattie 1906. BM Oc,G.T.2045

People with ancient traditions…

Tanna Island, Vanuatu……peace and
respect are major values and organisational principles.
No one goes hungry. There are no poor people.
Everybody has a house, a garden and a family. There
are no rich people either — they share everything.
David Becker. A photographer who lived
with the people of Tanna for more than 30 years

IanouLoul, Tanna, Vanuatu

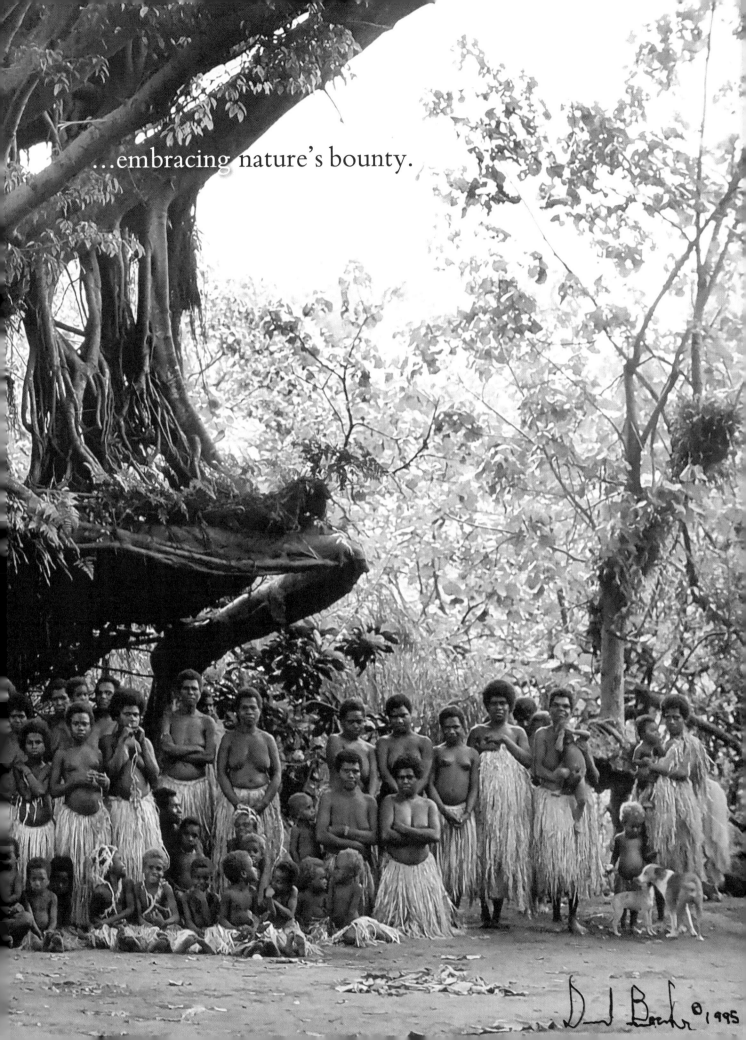

...embracing nature's bounty.

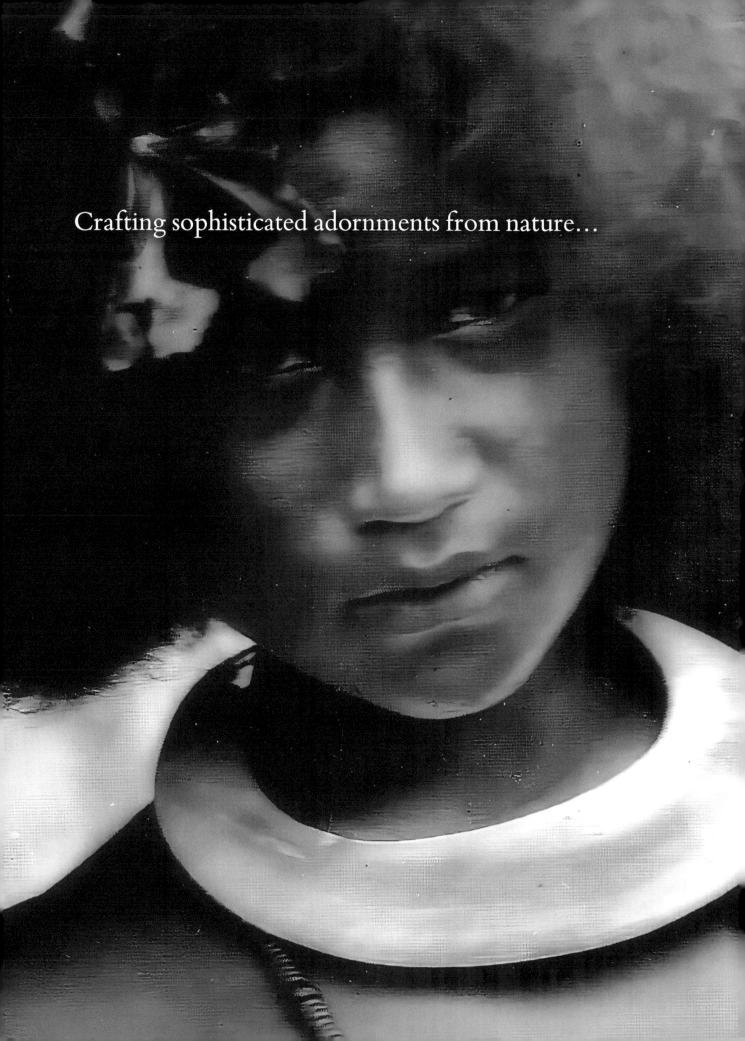

Crafting sophisticated adornments from nature…

...things that became valued heirlooms...

...and complex currencies.

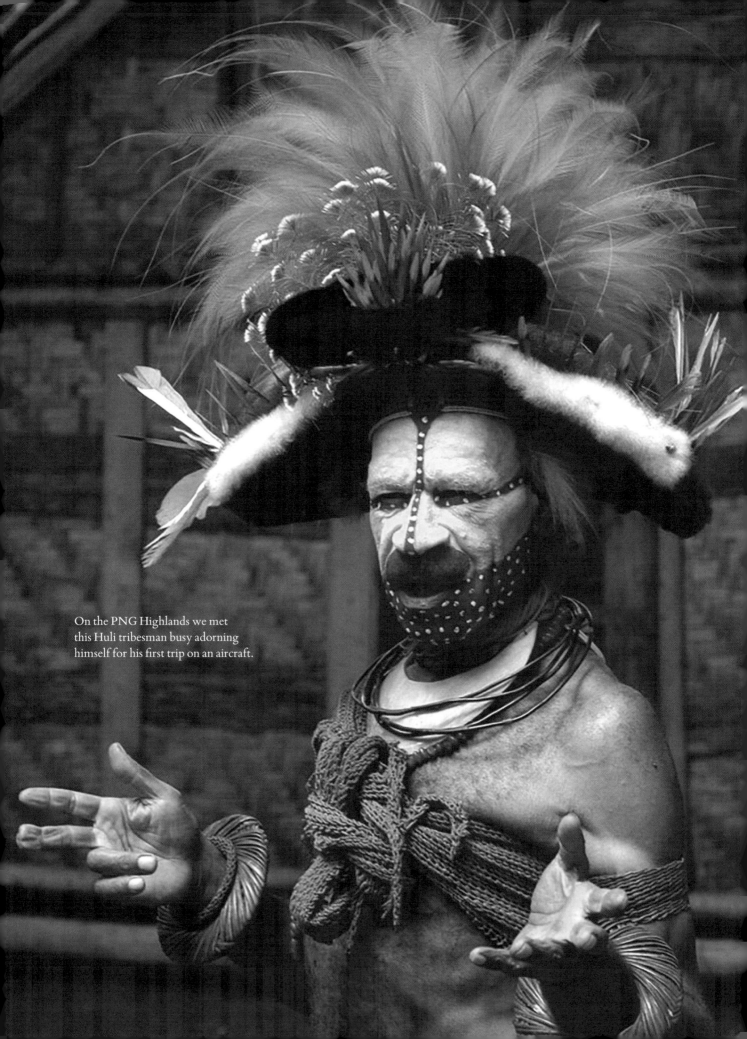

On the PNG Highlands we met
this Huli tribesman busy adorning
himself for his first trip on an aircraft.

The collection as classroom

My collecting journey…to Pacific adornments

I love nature and natural things. Looking back on it now, I have always collected stuff. Curiosity seems to be my defining characteristic. I have always surrounded myself with my own cabinet of curiosities. Friends always wanted to come and see the latest additions to *Wolfgang's Wunderkammer*. My collections are dynamic, growing and always changing – and sometimes just plain weird. From collecting grass species on the fringes of my school playing fields, Dinky Toys, the history of space travel (as I wondered if I would ever be short enough to fit into one of the Mercury capsules), advertising memorabilia, shells and fossils, to tribal art and ethnographica. Each new focus fuels my imagination – it is always my way of *learning by doing*.

Scuba diving with my wife Terri first brought me to Indonesia, New Guinea and the Pacific Ocean, before I ever heard the words Oceania or Melanesia, always seeking out the most remote places and fabled 'never-dived' coral reefs. But, even the most avid divers have to come to land sometimes. We would commune with the locals and watch them use natural resources to craft magnificent objects to support their everyday needs – physical, social or spiritual, but always eminently practical. Often these objects would end up being worn – to adorn, to celebrate or to display status, and bring prestige to their clan.

Terri and I were captivated. Memories of astonishing adornments and celebrations stayed with us long after we returned home. Body decoration is a presentation of oneself to the world. The Huli clansman pictured on the facing page was getting dressed for his first trip in a missionary plane on the Highlands of New Guinea, the second-biggest island on the planet (after Greenland) – an island that has almost no roads but is said to have more airstrips than France and Germany put together.

The colour balance of feathers and paint, brilliant reds and yellows, are as intense as his look, all offset by the simple but important pearl shell necklace.

SHELL DISC MONEY.
BUIN. SOLOMON ISLANDS.

Marqua...
3331

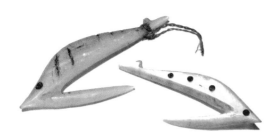

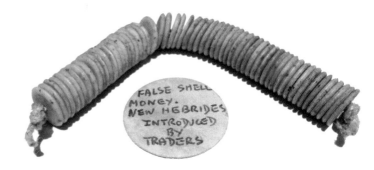

FALSE SHELL
MONEY.
NEW HEBRIDES
INTRODUCED
BY
TRADERS

3333
Rakane

New Guinea
Stone Money
Korari Tribe

CONE SHELL DISC
CURRENCY.
KIETA
NEW. GUINEA.

My existing collection of South Seas objects was supercharged with an
auction of *SGM Adams Collection of Curious Money.*

There are more than one thousand languages in the region. It was astonishing to think that people living just over the next mountain might speak a different language and have a completely different culture to one's own. This was the only place on earth where you could still meet someone who could remember what human flesh tasted like.

Of course, on each trip some items came home with us. They inhabited shelves, plinths, cabinets and drawers until we realized that we had 'a collection' and our interests zoomed in on some specifics. Due to my long interest in seashells and fossils, I was always intrigued by any objects that included shell material – especially the Chambered Nautilus and giant clam shells.

Having spent my business career trying to understand the future, including 'the future of money' (digital cash and all that stuff) I was fascinated by the shell money we came across, and the trading networks that emerged from its use.

One auction lit a fire under me : the *SGM Adams Collection of Curious Money*. Samuel George Meyers Adams was born in Yorkshire in 1918 and was known as 'Meyers' all his life. Like most English boys of the time after the First World War, he collected stamps, coins, cigarette cards and packets.

After the Second World War, on day trips to London, Adams would seek out soldiers at train stations as they returned from the war in the Pacific. Few of them carried any money but were happy to have Adams buy some of their 'South Sea Souvenirs'. This was where he developed the taste for what he called 'curious money', primal currencies made of shells, teeth and other exotic materials. An interest he pursued in parallel to his career as a jeweller and renowned medal-maker. He produced one of the first medallions commemorating Churchill's death and was elected Vice president of Yorkshire Numismatic Society in 1973. He died in January 1976, aged 57.

It was the sale of his lovingly annotated collection that amplified my interest in the existing Oceania objects we had collected on our trips. I started looking at them as more than just individual objects or 'stuff'.

Gradually my focus shifted from currency objects to those used for adornment and prestige – and the social and economic systems that surrounded them. I was starting to see them as a 'whole'. I was starting to *see the wood for the trees* in my collection.

SYNONYMS
object, article, thing, artefact
INFORMAL
whatsit, whatchamacallit, thingummy, thingy, thingamabob, thingamajig, stuff

Adornment

Throughout the ages, humans have sought out ways to enhance their appearance, prestige, status and power, if for nothing else than to attract a potential partner. It's only natural.

Amongst the oldest adornments known are perforated shell beads, roughly 10 mm across, dating back 76,000 years – see image at right. They were found in the famous Blombos Cave site on South Africa's south coast, in clusters of two to seventeen. The shells are of a tiny mollusc *Nassarius* sp.

We will meet these Nassa shells again later in the book – as the dominant shell currency in Papua New Guinea – some 70,000 years later, and on the other side of the planet.

I have been fortunate to be able to explore the earliest known city in the world, Çatalhöyük, a settlement of some 10,000 people in southern Anatolia, Turkey, that existed from 7,100 BC to 5,700 BC. Even here, archaeologists found beads made of perforated shells, stone, bone and teeth (including human teeth) that were used as adornments.

Amongst the oldest shell adornments discovered in the Asia–Pacific region are these worked, perforated

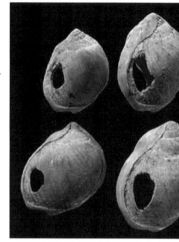

The oldest definite personal adornments yet found – a necklace made of Nassa shells, 76,000 years ago.

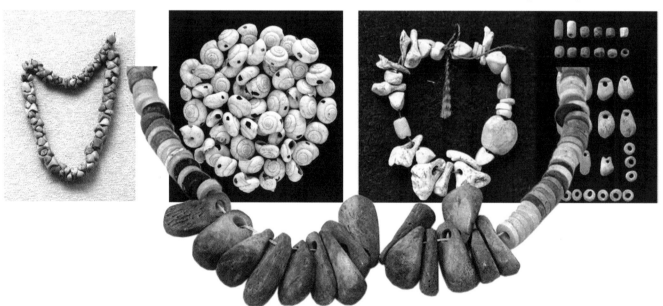

Miscellaneous stone adornments from the Çatalhöyük excavations and (second from left) ancient *Cernuella* sp. shell beads from around the Mediterranean. **Photo Jason Quinlan**

Before we utter a word, we define ourselves by the way we adapt our appearance. The human drive to adorn describes aspects of self and is a human skill as relevant as spoken language.

Sarah Corbett

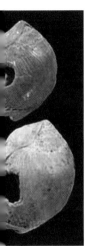

and pigment-stained *Nautilus* shell fragments from Jerimalai in Timor-Leste, dating back 6,500 years. Here, worked *Turbo*, *Trochus*, *Oliva* and *Haliotis* shells of similar age have also been documented. Wear marks indicate that the shells were in fact strung and worn as adornments.

These early adornments were made from whatever was available – and they are important for understanding both the cultures and the evolving trading networks that connected them.

Natural gold

In the West we are used to precious adornments made of shiny metal and rare stones. Think gold and silver, diamonds and rubies. We call this 'jewelry' or 'jewellery', depending on where in the English-speaking world you live.

The islanders of the South Seas had no access to any of these metals or precious stones. Precious to them instead were natural materials such as shells, feathers, teeth and all manner of fibres and pigments. The rarer and more difficult to obtain, the more highly they were regarded.

The list of natural raw materials used by South Seas islanders easily slips beyond the *normal* – into the wildly exotic – from wing bones of giant fruit bats to the fossilised shells of giant clams, many millions of years old. They crafted these natural materials with unimaginable precision and imagination – and great respect. These natural raw materials were the islanders' *natural gold*.

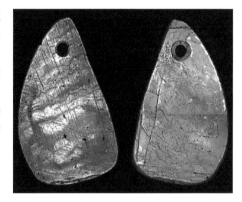

Shell fragments perforated to be worn as adornments from one of the oldest sites in the Asia-Pacific region. Jerimalai, Timor-Leste.

Ritual adornment

In the South Seas, self-decoration is often associated with festivals and ceremonies, and not so much as day-to-day wear. Rituals present special highly-orchestrated opportunities for people to reinforce their identity as members of a group or clan.

Particular combinations of body painting and adornments signify who you are and where you are from.

The Pitt-Rivers Museum

Adornments made from shells, feathers or teeth are not only decorations to wear but an integral part of traditional wealth and currency. A *toea* arm ring, such as that worn in the image at bottom right, would purchase 100 kg of sago or a massive log – extremely valuable for constructing canoes on a *Hiri* expedition. Such objects would also be used in various kinds of exchanges to pay for bridal dowries, as compensation for various disputes and used to give wealth to others, building relationships and creating future obligations.

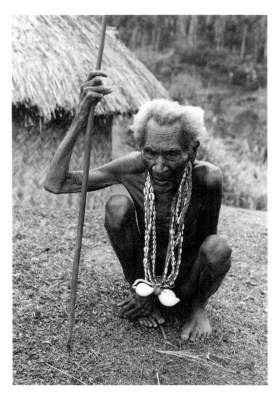

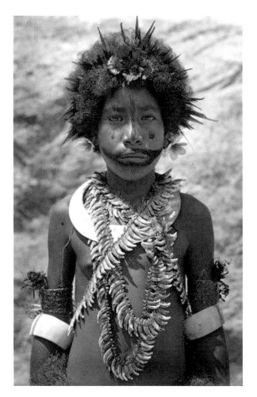

A man from the Bena Bena or Kamano people in an Eastern Highlands hamlet, decorated to show his joy for some unknown event. Among them, the egg cowrie *Ovula ovum* was most highly prized.
Photo: Stan Moriarty, 1966

Motu child wearing *dodoma* dog teeth necklaces, *toea* cone shell arm rings, woven fibre arm rings, and a *kina* pearl shell necklace. Elevala Village, Port Moresby, Papua New Guinea. **Photo: Frank Hurley V.4415, 1921**

18

Trade and Primal Currencies

For thousands of years cowrie shells provided the basics of an international monetary system across parts of Asia and Africa. Money cowries had all the characteristics you would expect of a physical currency – they were portable, durable, storable and almost indestructible. Early metal coins emerged in nations who had access to those resources. It didn't take long for leaders and governments to monopolise formal systems of exchange.

Seashells were money before coins, jewellery before gems, art before canvas.
Cynthia Barnett 2021

Because the people of the Pacific never had access to metals, their currencies continued to be based on materials from nature – primarily shells – and many sophisticated shell-based currencies developed. Somewhat surprisingly, the Australian and Polynesian societies never developed a shell-based currency as their Melanesian neighbours did.

Over the years, the South Seas cultures have seen a plethora of currencies come and go as successive colonial and occupying administrations passed. Throughout much of this, some of their informal primal currencies remained – and some morphed into adornments and powerful prestige objects.

"A currency is not a lifeless object, but a social institution"
Paul Einzig 1966

Reciprocity and 'gift-giving' cultures remained prominent and the borderline between various exchanges and currency became blurred. Objects used in presentations acquired formal value and were used as currency in exchanges – and were accumulated as both valuable and beautiful objects. Currencies became adornments and statements of wealth and prestige. It is sometimes difficult to tell if we are looking at 'valuable adornments' or 'beautiful money'.

Tok pisin, often referred to simply as Pidgin English, is an official language of Papua New Guinea, the lingua franca of the Solomon Islands and the most widely used language in the region. You will find many tok pisin terms throughout the book.

Objects and their value

I soon became aware that almost every object in these cultures have material, social and spiritual dimensions, and fulfilled multiple roles. The perceived value might change dynamically depending on its use and who owned the object at the time. Objects might be deconstructed, re-worked and made again into one of another purpose completely. Sometimes, the object might even be destroyed or buried when its purpose had been fulfilled.

The exploration of the dynamic value dimensions of objects is a key feature of my book. We'll learn that the real power is not in the objects themselves, but in the relationships they facilitate. Often the very act of giving was the ultimate expression of respect and honour – and this meant that objects involved in these exchanges had to be made with the highest standards and quality.

Objects become collections

As time went by, and my network of relationships grew, I was able to access old collections that were about to be sold, and acquire a few new objects, each one adding to my understanding. The addiction was complete.

I delighted learning from seeing and handling new items, but it was the interaction with a multitude of experts, most of them generous with their time and knowledge, that made the real difference to me. They were my 'gurus' and there is a tribute to them at the end of the book. Because of them, my growing collection literally became my classroom.

That is enough of my journey here – let's dive into the book.

This is not a book about the 'very best' objects in museums around the world, annotated by the top experts in each field. Many of you will have seen those images and their histories before. It's not a book

intended for those of you who have seen and know it all – even though you may well enjoy picking holes in my naivety.

My collection includes objects hundreds of years old and much more recent objects. From primal cultures closed to outside influence, the so-called 'pre-contact' days (at least before European adventurres), to those actively shaped by traders, missionaries and colonial administrators, to the ongoing cultural evolution shaped by commerce and industry today. The material culture 'post-contact' remains equally fascinating to me.

I have always been most interested in objects that told a story – objects that are bridges and catalysts into another world. The dust and grime you see in some of my photos is an essential part of their story. The book is positioned in the middle ground between 'old-school' collectors, dealers and academia, and the fresh new faces who are perhaps experiencing this topic for the first time –may you all find unexpected delights and a surprise or two within.

I hope that this is not just another Tribal Art book. I want it to be a fresh look at the old subjects. Some of the younger readers will undoubtedly become the respected academics, traders and collectors of tomorrow. Some will be inspired to create modern versions of these exotic designs and continue the creative flow into the future. For some, it may become a journey of discovery not unlike my own. For all of you, I hope this book can be fun, and that perhaps my 'gurus' will accept this book as another perspective on 'your' world, and perhaps open up a few yet untrodden paths for you.

The Western Tribal Art Market treats as 'important' carved figures, masks, shields and weapons but largely ignores body adornments and items of currency as somewhat inferior to these larger and more popular items. Yet, from a local cultural and spiritual context these objects are an essential part of life – in all its dimensions. This book gets behind the passion, the unique skills and the craftsmanship of the mostly unrecognised individuals who made these objects – and celebrates their unparalleled delight in visual beauty, the drama of adornment, cultures permeated by myths and magic, plus their unique mastery of natural materials.

Wolfgang Grulke,
Oborne, Dorset, UK
November 2021

This book is a celebration of creative cultures told through the lens of my collection. It's about passion and learning, the consequence of curiosity and the thrill of discovery. It is unapologetically anecdotal and selfishly visual.
That's my way of understanding, loving and learning.
Share with me.

THE SOUTH SEA

The place, the people and their history

Two hundred years ago returning European explorers told tales of the Pacific islands as a place of both savage cultures and unbounded beauty. Since then, these islands have been eulogised by many as a distant and idealised paradise – seductive spells of relaxed tropical life under swaying palms, beautiful women garlanded with flowers and heroic male characters ready for ceremonies and pleasures of all imagined kinds. Beyond these stereotypes, we have since learned of a diverse people with a vastly different range of beliefs, myths, origin stories and exciting material cultures.

From the start of the 19th century, the observers began to change the observed. First, there was a flood of dedicated missionaries and the push to convert to Christianity (more than 90% of the population is now Christian). Then came colonialism and industrialisation – with the intensive search for natural resources to be exploited and predictably, the seduction of 'Western Values'.

Oceania's 40 million people speak more than 1000 languages.

Today, this area of the south-west Pacific is called Oceania, comprising the four regions of Australia, Melanesia, Micronesia and Polynesia. More than two centuries of colonial expansion have altered much of the South Pacific, and little of the *South Sea Paradise* remains. The region where this ideal has best survived, where intervention was later and lighter, is Melanesia. Here, the non-hierarchical social and cultural systems proved more resilient to the three-pronged attack of colonial administrations, colonial traders and missionary zeal. Melanesia accounts for 90% of the population of Oceania and includes the four independent countries of Fiji, Vanuatu, Solomon Islands, Papua New Guinea, as well as the French special region of New Caledonia, and parts of Indonesia – particularly Papua Province,

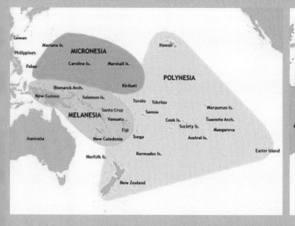

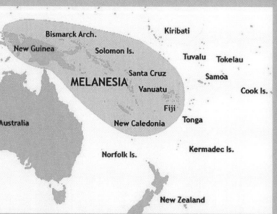

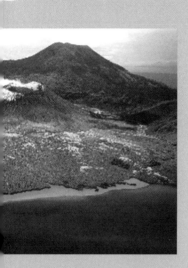

the western portion of the island of New Guinea. More detailed maps are found on the endpapers of this book.

New Guinea is by far the largest of the South Sea islands and has been divided, initially by Dutch, German and British colonial administrations, and later by those of Australia and Indonesia. Resulting in many name changes. In this book I use 'Papua' to mean the western portion of the island of New Guinea, officially called Papua Province of Indonesia, and I use 'Papua New Guinea' (or 'PNG') to mean the independent country that makes up the eastern part of the island of New Guinea. I use 'New Guinea' to refer to the whole island and 'New Guinea Highlands' to mean the mountainous interior that spreads across both Papua and PNG.

It is vital to understand the geography and geology of this region which is characterised by two active volcanic belts – one across the island of New Guinea and the other off the eastern coast of New Guinea, from Rabaul and through to the Solomon Islands.

Below left is an exaggerated relief map of New Guinea, the world's second-largest island, highlights its backbone of mountains – with the Highlands region and the Bismarck Archipelago beyond. Massive volcanic eruptions in primordial times created these steep mountains and deposited rivers of lava and ash fields that have now transformed into fertile lands and dense vegetation, rain forests and high alpine meadows.

Before the first human colonisations the region was truly inhabited by 'dragons': cassowaries heavier than 200 kg, lizards that weighed a ton and monstrous crocodiles and snakes. Today it is estimated that 2,500 species of orchids inhabit these islands, and it is still the only place where the spectacular birds of paradise roam.

New Guinea has several great rivers, all of which embrace virgin forests, winding waterways and remote villages. The Sepik, Fly, Ramu, Baliem and Mamberamo are the most significant of these productive waterways. As can be expected, people are clustered along coasts, rivers and on the fertile highlands.

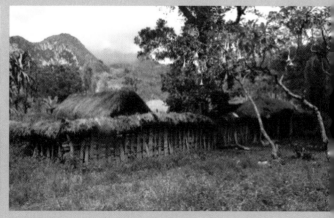

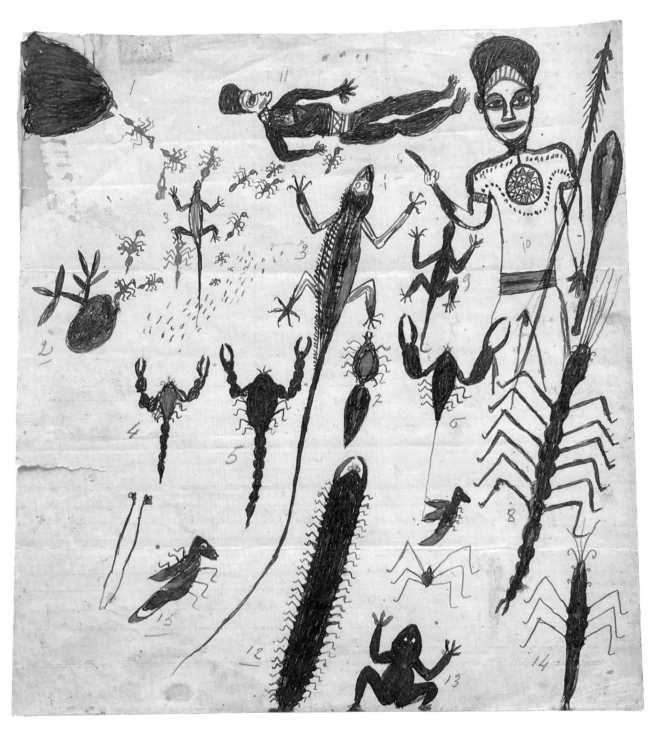

This recently rediscovered drawing, titled Susagu calling for a feast, *dates from the mid-1930s and was drawn by Herman Somuk, a village chief from Buka Island, Bougainville, the eastern-most island of Papua New Guinea. The figure on the right, carrying a spear and club and wearing a kind of* kapkap *adornment, is Susagu, a character in Buka mythology. Susagu is a young orphan from the village of Tousahun in which almost all of the inhabitants were killed by outsiders. As an adult, Susagu decides on revenge by going to meet Mouketek, the murderer of his parents. He captures Mouketek from an enemy village and organises a great feast, inviting the inhabitants of "all the villages". Shortly before their arrival, Susagu kills Mouketek – his corpse is represented by the horizontal blood-stained figure. The animals represent the offerings at the celebratory feast.* AM

Myths and Origin Stories

Towards the climax in Dan Brown's book *Origin*, the hero Robert Langdon's friend Edmond Kirsch declares that two fundamental questions have captivated humans since we first became self-aware:

Where do we come from?
Where are we going?

These are questions about our origin and our destiny. In terms of the former, the people of the South Seas appear to have paid fairly little attention to the geological and archaeological evidence of their past, but their myths and origin stories are ubiquitous and remain embedded in rituals, feasts and celebrations. They have strong influence over human affairs and are of profound consequence – despite centuries of persistent conversion to Christian beliefs.

Although there is a relative absence of myths concerned with the origin of the stars, sun and earth, there are many about the concept of a primeval sea and the origins of animals and humans. Because these have developed in oral traditions, there are multiple versions and much local adaptation within the various language groups.

Mankind and the animals are typically created by some spirit or pre-existing being from mud, blood, wood or fire, or alternatively appear spontaneously and magically, either on land or in the sea.

These myths range from simple to incredibly complex tales which seem to become more interesting with each new telling. As with all good stories, the relevance, and the beauty, is in the detail. Following are just a few examples.

The whole village went to a ceremony in a neighbouring village, but a crippled man was left behind. While alone, he was approached by a sea spirit and given this mask, and its knowledge.

This myth is pervasive east of the Ramu River delta, PNG. Chris Boylan took this photo in Sisimangu village in 1992, of a dancer wearing a complex shell and dog teeth dance mask *gupai gap*. He is covered in leaves and the mask obscures his face – the whole represents the sea spirit. These iconic masks are only worn in this handful of villages.

Man was alone and longed for a wife. He took an axe, cut down a tree, carved the figure of a woman, and wished it to become one.

Admiralty Islands myth

Adaro the Sea-spirit

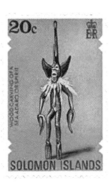

The story of the *Adaro*, a malevolent merman-like sea spirit from the mythology of the Solomon Islands is one of my favourites. *Adaro* is said to arise from the wicked part of a person's spirit, which is divided between the *Aunga* (good) which dies, and the *Adaro* (evil) which stays on as a ghost. *Adaro* is variously described as a man with gills behind his ears, tail fins for feet, a horn like a shark's dorsal fin, and a swordfish- or sawfish-like spear growing out of his head. He may also travel in waterspouts and along rainbows and is said to kill unwary fishermen by firing flying fish at them.

The spiritual and functional objects made to represent *Adaro* have clearly been fired by creative juices, such as the *Adaro* shown here, imaginatively carved from turtle shell. So pervasive is this myth that *Adaro* is found in many guises and has even made it onto Solomon Islands stamps and coins.

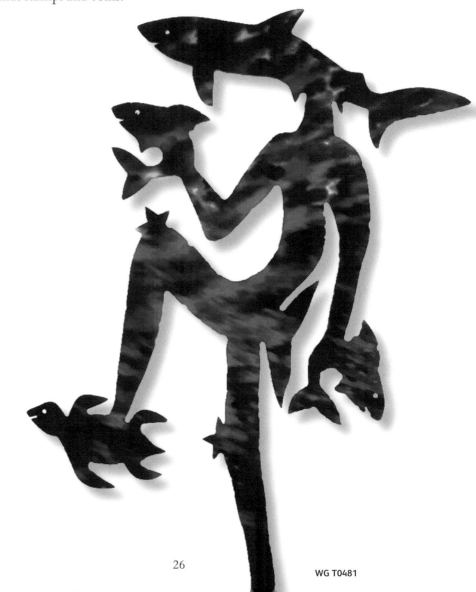

WG T0481

Two Brothers & life's duality

The duality of mankind, light and darkness, good and evil, are ubiquitous themes in parables and myths. By way of illustrating this duality, *Two Brothers* appear as central characters in many myths throughout the South Seas. The older brother is invariably more conservative and follows customs and laws; the younger brother is portrayed as unpredictable and even malicious, but he embraces the idea that *Change is Good*, and is often the creative one. The brothers quarrel constantly but also use their magic for the betterment of everyone, making things 'come into the world' such as places, food, objects and prosperous trading networks. Invariably, it is the younger brother who turns out to be more important and revered. The older brother represents the earthbound rational man, while the younger embodies the greater creative spiritual force.

The Kambot people who live in East Sepik Province, have their own version of the Two Brothers myth – of Wain, the older brother who is conservative while Mopul, the younger, is creative, innovative and has access to magic and other powers that Wain does not. After personal conflicts over Wain's wife, Mopul disappears in the ensuing conflict, never to be seen again. The descendants of Wain establish the village of Kambot on the Keram River and live there till the present day. It is ironic that Mopul, the younger brother, remains revered as the paramount ancestor figure of the Kambot people. It is his image that is painted on the façade of their Spirit House. Wain, the elder brother, is never depicted in important and sacred representations.

This bark painting in the National Museum and Art Gallery of Papua New Guinea, features the younger brother Mopul. The birds above his shoulders are cassowaries. Above his head is his dog, plus a lizard and wallaby. Mopul is elaborately adorned: his headdress has cockerel tail feathers and fish bones. Around his neck is a crescent pearl shell *kina* and an oval shell. On his shoulders are the scarification marks of a fully initiated man and he wears adornments of dog teeth, cowrie and Nassa shells on his forehead and around his waist.

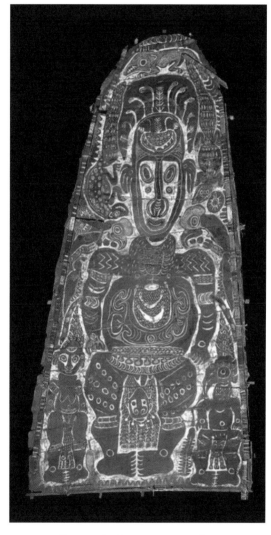

Painting by Simon Nowep who worked in the village of Kambot in the 1960s–1980s.

Dema: The spiritual essence of things

Dema ceremonies feature some of the most spectacular adornments ever seen in the South Seas.

The central concept of the Marind-anim culture, which occupies a vast area in south-eastern Papua, is that of *dema*, variously a spirit, totem-ancestor and/or spiritual being. *Demas* prefer to inhabit rivers, forests, hills, but are not bound by them. Stars can be *demas* and can visit a home when not occupied in lighting up the sky. This culture belives that they owe their origin to the *demas*; before humans were humans, they too were *demas*. The word *dema* is used either as a noun or as a powerful adjective indicating *the supernatural essence of all things*.

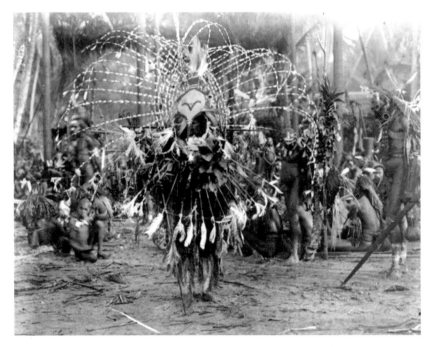

Mayo-Marind (a sub-culture of Marind-anim people) performing their fabled *dema* ceremonial dances. Early 20th century **NL RV-1999-550 and TM-10008117**

Dema is not used lightly or carelessly. It is surrounded with awe and mystery. When a Marind wants to relate mythical adventures he lowers his voice to a mysterious whisper, interspersing his words with meaningful pauses and clicking of his tongue, with long drawn-out whistles of amazement, as he slowly proceeds with his story, emphasizing his words with impressive gestures.

Van Baal, D. J. 1966
Dema: Description and analysis of Marind-anim culture.

These drawings by Father P. Vertenten between 1910–1930 show a Mayo-Marind dancer wearing a mask representing a *dema* cormorant totem figure called *kar-a-kar*. The cormorant plays an important role in these rituals. In his hands the dancer holds bundles of leaves. The *kar-a-kar* dances in and out of the hut where the deceased lies at night, all the time imitating the sound of the cormorant. Only at dawn do the *demas* of the stork *ndik,* and the dog *ngot*, appear.

During ceremonies, other *dema* totems were displayed attached to sticks. The pigeon *dema* is a spirit animal rooted in Marind mythology, through a story in which a man is re-incarnated as a pigeon after being wrapped in banana-leaves.

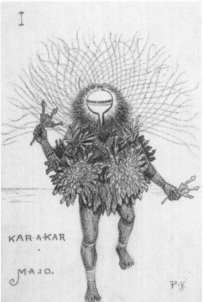 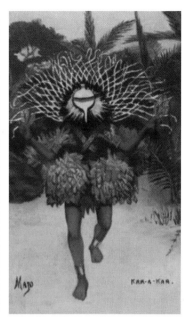

A Mayo–Marind dancer representing a *dema* cormorant totem figure called kar-a-kar.
SP TM-5969-44 and SP TM-5969-78

A pigeon dema totem at right is carved from wood and decorated with Job's Tears seeds and Abrus seeds. Size: 330 x 340 mm. **NL RV-2385-16**

Spectacular as these early 20th century black and white images of the events are, when colourised with today's technology, the impact the spiritual mystery can truly come to life…just turn the page to see one of these ceremonies in imagined colour.

"*Dema* has to be seen to appreciate it fully. What can a few dead photos say? I would love you to see the scenes in all their splendid colour, in the elegance of their graceful spontaneous rythms, the totally original art of these people of nature, uninhibited, expressing beauty in the depths of their souls, their spiritual conception of the great questions of life."

Translated from Pater H. Geurtjens 1933
Onder de Kaka-kaja's.

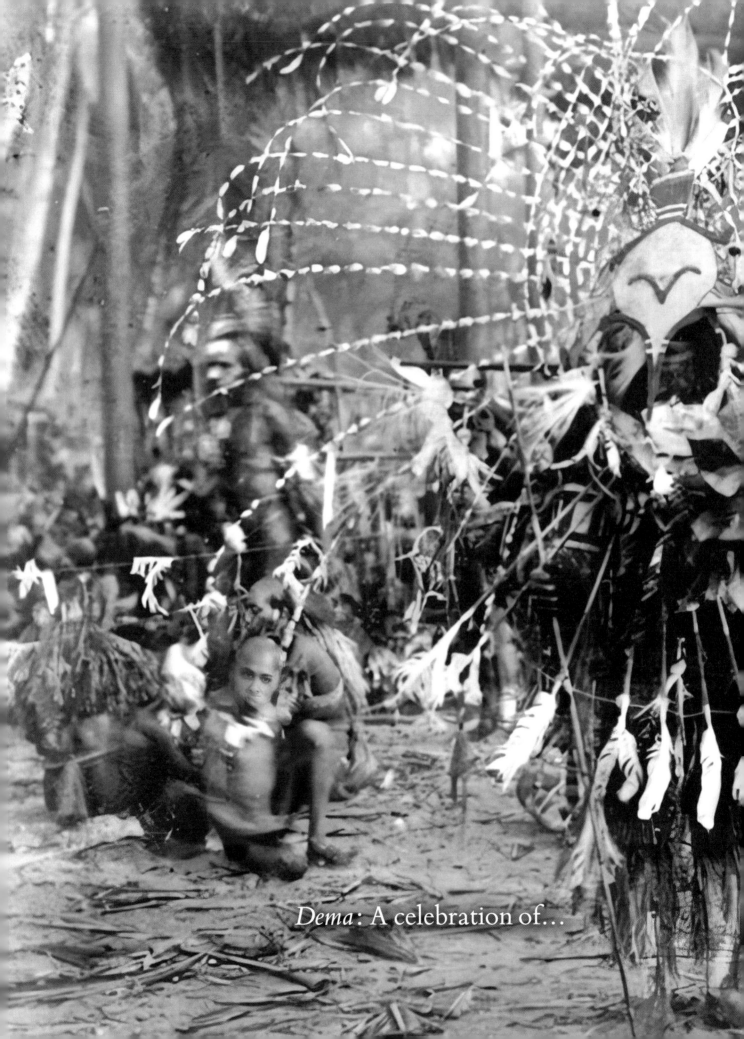

Dema: A celebration of…

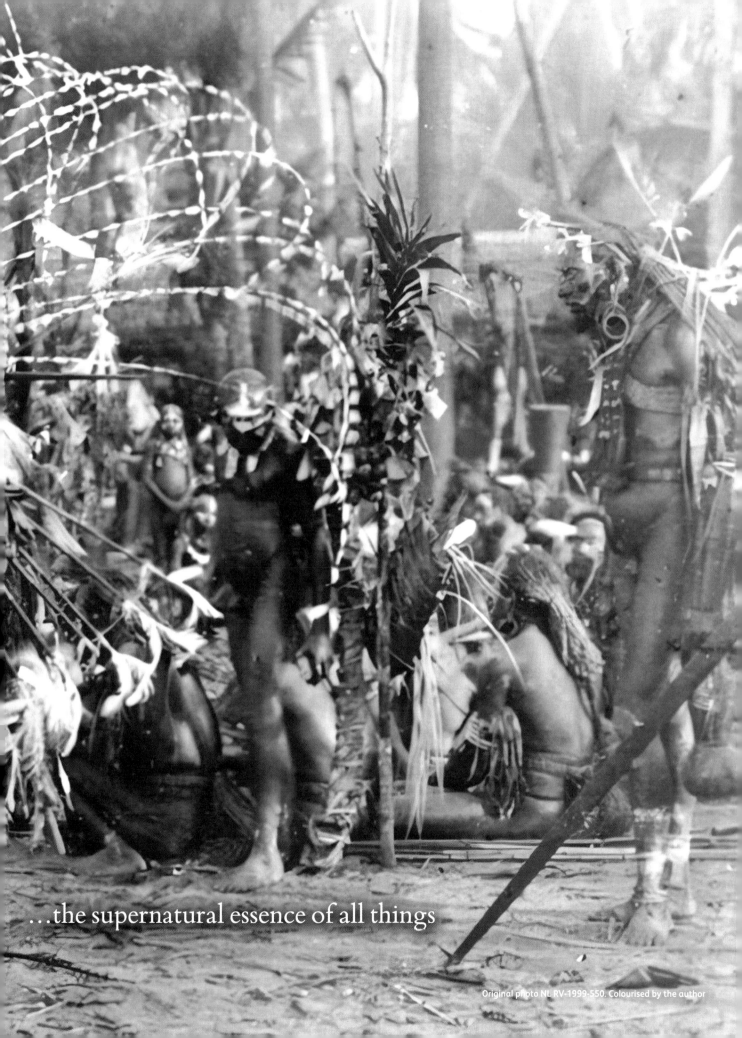

...the supernatural essence of all things

Origin Stories

Each of us is aware of one or more 'origin stories'. Some we believe in, and others we consider might be possible. Others we scorn. For you, it may be a myth, religion or science that wins the day.

In the South Seas islands, stories about how 'the world' was created are rather less common than specific local myths, examples of which we have seen earlier. In 'origin stories' that do exist, there is a consistent thread that life originated from within the islands rather than arriving from somewhere far away.

To the people of the Sepik River region of New Guinea, the crocodile symbolizes strength, power and manhood. It is not surprising that crocodiles feature heavily in their myths and origin stories, and some tell how crocodiles migrated from the Sepik River onto land to eventually become humans.

A sculpture of *Kumbiamu*, the Creator Spirit. Carved by Apel Paimbun (c.1932–2000) of Tigaui village, Middle Sepik in 1975. The Creator was generally depicted as half man and half crocodile, with an enlarged head and projecting eyes. **CB**

The Great Crocodile Creator

In the clan-structured society of the Iatmul people of the Middle Sepik, each clan has their own crocodile spirit name and story. One of these is told below. Literally, *Kumbiamu* brought all the features of the world into existence—trees, mountains, stars, winds, rains, tributaries, villages, actions, virtually everything in the world. The names he gave them are magical totemic names still used today.

Kumbiamu, *the Great Crocodile Creator*
In the beginning, the world was covered in water. The Great Crocodile Creator, Kumbiamu, *lived alone in the water, the only creature in his vast realm. He decided to build land, and using his powerful tail, scooped ground until it rose above the water; but every time he attempted to climb onto the land, it sank again. Finally, he mixed his own faeces with the ground, and when he crawled onto the land it remained firm.*
In celebration he decorated himself with body ornaments using shells, fibres and feathers. Dancing on the newly created land; he threw off his decorations – trees and plants grew from what fell on the land; other decorations fell into the water to create fish and water creatures; feathers flew into the sky to become birds.

Told by Yambei (who died in the 1990s) a Big Man of Tigaui village, Middle Sepik River, PNG.

In the context of this book, it is interesting to see how decorating the body, and natural adornments, are key features in many of these stories.

The Iatmul people have many myths about the creation of humans. The most important myths surround a woman and a male bird, always an eagle, and the original creator female human who lays eggs from which hatch many different creatures. This creation myth is carved into the large gable figure on some Sepik Spirit Houses that depicts a female figure surmounted by an eagle.

Connection to the Crocodile Creator is central to the skin cutting ceremonies of the Sepik region. During rites of passage, the young men of the Chambri tribe of the east Sepik proudly have hundreds of deep scars cut into their skin to resemble the look and feel of a crocodile's body.

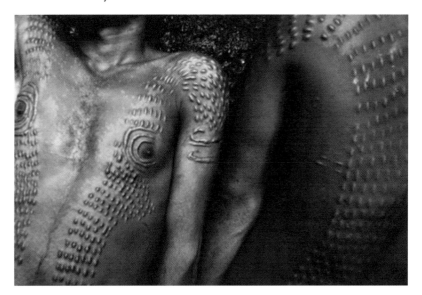

Photos: Left - David Kirkland; right CB. Yamok village, Sepik River, 1998.

Traditionally they were ensconced within the Spirit House for many months, where they learned much of the secret knowledge passed onto them by the initiated men – knowledge of the spirits, war, headhunting and much more. When young men enter the Spirit House for a skin cutting ceremony, they entered the "crocodile's nest", to emerge finally as men and fierce warriors.

The Bulaa dog and python myth

Ethnographer Reginald E. Guise lived amongst the Hula or Bula coastal people, south of Port Moresby in Bulaa village, from 1883 for almost two decades. This, in summary, is their origin myth, published in The Journal of the Anthropological Institute of Great Britain and Ireland, Nov 1899, and pointed out to us by Dr Dolly Guise, his great grand-daughter and one of PNG's first indigenous anthropologists:

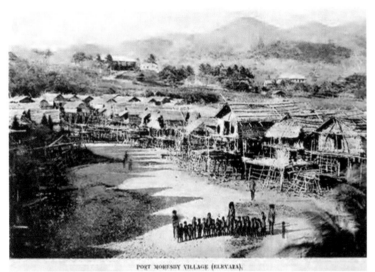

Port Moresby Village. Early 20th century postcard

Many ages ago the surface of the earth was uninhabited, but underneath the surface lived a dog and a python. One day the dog met the python and, remarking that they were both living lonely lives, suggested that they should marry. In time the python produced two male children and one female child. In time, the two men married the one woman. To one she bore two girls and to the other two boys. They too married and had many offspring.

One day the dog organised a hunting party, and they came across an iguana in a lofty areca nut palm. The dog ordered one of his sons to dislodge the iguana. He climbed up towards it only to find that it had escaped up the tree and onto the crust of the earth through a hole. He followed it into a beautiful world bathed in bright sunshine. He totally forgot about the iguana.

The son returned to his relations, described what he had seen, and urged them to leave the gloom and darkness in which they lived, and follow him. Six couples agreed to join him, but the dog (their father and grandfather) was enraged and threatened to cut down the palm tree should they carry out their plan. The following day they left for the surface and the dog cut down the palm to prevent their return.

On their arrival at the top, each couple took a different direction and formed six villages. Sometime afterwards, feeling the approach of death, the dog's son called together his relations and gave them strict injunctions that on the death of anyone who had come from the bowels of the earth, his remains and all utensils belonging to him should be placed at the mouth of a cave. In obedience to his commands this was done, and their skulls and bones may be seen there at the present day.

The Aboriginal Creator of Life

In *Dreamtime*, the world was flat and cold, dry, void of all living things, but below in mysterious caverns, the *Rainbow Serpent* slumbered with all animal tribes in her stomach awaiting their birth.

She emerged, calling the animals to awaken, created the sun and fire, flooded the land with water and moved across the landscape forming mountains, valleys, rivers, and waterholes. In the Kimberlys, it is believed the *Rainbow Serpent* deposited 'spirit children' in waterholes, and women would become impregnated as they waded in the water.

Although details vary from group to group, essentially, the *Rainbow Serpent* was the *Creator of Life*. She is associated most strongly with water, lightning and thunder. The earliest known depictions of the Rainbow Serpent are on rock art dating back more than 6,000 years.

Huli Origins and the Fertility of the Environment

In the Huli culture, the world was originally formless clay-like mud. The Sun moved above the world warming and strengthening it while a Serpent glided across the landscape, forming mountains and valleys and rivers. In Huli territory there are ritual roads that criss-cross the landscape and form *sacred nodes* at their intersections. These may be a hilltop, cave, waterfall or some other significant natural location and it is at these *sacred nodes* that the mythic Creator Serpent rests on its journey across the land.

The Huli believe that fertility is morally constituted. Hence, it is of consequence to act and behave in certain moral ways for the world to remain fertile, and for fertility not to dissipate over time. The fertility of gardens, animals, human procreation, earthquakes, volcanic eruptions and frosts are all seen as part of the overall balance of the world.

Some Hulis consider that mining goes against these ancient views of fertility and balance. However, mining is a major employer in their area, and economic realities often trump the old traditions.

Origin Stories from Science
Early Migrations/Material Cultures

Around 100 million years ago, the Australian/New Guinea land mass separated from Antarctica, and they remained connected until relatively recently. Archaeological evidence suggests human occupation of both New Guinea and Australia began around 60,000 years ago and by 30,000 years ago humans had settled the New Guinea Highlands. These early migrations spread as far as Fiji and became the foundation of the Melanesian cultures. As the climate warmed after the last ice age, around 10,000 years ago, the seas slowly rose and cut off land bridges connecting New Guinea to both Asia and Australia. If you look at the map on the book's inside covers you can vividly see the shallow sea floor in the Torres Strait, between Australia and New Guinea.

Locals have used shells for carving tools and making adornments here for thousands of years. The first evidence goes back 11,000 years, to several clam shell adzes that were found in a Pamwak Rockshelter in Manus Province of PNG. The first evidence of shell use in the Highlands, at much the same time, was of fresh-water mussels that furnished lustrous body adornments. These valuables began to be used as material symbols of the interactions and relationships between individuals, groups, and whole societies.

Near Misool, an island west of New Guinea, fascinating ochre rock paintings have been found that depict human figures, fish, flowers and plants, tools and vessels, and the occasional hand. They date back almost 5,000 years.

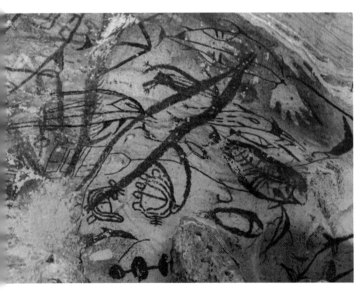

Rock paintings off the island of Misool, Raja Ampat. mostly done in ochre. It is estimated that they are anywhere between 3,000 to 5,000 years old.

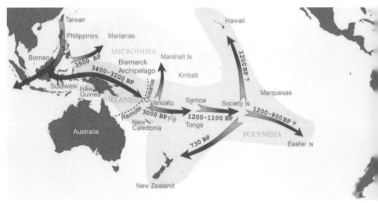

Tracking later human migration into Micronesia and Polynesia.
Elizabeth A. Matisoo-Smith, PNAS November 3, 2015

By the mid–Holocene, 4,000–3,000 years ago, shell artefact manufacture increased exponentially around the time of the Austronesian migrations associated with the distinctive Lapita geometric dentate-stamped pottery, and the use and widespread distribution of obsidian.

The Lapita people were expert navigators and seafarers. They populated some regions of New Guinea and Melanesia, but moved outwards into the Pacific Ocean, populating the far-flung islands from New Zealand to Hawaii and Easter Island. This movement of people across the Pacific is one of the greatest migration stories of human history.

Lapita bracelets and pendants discovered alongside the pottery represent the first records of giant clam shell being used to shape ornaments and jewellery in Oceania. They were found primarily in the tombs of chiefs and notables and were likely reserved for their use and could have been used as trade valuables and informal currencies. The bracelets certainly made their way onto many other islands in the South Seas, and perhaps influenced the Solomon Islands material culture and their obsession with rings made from clam shells.

Some early cone shell artefacts found during archaeological digs, and in shell middens along the Collingwood Bay coast of eastern New Guinea, have been dated to between 1,000–500 years old in studies by Harry Beran and others. They represent the earliest representation of the Massim curvilinear design style that continued to be produced by Massim woodcarvers in the 19th and 20th centuries.

Lapita pottery from Vanuatu,
Museum in Port Vila.
Photo Torben Brinker

Lapita bracelets carved from
fossil giant clam shell ca.
1000–500 years ago. Found
in the Philippines.
WGT0288 and WGT0289

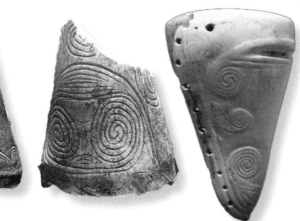

Australian Museum Sydney. E.15597, E.15595A. 105 mm and 80 mm. AM Oceanic Art,1995. 17 MH Archive

37

South Seas society and rituals

Early European explorers

When, in 1519, Ferdinand Magellan became the first European to cross the Pacific Ocean, the 'Spice Islands' (in modern-day Indonesia) were already well known. By the middle of the 18th century, the battle for European dominance of the oceans became heated. Britain, France, Spain, Portugal and the Netherlands had already spent several centuries traversing the globe in search of new land to conquer and resources to exploit, but the Pacific – and specifically, the fabled 'South Seas' – remained largely unknown but were thought to have the potential for enormous wealth.

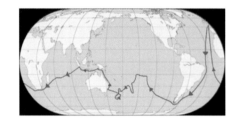

The first expedition of James Cook to the South Pacific Ocean aboard HMS Endeavour, from 1768 to 1771, included stops at several Pacific islands to claim them for Great Britain. These were necessary stops to provision their ships with fresh food and water. On his second voyage from 1772 to 1775 his visits included Easter Island, the Marquesas, Tahiti and New Caledonia.

It would not be too long before the first European explorers were followed by adventurers, explorers, researchers and missionaries. The languages they encountered were extremely varied and complex. Without a common language their conversations and understanding must have been no more than trivial. The societal mores and the associated rituals must have seemed bizarre and alien.

Big Men, spirit houses & initiation

In the broadest sense, the societies of the peoples of the Pacific can be divided into two major groups: Big Man societies in Melanesia (termed the South Seas in this book) and *Hierarchical* or *Chiefly* societies in Polynesia and Micronesia. These divisions relate closely to the migrations discussed on the previous pages. The earlier migrations 60 to 30,000 years ago were characterised by egalitarian social structures (think of them as 'first among equals'), and the Austronesian migrations 4,000 to 3,000 years ago that manifested inherent chiefly structures, such as in Polynesia.

Migrations are complex systems, and there is much overlapping. For example, as the Austronesians expanded eastwards, they mixed

with the earlier settled populations. Along with bestowing pottery and other new ideas, some communities developed chiefly societies. The Trobriand Islands off eastern New Guinea is a compelling example, as is Manam Island off the north coast of New Guinea, with its system of hereditary chiefs called *kukarai*. The same mix occurred in the Solomon Islands, Vanuatu and New Caledonia. Fiji is an example of a predominantly Melanesian population overlaid by the Austronesian hierarchical society, with chiefs at the apex.

In most South Seas settlements, a Spirit House or Men's House was central, and the exclusive domain of men. Male and female development within society was structured and pre-ordained. In many coastal and riverine regions, such as the Sepik River and Papuan Gulf areas of New Guinea, lavish Spirit Houses, containing the ritual power of men, decorated inside and outside, dominated a village.

The Spirit House is lavishly decorated internally and externally. After use, artefacts that are retained and not intended to be seen by the uninitiated are kept on display here. The floor, walls, ceiling and all contents are believed to be inhabited by ancestral spirits.

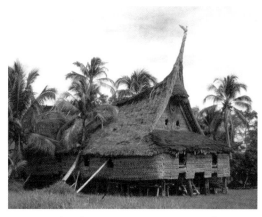

A lavish new Guinea Spirit House"
Photo: CB

In Polynesia, Spirit Houses were built on layered stone platforms. In Fiji they were known as Bure kalou and rose to six stories high. A class of priests, under the chief, had sole charge of these temple grounds.

Initiated men congregated inside the Spirit House and oratory was important – plans for warfare and headhunting expeditions were initiated here. The initiation of young men was an important part of the process to develop youths into men and warriors. In the Highlands regions, men lived totally separate from women, together in a central Men's House. At a young age, boys were separated from their mothers (and unwanted female influences) to begin their male education. Highlanders never developed extravagant Spirit Houses like coastal groups, and had simpler but still intense rites of passage for young men. But everywhere the spirits were both feared and respected.

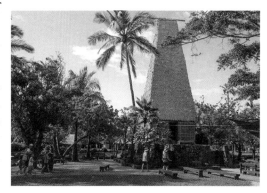

Fijian *Bure kalou* Spirit House.
Photo: Polynesian Cultural Centre Hawaii

Male initiation, through the associated rituals, was the path to manhood and customary knowledge. They could pursue individual aspirations to rise in status and become 'Big Men'. Initiation could be a single (often intense) experience, or gradual growth through numerous initiation levels.

The scarification rituals of the Chambri tribe allowed boys to take the form of crocodiles. Iatmul youths entering manhood traditionally had to take an enemy head. For the Abelam there were up to thirteen initiation levels to reach superior understanding of both manhood and the spiritual world. The spirits were central to these rituals and ceremonies, often intimately entwined with fertility rites, as therein lay the future strength of the tribe.

Associated with rites of passage were major ceremonies that demanded body adornment of the highest calibre. The body itself needed to glow with good health, showing off the strength of the community. Shell, fibre and feather adornments complemented the bodies, further demonstrating wealth and status.

Important for achievement of high status was also skill in oratory, where a man would set forth his viewpoints and convictions, that would guide his society. A chief or a Big Man could maintain recognition through skilled persuasion and display of wisdom. He would have a large group of followers, both from his clan and from other clans, providing them with advice, protection and economic assistance, in return receiving support which he would use to further increase his status.

In the Solomon Islands, bonito is a favourite food fish. Amongst the Sa'a people of southern Malaita, bonito are thought of as the manifestations of sacred deities and can only be hunted by initiated men – they have first to be part of the 'bonito cult'. During the hot months of shifting winds from March to June, men would go on fishing expeditions to hunt schools of bonito, tuna and skipjack – always accompanied by ceremonies and rituals.

At the time of independence, the Solomon Islands, Fiji and Vanuatu recognised the status of chiefs through specifying constitutional roles for chiefs in government. By contrast, the roles of the Big Man in New Guinea were surprisingly undefined. The Constitution of the Independent State of Papua New Guinea (PNG), despite its length of 123 pages as initially published in 1975, made no mention whatsoever of their role. Subsequently, PNG introduced a system of honours, with the title *Grand Chief* – an honorary title only, but one that connected them more closely to their Pacific neighbours.

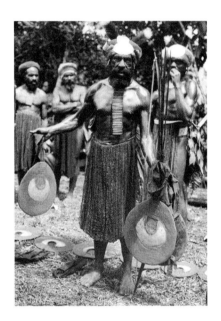

A Melpa Big Man holding two *Moka kina* at a *Moka* exchange ceremony, Keltiga village, Mount Hagen, Western Highlands.
Photo: Stan Moriarty 1963

The betel nut tradition

The Areca palm *Areca catechu* grows in much of Melanesia and Southeast Asia, and parts of east Africa. The fruit, a nut, is commonly referred to as 'betel nut' and is sometimes confused with 'betel leaves' *Piper betle* that are often used to wrap it.

Usually, a few slices of the nut are wrapped in a leaf along with lime (burnt coral) and may include clove, cardamom or other spices for extra flavouring. Betel leaf has a fresh, peppery taste, but it can be bitter to some degree, depending on the variety.

A common sight in local markets are the betel sellers. Nuts, leaves and small bags of powdered white lime are proudly displayed, as well as beautifully woven baskets in which betel chewing paraphernalia is kept. The varied utensils associated with betel chewing, such as spatulas, are also prestigious and fascinating in their own right.

Chewing the mixture of areca nut, betel leaf and lime is a tradition, custom, and ritual which dates back thousands of years. The combination acts as a mild stimulant. It is said to cause euphoria, good humour, reduce hunger pangs and an increased capacity for work. The visual evidence that remains are the unmistakeable red stains on the gums and teeth of users.

Betel chewing is a central part of life. Children start chewing when only a few years old. Adults chew when they make love, meet friends, work in the garden, attend feasts and during canoe voyages.
Sometimes, betel nuts are placed in the hands of a corpse for the guardian of the place of the dead, so he will let the spirit pass.

Harry Beran 1988

41

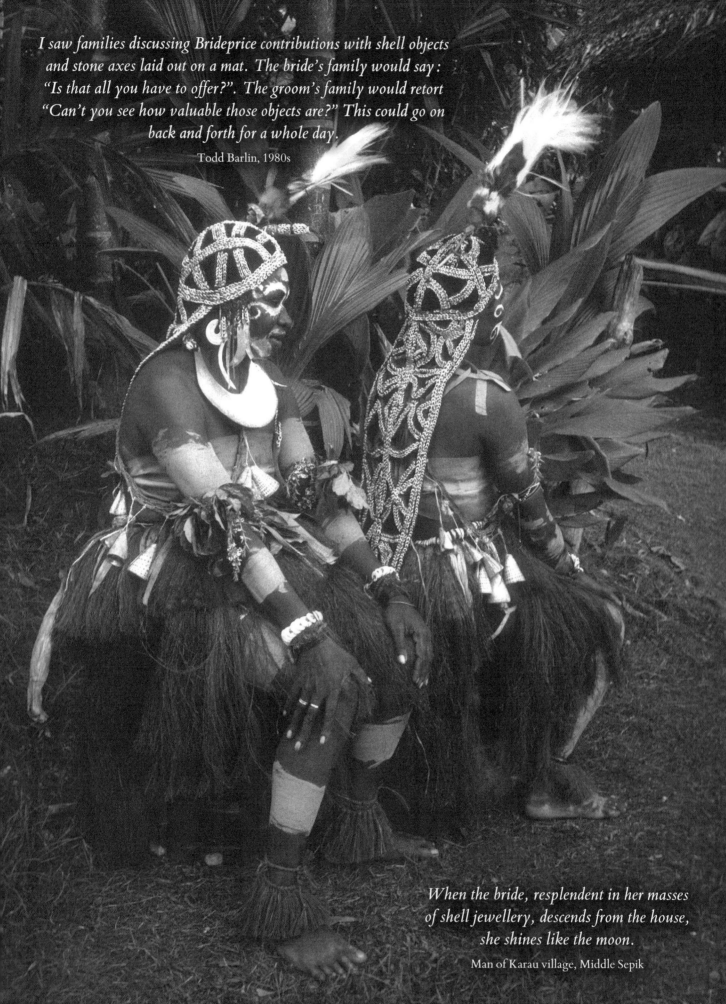

I saw families discussing Brideprice contributions with shell objects and stone axes laid out on a mat. The bride's family would say: "Is that all you have to offer?". The groom's family would retort "Can't you see how valuable those objects are?" This could go on back and forth for a whole day.

Todd Barlin, 1980s

When the bride, resplendent in her masses of shell jewellery, descends from the house, she shines like the moon.

Man of Karau village, Middle Sepik

Brideprice is effectively an important economic value system — a way to re-cycle value, through objects that have prestige, power and signify wealth.

Brideprice

The practice of giving 'brideprice' remains common in the South Seas, even though marriage customs vary widely and there are strong modern influences. Giving and receiving brideprice can take the form of money, currency objects, property, or other forms of value, such as pigs, and even promises, paid by a groom or his family to the family of the woman he intends to marry. At a superficial level this has been seen by outsiders as the idea of women being bought and sold as commodities. Nothing could be further from the truth.

In brideprice, not only does the bridegroom's family have to pay, but so does the bride's family. It is more accurately an exchange of value between two families, sometimes involving objects that have a history through several generations. But, apart from the physical items exchanged, brideprice fulfils important social and spiritual roles. It helps families acquire wider social bonds and build long-term relationships.

Brideprice is seen as compensation for the loss of a daughter, in an emotional sense, her skills and labour, her children and their future contribution to the family. Essentially, brideprice acquires ownership of the progeny into the father's clan/tribe.

Opposite, two sisters in Tigaui village, Middle Sepik, are adorned for marriage. The most important wedding gift is the bridal veil *ambusap*, a woven headpiece of fibre, stitched all over with Nassa and cowrie shells. The best of these has crocodile heads beautifully woven into the tip of the veil. These are examples of the few genuine heirlooms of Sepik River cultures, passed on from mother to daughter and down the female line.

In the Solomon Islands, and especially on the island of Malaita, the Brideprice tradition is centred around traditional shell-money manufactured in Langalanga. This shell-money is also used as adornments, prestige items and for other exchanges including funeral feasts and compensation. It has a clear cash-equivalent value. Much of it is inherited, from father to son.

A crocodile head beautifully woven into the tip of a bridal veil. GR, WG T0378

At left and right is a brideprice ritual object from the Washkuk Hills, East Sepik, size 1510 x 70 mm CB

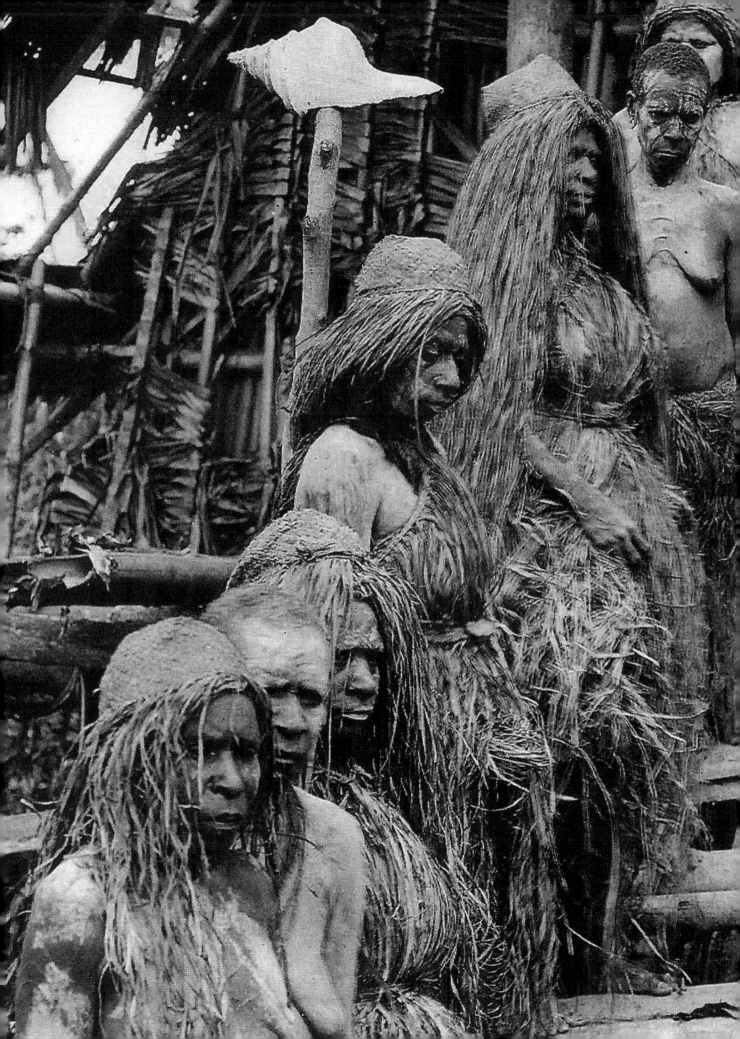

Mourning, and mourning dress

When a loved one is lost, village life takes on a whole new perspective. Not only do immediate relatives mourn the deceased but so do the extended family and friends who will travel from near and far. Mourning is a lengthy and sometimes complicated process. Women are usually expected to express their emotions and lead the wailing, while men are discouraged from doing so.

On the New Guinea Highlands, white is the colour of mourning (not black as with Europeans) and women are daubed in white (often grey) clay, covered with an old veil (also soaked in mud) and a multitude of Job's Tears seed necklaces. The extended family and clan members may gather in a specially constructed *haus krai* (Pidgin for 'house of crying').

Frank Hurley visited Adulu Village near the mouth of the Fly River in the 1920s. A colourised section from one of his photos is on the facing page. He likened the appearance of the traditional mourning dress to wearing "sackcloth and ashes", the Christian allusion to mourning. The women of Adulu have taken this idea almost literally, having covered themselves with long strands of grass and the clay ooze from the Fly River. Hurley continues: "It wreathes the unfortunate females in hideous shrouds – suggesting the furies – a terrible aspect".

Covering parts of the body with clay or mud acts as a barrier to protect the living against the potentially dangerous spirit of the dead person. Only after a ceremony in which the spirit is led to the next world can the mourning costume (and the mud) be safely removed. Hurley's photo was taken at the end of such a mourning period, with only the woman near the top still wearing her complete costume. A large Trumpet shell *Syrinx aruanus* rests atop a pole, almost as if crowning this important occasion.

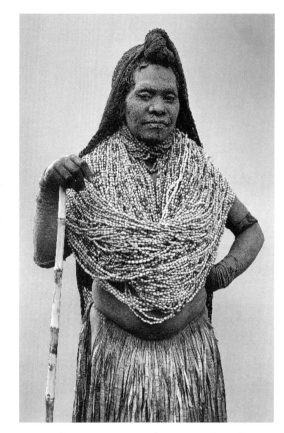

A widow in mourning. She is covered in white clay and wears multiple strands of Job's Tears seeds. According to custom, she may discard one strand each day during the initial period of mourning. She may wear this costume from a few months to a couple of years. Mendi area, Southern Highlands.
Photo: Malcolm Kirk 1981 Man as Art

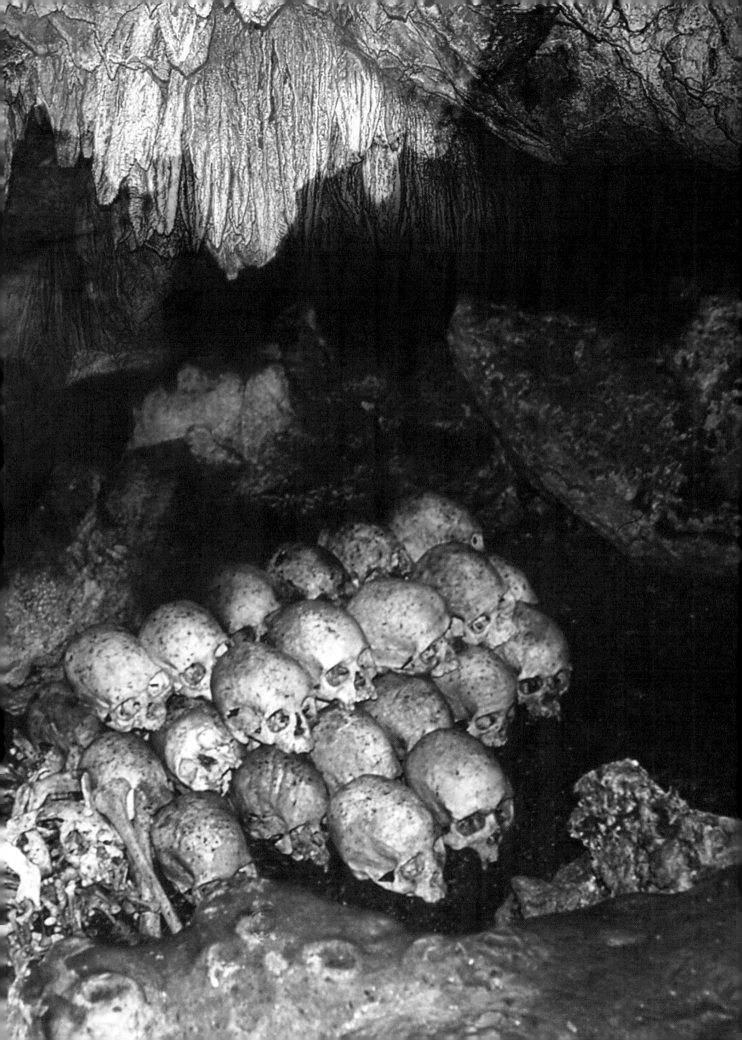

Ancestor culture

Despite the vast number of tribes, languages and culture in the South Seas, there is an underlying unity in the way ancestors are revered. It is deemed necessary to obtain and retain the support of one's ancestors, both actual and mythical. The spirits of the living and the dead are also seen as fully intertwined with the spirits of certain animals – such as the crocodile, pig and cassowary. Everything, both animate and inanimate, living or dead, has a spiritual essence that survives always and needs to be constantly acknowledged and appeased.

In the New Guinea Highlands it is believed the spirits eventually depart their ancestral land, and dwell on the high mountain walls, after everyone they know in life has also died. The skulls of the departed are eventually carried up to these high mountains, where they are placed in caves, or among sacred groves where they watch over the valley and the living.

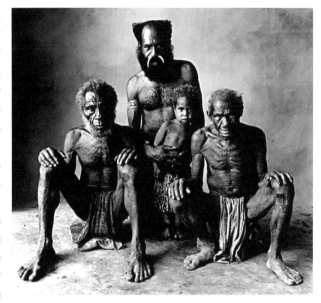

Four generations of New Guinea men.
Photo by Irving Penn, 1970. The Irving Penn Foundation

Spirits must be both respected and feared. This is one reason funerals are intertwined with the giving away of shell wealth. Ancestral spirits can be vengeful if customs are not carried out.

I had the opportunity to explore one of these, the Tawali Skull Cave (illustrated on the facing page) near Bilubilu on the East Cape of Milne Bay Province, the country's easternmost mainland point. The cave is situated toward the top of a cliff and the path leading to the cave is densely forested, moist, slippery and tough to negotiate. The roof is populated with dramatic stalactites, making it one of the most dramatic remaining skull caves.

Similar reverence to the remains of ancestors is shown in the Solomon Islands where, especially in the Western Province, the remains of many skull houses are found. They may contain the skulls of vanquished warriors, but more usually, the skulls of renowned chiefs plus shell valuables from his life. Their skull house is typically a much more informal structure, remotely situated.

It was into this cultural new world that the first explorers and missionaries arrived.

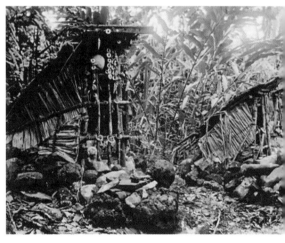

View of forest at Pa Na Gundu, Simbo Island, Solomon Islands, with skull house made of wood and leaves, containing skulls inside and the outside adorned with shell rings and shells. Photo signed Charles Seligman. BM Oc,B29.12

The Tawali Skull Cave near Bilubilu on the East Cape of Milne Bay Province

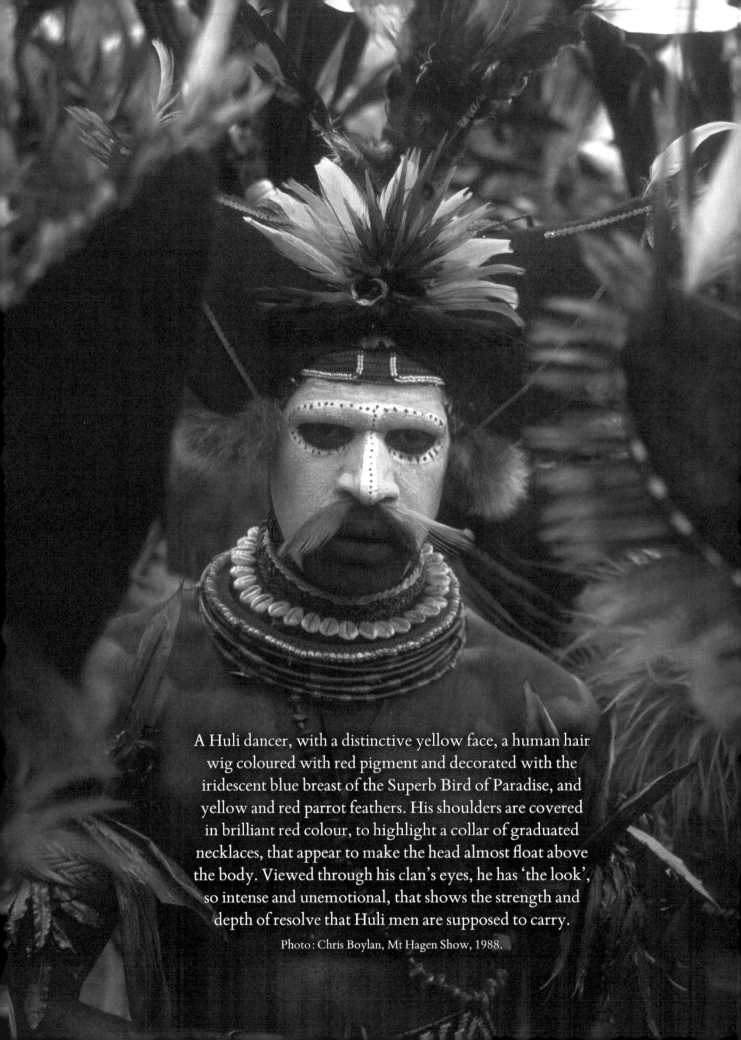

A Huli dancer, with a distinctive yellow face, a human hair wig coloured with red pigment and decorated with the iridescent blue breast of the Superb Bird of Paradise, and yellow and red parrot feathers. His shoulders are covered in brilliant red colour, to highlight a collar of graduated necklaces, that appear to make the head almost float above the body. Viewed through his clan's eyes, he has 'the look', so intense and unemotional, that shows the strength and depth of resolve that Huli men are supposed to carry.

Photo: Chris Boylan, Mt Hagen Show, 1988.

The Missionary Invasion

An Evangelical religious revival swept through Britain in the 1780s and 1790s aiming to *"revitalise the nation by taking the Good News of the Bible to non-believers"*, who would then be able receive God's grace and salvation.

These organisations were already campaigning against the slave trade, so reports coming back from expeditions to the remote South Seas describing the people as 'savages', roused their Christian concern for these people living at the edge of humanity, and with their 'false divinities'.

The Christian groups saw it as their responsibility, based on the grand principles of Christian benevolence, to "illuminate their dark and sinful world", to "rescue these savages from the heavy curse that rests upon them" and to "secure their elevation to children of God and to gladden their hearts with the prospects of immortality". In an analogy to European wheat fields, they regarded the South Seas as "ripe for the sickle".

"They were in a deplorable state of wretched heathen darkness, disgusting cannibals feeding on the flesh of slain enemies, deep moral degradation, barbarous, idolatrous naked pagans. The blackest ink that ever-stained paper is none too dark to describe them. Their objects were altogether rude, senseless, shapeless."

Selected comments from early missionary reports.

It is ironic that in many cases, and after some years, missionaries would find them to be honest, good-natured, happy and generous people. They would admire their ingenuity, perception, and thirst for knowledge. They were amazed at their patience and skills as craftsmen, using simple tools such as sharks' teeth and shells. They supposed they could even be "intelligent with no inferior powers of imagination".

Adorned and decorated, a chief or warrior displays a mixture of cool bravado and aggression — looking their very best, for maximum prestige, boosting confidence and protection by the spirits — they can be thought of as 'hostile dandies'.

Ron Radford, Director, National Gallery of Australia, Canberra. 2011.

In 1796 the London Missionary Society engaged the *Duff* to take the first party of 39 'missionaries' (actually, only four were ordained ministers) to the South Pacific and deliver them and their families (consisting of thirty men, six wives, and three children) to their postings in Tahiti, Tonga, and the Marquesas Islands. None of them spoke any of the local languages.

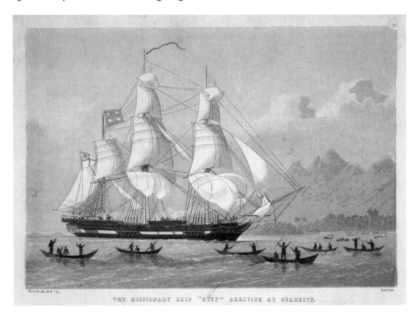

The missionary ship "Duff" arriving [ca 1797] at Otaheite, showing Tahitians waving in their canoes in the foreground.
Kronheim and Co. London 1820s

It took more than 15 years before significant headway was made to convert the locals. The paramount chief of Tahiti, Pomare II, was one of the first 'influencers' to be baptised into Christianity in 1812 and it proved to be a turning point for local missions, who proclaimed this conversion to be "one of the greatest miracles of Grace ever exhibited on the stage of this world."

Mission stations started being established across the South Seas and the destruction of 'idols and anything smacking of idolatry' began.

The missionaries' primary mission was to convert the inhabitants to Christianity. This required the "physical destruction of the emblems of Satan's kingdom", and this would be palpable proof of conversion and Christian victory. The mantra was: "Give up your

spiritual artefacts if you want to be a proper Christian". Churches would be built exactly on the site of local temples and shrines.

Ceremonial burnings, in which locals had to put their own objects into fires, were an essential part of the very public and conspicuous conversion process – demonstrating that these idols and objects made from wood, feathers, sennit (coconut fibre) and tapa cloth, reduced to ashes, had no power anymore.

A graphic example of the destruction wrought by Christian conversion is demonstrated in this poignant photo from the 1901 Haddon expedition to the Torres Strait. Shown are several of the locals on the remains of a divination shrine, the shells and rocks of the shrine that had represented the villages on Murray Island (also known as Mer), a small volcanic island in the eastern section of Torres Strait. The shrine had been "*considerably damaged and burned*" together with objects that had been previously buried or hidden from view in huts or in the forest, to ensure that beliefs and traditions would be abandoned.

With these ceremonial burnings the 'pagans' had been delivered from their 'superstitions' – or at least shifted from one belief system to another.

"It is nothing but wood and feathers and coconut husk that your own hands have made…they are worthless things and will all be cast away and become food for the flames."

Williams' translation of a letter from Papeiha, quoted in David Shaw King's 2011 book *Food for the Flames.*

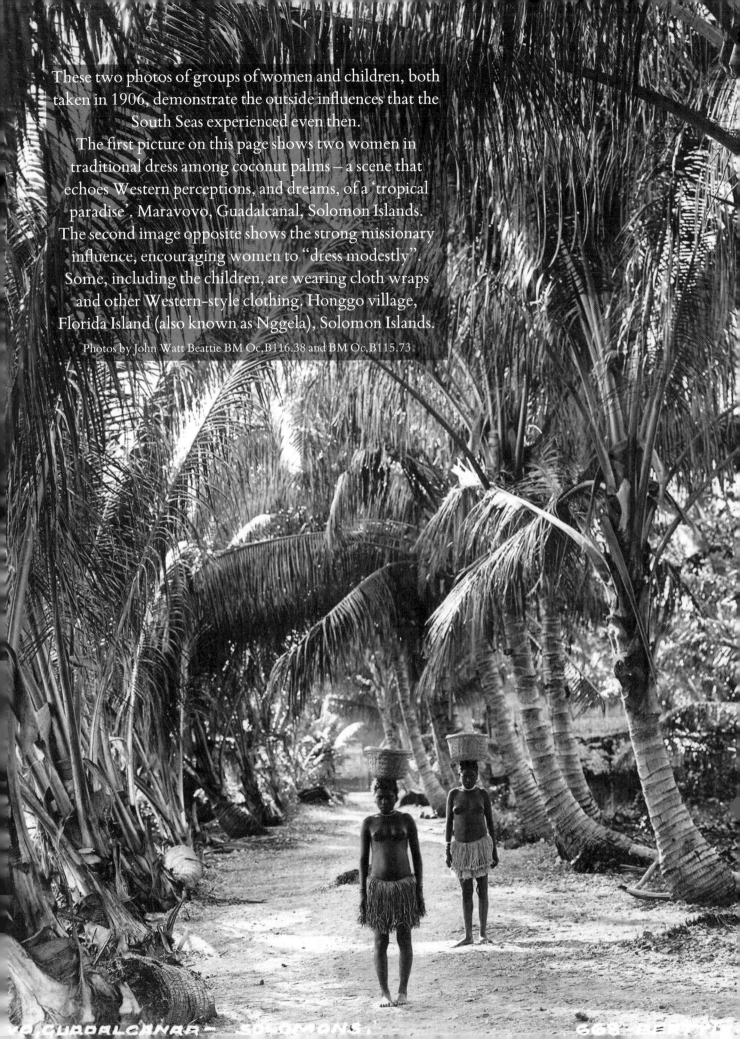

These two photos of groups of women and children, both taken in 1906, demonstrate the outside influences that the South Seas experienced even then.

The first picture on this page shows two women in traditional dress among coconut palms – a scene that echoes Western perceptions, and dreams, of a 'tropical paradise'. Maravovo, Guadalcanal, Solomon Islands.

The second image opposite shows the strong missionary influence, encouraging women to "dress modestly". Some, including the children, are wearing cloth wraps and other Western-style clothing. Honggo village, Florida Island (also known as Nggela), Solomon Islands.

Photos by John Watt Beattie BM Oc,B116.38 and BM Oc,B115.73

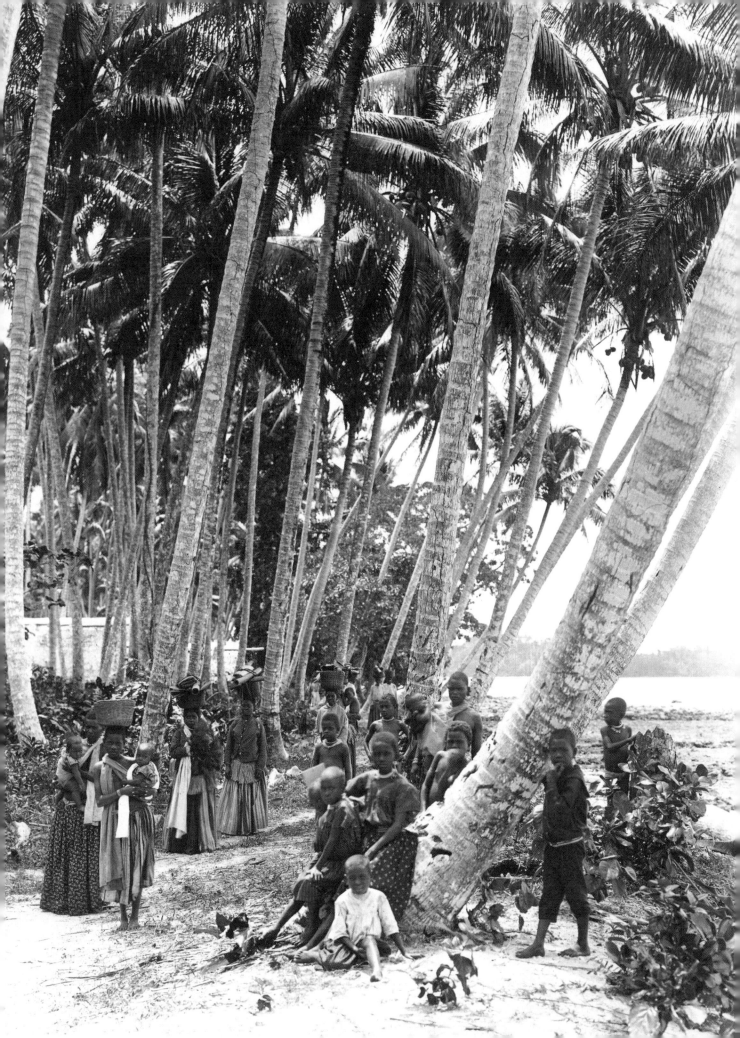

The ceremonial burning of the 'pagan' objects has been called 'cultural genocide' by some. As a result, over the past two centuries, many of the people of the South Seas have become adherents of Christianity in its various forms. A recent survey found that more than 90% are now Christians.

Even while ethnographers and collectors began poring over the local cultures in the wake of the missionary invasion, the missionaries themselves began sending the most important 'relics' back to their European headquarters, in the UK creating the seed of what was to become the London Missionary Society Museum in 1815. Its ambition was to display *Trophies of Christianity* and to demonstrate *the evangelist triumph over paganism.* Paradoxically, they ended up preserving some of the best relics of the culture they maligned so much.

David Shaw King, in his 2011 book *Food for the Flames.* makes a rather ironic comment *'We owe a debt of gratitude to the early missionaries for sparing what they did. They could easily have left not a trace'.*

Missionary museums

The view inside the main room of the London Missionary Society Museum was astonishing. Nowhere else was there such an impressive display of 'pagan' material culture, primarily from Africa and the South Seas.

Soon, gifts of these were being made to other British missionary societies, spawning Missionary Museums in many cities including Edinburgh, Oxford and Cambridge, and eventually across Europe. In 1832, William Ellis, foreign secretary of the LMS, sent "a few curiosities" from their museum to the Mission College in Barmen, Germany. It was suggested that they might be useful in conveying *a lively impression of the degradation and the polluting character of the heathens.*

Today, these 'missionary museums' and their accumulated 'curiosities' represent a potentially embarrassing legacy and outdated ethnocentric assumptions, but they remain totally fascinating time capsules.

In the wake of the original Wunderkammers, between the 1870s and 1930s, more than a million items must have been collected and removed from the South Seas by missionaries, government officials, anthropologists, ethnographers and travellers.

The Pitt-Rivers story

Today it is one of the great ethnographic museums in the world. The Pitt-Rivers Museum was founded in 1884, when General Pitt-Rivers, an influential figure in the development of evolutionary anthropology, gave his collection to the University of Oxford. After a military career, in 1880, he unexpectedly inherited a substantial estate from his great uncle, and he retired from the military in 1882, at the age of 55.

His interest in collecting archaeological and ethnographic objects came out of his early interests in firearms and weapons. He collected objects during working trips abroad, but the vast majority of objects came from agents abroad, dealers, auction houses, and fellow members of the Anthropological Institute. The General gave his collection to the University of Oxford on condition that they built a museum to house it, appoint a lecturer to teach about it and maintain the general mode of display. The Museum first opened to visitors in 1887 and was fully open by 1892.

Unusually, at the Pitt Rivers Museum objects are primarily arranged not according to region, but by type: musical instruments, weapons, masks, textiles and adornments are all displayed to show the diversity of objects and their use. Parallels and juxtapositions are everywhere. Everything seems overly crowded, because a large percentage of the total collection is on view. It is a unique institution that remains largely true to its original intentions.

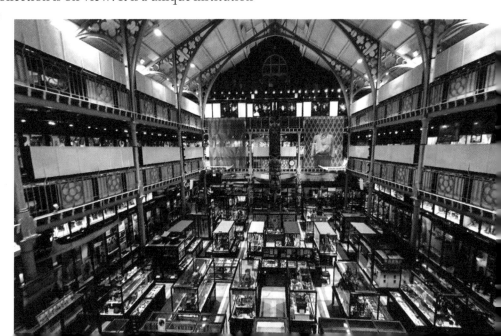

Colonialism

The potential resources available on these islands were becoming increasingly attractive to European powers intent on colonial expansion. They carved up geographies for themselves, taking scant notice of clan and tribal identities, in many cases cutting right across them.

In 1884, Britain declared the region of Port Moresby, New Guinea, a British Protectorate and Germany annexed part of north-eastern New Guinea, where German missionaries had already established themselves. Subsequently the island of New Guinea was arbitrarily divided into three parts. Someone took a ruler and divided the island north to south. The Dutch took the western part (Dutch New Guinea, later Irian Jaya, and now the Papua Province of Indonesia), Germany took the northeast, and the British were allocated the southeast. In 1905 Britain transferred their portion to the government of Australia, and that portion, now the country of Papua New Guinea, finally gained its independence in 1975.

In 1936, a Dutch geologist climbed the slopes of the world's highest island peak: Mount Carstensz (now called Puncak Jaya), an often snow-covered 4,884 m crag not far from the equator. He noticed rocks veined with green streaks – later confirmed to be extremely rich gold and copper deposits.

The world's highest island peak: Mount Puncak Jaya, Papua on the islands of New Guinea.

Industrialisation

For thousands of years the people of New Guinea have traded bird feathers, and some stone implements and ochre, and used clay to make pottery. Gold was first noticed there in 1852 as traces in pottery from Redscar Bay near Port Moresby. After that, Europeans assumed that they would find gold in New Guinea. In 1922, New Guinea was made a Mandated Territory of Australia by the League of Nations and in 1923–24 the first miner's rights were issued in the Territory. The first substantial gold deposits were found at Edie Creek in 1926. The trouble was its remote location – typical of the mountainous terrain and steep valleys – a six-hour trek on foot to get supplies in and gold out.

In 1970 the Dutch de-colonised and Dutch New Guinea was made the 26th province of Indonesia, a signal for the fights over the region's resources to begin all over again. Today, the Grasberg mine, one of the biggest gold mines in the world – and third largest copper mine – has become Indonesia's biggest taxpayer. But it is the centre of controversy between the Indonesian government and the local Papuan population. Indigenous tribes claim their communities have been racked with poverty, disease, oppression and environmental degradation since the mine began operations in 1973.

A 1983 documentary film, *First Contact*, by Bob Connolly and Robin Anderson recounts some of the first contacts between gold-prospecting Australians and the tribes of the interior highlands of New Guinea.

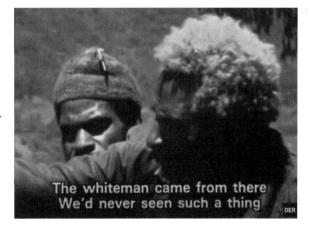

The whiteman came from there
We'd never seen such a thing

Soon an airstrip was built and in 1928 the first planes were shipped from Australia. This was the beginning a rush into mining, industrialisation and the creation of New Guinea's unique small-plane infrastructure. The effect on the lives of the local communities was immense and is best mirrored in the chaotic 'development' of the city of Port Moresby.

If that wasn't bad enough, then came WWII.

"The whiteman came from there. We'd never seen such a thing. Did he come from the ground? Did he come from the sky? The water? We were confused. I was with my father. I was so terrified I couldn't even look at him, and I cried."

From the 1983 documentary film, *First Contact*,

Endings and beginnings

During WWII, the Japanese battled their way across the Pacific and eventually reached as far south as New Guinea and the Solomon Islands. Having already assumed the administration of the eastern half of New Guinea, the Australians fought back.

The local tribes had never seen anything like it. Having experienced more than a century of European colonialism, they watched two alien tribes fighting each other with their 'fantastic machines'.

The sudden arrival, and equally sudden departure, of such unfathomable invaders had lasting effects on the people, culture and infrastructure of this region between 1941 and 1945 – just to satisfy the logistical requirements of the Allies in their war against Japan.

Soldiers returning home to Europe after the war took with them a myriad of 'souvenirs' that helped fuel interest in this part of the world.

The value of Things, Objects and Stuff

In larger collections, such as those in London, Paris and Berlin, many South Seas artefacts were presented primarily as 'ethnographic specimens', examples of objects that were made, without significant acknowledgement of their purpose or their complex histories, or even of the religious encounters from which they came to be there.

Even in Victorian times, most visitors would have taken home a souvenir or 'curio' from their visit, but that term would never have been used by a serious museum curator – even for the same object. The word 'curio' expresses a rather dismissive attitude towards the objects, suggesting a lowly and relatively insignificant object. Museum curators would more likely have been proud of their 'Important Ethnographic Objects'.

One of the first things that the early European explorers noted was the elaborate adornments that characterised the local welcoming committees. Their material culture was much easier to observe than the spiritual underpinnings. It seemed that every part of their bodies

was adorned with natural materials – from feathers and fibres to teeth and coloured dyes – their *Natural Gold.*

Their material culture appeared to be a great entanglement of persons and things, minds and bodies – a dynamic way in which these communities materialised their relationships, desires and values – and integrated them with the spiritual world.

All of the objects seemed to serve, and still do today, a dizzying multitude of functions – sometimes several at the same time. The beauty of shell currencies meant that they could easily be strung on fibres as adornments. Shell rings, from the size of beads to those weighing several kilos, could be worn as body adornments. Some of the most complex *kapkaps*, the epitome of prestige, power and adornment, were regularly traded amongst different islands and with visitors, making them effective currencies.

In the introduction I talked rather frivolously about things, thingamabobs, stuff and objects. But what do we mean when we call things 'objects'?

Objects beyond the physical

Objects such as those given as part of Brideprice clearly give prestige, status and power to the receiver – but we'll see that the spiritual aspects are often more important than the physical. Even though the things themselves may be beautifully crafted and 'valuable' in their own right, it is the utility, the spiritual context and the outcome of their use that really matters.

Some traditional things have such powerful spiritual associations and may be defined as *tabu*, meaning sacrosanct, without any specific explanation. A few of them may never have been seen. They exist only in the telling.

Precious objects may contain the knowledge of their history, who owned them and where they travelled associated with them. This information is dutifully passed on with each transaction and generation. The value exists in the relationships between the objects

These are beautiful South Sea islands inhabited by warm and friendly people. Soon after my arrival to Gawa Island, the kula canoe master carver Kanamweya arrived to say hello. After a while, I noticed that he had taken my hand as we stood close together.

Harry Beran

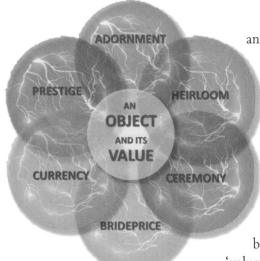

ADORNMENT

PRESTIGE

HEIRLOOM

AN **OBJECT** AND ITS **VALUE**

CURRENCY

CEREMONY

BRIDEPRICE

All have material, social and spiritual dimensions

and their owners.

Some objects that appear to be adornments are never worn, and some are never seen in public. Some prestige and *heirloom* items may only be revealed, with great drama, at specific ceremonies. The drama of revelation and performance contrast with much of local day-to-day life. Some of these objects may have been kept as family or clan treasures and handed down from generation to generation.

It must be said that many of the really treasured items may just be a fragment of shell that was once part of a precious *kapkap*, or simply an irregular piece of wood. They may have been 'family treasures' to the owners but appear as nothing of 'value' or even 'beauty' to our eyes.

Because of the secrecy attached to them, some heirloom objects managed to escape missionary conversions and burnings, changes in fashion and trophy hunters. These 'things' represent ethereal and fragile moments of human aspirations and belief systems that might otherwise have vanished for ever.

This beautiful set of traditional body adornments includes some made from clam, *Conus* and Nassa shells, and tied with woven and plaited natural fibres. They were collected by Todd Barlin in 1986 in the Humboldt Bay Area on the north coast of Papua. **TB**

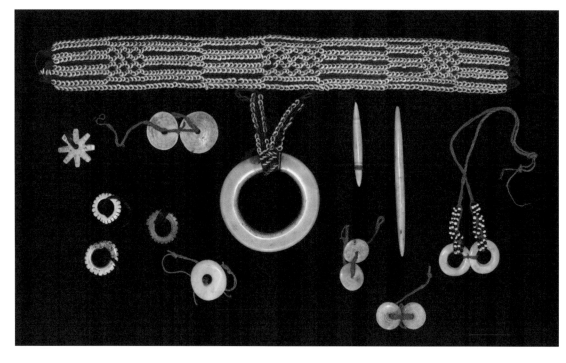

The old man told me they had been hidden and unused for two generations, a family heirloom that no longer had the traditional value as currency or brideprice. They have been in my private collection since then.

Todd Barlin

What's in a name?

We Europeans have a long tradition of naming things, places, objects and traditions. We created borders where none had existed before – just think of that straight line going north-south through the centre of the island of New Guinea.

Items that were collected in the 19th century on the island of Bougainville were catalogued as being from the 'Solomon Islands', and correctly so. Historically the Bougainville region was known as the North Solomons, however, in 1976 it was integrated into the country of Papua New Guinea, so you can understand that any surviving labels may become a little confusing over time.

The recently-created provincial borders in PNG cut straight through cultural groups that formerly had natural cultural cohesion. At the stroke of a pen, people who had lived side-by-side for thousands of years, were suddenly either side of an 'artificial' border and had to look to new provincial capitals with different cultures for services.

When an academic study states that an object was used by the Kwaio people it seems so definitive. In reality, borders between tribes and their usage of objects were extremely porous. Things were also traded across vast distances since time immemorial. Chaos was totally natural, but definitive areas and borders…. were quite unnatural.

A single object would have had many different names depending on who you asked, so, as a result of specific advice from Ben Burt at the British Museum, I have tried wherever possible to use only the most common names. I know to simplify is dangerous – it hides the astounding variety and nuances and breadth of cultures that occur in these islands, but please bear with me as we tread passionately into aspects of the material culture of the South Seas.

Body ornaments and traditional currencies are some of the finest objects ever made by indigenous people.

Naturalia
Pertaining to nature.

Turbo
Cockle
Pearl
Clam
Spondylus
Nassa
Conus
Architectonica
Cowrie
Trochus
Tusk
Ulcto
Nautilus
Strombus

Clay
Lime
Leaves
Bark
Roots
Bamboo
Palm
Ficus
Orchid
Coconut
Pandanus
Abiscirus
Coix

Shells

Pigments

Trees

Plants

Fibres

Seeds/Nuts

Birds
Paradise
Hornbill
Frigate
Parrot
Cockatoo
Pigeon
Cassowary
Hummingbird

Shark
Fish
Dugong
Whale
Dolphin
Dog
Pig
Rat
Cuscus
Bat
Human

Feathers

Teeth

Bone

Hair

Carapace

Keratin

Reptile

Insect

Chitin

Turtle

other
Insects

Beetles

Natural
Gold

Stone

Slate
Crystals
Coral
Fossils
Obsidian

Artificialia
Created by humans.

Metal Porcelain Paper
glass Plastic Wire Nylon

CHAPTER 2

NATURAL GOLD

Treasured raw materials

In Western societies we are used to precious adornments made of rare metals and precious stones. Think gold and silver, diamonds and rubies. South Sea cultures had no access to any of these – even though some localised gold deposits were discovered in the 19th century. Precious to them was a plethora of natural materials such as shell, feathers and fibres that they crafted with unimaginable precision and imagination into objects of value – for simple adornment, or as objects of prestige, status and wealth – or even for protection from evil spirits.

In the European *Wunderkammer* of the 18th century these items would be classed as *Naturalia* – objects made from natural materials. Neich and Pereira came up with this list in their 2004 book *Pacific Jewelry and Adornment*:

> Coral, jade, slate, bone, palm wood, bamboo, human hair, human teeth, shark teeth, whale teeth, porpoise teeth, flying-fox teeth, cuscus teeth, dog teeth, boar tusks, fish teeth, fish vertebrae, *Nautilus* shells, turtle shells, pearl shells, marsupial fur, flying-fox fur, coconut shells, glass trade-beads, *Spondylus* shells, Nassa shells, *Ovula* shells, oyster shells, cowrie shells, *Cassis* shells, *Conus* shells, *Tridacna* giant clam shells (both modern and fossilised), *Trochus* shells, frigate bird feathers, bird-of-paradise feathers, cassowary feathers, *Arbrus* seeds, *Coix lachryma-jobi* seeds, everlasting daisies, orchid stems, *Pangium edule* nuts, *Parinarium* seeds and beetle carapaces.

Their list seems exhaustive, but one could easily add the wing bones of fruit bats, beetle wings, marsupial rat teeth, red honeybird feathers, crystals – and plastic. Towards the middle of the 20th century when bits of plastic started washing up on island shores, some became a highly desirable raw material. In the context of the *Wunderkammer*, these items would be classed as *Artificialia* – objects made by humans. The graphic on the facing page is a useful visual summary of the most likely materials you will encounter looking at South Seas adornments and currencies.

The appeal and value of these items increased proportionally with their rarity and difficulty of the terrain in which they could be obtained. Marine shells traded up from the coast became more and more valuable in direct proportion to their distance from the sea, until value eventually reached its pinnacle on the Highlands.

Just think about these modest materials as the South Seas' *Natural Gold*.

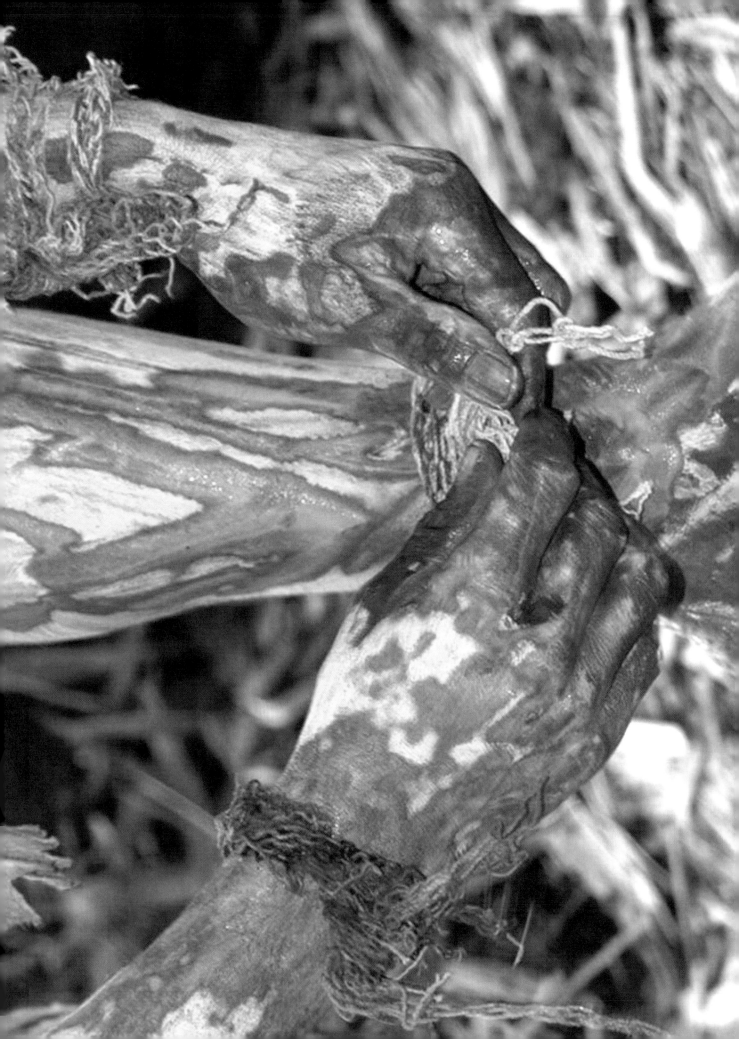

The *Mudmen* of the Asaro tribe are known as such for a ceremonial dance centred on bizarre mud masks adorned with odd-shaped pigs' teeth. The ceremony is one of the most dramatic and eerie experiences to be had on the New Guinea Highlands. Although, during the last century, the masks have evolved from simple fibre frames to ones made completely from mud, the ghoulish drama continues to be powerfully strange and quite overwhelming.

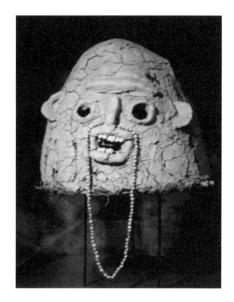

But, as usual, beyond the obvious visual dominance of the masks, the beauty is in the detail. As we sat with them and watched the men going through the quiet and deliberate process of preparing for the performance, daubing their bodies with clay to enhance their ghostly appearance, I noticed one individual sorting a few unravelled bits of fibre and tying them around his ankles and wrists. These ephemeral materials were given as much care and attention as the frightening clay masks. To me, those small ties represented the essence of primal adornment – the act of tying them and spiritual importance in wearing them was much more important than the materials themselves. To this one individual, these humble adornments were truly 'natural gold'.

Let's take a closer look at some of these natural materials and how they were turned to 'gold'.

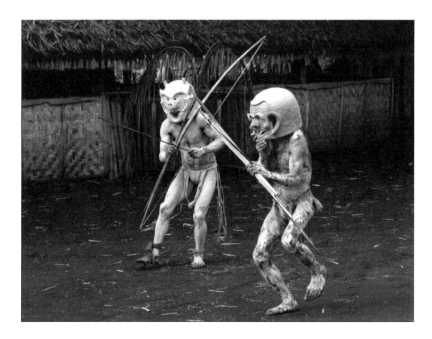

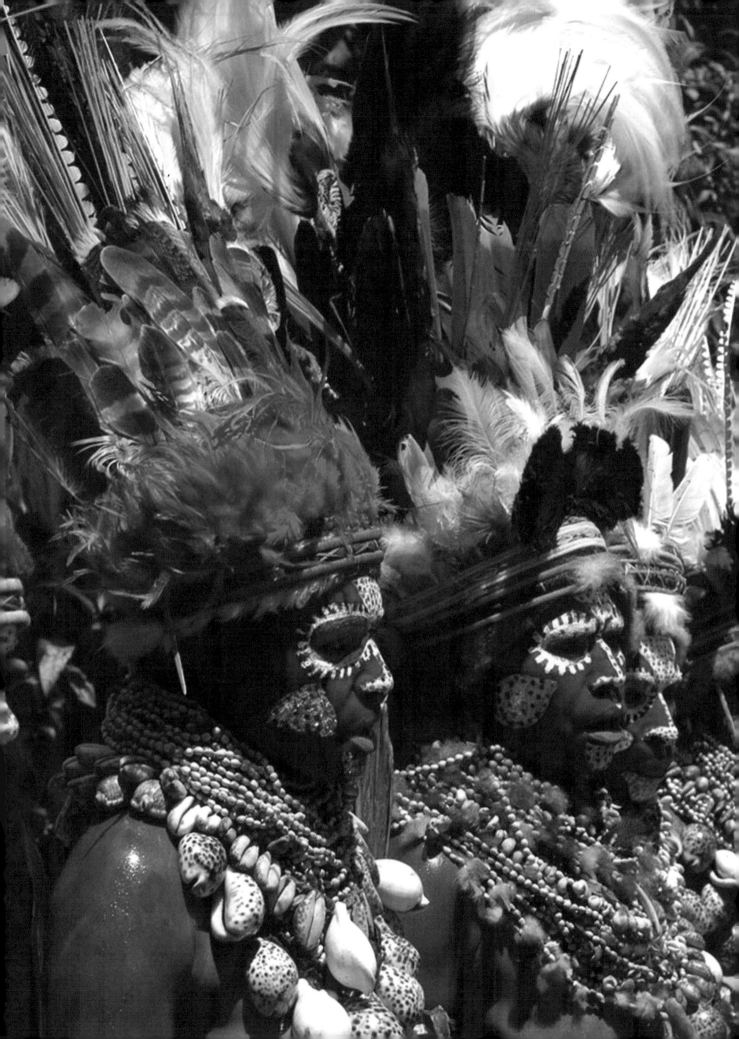

Shells, natural fibres and feathers

Take part in a celebration on almost any South Seas island, and shells, natural fibres and feathers will be central in their adornments. The shells of marine molluscs, 'sea-shells', have fascinated us throughout human history. It has been no different across the Pacific. Ancient beliefs imagined pearl shells growing on trees, growing large and lustrous only in the most favourable circumstances.

It is perhaps not surprising that coastal people should find so many uses for shells, but even on the New Guinea Highlands, about as far away from the ocean as you can get on an island, the use of shells as adornments is ubiquitous. There is almost no ceremonial object that does not contain some kind of marine material, no matter how far you are from the sea.

Shells and shell-beads used as money also became pervasive in these island cultures, especially around New Britain in north-eastern New Guinea, the Solomon Islands and New Caledonia. Just as money-cowries were the oldest forms of exchange in southern Asia and Africa, so shells and shell-beads became the basis for payment systems, markers of wealth, building relationships and as ritual objects.

In this section we will explore some the most common natural raw materials, why they were valued as much as 'natural gold' and how they were used to make beautiful things of great value.

A myth amongst the Wola people in the PNG Southern Highlands tells the story of how pearl shells first came to them: *One moonlit night a long time ago, a fine young man decided to go hunting marsupials in the forest. After walking a long way, he came to a tree, where many beautiful birds were feeding and singing. "When it is dark", he said, "birds do not sing but sleep." He climbed the tree to find the birds and found a beautiful young woman. She hit him with her* tapa *beater. He ran off, but returned the next day, and found the tree covered in red pearl shells, growing like bracket fungus out of the tree trunk. This is how our ancestors first found pearl shells.*

Paul Sillitoe 1979 *Give and Take in Wola Society.*
At right: A Bracket Fungus *Anthracophyllum archeri*

Elaborately adorned women of the Melpa people during an important Sing-sing.

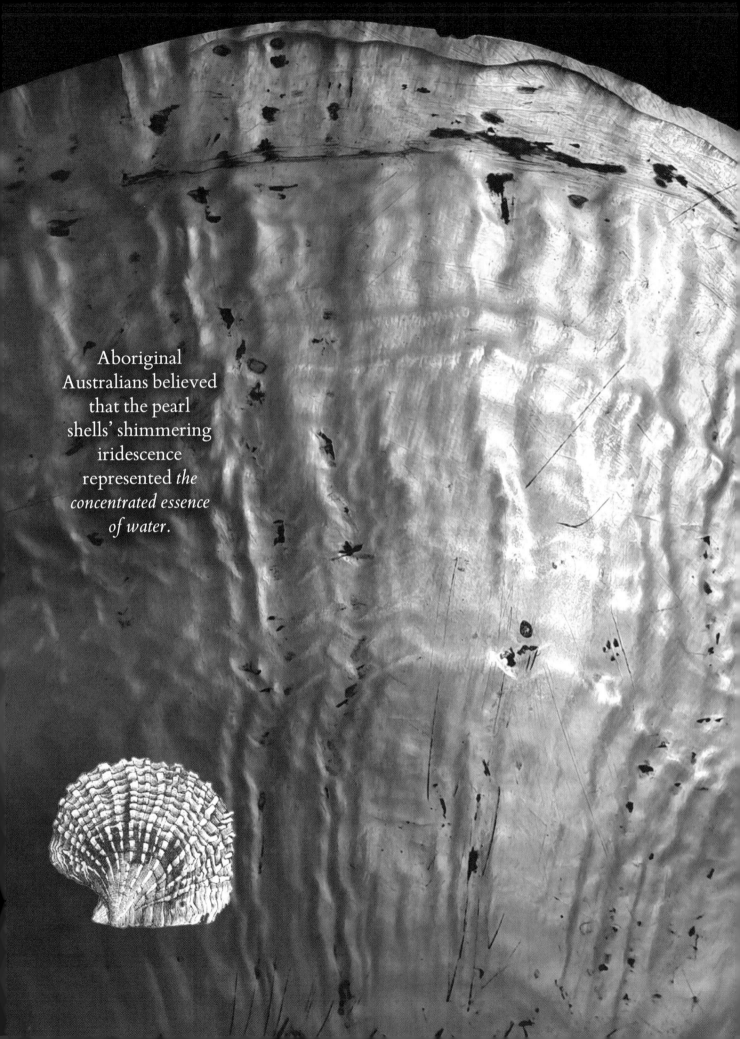

Aboriginal Australians believed that the pearl shells' shimmering iridescence represented *the concentrated essence of water.*

Pearl shells

The seas and reefs of the western Pacific are renowned for large and spectacular shells. These include pearl oysters of the genus *Pinctada* – which are not closely related to either the edible oysters or the freshwater pearl mussels – but all display the magnificent luminescent mother-of-pearl on the inside of their shells. The outside of a living shell is usually encrusted with marine growth and requires hard work to polish down to the nacre underneath. The various species of *Pinctada* produce pearls of different colours depending on the natural colour of the nacre inside the shell.

The shells of the pearl oyster were not only beautiful but also hard, 'permanent' and transportable, making them eminently suitable as a currency and for body adornment. The Gold Lip Pearl Oyster *Pinctada maxima* has always been the most popular, producing the most spectacular adornments.

Pearl farming was practiced in Europe since ancient times and in China since the Song Dynasty (960–1270 AD). The waters of the Torres Strait, between PNG and Australia, was seen one of the world's best fishing grounds for natural pearls, and from the 1860s became the centre of a pearl industry – and a source of pearl shells.

During the 20th century, farming of cultured pearls took off as a major industry, especially in Japan. Fresh supplies of pearl shells, as a waste-product of pearl farming, started to be available across the western Pacific.

From coastal New Guinea, pearl shells were traded into the remote Highlands, the value increasing proportionally with their distance from the coast. In the 1930s, when the Leahy brothers came into the Highlands searching for gold, they found people who valued the gold-lipped pearl shell as much as the miners valued gold. Highlanders gratefully exchanged their labour and land for access to this formerly rare commodity. The lustrous beauty of the pearl shell as body adornment and its economic value became an integral part of Highlands culture.

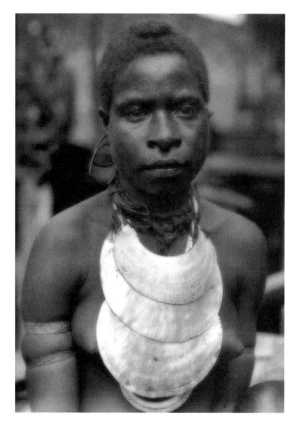

Girl proudly adorned with multiple pearl shell necklaces. Kaimari, Papuan Gulf. **Photo: FH BM Oc,B122.27**

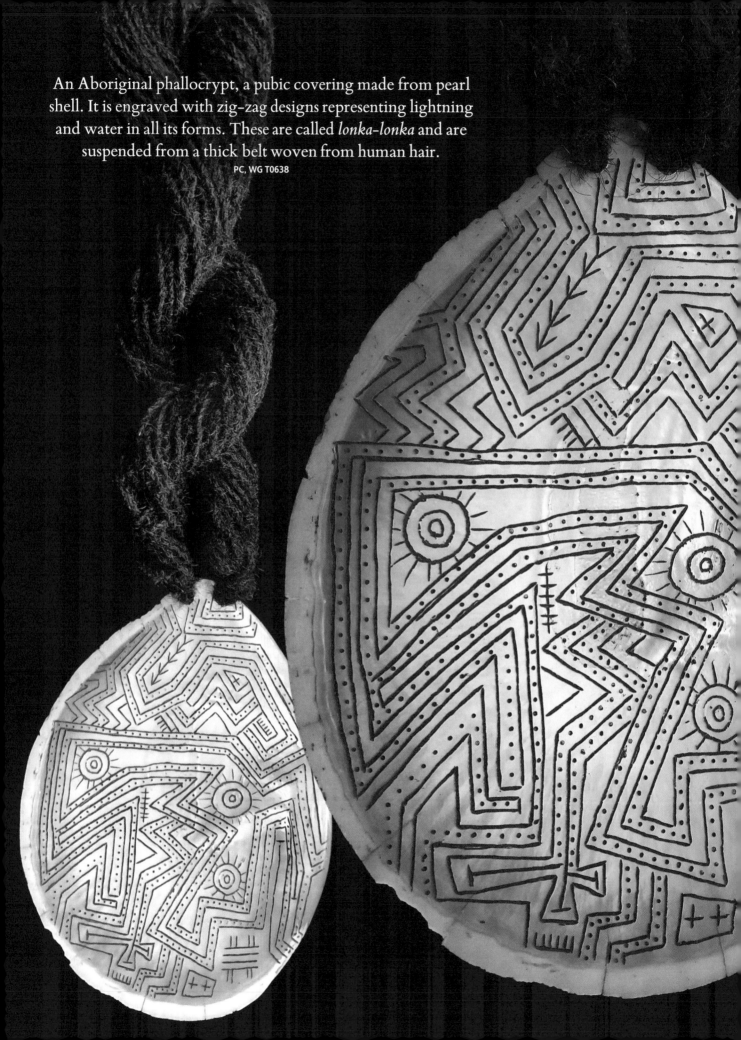

An Aboriginal phallocrypt, a pubic covering made from pearl shell. It is engraved with zig-zag designs representing lightning and water in all its forms. These are called *lonka-lonka* and are suspended from a thick belt woven from human hair.

PC, WG T0638

Pearl shells
Aboriginal phallocrypts

Australia's aboriginal people viewed the iridescence of pearl shells as being associated with strong magic. They have been highly prized and used in trade and exchange, male initiation, 'love magic' and as personal adornment, stretching back 30,000 years. The white or pearly lustrous shell against an ochred body creates a startling impact.

Since the start of the 19th century, the Aboriginal people made phallocrypts of pearl shell, pubic coverings they called *lonka-lonka*, and traded them from the Kimberly coast of Australia, more than 1,500 km into the vast central deserts.

In addition to their use as phallocrypts, for specific rituals, both men and women would wear these engraved pearl shells, or smaller pearl shell slivers, around the neck and in headbands.

The abstract zig-zag designs carved into the shells represented lightning and water in all its forms, and the human interactions with this life force.

The Pitjantjatjara people of the Central Australian Desert believed that the animated essence of pearl shells lived in a sacred waterhole. Medicine men would first disperse the guardians of the Rainbow Serpent, *whose skin shimmered in the sunlight, and then spear the pearl shells as they swam by. The shells were then left to dry and harden in the sun. The suspension holes in the shells were said to be the holes left by the spear thrusts.*

GR, WGT0383, GR, WGT0382

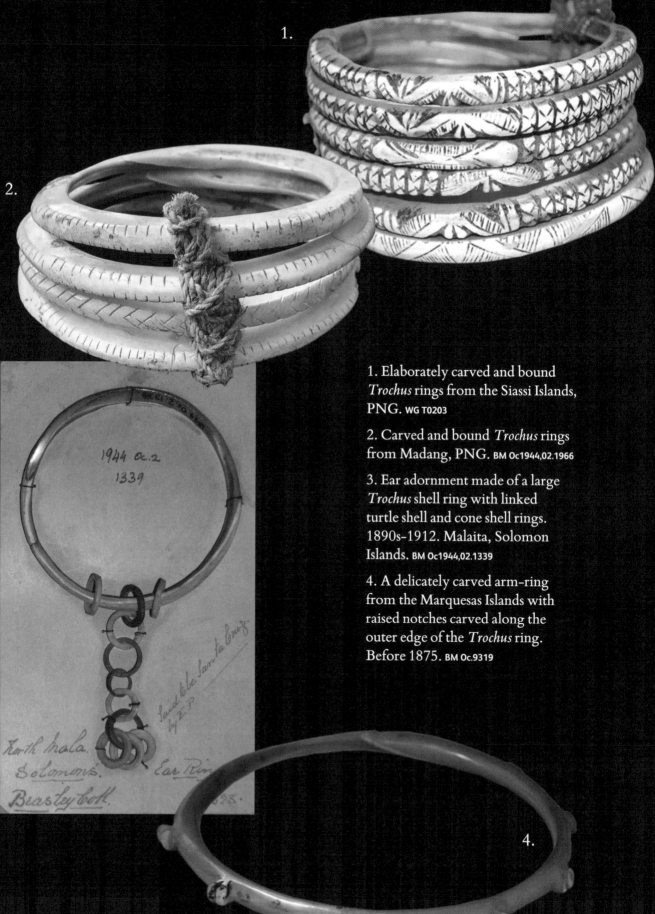

1. Elaborately carved and bound *Trochus* rings from the Siassi Islands, PNG. WG T0203

2. Carved and bound *Trochus* rings from Madang, PNG. BM Oc1944,02.1966

3. Ear adornment made of a large *Trochus* shell ring with linked turtle shell and cone shell rings. 1890s–1912. Malaita, Solomon Islands. BM Oc1944,02.1339

4. A delicately carved arm-ring from the Marquesas Islands with raised notches carved along the outer edge of the *Trochus* ring. Before 1875. BM Oc.9319

Trochus shells

Trochus shells are medium-sized marine molluscs with a pearly inside to their shells. These shells are common on shallow reef habitats and have a broadly conical spire, a flat base and are popularly called 'top shells' for their similarity to the children's toys.

Trochus shell armbands appear in archaeological evidence in the Wahgi Valley of the Papua New Guinea Highlands dating back about 10,000 years – the shells having been traded up from the coast.

Trochus niloticus (or more correctly now *Tectus niloticus*) was traditionally the most common species used for carving. The shell bases were cut horizontally and polished to form armbands. On the loose rings above the characteristic kink in the shell rings is evident. They were typically worn on the upper arm by men and women. Some were elaborately incised along the edge and sometimes bound together in multiples with natural fibre as shown in the image at top left.

Due to the 'ready-made' shell form and size, *Trochus* rings were much easier to make than those laboriously carved from clam shells, so they never attained the high value of those.

Trochus *shell armbands are amongst the earliest known adornments made from marine shells.*

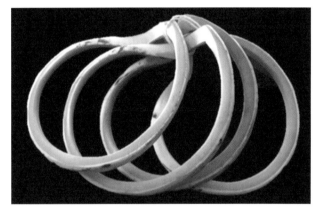

Four *Trochus* shell armbands. Malaita, Solomon Islands.
WG T0413

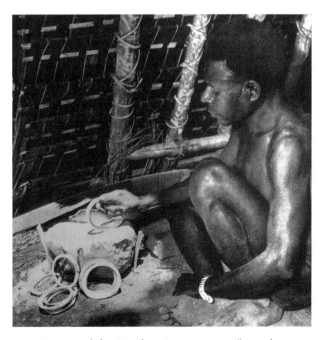

A man polishes Trochus rings on a stone "to make them as smooth as silk". **Photo ca. 1956 from:** *Tambaran: An Encounter with Cultures in Decline in New Guinea.* Rene Gardi

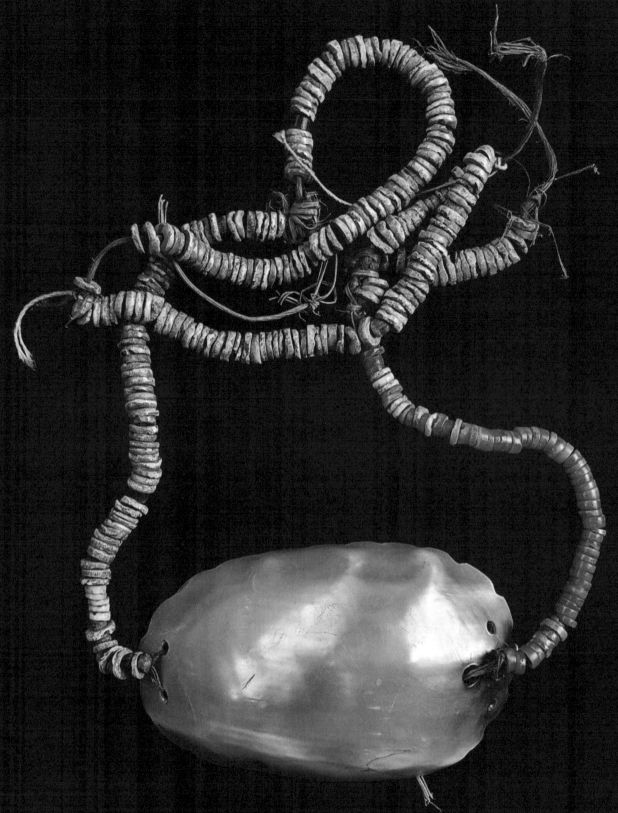

A 19th century necklace from Malaita in the Solomon Islands, heavily used, abused and repaired, is hung from a coconut fibre strand of hand-made shell-money beads (*Conus* and *Spondylus* shells) and with a polished *Turbo* shell medallion at its centre. To me, there is such a beauty in these shabby-chic objects, precious to the people who made them, but often discarded or ignominiously placed in Western auction job-lots.

SK, WG T0180

Turbo shells

Shells in the family Turbinidae, known as *Turbo* or Turban shells, are typically large species with a thick layer of mother-of-pearl. They have been a primary food source in the South Sea islands and the discarded shells have been commercially exported as a source of mother-of-pearl. It is somewhat surprising therefore that one seldom sees *Turbo* shell being used in adornments in the region, those used as a necklace on the cover photo of this book are somewhat of an exception.

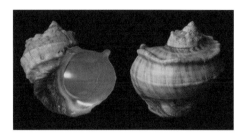

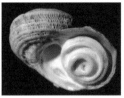
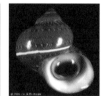

Many *Turbo* species have an extremely attractive operculum – the 'trapdoor' that closes off the aperture of the shell when the soft parts are retracted – and these can be found integrated into carvings and adornments and used as 'eyes' in ceremonial masks such as the *tatanua* masks of the Malangan people of New Ireland (see at right). They represent the spirits of ancestors and are used only once – and typically destroyed after use.

Other examples of *Turbo* shell use are found in the Sepik area, where the shells are included in brideprice payments and attached to walking canes. Towards the Prince Alexander Mountains, *Turbo* shells are attached to elaborate cane masks called *talipun* by the Yangoru Boiken people – these are similar to the Abelam yam masks.

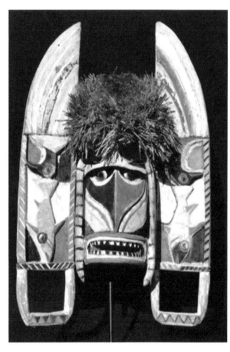

A *tatanua* mask using Turbo shell opercula for eyes. From the Malangan people of New Ireland. **AB**

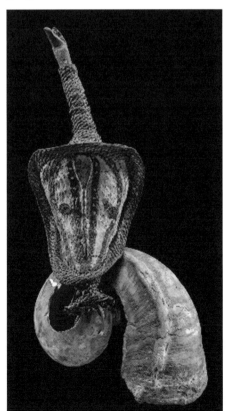

A large *Turbo* shell attached to an elaborate cane mask called *talipun* by the Yangoru Boiken people. **UK Mepm149**

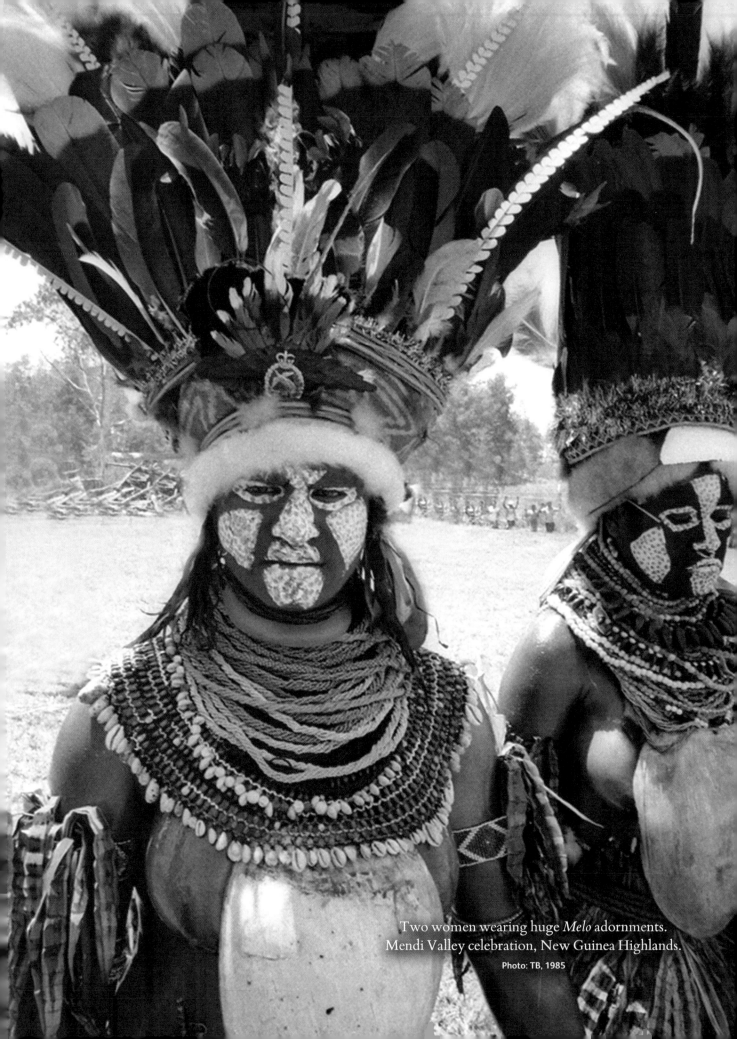

Two women wearing huge *Melo* adornments.
Mendi Valley celebration, New Guinea Highlands.

Photo: TB, 1985

Bailer Shells

Melo and *Cymbium* are genera of extremely large marine molluscs in the family Volutidae, the Volutes. Their shells were used as scoops by people to bail out their boats – hence the common names: *Bailer* or *Baler* shells, and *Melon* shell because of the similarity to that fruit. When parts of these shells are used in small objects, they are difficult to identify so we use *Melo* as a common term throughout the book. The largest of these shells can reach over 500 mm.

Mostly used amongst the people of the New Guinea Highlands, these shells would have been traded from the coast and were highly valued as wealth items, currency, used in brideprice and as important ornaments during ceremonies.

These *Melo* shell pectorals would have been worn by both men and women, hung by the fibre cord around the neck, developing a warm patina from wearing and handling over many generations. Some were incised with simple designs and occasionally with abstract, perhaps even zoomorphic, motifs – such as the one at left. CB

Melo and *Cymbium* shells.

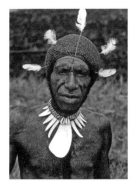

In the Sepik and Papuan Gulf regions, *Melo* shells were used for phallocrypts, and small oblong pieces were cut and used as bases for various *kapkap* adornments. The Asmat people of Papua used these shells as head-rests, as water scoops when preparing sago and to make their elaborate *bipaneu* nose adornments – discussed later in this book. Amongst the Dani people of Papua, *Melo* shells segments were cut and used to make distinctive *mikak* pectoral adornments in a large variety of configurations such as those below.

Melo shell breast adornments incised with simple designs. **WG T396A and WG T0275**

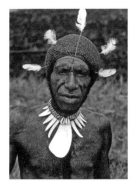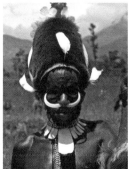

Photos SP 1956

77

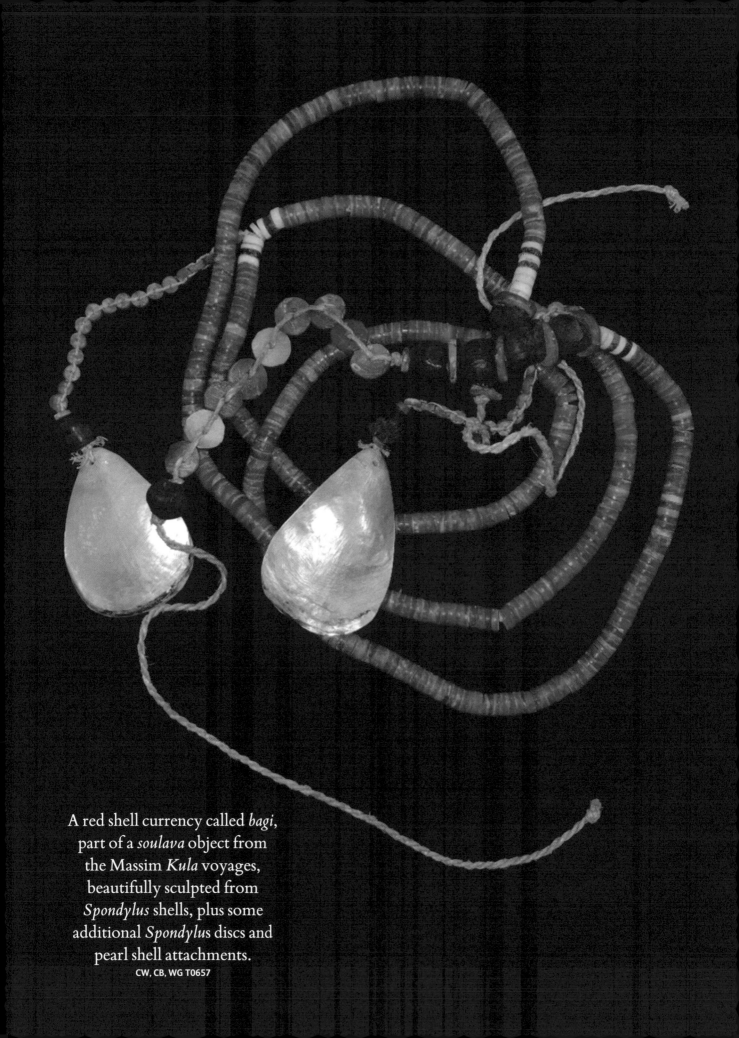

A red shell currency called *bagi*,
part of a *soulava* object from
the Massim *Kula* voyages,
beautifully sculpted from
Spondylus shells, plus some
additional *Spondylus* discs and
pearl shell attachments.
CW, CB, WG T0657

Spondylus shells

The *Spondylus* and *Chama* genera of marine molluscs include a wide variety of spiny shells that cement themselves to rocks. These, together with the Pectens, are the most popular group of bivalves for collectors world-wide. Like the pearl shells, the outside of living *Spondylus* shells is encrusted with marine growth and requires hard work to polish down to the colourful shell material. I'll group them under the term *Spondylus* in this book.

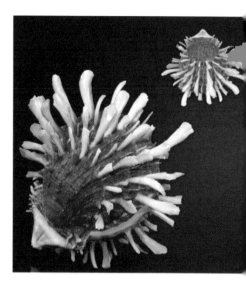

The two halves of their shells are joined with a ball-and-socket hinge, rather than the toothed hinge common in other bivalves. They have been known to produce pearls and many live in deep water, making them difficult to obtain, which adds to their value.

The shells with red colours are the most highly esteemed for making valuable beads used as currency and adornment, although those with 'less valuable' white shell material, are also used.

Archaeological evidence indicates that people in Europe were trading *Spondylus* shells to make ornaments throughout 5350 to 4200 BC. The shells were harvested in the Aegean and transported across the continent. Similar evidence from Colombia and Ecuador shows their importance to Andean peoples since pre-Columbian times, as currency, adornment and spiritual offerings. *Spondylus* shells were also harvested from the Gulf of California and traded to tribes through Mexico and the American Southwest.

A *bagi* origin story.
Legend on Goodenough Island in Milne Bay has it that a woman gave birth to a snake, and later a girl. She kept the two apart and hid the snake in a cave, but she would always cook for both and take the snake its share of food. The girl became curious to know where her mum went with the extra food. Eventually her mum took her to the cave. When the girl saw the snake, she screamed. The snake became sad and hurt by her reaction and left home, on a very long journey, finally settling on Rossel Island. Here in the Calvados Chain, there is a passage in a shape of a snake. It is believed that bagi *came from this snake that was rejected from its home.*
Told by Janetserah Omuru

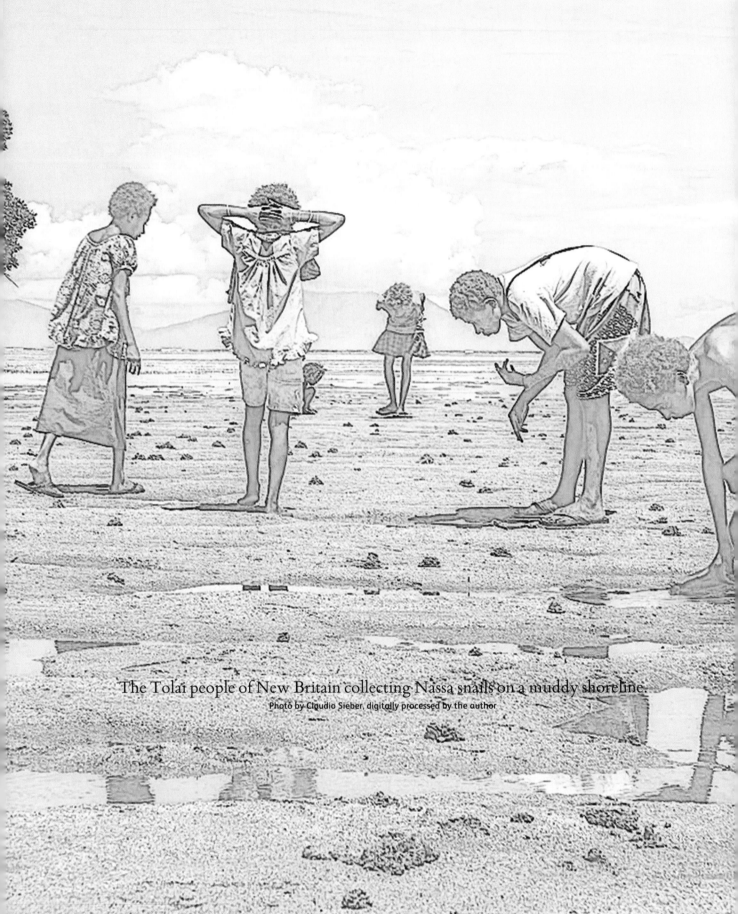

The Tolai people of New Britain collecting Nassa snails on a muddy shoreline.

Nassa Shells

The small unimpressive shells of the family Nassariidae are commonly called Nassa shells. They are prolific in the shallow seas of the Indo-Pacific and the tops are knocked off to create a hole through which they can be threaded. Despite rather modest appearance, they have a long history of being used in adornments, with the earliest archaeological records in this region going back to 6,500-year-old shells discovered in Timor-Leste. These worked and perforated shells show signs of being used as adornments attached to woven items, such as this later example at right.

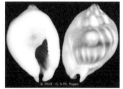 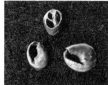

Worked and perforated Nassa shells used on a red fabric headband from Timor. MV E89272

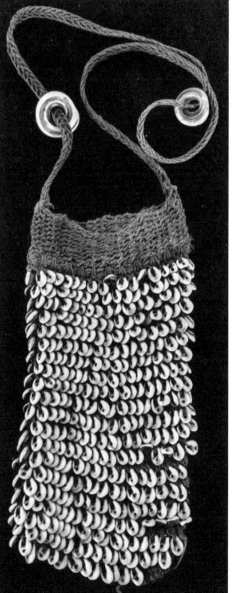

Nassa shells are the basis for a ubiquitous and important currency amongst the Tolai people of northern New Britain in Papua New Guinea, which is discussed further in the *Value Networks* chapter.

Nassa shells are found in many utilitarian objects, such as *bilum* bags, and adornments, where they may totally cover a woven object. One example are the Dani mens' chest adornments, known as *wopok*, on which they were worn as protection from arrows and malevolent spirits in battle.

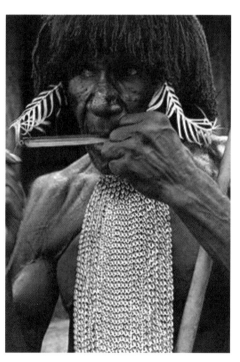

Dani man wearing a *wopok* chest adornment made of Nassa shells. Baliem Valley, Papua. CB

A small *bilum* amulet bag adorned all over with Nassa shells. GR, WG T0398

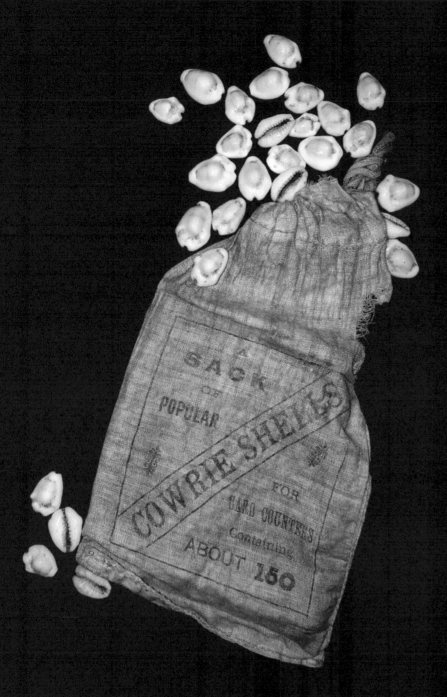

From the 19th century, demand for money cowries declined and excess quantities of *Cypraea moneta* shells were sold in these small sacks to be used as game counters.

A SACK OF POPULAR COWRIE SHELLS FOR CARD COUNTERS Containing ABOUT 150

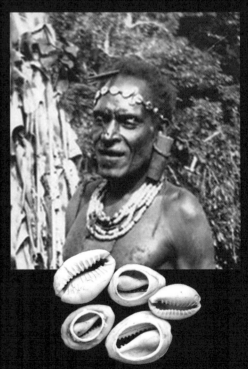

A Kapauku man at Bisano on the banks of the Mamberamo River delta in central Papua wearing their cowrie shell currency in the form of a headband and necklaces. In his hair he wears a small wooden comb which is used for eating purposes and is simply kept in the hair for convenience. In his pierced ear lobe, he carries a bamboo tobacco container. Photo: SP, Le Roux, Stirling Expedition 1926

Le Roux, writing in his 1950 study on the *Mountain Papuans* writes that the cowrie shells are broken open before being attached to the woven straps "so that their soul is visible". The flat, buffed back of the shell is called *agón*, literally 'vagina in the pear-shaped soul'.

Cowrie shells

Cowrie (or sometimes 'cowry', but the plural is always 'cowries') is the common name for a group of marine molluscs in the genus *Cypraea* and the family Cypraeidae. The animals start off with an obvious spiral-shaped shell but in maturity develop heavy exterior shell deposits that give cowrie shells their instantly-recognisable shape and lustre, making them the favourite for shell collectors and for adornments wherever they were found.

young adult

Cypraea tigris · Praslin 1979

The beautiful shiny shells are said to be the origin of the word 'porcelain' – after the old Italian term 'porcellana' for the cowrie shell. Cowries have been used as currency, adornment and/or ceremonial purposes in almost all cultures.

If you study the history of currencies, in the beginning, long before there were coins, there were cowrie shells. Not just any cowrie shells, but the money cowrie *Cypraea moneta*, a shell with a unique ethnographic history. They were mainly harvested in the Maldives Islands in the central Indian Ocean where the sandy shallow seas produced the smallest, hardest cowries in vast profusion. Cowries became a powerful currency in Asia and eventually throughout much of Africa, including being vital as small change in the slave trade. The Chinese character for money originated as a stylized drawing of a cowrie shell (貝) and shells were replicated in gold and other materials. They were also used as ballast in sailing ships returning from India to Europe and, from the 19th century, excess quantities were sold off as game counters in small sacks, as shown in the image opposite.

Throughout the South Seas, cowries were used extensively as part of adornments, in masks and as valuables in exchange. It's perhaps surprising that, with such a profusion of cowries, only the Kapauku, who live in the central highlands of Papua, seem to have used cowries as a true currency. Their unique capitalist economy was characterised by the pursuit of wealth, status and an overriding ethic of individualism.

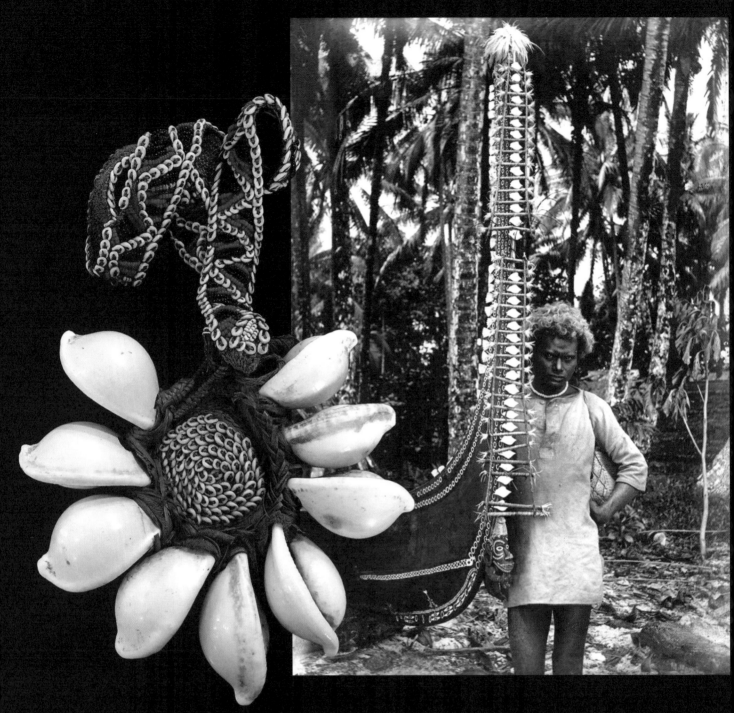

A spectacular chest/back ornament dominated by a circle of egg-cowries – on a spectacular woven neckband adorned with Nassa shells and glass beads. Huon Gulf, Morobe Province, PNG.

RP, GR, WG T0397

A blonde-haired man, Maku, standing next to the prow of a canoe adorned with egg cowries, Marovo, New Georgia, Solomon Islands.

Photo by: Lieutenant B T Somerville 1893–1894

BM Oc,B36.2

Naturally blonde hair is rare, occurring primarily in Northern Europe, but also due to a genetic anomaly in the Solomon Islands, which has nothing in common with the blond hair of Europeans and has evolved independently. Five to ten percent of people here have naturally blonde hair – contrasting with the darkest skin pigmentation outside Africa.

A neck adornment featuring two *Ovula ovum* egg cowries. Huon Gulf, Morobe Province, PNG.

CH, WG T0281

Cowrie shells

Many different species of cowries are used in South Seas adornments. Especially popular are large cowries, such as the Tiger Cowrie *Cypraea tigris* and the egg cowrie *Ovula ovum*. Strictly-speaking however, egg cowries are not true cowries at all. They are an unrelated species, *Ovula ovum*, which is more correctly called the 'false cowrie'.

The Golden Cowrie *Cypraea aurantium*

In Fiji, the golden cowrie *Cypraea aurantium* is called *bulikula* and worn on a string around the neck by chiefs as a badge of rank, even today. The National Women's Rugby League team is called *Bulikula* because, in the words of Fiji's President, "it resembles a dazzling uniqueness of beauty…just like our women."

The large white egg cowries are common in New Guinea adornments. Examples are shown on the facing page – their dazzling white has made them an extremely popular trade item from the coast to the Highlands. They adorn a multitude of objects and are especially popular on trading and war canoes across the South Seas.

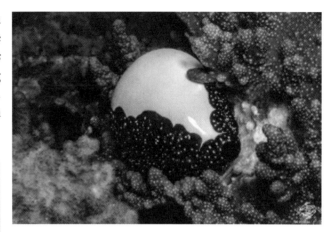

A living *Ovula ovum* mollusc on a reef showing off its dramatic black and yellow mantle, which usually covers the white shell completely.

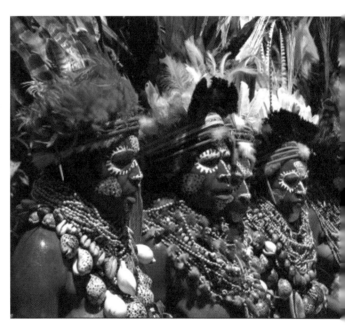

Wenga women in the Wahgi Valley wearing profusion of Tiger Cowries *Cypraea tigris* and egg cowries *Ovula ovum* during a *singsing* on the New Guinea Highlands 2002.

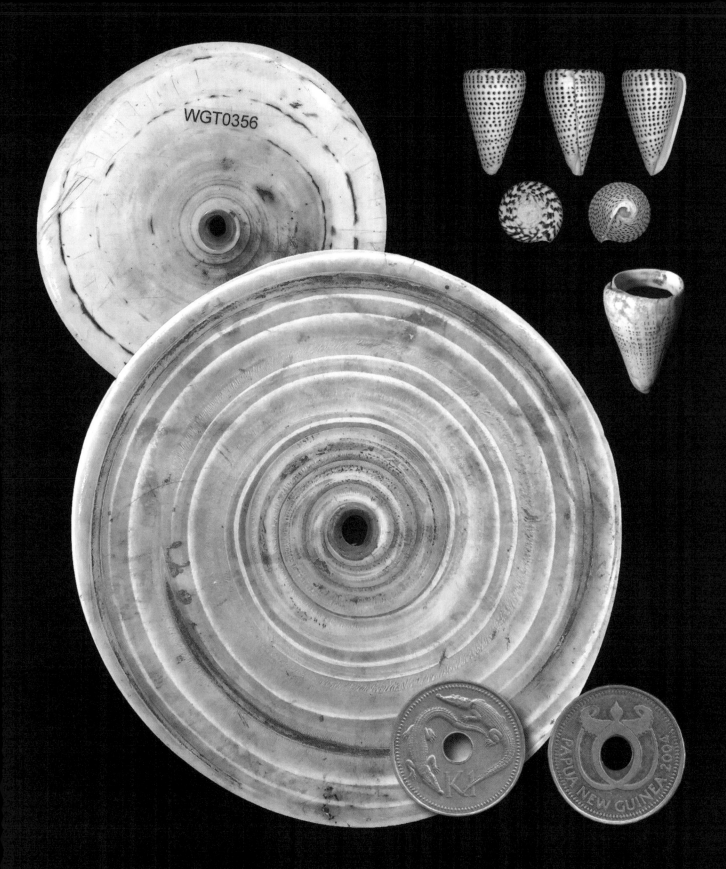

WGT0356

This tactile spiral disc is a valuable breast adornment *dibidibi* from Manus in the Admiralty Islands. It is made from the top of a large cone shell polished to a high gloss and is used as an adornment, prestige item and currency. CB, WG T0356

PNG coins also have a hole in the centre, quite reminiscent of this traditional currency.

Conus shells

Conus marine gastropods are common in shallow reef habitats all across the Indo-Pacific and are known as 'cone shells' for obvious reasons. They live primarily in shallow grass beds and are predatory and venomous. *Conus litteratus* and *C. leopardus* produce thick and heavy shells, up to 222 mm in size, with a flat spire which makes them eminently suitable for rings and disc-shaped adornments.

An interesting characteristic of cone shells is that the earliest internal shell walls are resorbed by the animal, so that when the shell is broken open, the internal structure easily disintegrates, leaving a loop that can be worn on the upper arm.

While used as adornments, these cone shell rings were important trade items locally and in the *Hiri* trade voyages, and an integral part of Brideprice. Depending on the area they were variously called *wauri, toea* or *mwali*.

When the top of a cone shell is polished into a flat disc and worn as a pendant (see opposite) it is known as *dibidibi* or *bŏŭmbŭ'l* in the Admiralty Islands.

The Motu word *toea* means both 'cone shell' and 'an arm ring made from cone shell'. In modern PNG currency – one hundred *toea* equals one *kina* – firmly establishing the importance of *Conus* shell adornments in the economic culture.

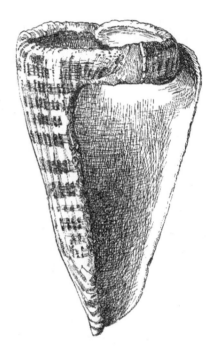

In the Highlands and in southern New Guinea, cone shells are further ground down so that they become true arm rings – sometimes engraved or adorned with shells and beads – such as the example of a *mwali* from Milne Bay at left.

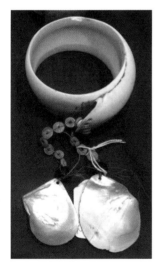

A *mwali* cone shell ring with attached *bagi* currency and pearl shell discs. Massim people in Milne Bay, PNG. PH, GR, WG T0459

Wauri cone shell rings collected from the Torres Strait and the Fly River delta circa 1910
NL VKK 248: 514

Distribution of Conus armbands.
McNiven, I.J. 2021

87

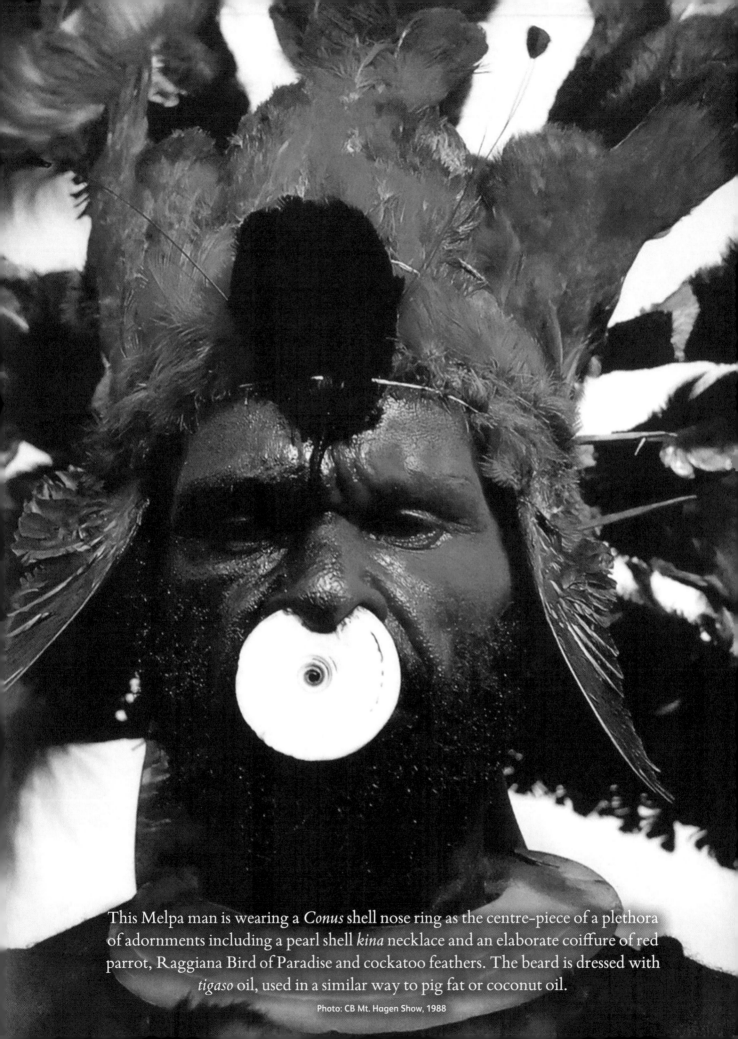

This Melpa man is wearing a *Conus* shell nose ring as the centre-piece of a plethora of adornments including a pearl shell *kina* necklace and an elaborate coiffure of red parrot, Raggiana Bird of Paradise and cockatoo feathers. The beard is dressed with *tigaso* oil, used in a similar way to pig fat or coconut oil.

Photo: CB Mt. Hagen Show, 1988

Conus shells

Wahgi Valley, PNG Highlands

In the Wahgi Valley in the Papua New Guinea Highlands, *Conus* shell nose rings were essential decorations for ceremonies. The Melpa man on the facing page is wearing a *Conus* shell nose ring as the centrepiece of a plethora of adornments which include a pearl shell *kina* necklace.

These two images, of the front and back of a Wahgi nose adornment, illustrate the characteristic dashes resulting from deep polishing of the *Conus* shell top and the spiral structure on the inside of the shell. The carved jagged edge adds an extra level of importance and prestige. Size 70 mm.

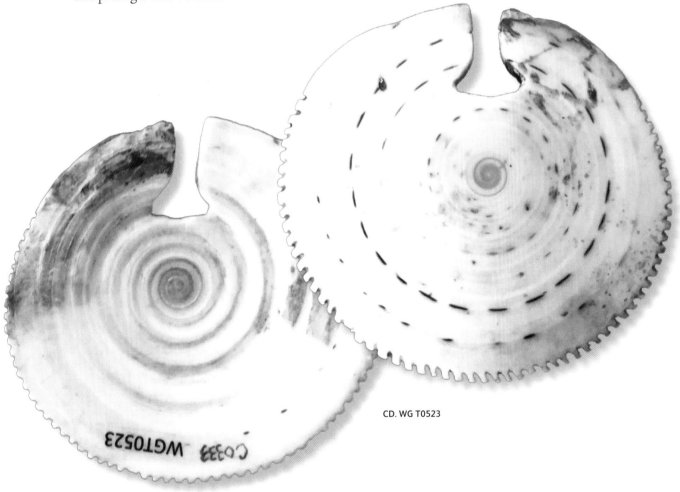

CD. WG T0523

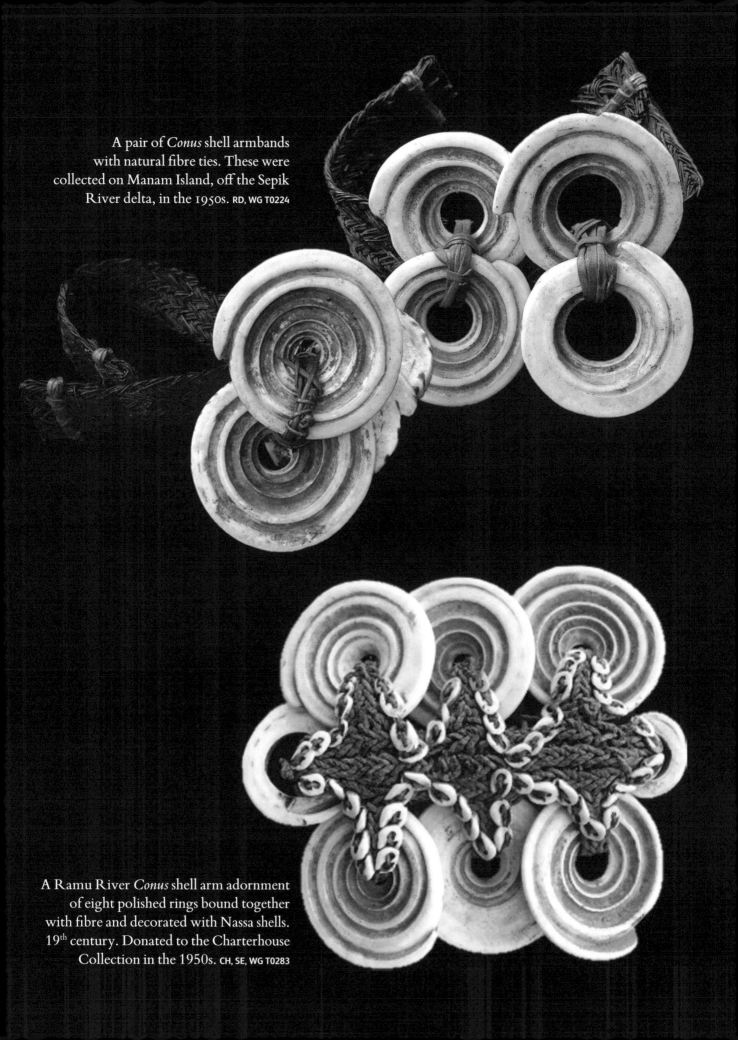

A pair of *Conus* shell armbands
with natural fibre ties. These were
collected on Manam Island, off the Sepik
River delta, in the 1950s. RD, WG T0224

A Ramu River *Conus* shell arm adornment
of eight polished rings bound together
with fibre and decorated with Nassa shells.
19th century. Donated to the Charterhouse
Collection in the 1950s. CH, SE, WG T0283

Conus shells

An infinite use for cone shell tops

Conus shell tops are found in an endless variety of South Seas adornments, from rattle-armbands to necklaces and adornments for ears and nose. Many are made to show up the spiral shapes of the cone shell, adding to the object's appeal.

Worked cone shell tops are found almost everywhere in the South Seas, from the New Guinea HIghlands to the Sepik and Ramu Rivers, and the off-shore islands. One of the most spectacular of these is Manam Island, which is dominated by an active volcano and located in the Bismarck Sea off the northeast coast of PNG. The island was evacuated in 2004 due to ongoing volcanic activity, and adornments from here are rarely seen.

In the example below, from the Anga people in the Eastern Highlands of New Guinea, the *Conus* shell tops have been very finely polished, each into a domed disc with just a small hole in the centre and woven onto a delicate natural fibre weave.

RP, GR, WG T0381

The Sepik River delta and Manam Island, with its volcano smoking away.

Photo: Mike Condon c. 1971

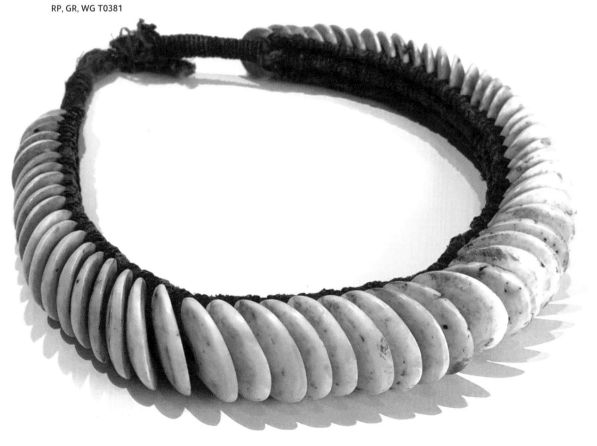

91

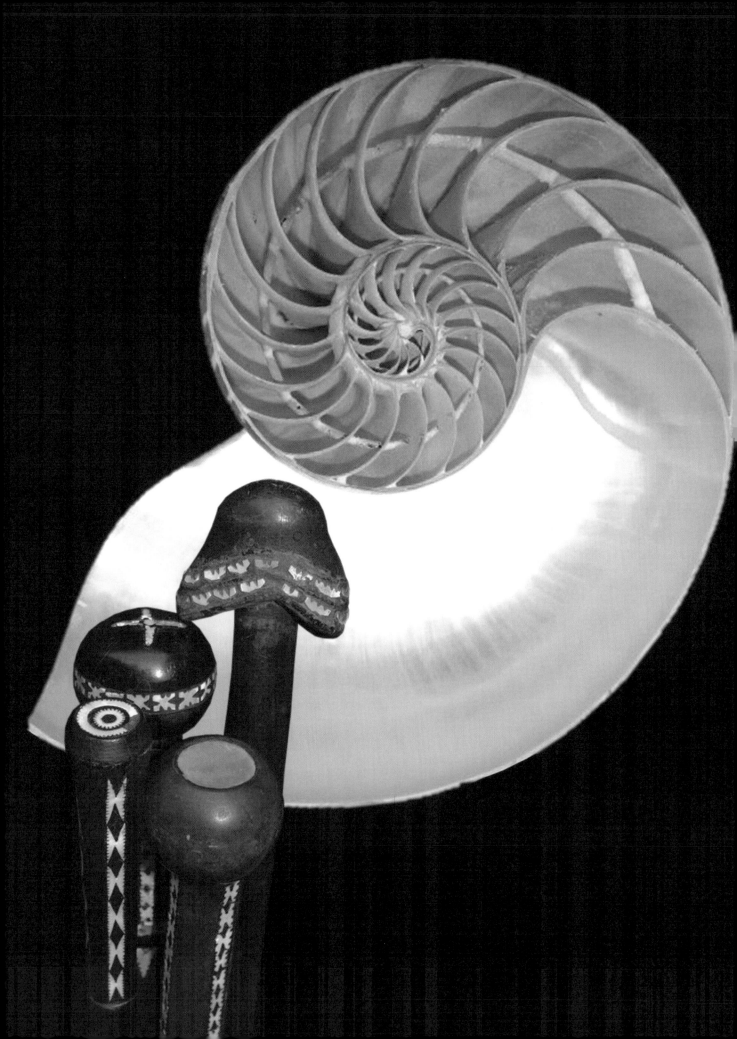

Nautilus shells

The Chambered Nautilus, formally a *Nautilus* sp., is one of the oldest living things on our planet. Unlike most of the 'sea shells' included here, the animal that makes this shell is not a gastropod, but a cephalopod, closely related to octopus and squid. *Nautilus* has survived whatever the world has thrown at it for more than 500 million years, persisting even as dinosaurs and many other life forms vanished. Since the dawn of civilisation its iconic spiral form has inspired artists, designers and architects – representing the renowned 'golden section'.

The South Seas are the centre of the world's *Nautilus* populations, living in deep habitats beyond 200 m around the islands, and dead shells are washed up on beaches only infrequently. Until the 20th century, when commercial fishing for *Nautilus* started, supply of the shells was always limited, so the 'value' perception has always remained high.

Almost all of what is normally termed 'pearl shell inlay', especially in Solomon Islands artefacts, is in fact *Nautilus* shell inlay – as seen in bowls, clubs, combs and shields etc. The *Nautilus* shell material is extremely luminescent on one side, consistently thin and fairly soft, making it easy to cut into tiles to be inlaid into prestigious objects – something which is difficult to do with the thicker pearl shell.

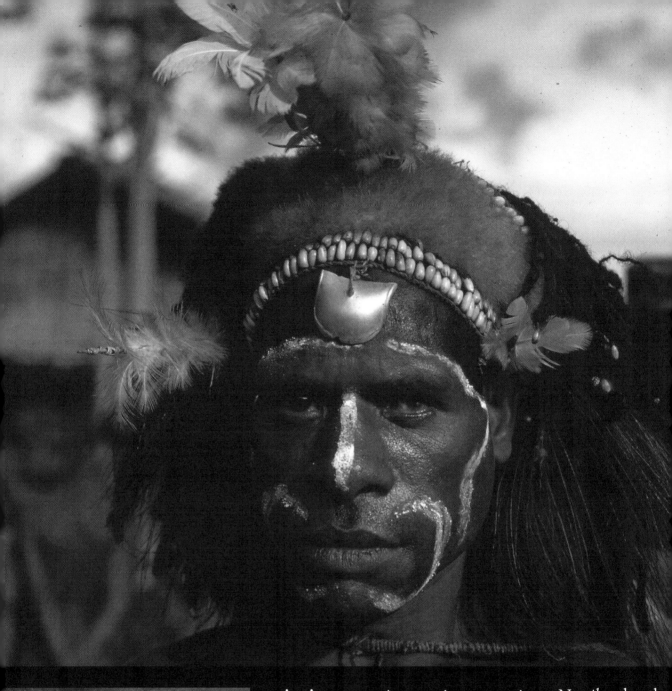

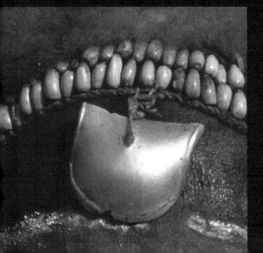

An Asmat warrior wearing a prominent *Nautilus* chamber wall pendant on his forehead and a cuscus fur headband adorned with Job's Tears seeds. Ocenep, Papua.
Photo: PS Henny van de Kerkhof 1970s

A Father who worked amongst the Asmat in the Sixties told me that the Nautilus chamber walls served as a mirror for evil spirits. When the spirits saw themselves in the shiny reflecting shell it would frighten them and they would quickly leave.

Klaas Schoof

Nautilus shells
Use of internal chamber walls

When *Nautilus* shells were broken up to make the tiles used for inlays, the material that made up the internal chamber walls, or *septum*, of the chambered shells was mostly cast aside. The approximate position of a *septum* is indicated on the *Nautilus* shell at right. The central hole in the chamber walls, the remnant of the siphuncle that connects the various *Nautilus* chambers, proved convenient for threading onto fibre string.

These chamber walls appear only in the most valued adornments and are rarely seen. A few examples are shown on this and the following pages.

In Papua, as a general rule, the Asmat use only the smaller and much more fragile *Nautilus* chamber walls while the Marind prefer to use rough fragments of *Nautilus* shell in their adornments.

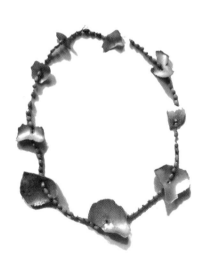

A well-used necklace made of Job's Tears seeds and *Nautilus* chamber walls, from the Kombai people of Papua. **KS**

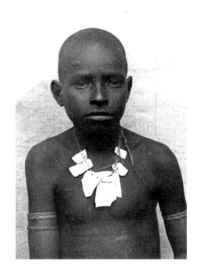

A Marind child wearing a necklace of fragments of *Nautilus* shell.
SP Afdrukken-Merauke-067b

This shell garland adorning a figure of the Virgin Mary, incorporates *Nautilus* chamber walls. Philippines. **GP**

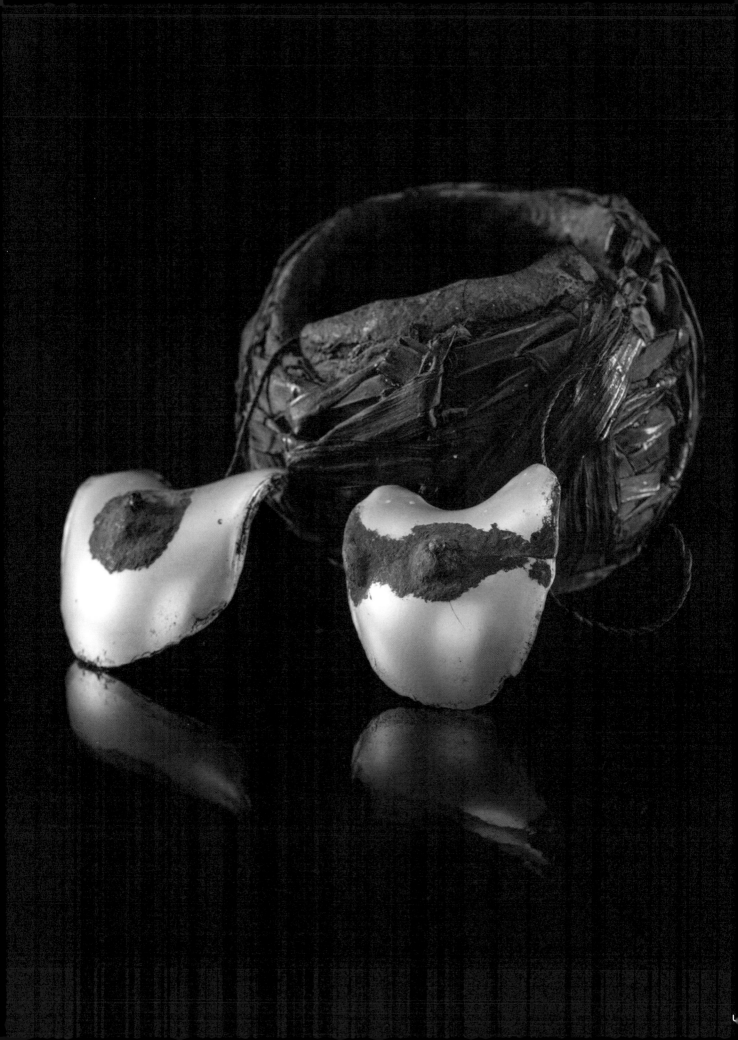

Nautilus shells

Ear adornments from chamber walls

One of the most unusual uses of the *Nautilus* chamber walls is seen in these rare ear adornments likely made for Big Men. Only a few pairs of these are known and two are illustrated here, both from the Highlands of New Guinea. The one on the facing page and at top right is from the Southern Highlands and the one below right is most likely from the Enga people in the Central Highlands.

Nautilus shell material was traded from the north coast to the Highlands, highly prized and difficult to obtain in pre-colonial times. These adornments were worn suspended by natural fibres threaded through the ears. They were prestige items worn only by the most important men and associated with magic rituals.

Two very different containers were used for these quite similar objects. The container on the facing page is woven from cane while the one at right is made from a dried fruit, carefully emptied and closed off with packing made from spiders' webs and grass burrs.

In both examples, the *Nautilus* chamber walls are packed with clay on the rear sides.

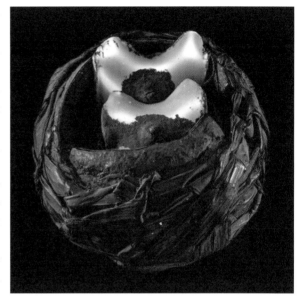

UK

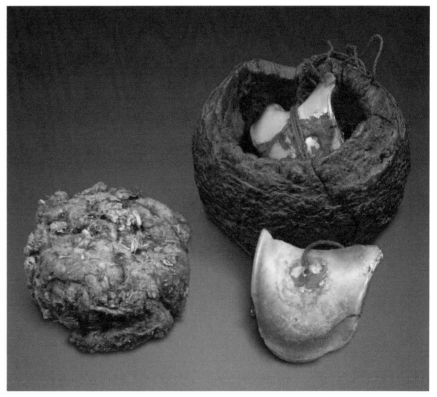

AM

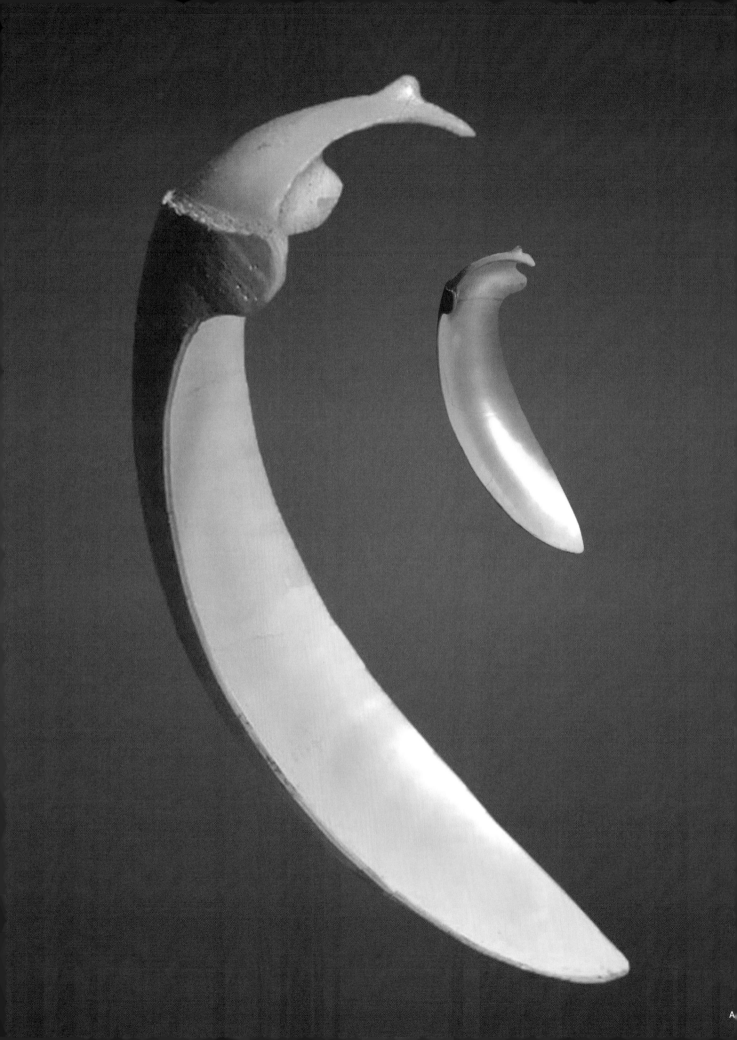

Nautilus shells

An aesthetic spoon from Papua

This fine and remarkably elegant spoon is made from a *Nautilus* shell and creatively incorporates the last chamber wall of the Chambered Nautilus. It certainly looks like a functional item, but it is clearly fragile and has been repaired. Anything made with such attention and aesthetic beauty was likely to have been primarily a prestige or ceremonial item.

Although this has been interpreted as being made "in the shape of a stylized bird.... perhaps the bird of paradise *Paradisaea raggiana* parading during the mating ritual or in flight", the top part, the 'handle', is actually the completely natural shape of the *Nautilus* shell including the last chamber wall and the protruding siphuncle. It is only the observer's imagination that creates the analogy to other natural shapes. It is one of the few known examples of this part of the *Nautilus* shell being utilised in this way, and certainly a masterpiece of the crafter's achievement.

It was collected by Rev. Father Vertenten, a Belgian missionary of the Congregation of the Sacred Heart Mission in Dutch New Guinea, before 1925, in the remote Asmat/Marind region of Papua.

The images below show how this unique piece would have been cut, carved and polished from body chamber of a Nautilus shell.

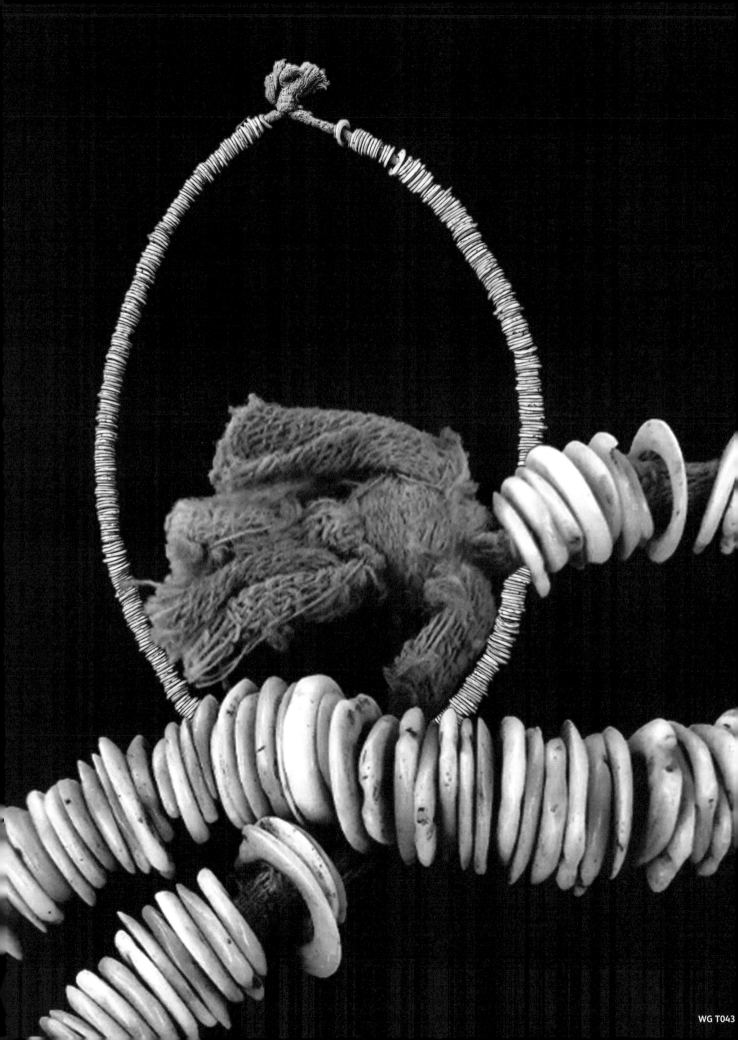

Strombus shells

Strombus shells, although common in South Seas shallows, are used only rarely in adornments or currencies. The Strawberry Conch *Strombus luhuanus* (recently renamed *Conomurex luhuanus*) is one of the shells that is used, but only on one remote island group.

People on the Banks Islands, a group of islands in northern Vanuatu, decided to explore options beyond cultural 'standards' and create objects that are somewhat different. Here local crafters cut the tops off small *Strombus* shells and polished them into fine slivers just 7–10 mm across – a tremendously laborious task. Due to the nature of the shell construction, the act of polishing off the top creates a natural hole through the centre – not unlike the making of *Conus* shell beads. These beads have been made into a necklace by having a thick woven natural fibre band drawn through them. To make the necklace shown on the facing page, would have required the polished tops of more than 500 shells.

This bead style was documented by Quiggin in her authoritative 1949 *Survey of Primitive Money* to be unique to the Banks Islands, and none were known to have been made after 1900. These *Strombus* beads were also used as a currency called *som*.

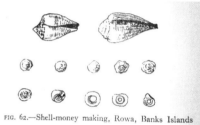

FIG. 62.—Shell-money making, Rowa, Banks Islands

Quiggin 1949 *Survey of Primitive Money*

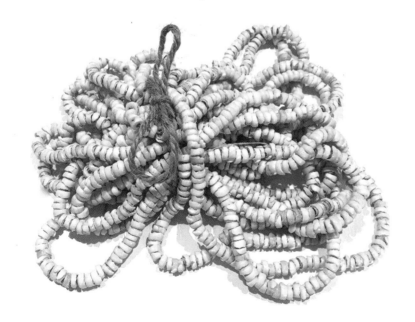

A similar style of bead from the Banks Islands is shown in this 4.5 m string of *Conus* shell tops, each bead 5-7 mm. Banks Islands, Vanuatu. **WG T0452**

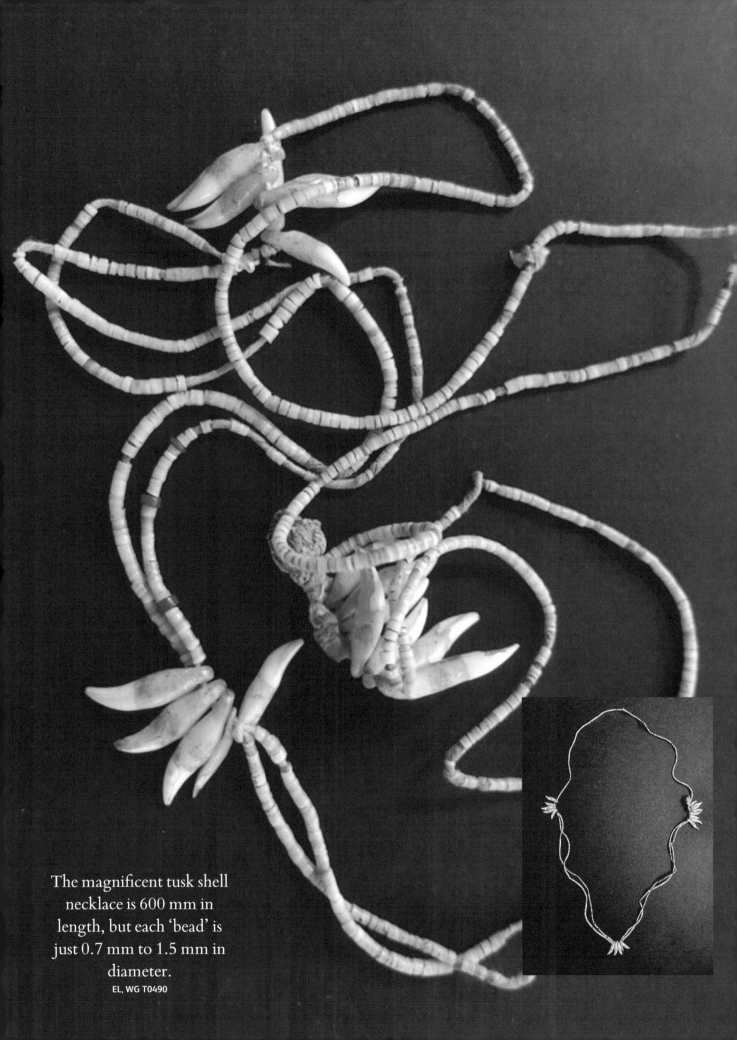

The magnificent tusk shell
necklace is 600 mm in
length, but each 'bead' is
just 0.7 mm to 1.5 mm in
diameter.
EL, WG T0490

Dentalium Tusk shells

A rare Solomon Islands necklace

Tusk shell strings were amongst the oldest trade items of some societies, including the Australian Aborigine, with archaeological evidence from a cave in the Napier Range in Western Australia dating their use as adornments back 30,000 years. Malinowski also brought some tusk shell adornments back from his studies of the *Kula* Ring in the Trobriand Islands. All examples of tusk shell adornments that I have seen have the shells strung length-wise.

However, the extremely fine necklace illustrated on the facing page is different. It was acquired by Eric Lancrenon from an old lady in Honiara, Solomon Islands. I knew that it was an extremely fine object but, on closer examination, I saw that these shell 'beads' were nothing like any of the Solomon Islands money-beads that I had previously seen.

Under a magnifying glass I realised that these fine tiny beads were not 'carved' at all. Each bead is a tubular cross-section cut from small tusk shells, perhaps of the genus *Dentalium*. Each shell 'bead' is just 0.7 mm to 1.5 mm in diameter. That's really tiny. They are as small as the smallest industrial glass seed beads.

The necklace is 600 mm in length and is shown in full on the facing page It is the only example that I have seen of tusk shells cut into such fine rings – a truly spectacular example of a skilled artist taking the care to make a truly precious adornment. For such fragile beads to survive is nothing short of a miracle.

Dentalium necklace with shells strung length-wise, from Malinowski's expeditions to the Trobriand Islands 1915–1918
BM 2012,2037.19

A comparison of the delicate necklace on the facing page with traditional Solomon Islands shell-money – each bead is just one-tenth of the size.

Close-up of the tusk-shell beads in this necklace. EL, WG T0490

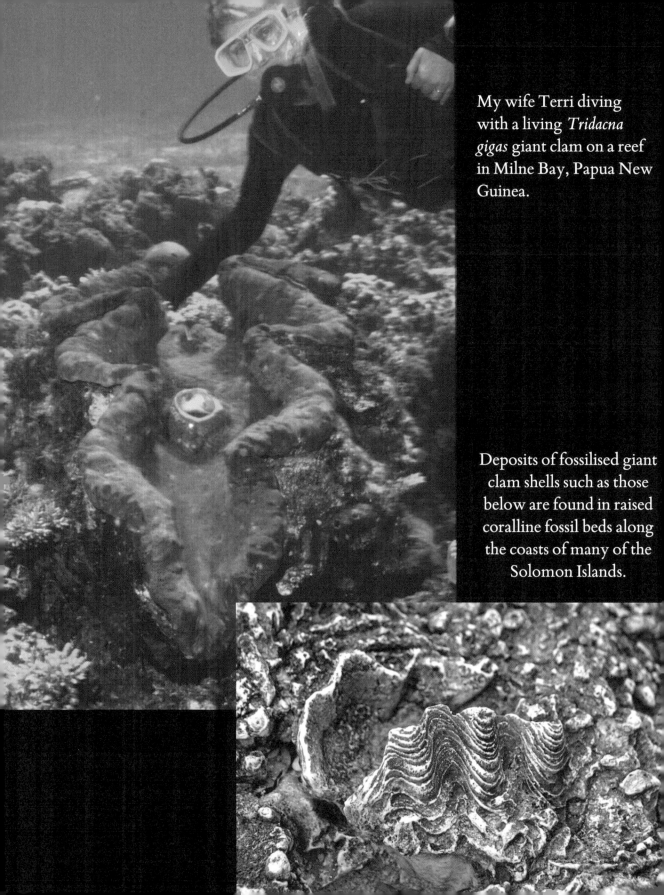

My wife Terri diving with a living *Tridacna gigas* giant clam on a reef in Milne Bay, Papua New Guinea.

Deposits of fossilised giant clam shells such as those below are found in raised coralline fossil beds along the coasts of many of the Solomon Islands.

Tridacna giant clam shells

The largest living species of giant clam is *Tridacna gigas* and has been an integral part of Indo-Pacific coral reef communities from 55 to 33 million years ago to the present. Giant clams grow rapidly and attain up to one meter in length in a few decades. Their lifespan often exceeds 60 years in the right conditions. Traditionally they have been used as part of the food supply and their substantial shells have been utilised for functional and adornment objects.

The islands of the Pacific originated as chains of volcanic islands, atolls and ancient coral reefs uplifted by geological processes – exposing fossil deposits many meters above sea-level. These include fossil and sub-fossil giant clam shells.

Amongst the heavily forested slopes of the Huon Peninsula in Papua New Guinea can be found fossilised giant clams, dating back 420,000 to 380,000 years, in ancient reef beds uplifted by geological processes to some 1,200 metres above sea level. Locals have 'mined' these and similar ancient deposits, some millions of years old, for hundreds of years, extracting the huge bivalves without questioning how these shells, identical to those on the reefs, could be found at these altitudes. Fossil clam shells from these and other northern Papua New Guinea sites were traded inland where shell rings were made.

In the Solomon Islands, raised coralline fossil beds are found around New Georgia, in Roviana and Marovo Lagoons, at Houniho on Makira, at Talise on Guadalcanal's south coast and on Choiseul. Here, ritual priests called *matazonga* would find and extract the fossil limestone, said to be imbued with powerful spiritual properties that would be transferred to objects made of them.

The spectacular clam shell rings from New Guinea and the Solomon Islands are discussed later in this book.

The forested slopes of the Huon Peninsula in Papua New Guinea where fossilised giant clams are found.

Researchers digging out fossilised giant clam shells.
Photos: Bridget Ayling

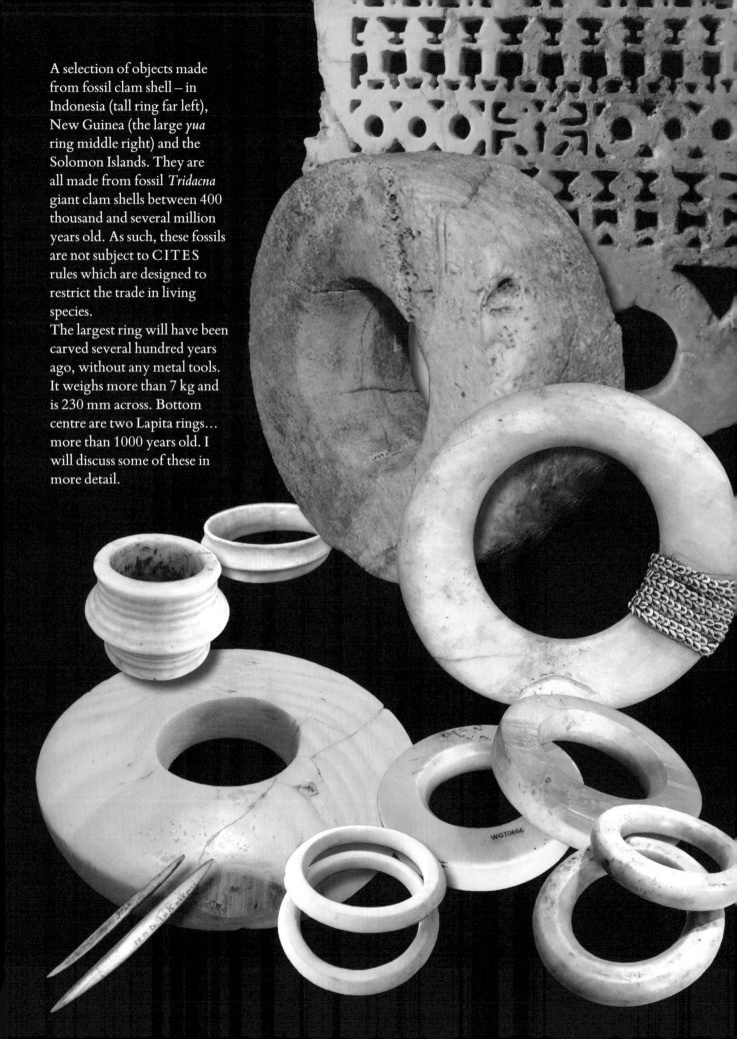

A selection of objects made from fossil clam shell – in Indonesia (tall ring far left), New Guinea (the large *yua* ring middle right) and the Solomon Islands. They are all made from fossil *Tridacna* giant clam shells between 400 thousand and several million years old. As such, these fossils are not subject to CITES rules which are designed to restrict the trade in living species.

The largest ring will have been carved several hundred years ago, without any metal tools. It weighs more than 7 kg and is 230 mm across. Bottom centre are two Lapita rings… more than 1000 years old. I will discuss some of these in more detail.

Tridacna giant clam shells

The aragonitic material of fresh giant clam shells is extremely hard, brittle and difficult to carve. By comparison, fossil clam shell material, buried for hundreds of thousands of years, can be easier to carve, and the resulting objects, at best, can look and feel like ivory.

Clam shell objects that appear smooth and sometimes even 'shiny' (like some rings on the facing page), may have been carved from fresh shells, or more likely been carved from materials classed as 'sub-fossil', from younger fossil deposits. Despite their 'new' look, the shell material in them could still be extremely old. Some older items, such as the large ring on the facing page, have been exposed to the elements or even buried for hundreds of years and take on a very pitted and weathered appearance.

Within both living and fossil clam shells are visible wavy growth layers. Studies have shown that during a cyclone the growth rate of clam shells decreases abruptly, and the resulting mineral structure of the growth layers can be used to reconstruct past climate and weather. Modern shells show resolution down to a daily record while fossil shells can provide accuracy down to monthly events. Because giant clam shells usually stay in one place on the reef in their lifetime, they represent effective records of climate and climate change for that period.

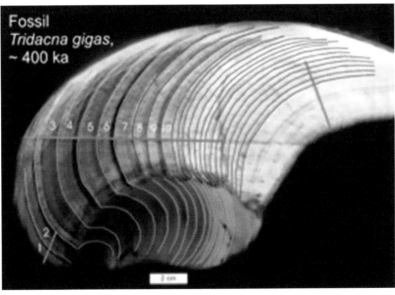

Wavy growth layers in fossil *Tridacna gigas* giant clam shells show climate patterns from almost half a million years ago. **Bridget Ayling**

These ear adornments feature shells of *Megalacron* sp. snails that occur only on the offshore Islands. The attachments are made from cassowary feather quills. Very little is known about this item other than it was collected by a missionary family in the early 20th century amongst the Asmat people of Papua. MH

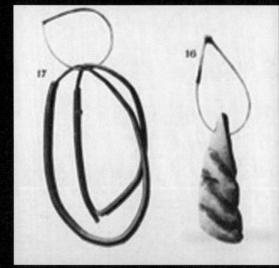

Cassowary feather quill attachments used in adornments. Van der Sande's 1907 book on New Guinea

Land snail shells

From the previous pages it will have become self-evident that shells of marine molluscs provide the basic raw materials for the making of many South Seas adornments. Even though the plains and jungles of the area abound with thousands of species of terrestrial molluscs, it is extremely unusual to see these 'land snails' featured in adornments.

Land snail shells are sometimes included in Papua Highlands 'magician bags' – amongst the plethora of marine shells, crystals etc – as these *Papua cingulata* land snails shown in the images at right.

Shown on the facing page is the only example I have seen of a South Sea adornment that features land snail shells as a central motif. The cassowary feather quills however seem to have been commonly used to suspend adornments.

Despite the abundance and attractiveness of land snail shells in the South Seas – even featured on New Guinea postage stamps – in adornments, there is a clear preference for shells of the marine variety.

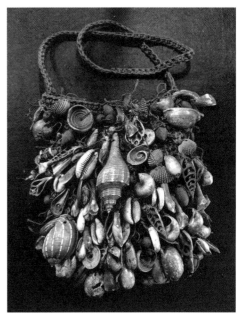

WG T0662

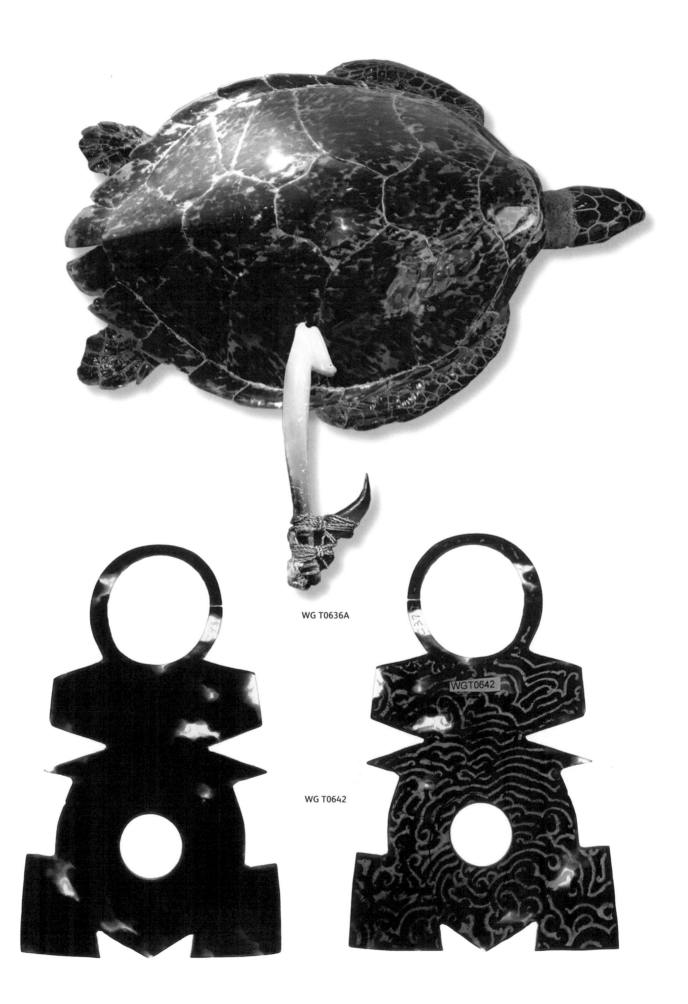

WG T0636A

WG T0642

WGT0642

Turtle shell

Some of the most magnificent adornments made by humans were made from 'tortoise shell'. It is actually a misnomer because the material actually comes from the shell of the hawksbill sea turtle *Eretmochelys imbricata*, and is composed of keratin, similar to our fingernails.

'Turtle' is an umbrella term for all reptiles in the order Testudines – these include tortoises (that live exclusively on land), plus turtles and terrapins which live in water nearly all the time, and only come ashore to lay eggs. In North America the umbrella term 'turtle' is common, while in Britain, 'turtle' is used for sea-dwelling species, but almost never for the land-dwelling variety.

Around the Pacific many objects were made from turtle shell, from utilitarian fish-hooks, which were also used as currency, to the most exotic items of adornment – you will see many throughout this book. Turtles were plentiful and were an integral part of the food supply. The discarded shells proved to be extremely easy to cut, bend and shape when heated. A single scute of an adult Hawksbill turtle could be as large as 220 x 120 mm – making it possible to make substantial objects even from a single scute.

Today turtles are critically endangered, not because of the sustainable usage of islanders over millennia, but because of industrial-level exploitation in the last fifty years. Plastics have increasingly been used in modern objects of adornment to simulate turtle shell. The best plastic products are hard to distinguish from real turtle shell.

The rare turtle shell nose ornament on the facing page is from the Ontong Java Atoll, located in the northern Solomon Islands, and it demonstrates the natural shell characteristics well. The image shows both the front and back of the object – the front has been polished to a high gloss, while the back shows the natural shell layering. This anthropomorphic design is characteristic of the Ontong Java Atoll and is used during initiation ceremonies. On death these items were usually buried with the deceased, hence their scarcity.

Plastic

Turtle shell

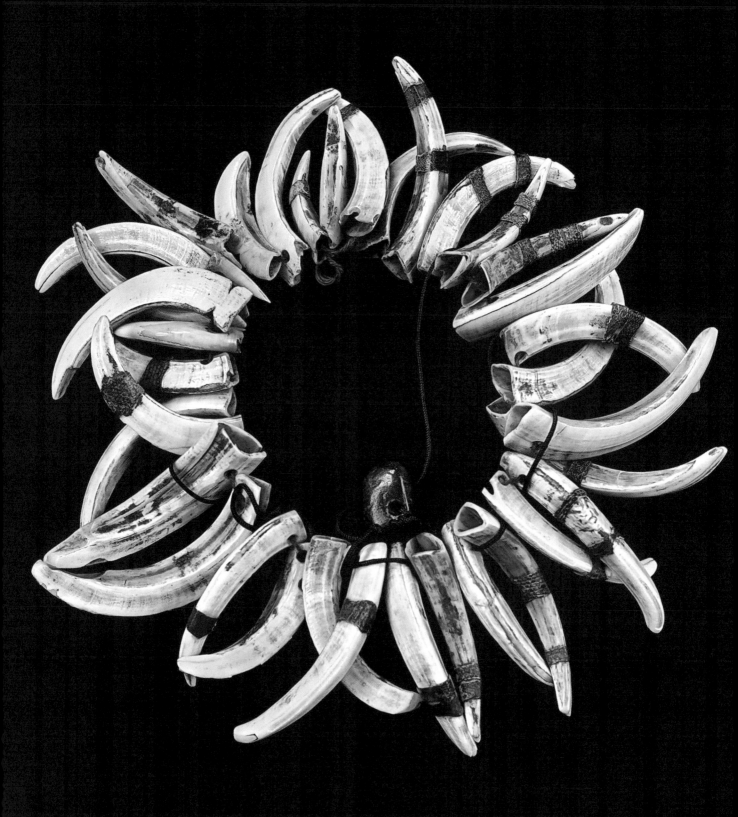

This adornment of pigs' teeth has been treasured and lovingly cared for over many years, perhaps through many owners. As each tooth has threatened to break, it has been carefully bound to prevent it splitting.
Sepik River, PNG. SK, WG T0177

Teeth

Since ancient times, teeth were used as aesthetic adornments as well as an exchange medium. They were highly suitable as a currency because of their consistent form and their hard, almost indestructible, nature. As adornments teeth were able to be arranged in symmetrical patterns when strung on lengths of fibre or woven into fabric – in the process only enhancing their value in exchanges. Teeth from every animal were used – nothing was off limits – human teeth of ancestors were especially valued.

It is somewhat surprising then that shark's teeth were used so rarely, especially in Melanesia. They appear in some Polynesian weapons and clubs but were rarely used in South Sea adornments. Shark teeth were used as cutting instruments, especially to cut turtle shell for adornments before metal tools and drills became common after World War II.

In this section we'll explore some of the many uses of teeth in South Seas adornments. The sheer number and variety of objects made using teeth is truly astonishing.

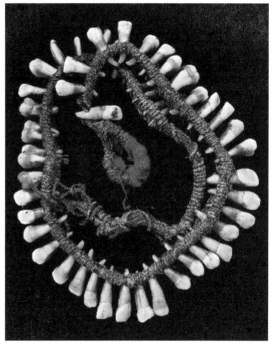

A necklace of human teeth intricately woven into a natural fibre band. Sepik, PNG, but also found in Fiji where this would be called *vuasagale*. WG T0465

A collection of necklaces that include teeth of various kinds. WG various

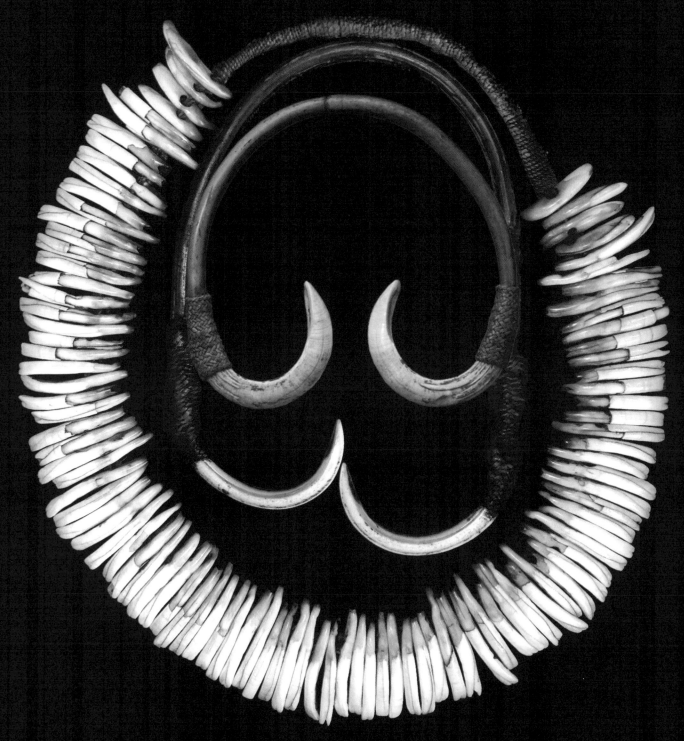

Above are examples of neck adornments from New Guinea highlighting the different shapes of pig teeth: the large necklace is populated with more than 100 carefully selected large incisors. With age and use, these have developed a wonderful patina not unlike ivory. Sisimin people, Om River, Sandaun Province (formerly West Sepik Province). WG T0402

The two neck adornments in the centre are called *yaawarozaanya* and feature large pig tusks mounted onto rattan with natural fibre weaving. The tusks would be worn to the front. These are from the Anga (formerly known as Kukukuku) people of Morobe Province in the Eastern Highlands. Lighter colour CB; darker colour RP, GR, WG T0362

Pig teeth and tusks

Pigs are central to life across the South Seas and are a major source of wealth and status. The animals themselves are so integrated into traditional life that it would be difficult to imagine life, and death, without them. Pigs are believed to have souls and are the path to power and prestige. Their teeth and tusks are commonly used in adornments, brideprice, as prestige items and currency.

Melanesian pigs are not those we are familiar with in the West, nor are they 'wild boars'. They were said to be a subspecies of ancient pigs brought here from SE Asia thousands of years ago.

The tusks of the male pigs are especially highly prized, and their value is directly proportional to their size. At some point someone must have discovered that if you removed the upper canine teeth, which serve to rub down the lower canines as they grow, then the lower canines could keep growing unimpeded. After six to seven years, they would grow into a full circle, actually growing through the lower jaw on their way – as shown in the image at right and on the following page. In collections, I have seen a few such tusks that comprise two full circles.

A true reflection of the value of pig tusks across the South Seas is evidenced by the replica pig tusks that are found laboriously and beautifully carved from clam shell.

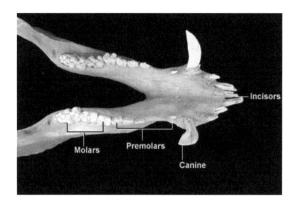

Pigs have four types of teeth: Best known are the huge CANINE tusks. These grow throughout life and can be encouraged to grow into full circles. The INCISORS are the long sharp front teeth. Both the canines and incisors are regularly used in adornments. MOLARS are hardly ever used in adornments.

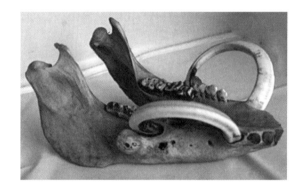

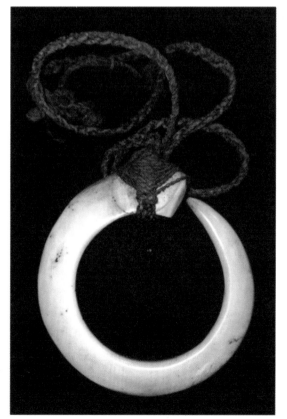

The finely-carved example of replica pig tusk carved from clam shell is from the Papuan Gulf, likely from the Kerema and Orokolo area. Note the distinctive 'diamond' style of weave at the top of the ring, which is typical of the area. **WG T0470**

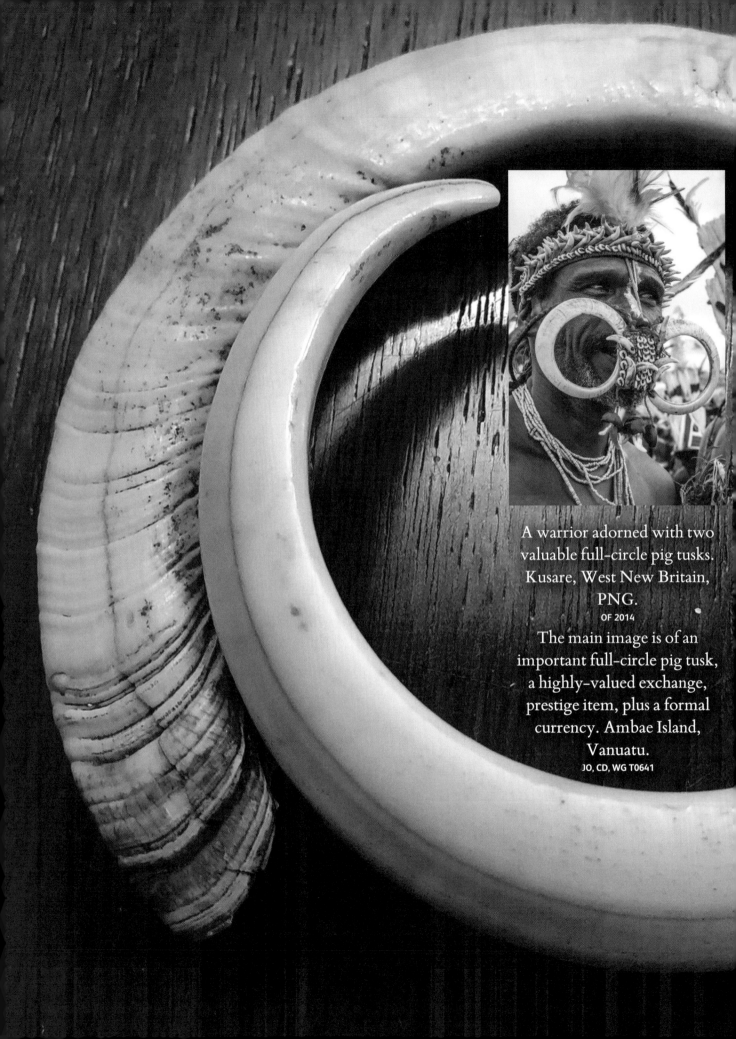

A warrior adorned with two valuable full-circle pig tusks. Kusare, West New Britain, PNG.

The main image is of an important full-circle pig tusk, a highly-valued exchange, prestige item, plus a formal currency. Ambae Island, Vanuatu.

> *"The area around Vanuatu was perpetually crisscrossed by inveterate Melanesian traders in their outrigger canoes in a never-ending series of voyages of cultural exchange, sale and purchase based upon and focused around the functional and sacred currency of the area: male tusker pigs."*
>
> Kirk Huffman 2013

In the northern Vanuatu islands, the relationships between pigs and humans have become so intertwined that pig tusks have become 'sacred money on legs', and recently, a formal currency.

Conversion to Christianity ensured that most of the islands drifted away from the traditional spiritual beliefs but, in the east of the islands, pigs and pig teeth remained more important than Christianity. It was here on Pentecost Island that the Tangbunia Bank was formed in 1983, making pig tusks legal tender, as well as dealing in other items of customary wealth such as hand-woven mats and shells.

Named Tangbunia, after the giant baskets in which local people traditionally stored their valuables, (and widely misreported as Tari Bunia Bank), the Bank is run by the Turaga indigenous movement and has fourteen branches throughout the island. Accounts at the bank are reckoned in *livatu*, a unit equivalent to the value of one fully-curved boar's tusk.

This alternative financial system addresses 80% of the population who are outside the cash-based economy and claims to have reserves worth US$1.4 billion.

A BBC report found the bank is like other banks in that it has "accounts, reserves, cheque books and tight security". The Chief explained that all branches were guarded by spirits and snakes. So far, apparently, there have been no robberies.

> *"On Pentecost Island there are 29 different language terms for tusk curvatures and their value."*
>
> Kirk Huffman 2013

In Vanuatu, the only traditional way to be considered 'rich' is based on how much you give away. In 2006 it was listed as The Happiest Nation on Earth *by the London-based New Economics Foundation.*

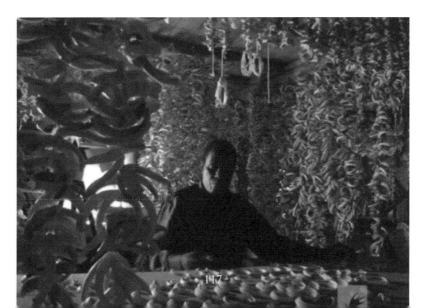

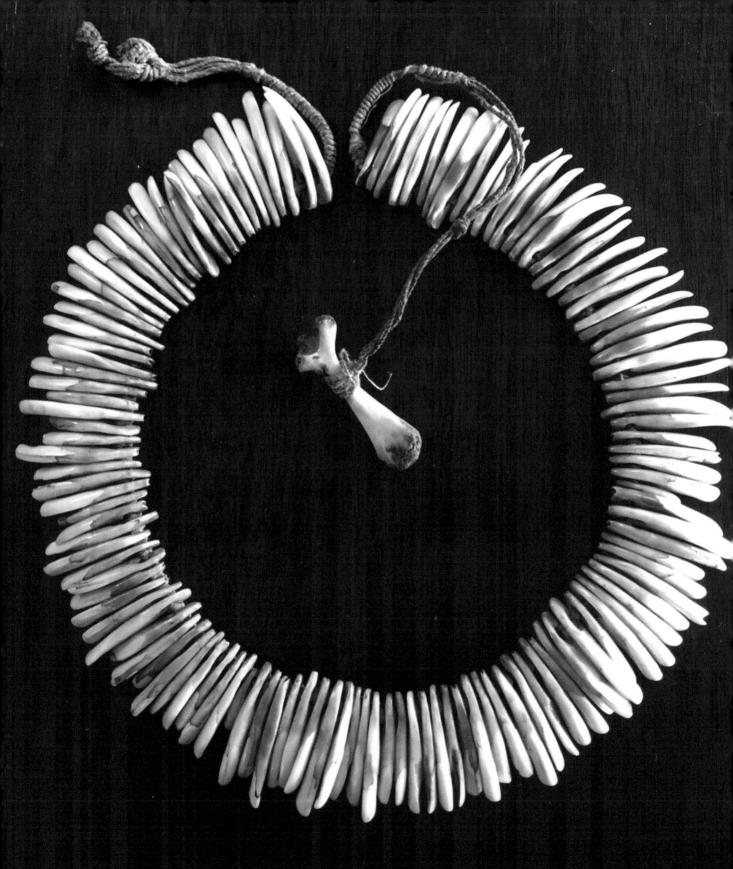

This elegant necklace from the New Guinea Highlands is made of fine small marsupial rat teeth, each tooth an average of just 30 mm long, bound into a natural fibre weave. Diameter 140 mm. It was originally collected by Barbara and Ron Perry in the 1970s. There are similar specimens in the Jolika collection.

RP, GR, WG T0472

Marsupial rat teeth

The order Peramelemorphia consists of 22 species of animals known as bandicoots and bilbies. They look like rodents, with a long pointy nose, can weigh up to 5 kg and show controversial evolutionary links with other marsupials through their feet, and the teeth. The one illustrated above is Raffray's bandicoot, an upland species that typically lives at elevations above 1,000 m. According to research done for the Jolika Collection, "marsupial rat" appears to be a generic term used for these small carnivorous marsupials.

Their small teeth are not to be confused with the similarly-shaped, but much larger pig teeth or incisors. Marsupial rat teeth are much more uncommon, valuable and esteemed.

When I discussed this with Todd Barlin, he recalled: "I collected similar necklaces amongst the Asmat tribe on the Upper Brazza River in Papua Province, Indonesia. Each animal only has four of these incisor teeth, and I was told that a man over a lifetime may kill and collect enough teeth to make a single necklace. These are valuable prestige items demonstrating his hunting prowess."

A good hunter over a lifetime may kill and collect enough marsupial rat teeth to make just a single necklace.

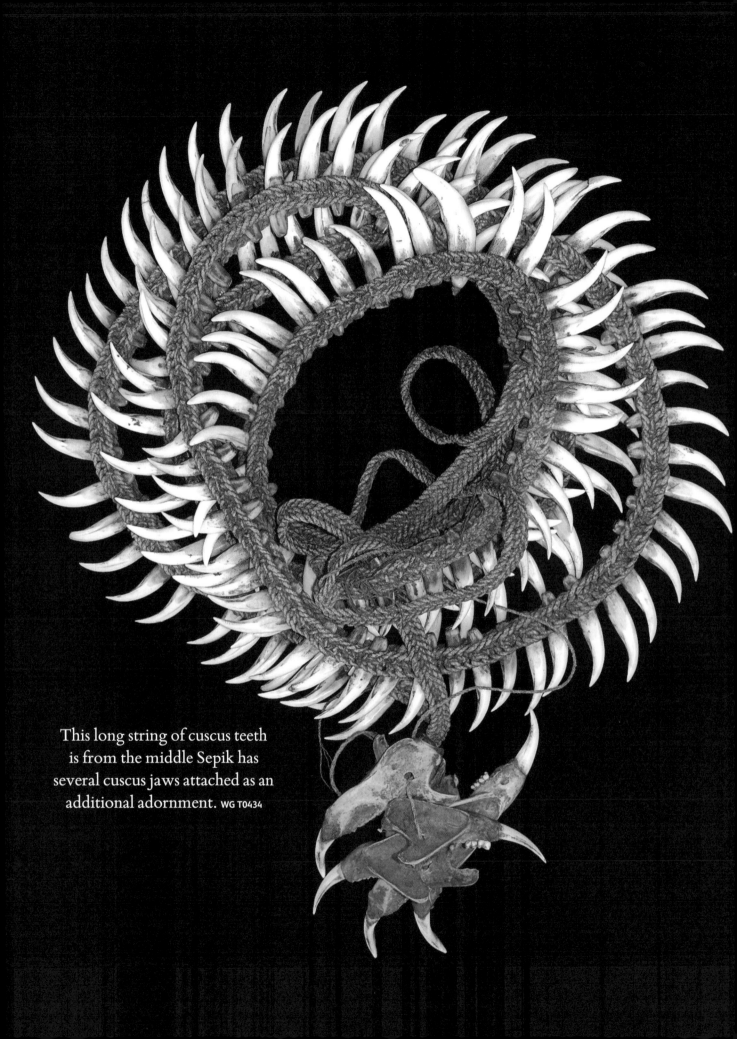

This long string of cuscus teeth is from the middle Sepik has several cuscus jaws attached as an additional adornment. WG T0434

Cuscus teeth

Lower incisors

The Phalangeridae family, or the possums, contains three genera. Somewhat confusingly, the common name given to the largest genera of the possums is 'cuscus'. They are nocturnal marsupials, can weigh up to 5 kg and share some characteristics with the lemurs of Madagascar. The females have a pouch and raise only one or two young at a time.

Of the cuscuses, the *Phalanger* sp. (commonly called the Mountain, Ground or Silky Cuscus) is the most common Highlands species and is the source of many trophy jaws and teeth for adornments. A hole is usually drilled through the bottom of the teeth before they are woven onto natural fibre bands.

The lower front teeth are long and extremely sharp and their jaws, with various teeth attached, are often found attached to magicians' bags and other paraphernalia.

Sometimes confused with dolphin teeth, cuscus teeth are never hollow like dolphin teeth.

The cuscus is one of Papua New Guinea's national symbols and appears on the modern coinage.

Cuscus skull – side view.

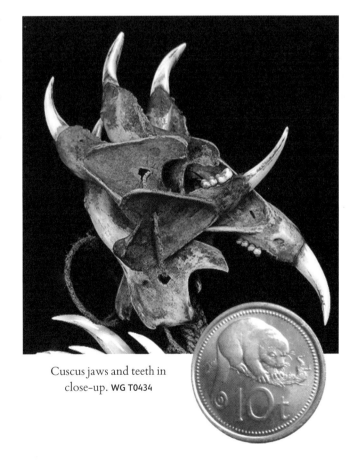

Cuscus jaws and teeth in close-up. **WG T0434**

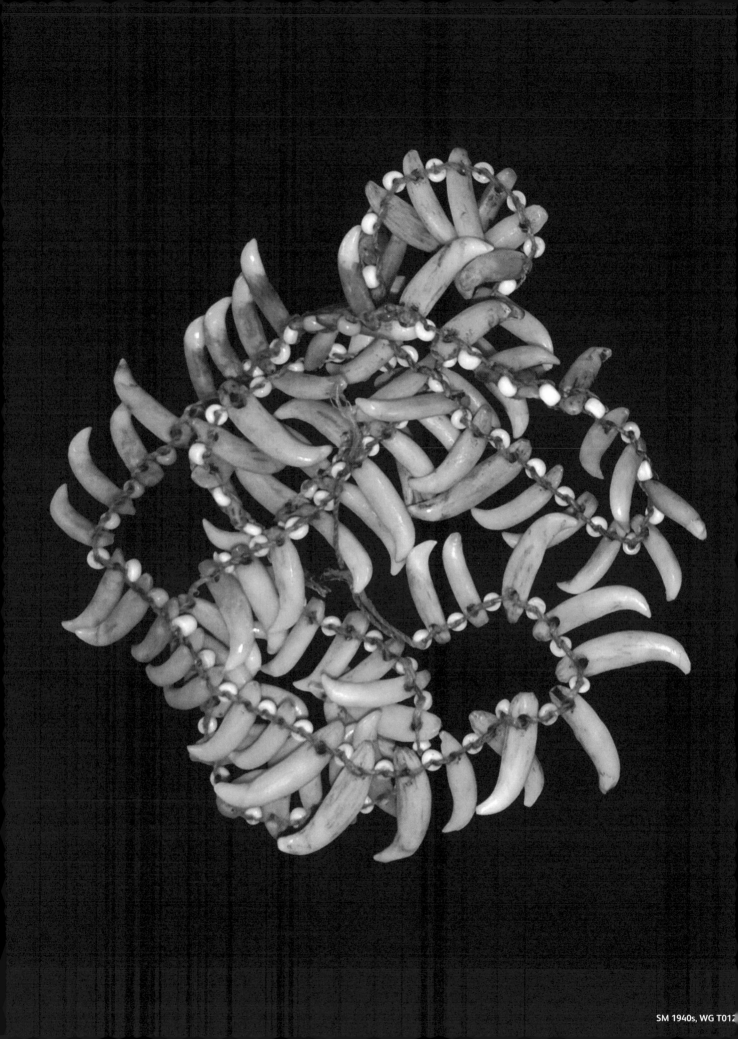

Cuscus teeth and fur

The upper canine teeth of a cuscus are completely different to the long sharp lower protruding teeth we saw on the previous page.

The Solomon Islands necklace illustrated on the facing page is made of these upper cuscus canines, likely from the common spotted cuscus *Spilocuscus maculatus*. Each tooth has a holed drilled into it and the group is then bound together with alternating glass beads on natural fibres.

Cuscus fur is used extensively in head adornments across New Guinea.

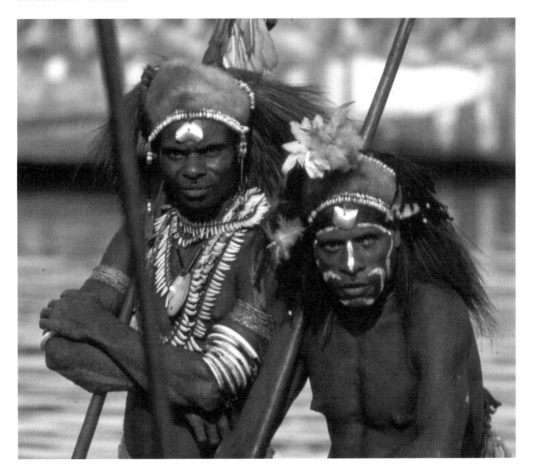

Two Asmat warriors in Ocenep. Papua, are resplendent in their impressive cuscus fur head coverings, adorned with Job's Tears seeds, Nautilus chamber walls and cockatoo feathers. Their necklaces are made of dog and cuscus teeth, and one man is wearing armbands made from plant weave and pig tusks.

Photo: SP Henny van de Kerkhof 1970s

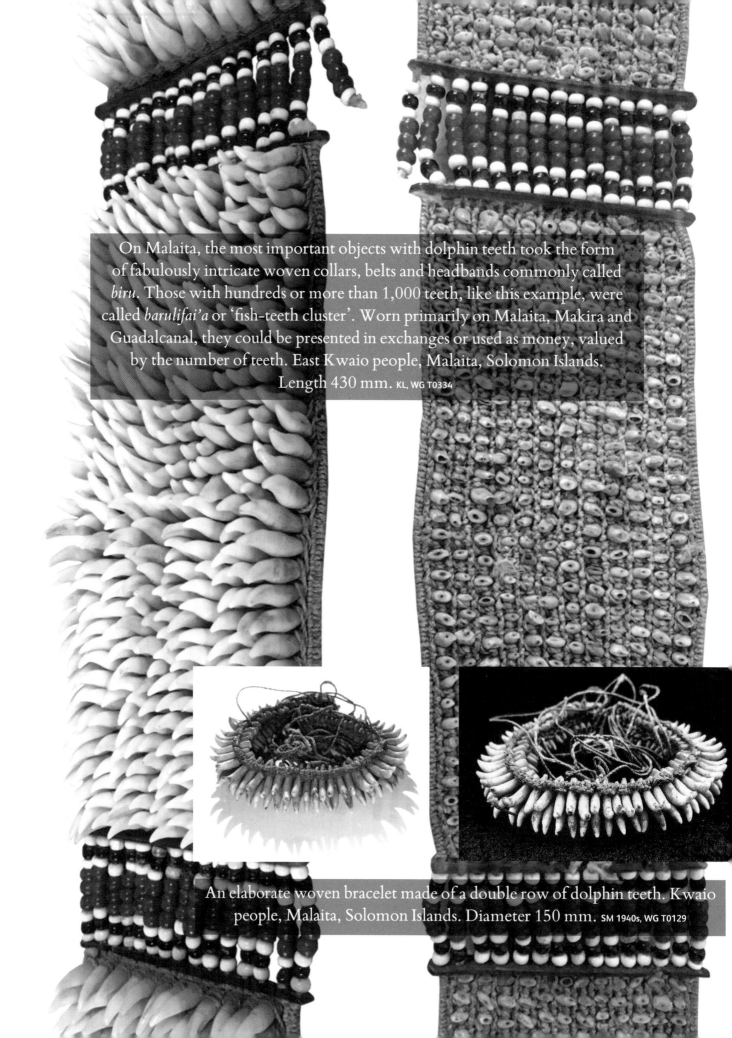

On Malaita, the most important objects with dolphin teeth took the form of fabulously intricate woven collars, belts and headbands commonly called *biru*. Those with hundreds or more than 1,000 teeth, like this example, were called *barulifai'a* or 'fish-teeth cluster'. Worn primarily on Malaita, Makira and Guadalcanal, they could be presented in exchanges or used as money, valued by the number of teeth. East Kwaio people, Malaita, Solomon Islands. Length 430 mm. KL, WG T0334

An elaborate woven bracelet made of a double row of dolphin teeth. Kwaio people, Malaita, Solomon Islands. Diameter 150 mm. SM 1940s, WG T0129

Dolphin teeth

Dolphins were hunted as a food source and the teeth used as currency and adornment were a by-product. Dolphin hunts have been an integral part of Solomon Islands culture throughout history. While these traditions may now have become politically incorrect in our eyes, to the Lau and Bita`ama Harbor people of northern Malaita their communal hunts are still a vital part of their culture.

Before a hunt began there would be a long period of spiritual preparation and important objects would be made to ensure the success of the hunt. The shield illustrated at right is one such example to engage spirits to help "call the fish". The animals were herded together with boats and then into a bay and onto the beach. The entire village would be involved, and the meat shared equally between households. No part of the animal was wasted. Hundreds of dolphins may be killed in each hunt, each possessing about 150 teeth. This goes some way to explain that an important adornment, such as shown on the facing page, may contain more than 1,000 dolphin teeth.

On the Solomon Islands and especially on the island of Malaita, dolphin teeth were a currency in their own right. In fact, while different parts of the island had specific different shell currencies, dolphin teeth were the only currency that was regularly used throughout Malaita, with set values per tooth, for different sizes from different species. Dolphin teeth are easily recognised by their hollow bases or roots and were widely traded from Malaita across the Solomon Islands and beyond.

When bounties were put up for the murder of Europeans, dolphin teeth were the best currency to offer, since everyone on Malaita who might be inclined to kill people would be attracted to it. Valuables given in formal exchange were made up primarily of dolphin teeth – any shell or glass beads added were ornamental, and secondary to the value of the teeth themselves.

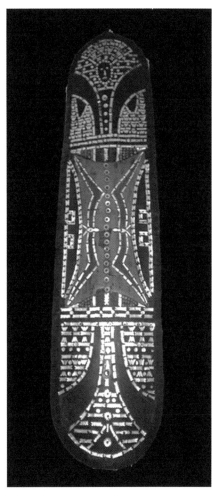

This magnificent shield used before and during dolphin hunts was made in the 1990s by Jack Doraania. He died March 2019.

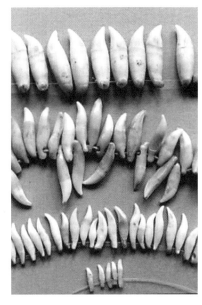

Photo: KK

125

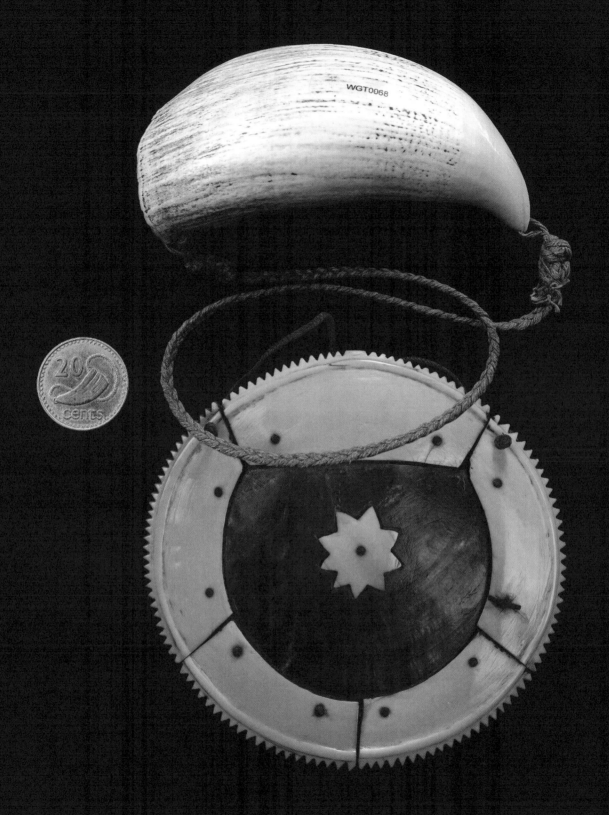

Fijian adornments — a *tabua* (top, size 155 mm across. WG T0068) and a *civavonovono* (below) breast adornments made of a sperm whale tooth, the lower made of a black lipped pearl-shell and surrounded by five pieces of 'whale ivory' with serrated outer edges. The pieces are secured with metal rivets through drilled holes, and with gum. The centre of the plate is decorated with a star shape. 200 mm across. Collected in 1904. BM Oc1931,0714.33

Whale teeth and bone
Breast adornments – Fiji and the Gilbert Islands

Whale teeth were treasured heirlooms around most South Seas islands as they were rarely found. In the Solomon Islands, around Morovo lagoon, they are called *kalo* and remain amongst the Babata tribe's main heirlooms even today.

Around Fiji, whale bone and teeth were considered sacred relics that contained the ocean god's divine essence. Known as *tabua*, the polished teeth of sperm whales are especially revered and the gifting of a *tabua* is a great ceremonial event, conveying high esteem and the sanctity of agreements, including marriage. A recent New York Times magazine headline put it succinctly: *In Fiji, Nothing Says 'I Love You' Like a Sperm Whale Tooth. Tabua* were also used as payments for contract killings in the 18th and 19th centuries, but today retain their value as important cultural items of great power.

The large *tabua* at top left has a thin, but well-used, plaited sennit suspension cord. These cords would be regularly replaced as they wore out during the lifetime of a *tabua*, which were used as powerful heirlooms for many generations. The tooth has interesting dental formations inside the root (see image at right).

The teeth vary in colour from a natural pale cream to a wonderful golden colour – these will have been rubbed with coconut oil and turmeric, or smoked, over many years.

Fijians in fact did not themselves hunt whales – they acquired the teeth from the neighbouring island of Tonga – where some of the most valuable Fijian whale objects were also made.

These adornments were also worn in the Gilbert Islands, between New Guinea and Hawaii, where, in a local tradition, sperm whale teeth were also halved, polished and worn around the neck.

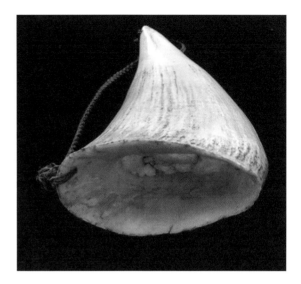

Various *tabua* showing the variety of colour tones created by oiling and smoking. **WG**

Split whale tooth adornment from the Gilbert Islands. 19th century. Size 190 mm. **CD C0176**

This classic Fijian *wasekaseka* worn by Fijian chiefs has thirty
polished sections of sperm whale teeth – the largest tooth is
120 mm long.
WG T0332

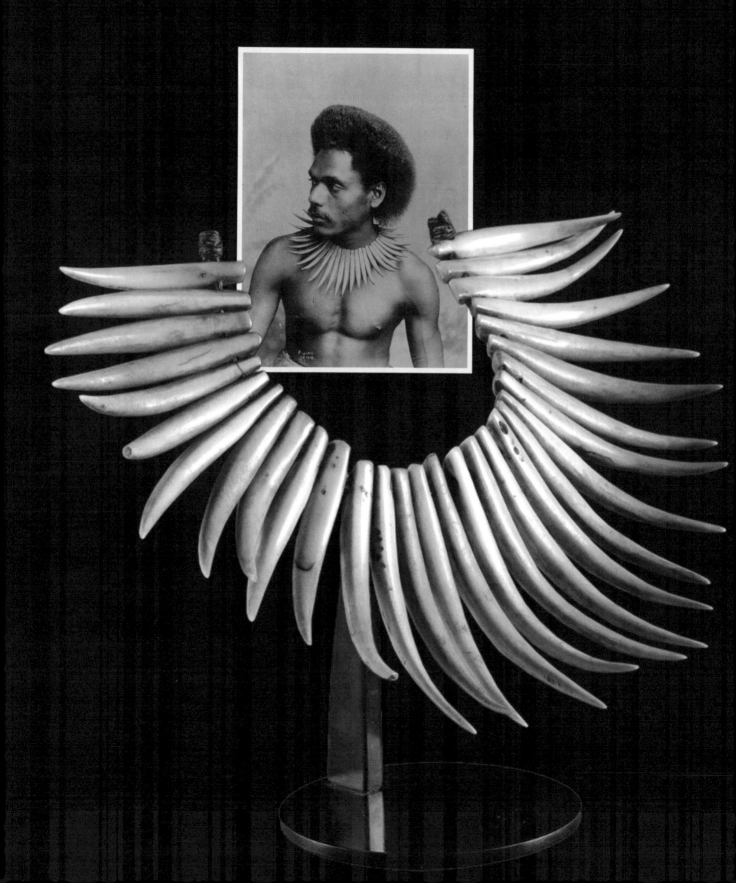

Whale teeth

Neck adornments – Fiji

There is a range of Fijian whale teeth necklaces (generically called *sisi*) that are made from polished slivers cut from large sperm whale teeth – an elaborate, labour-intensive process. They are mostly tied with sennit cords, replaced from time to time with usage. They were worn by Fijian chiefs in the mid-to-late 19th century and must have given them the most dramatic appearance – as well as being aesthetically beautiful and perfect examples of South Seas craftsmanship.

Some *sisi or waseisei* are made from much shorter and stubbier whale teeth slivers.

The example at right has tusks all shorter than 77 mm.

The example below, in the British Museum Collection, is a necklace made from smaller, but whole, Pilot Whale teeth. The necklace includes two blue plastic beads, all strung together with a coconut fibre sennit cord. It was collected in Fiji by Rev. Robert Young in the mid-19th century. Size 160 x 195 mm.

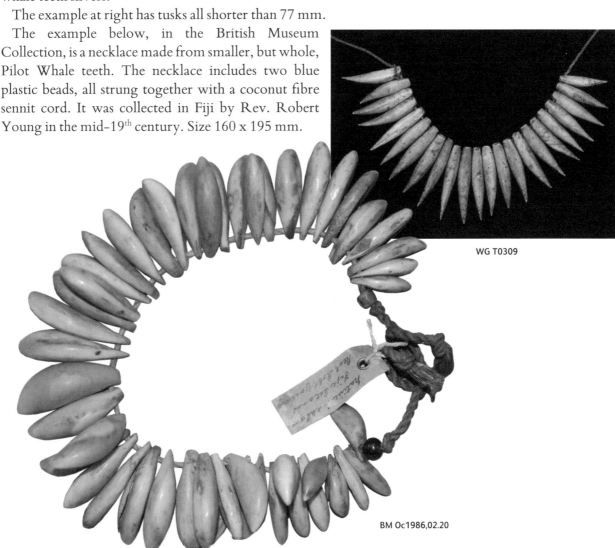

WG T0309

BM Oc1986,02.20

129

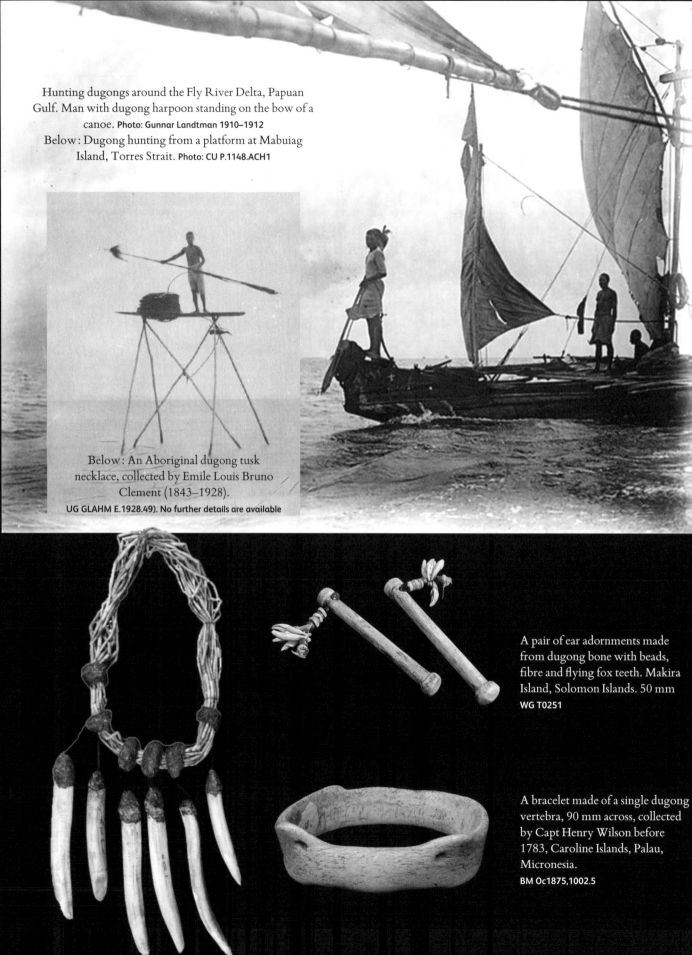

Hunting dugongs around the Fly River Delta, Papuan Gulf. Man with dugong harpoon standing on the bow of a canoe. Photo: Gunnar Landtman 1910–1912
Below: Dugong hunting from a platform at Mabuiag Island, Torres Strait. Photo: CU P.1148.ACH1

Below: An Aboriginal dugong tusk necklace, collected by Emile Louis Bruno Clement (1843–1928). UG GLAHM E.1928.49). No further details are available

A pair of ear adornments made from dugong bone with beads, fibre and flying fox teeth. Makira Island, Solomon Islands. 50 mm
WG T0251

A bracelet made of a single dugong vertebra, 90 mm across, collected by Capt Henry Wilson before 1783, Caroline Islands, Palau, Micronesia.
BM Oc1875,1002.5

Dugong tusks, teeth & bone

The dugong *Dugong dugon*, or 'sea cow', is a large herbivorous marine mammal that feeds exclusively on seagrass and is thus limited to coastal habitats where seagrass is in abundance. They live in suitable environments in the Indian and western Pacific Oceans and were traditionally hunted for their meat and oil. Tusks, teeth and bones would have been by-products of such hunts.

Dugongs are highly esteemed animals, especially around the Torres Strait islands and there are several personal charms of dugongs in museum collections attesting to their important role.

Dugongs have a pair of substantial tusks, and their cheekteeth are strangely columnar, with simple, flat crowns. The cheekteeth move forward in the jaw as the animal ages, eventually dropping out, not unlike elephants.

Dugong bones are among the densest in the animal kingdom. Like other related animals, dugongs experience a condition in which the ribs and other long bones are unusually solid and contain little or no marrow. This makes their bones ideally suited for carving.

Despite their previous abundance in the area, objects using dugong bones or teeth are extremely rare, and adornments even more so.

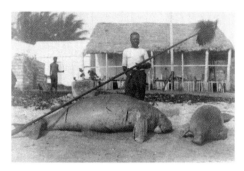

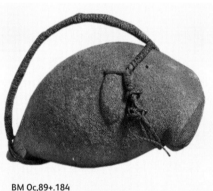

BM Oc,89+.184

BM Oc1903-128

BM Oc1936,1207.9

An ancient family heirloom made from a dugong tusk which has superb patina from extensive care. It is called *piorbo-dynena-ngeye-gwaye* and the owner was Steven Kayobu of Abeleti Village, Rossel Island. CD C.1085

These early 19th century examples of dugong charms show the importance of these animals in South Seas culture.

Dugong cheekteeth showing the columnar structure and flat crowns.

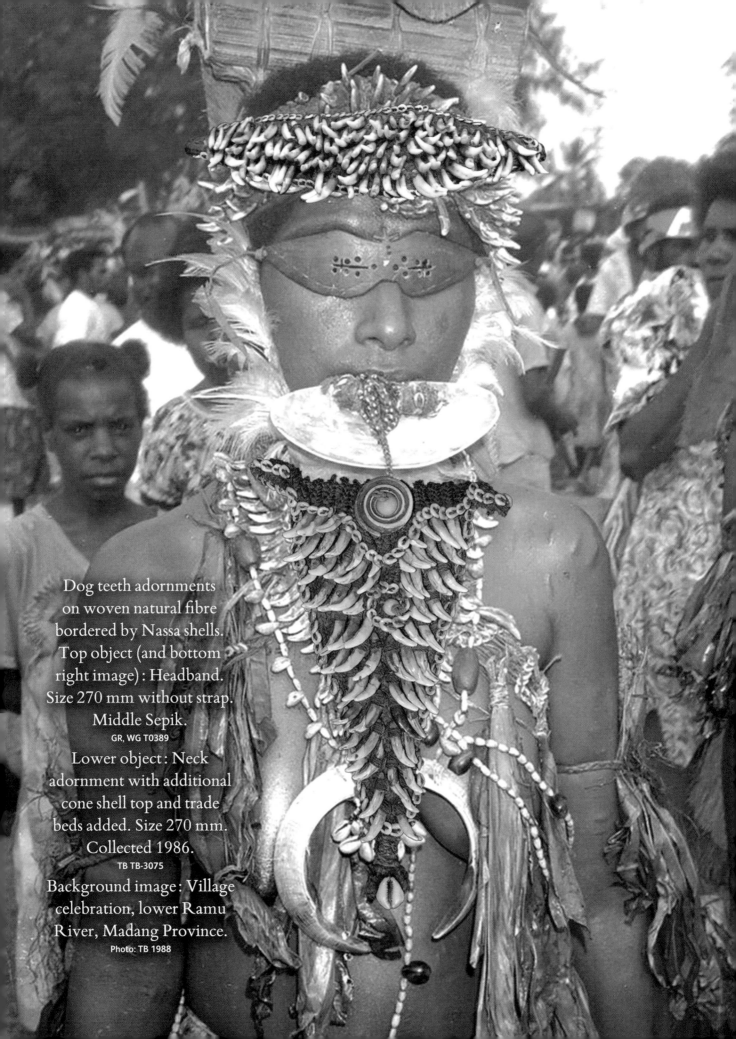

Dog teeth adornments on woven natural fibre bordered by Nassa shells. Top object (and bottom right image) : Headband. Size 270 mm without strap. Middle Sepik.

GR, WG T0389

Lower object : Neck adornment with additional cone shell top and trade beds added. Size 270 mm. Collected 1986.

TB TB-3075

Background image : Village celebration, lower Ramu River, Madang Province.

Photo: TB 1988

Dog teeth

Dogs are an important part of New Guinea village life and dogs' teeth are one of the most important types of traditional wealth, used as currency, for brideprice and as adornments. The quantity was restricted because only the canine teeth of adult dogs were accepted as a means of payment.

Holes are drilled into the roots of the canine teeth, and they are woven into necklaces, headdresses and other elaborate adornments – becoming an important part of any New Guinea feast or celebration.

Dog teeth adornments are found over the entire island of New Guinea and the islands of the Torres Strait, as is shown in this McNiven map.

In the late 19th century, the German colonial government arranged to have ceramic copies of dog teeth made to pay plantation workers. Those white ceramic dog teeth are seen mixed in with real dog teeth on many adornments – for more see *Artificialia* at the end of this chapter.

The native dogs in New Guinea are similar to the Australian Dingo. They were brought from SE Asia, some researchers say, up to 5000 years ago.

Distribution of dog teeth adornments in New Guinea and the islands of the Torres Strait. I. J. McNiven 2021

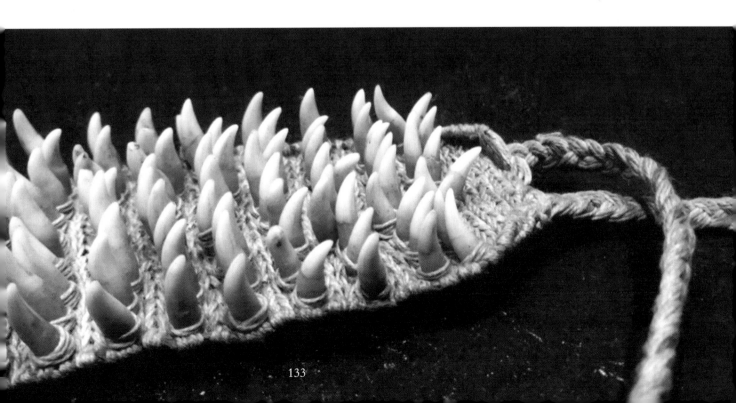

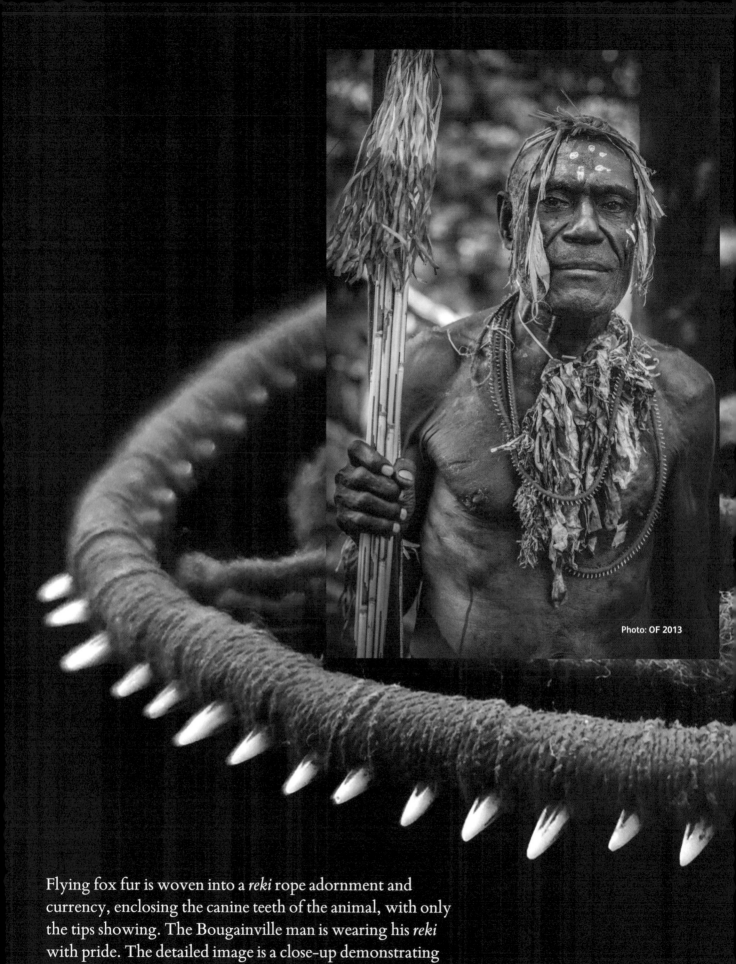

Photo: OF 2013

Flying fox fur is woven into a *reki* rope adornment and currency, enclosing the canine teeth of the animal, with only the tips showing. The Bougainville man is wearing his *reki* with pride. The detailed image is a close-up demonstrating how these are made. SM 1940s, WG T0077

Flying Fox teeth and fur

The South Seas are home to several species of fruit bat in the genus *Pteropus*, also called 'megabats', that include some large species with a wingspan of more than one metre. Due to the appearance of their face and golden-brown fur they are commonly called 'flying foxes'. They are usually seen at dusk emerging in large numbers as they leave their daytime roosts to feed. Their flesh is a common local food source and both teeth and fur are used in adornments and currencies.

Numerous myths evoke the origins of humanity as coming from flying fox ancestors. In both the Sepik and Asmat cultures, flying foxes are spiritually connected with headhunting. The consumption of certain berries and fruits by bats is equated with the taking of heads. In the Sepik region there is an intimate connection between flying foxes and human sexuality and procreation. These beliefs can help explain the frequency of representations of these animals in the material culture of New Guinea.

On the convergence of the colonial boundaries between Papua New Guinea and the Solomon Islands lie three island groups – Buka, Bougainville and Nissan – where a unique form of currency has developed that is found nowhere else. Flying fox fur is woven into a rope to enclose the canine teeth of the animal, with only the tips showing. On Buka this is called *imun* or *paio*, and *reki* on Bougainville. It has been suggested that since the 1930s no one can remember the process for making them.

In New Caledonia, ropes were made from flying fox fur and were used to wrap the handles of ceremonial jade axes, clubs and in necklaces. They were also major component of Kanak currency and became major heirlooms.

This delicate wristlet of glass beads and tiny flying fox teeth was collected in Bougainville during WWII. **SM, WG T0074**

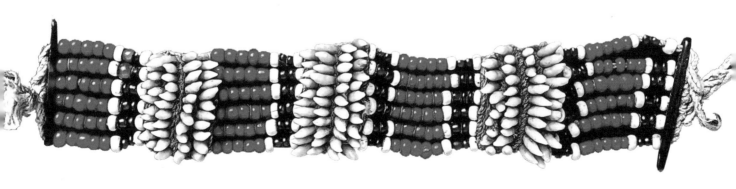

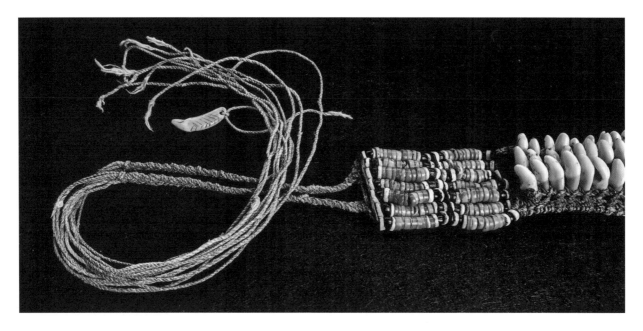

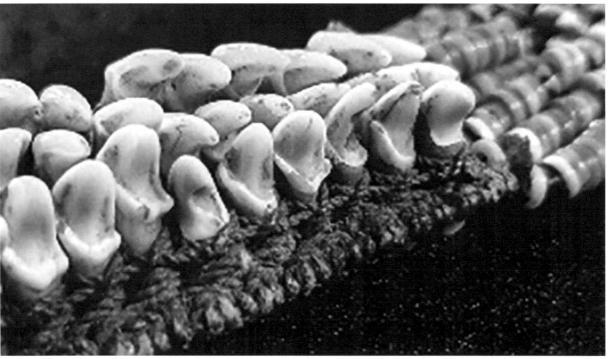

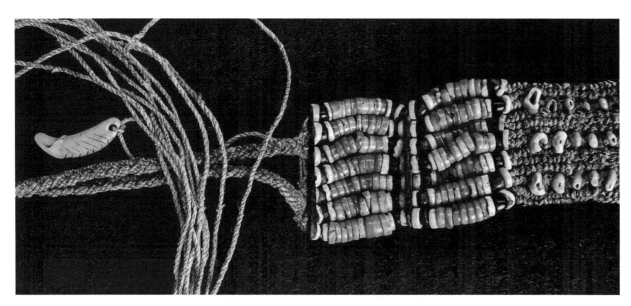

Flying Fox teeth
Solomon Islands

Fruit bats, or Flying Foxes, have four canine teeth that are easily differentiated from dolphin teeth by their flattened out crown, giving it a distinct ridged structure at the top. They are sometimes confused with dog teeth but, like dolphin teeth, their roots are also open at the ends, as can be clearly seen in the photos opposite.

Illustrated on this spread is a valuable *biru* headband from Malaita in the Solomon Islands. It is made from more than a hundred large flying fox canines bound into a natural fibre weave, with end pieces made of Langalanga shell money-beads, and natural fibre draw strings adorned with, at one end an engraved flying fox tooth (perhaps traded from the Admiralty Islands where this style of engraving was typical), and a human ancestor tooth at the other end. These *biru* headbands would be worn by both men and women. If used as currency in exchanges their value would be directly proportional to the number and size of the teeth.

On the island of Makira, in the eastern Solomon Islands, flying fox teeth are still more valuable than coins. Their use as a currency has contributed to widespread hunting of flying foxes and is said to be driving one of the species on the island toward extinction.

FR, WG T0579

Flying Fox wing bones

Structure of bat wing bones.
Image: BoneClones.com

The Yali are major tribal group amongst the Dani in Papua Province, Indonesia, and live to the east of the remote Baliem Valley in the Papuan Highlands. The Dani word *yali* means *lands of the east*. The villages are only accessible by walking for several hours.

The three Yali ceremonial belts below are made of flying fox wing bones strung on natural fibre. They are around

1100 mm in length (without the ties) and the middle one has been repaired with yellow orchid fibre. KL, WG T0588, WG T0589, WG T0590

Anton Ploeg, writing in *New Guinea Highlands Art from the Jolika Collection*, states that these objects probably pre-date colonization, at which time imported bailer shells appear to have replaced ornaments of bat wing bones.

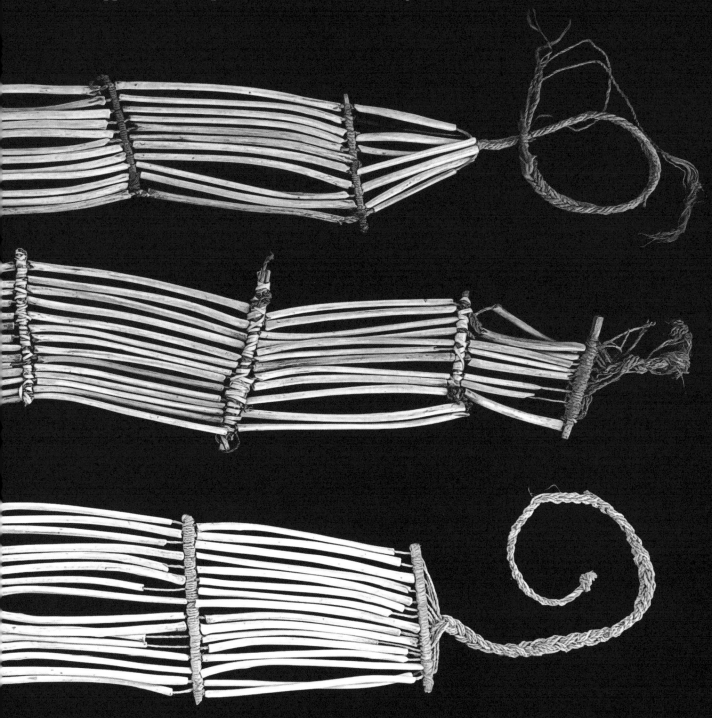

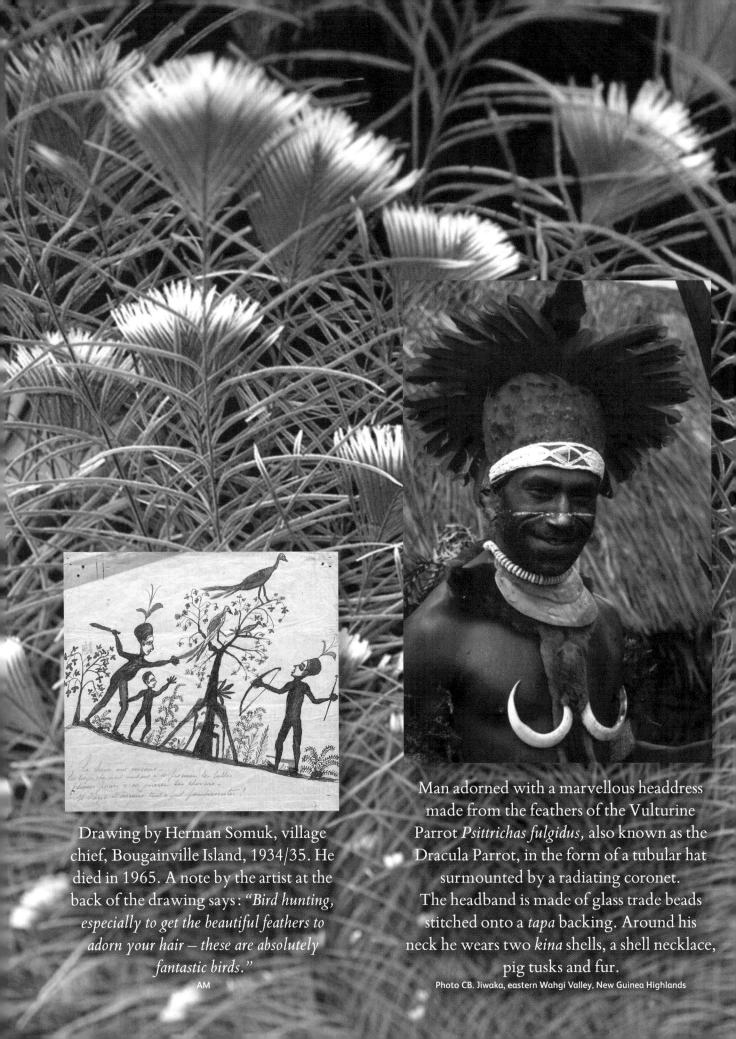

Drawing by Herman Somuk, village chief, Bougainville Island, 1934/35. He died in 1965. A note by the artist at the back of the drawing says: *"Bird hunting, especially to get the beautiful feathers to adorn your hair – these are absolutely fantastic birds."*

AM

Man adorned with a marvellous headdress made from the feathers of the Vulturine Parrot *Psittrichas fulgidus,* also known as the Dracula Parrot, in the form of a tubular hat surmounted by a radiating coronet. The headband is made of glass trade beads stitched onto a *tapa* backing. Around his neck he wears two *kina* shells, a shell necklace, pig tusks and fur.

Photo CB. Jiwaka, eastern Wahgi Valley, New Guinea Highlands

Feathers

New Guinea and the other South Sea islands have been separated from the rest of the world for so long that their isolation has resulted in the evolution of some of the most diverse and spectacular bird families.

Feathers of parrots, pigeons, cockatoos, hornbills, cuckoos, cassowaries, honey eaters and birds of paradise (and many others) have become an integral and indispensable part of culture, myth and adornment in the region. Each species is believed to possess valuable innate qualities such as astuteness, happiness, courage, loquacity – which can be taken on by the wearer under the right conditions.

For more than two thousand years, Asian and European royalty's unabating passion for bird of paradise feathers sustained a trade that brought more people into contact with this remote region than any other. In the late 19th century almost every substantial country-house in England would have glass-domed displays of exotic birds in the library, even as the lady of the house was adorned with its feathers. When the passion for plumes by fashion-conscious European women ended in the 1920s, the bird of paradise feather market collapsed.

A mid-19th century glass dome containing a rare subspecies of the Raggiana Bird of Paradise *Paradisaea raggiana augustavictoriae*.

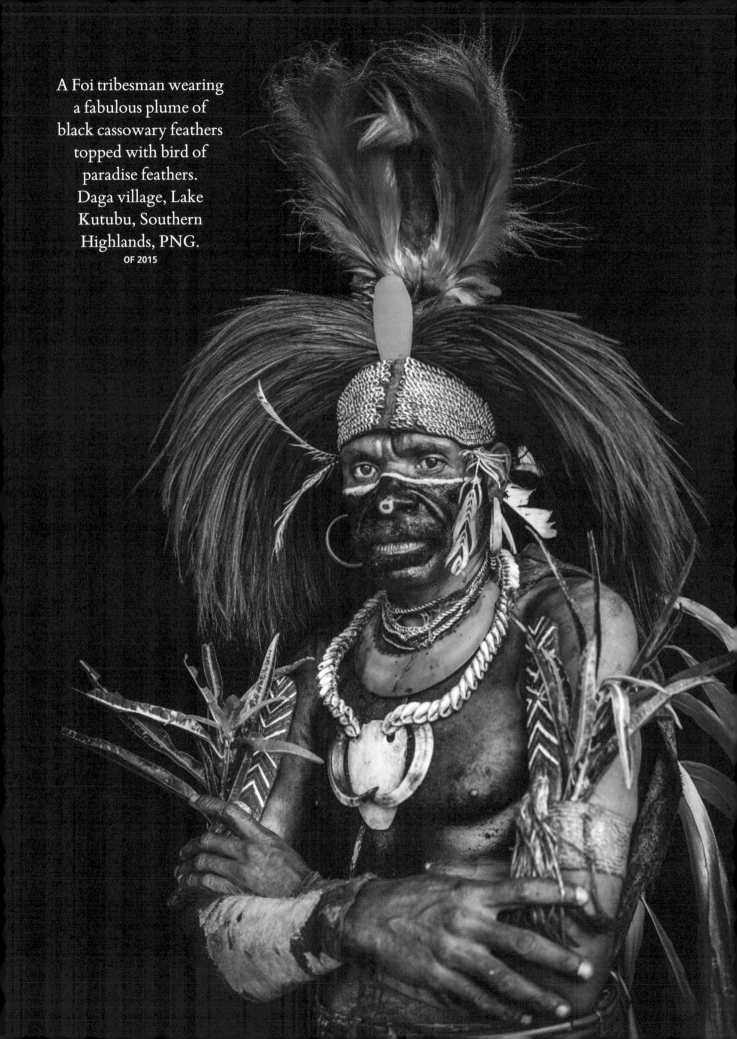

A Foi tribesman wearing a fabulous plume of black cassowary feathers topped with bird of paradise feathers. Daga village, Lake Kutubu, Southern Highlands, PNG.

Cassowary feathers

The cassowary is a large flightless bird native to the tropical forests of New Guinea and north-eastern Australia. It is the second-largest living bird after the ostrich, weighing as much as 60 kg. Locals rear wild-caught birds and raise them as poultry, for use as food and in ceremonial gift exchanges. Some captive cassowaries are known to have lived more than 60 years.

The cassowary is sometimes called 'the world's most dangerous bird' because "one of its toes has a long, murderous nail which can sever an arm or eviscerate an abdomen with ease". The reality is not as dramatic – very few deaths have been recorded and no abdomens were involved.

Its other tag as "the rainforest gardener" is well deserved. Cassowaries are the only animals capable of distributing the seeds of more than 70 species of trees whose fruit is too large for any other forest dwelling animal to eat and distribute – making it vital to the local ecology.

The cassowary is highly regarded in traditional myths as a source of life and spiritual energy, and it features in secret rituals. Their bones are used for tools and weapons. Their robust feathers are used in personal ornaments and in decorating sacred objects, dugong harpoons, fighting clubs, canoes etc.

The hollow feather quills are cut up and strung on necklaces and integrated into other adornments such as these classic *nanemo* headbands, such as the example shown below, an essential item of personal decoration and a valuable currency around Collingwood Bay, eastern PNG. The orange rectangles are carved from *Spondylus* shell, highly polished from years of use, with cassowary quill spacers.

A seated cassowary showing off its dramatic toe nails.

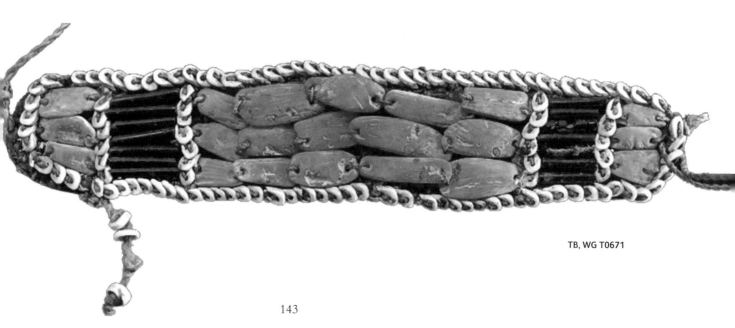

TB, WG T0671

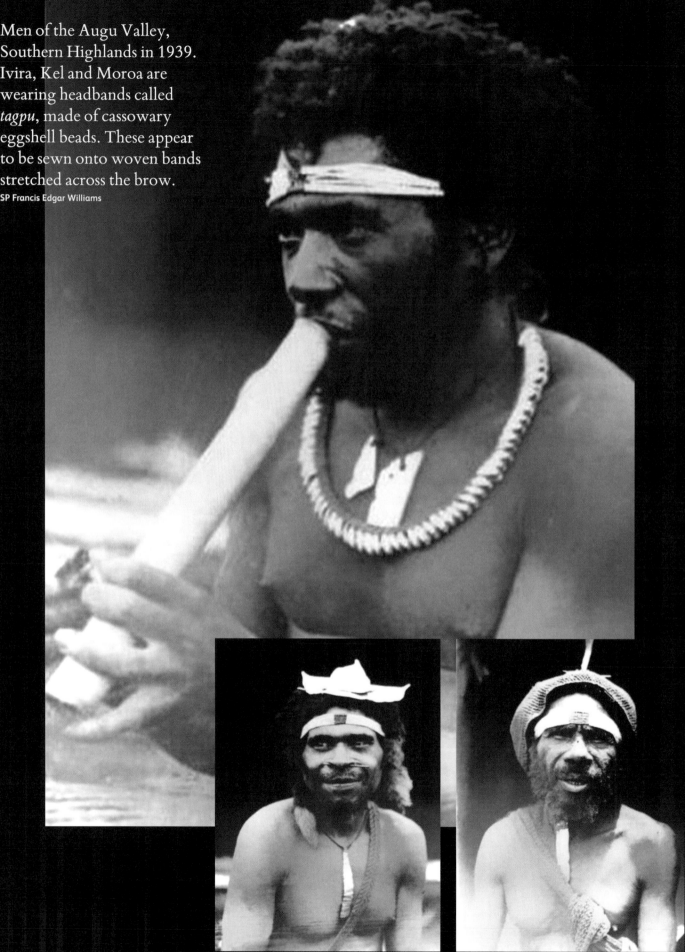

Men of the Augu Valley, Southern Highlands in 1939. Ivira, Kel and Moroa are wearing headbands called *tagpu*, made of cassowary eggshell beads. These appear to be sewn onto woven bands stretched across the brow.
SP Francis Edgar Williams

Cassowary egg-shell beads

In Africa, ostrich eggshells were extensively carved and drilled to make beads used in adornment and exchange. It has always been of interest to me that in New Guinea, where the large cassowary birds are so much an integral part of cultural and ceremonial life, and their feathers and bones are prolific in adornments, that the cassowary eggshells have not been more utilised for beads.

One of the few researchers that reported on their use was Richard Salisbury-Rowswell, writing in his 1957 report on the *Economic Change Among the Siane Tribes of New Guinea*, and reporting on the *gima* trading activities around Goroka, in the eastern Highlands of New Guinea. *Gima* were public rituals, involving the handing over of commodities termed *neta* or "things", which were owned by individuals. He described these objects as "valuables" and listed various types of shell, stone axes and feather plumes – but also included "chips of cassowary egg-shell sewn on to bark or threaded like beads." In 1953, during his last visit, he commented: "Cassowary eggshell beads are not seen any more."

The only images I have seen of these cassowary eggshell beads being worn were taken by anthropologist Francis Edgar Williams during his expeditions in eastern New Guinea (incorrectly referred to as 'Papua' in some of his works and the books written about him) in the Augu Valley, Southern Highlands in 1939 – shown on the facing page. Williams noted that these were used as trade items.

From the little research that is known, and these photos, it appears that these cassowary eggshell-beads are remarkably similar to the ostrich eggshell-beads worn in Africa, and that they were used in the New Guinea Highlands as precious adornments and as exchange items.

The green eggs of the cassowary. The eggshells darken over time to deep olive green. Each one is about 120 mm, slightly smaller than ostrich eggs.

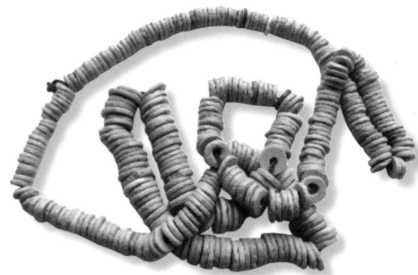

Southern African ostrich shell beads similar to the New Guinea examples of which no detailed images are known.

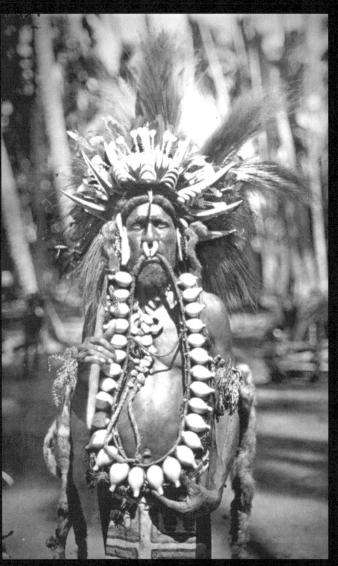

The dramatic crown made from multiple hornbill beaks is characteristic of Oro Province chiefs. **Photo: FH Eroro village 1922**

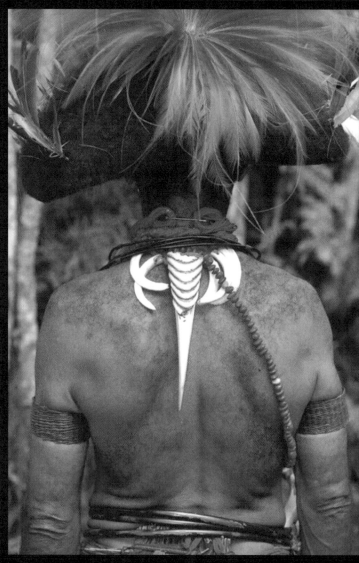

Huli man sporting a hornbill beak adornment surrounded by pig tusks. **CB**

Hornbills are known to eat 20–30% of their body weight in fruit each day.

We call this bird 'kokomo'. It is believed that some people can transform into these birds.

Vance Ades Solmien, Madang, PNG

Beaks

Bird beaks are primarily made of keratin, a material which we have already met in the form of turtle shells. Keratin is also a component of human fingernails and hair.

The charismatic prominent beaks of the hornbill are popular amongst Huli men as back adornments in the New Guinea Highlands, and in Oro Province, Papua New Guinea, as head adornments, as are their iridescent feathers.

Huli men of the New Guinea Highlands combine single hornbill beaks, highlighted in natural pigments, with split pig tusks on either side, and wear them as back adornments. In Oro Province, eastern New Guinea, they are used extravagantly in multiples, creating a dramatic starred crown on the head of chiefs during important celebrations.

In Papua, amongst the western Dani people, the beak of the black sicklebill *Epimachus* sp., the second largest bird of paradise species, is used as a nose adornment by several tribes – and these are still widely worn today.

Our pet hornbill. **Photo Brian Telford 1975**

Black sicklebill beaks being worn in different styles by men in the western Dani area of Papua. **SP H vd Kerkhof**

The Black Sicklebill *Epimachus* sp.

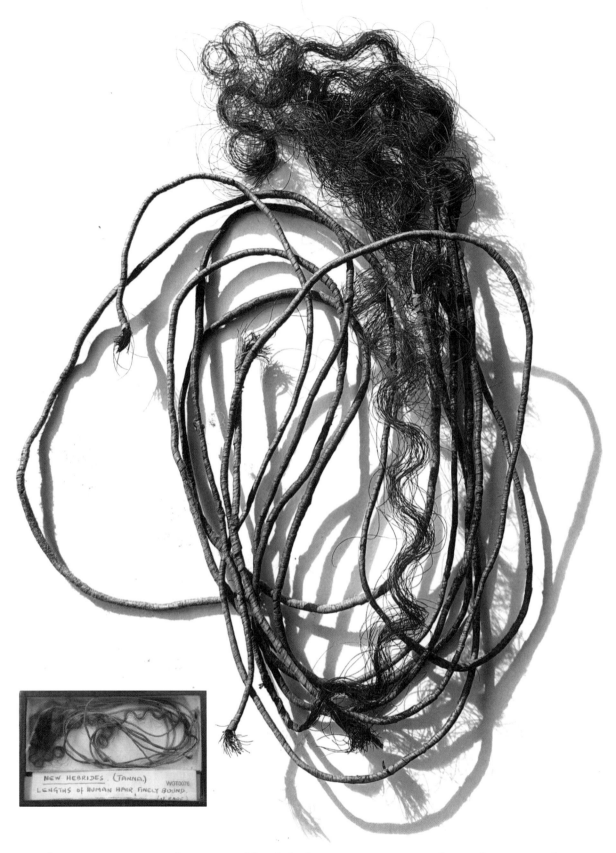

This rare item turned up in a soldier's belongings returning from the war in the Pacific in 1945. The plaited strands of human hair are finely bound in natural fibre, and were collected on Tanna Island, Vanuatu (previously called the New Hebrides, until independence in 1980). Accompanying notes implied that it was used for "trade". The above object must have been highly valued, and is quite beautiful when viewed close-up. SM, WG T0076

Human hair

Hair and hairstyles have been used as adornment of the human body since time immemorial. In the South Seas this has been taken to extremes – notably in the Marind-anim culture of remote southeast Papua and amongst several tribes in the New Guinea Highlands.

The port of Merauke is the easternmost community in Papua, on the Maro River. We already met the Marind-anim culture in the *South Seas* chapter, and their unique passion for spectacular adornments extends to their hairdos. For men, bundles of palm leaves are added as hair extensions, more than a hundred braids ending in a knot. The women are not as colourfully adorned, but the hair extensions are longer and are made of flexible bark. The women also shine their hair with oil and paint.

On the New Guinea Highlands human hair was cultivated and integrated into elaborate, and sometimes fanciful wigs which were then used as receptacles for a plethora of natural adornments. The example below of a Pongera man wearing his traditional *kembena* 'bullock-horn' hair wig illustrates that beautifully. The assemblage includes feathers, cuscus fur, plant stems, split bamboo, dried flowers, seedpods, rattan and plaited plant fibres.

Amongst Aboriginal Australians, human hair was used to make plaited cords tied around the waist to support phallocrypts (see *Pearl Shells* earlier in this chapter).

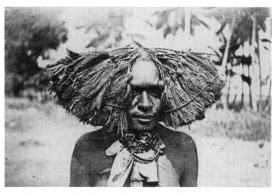

The spectacular hair adornment of a Merauke man.
SP Afdrukken-Merauke-013b

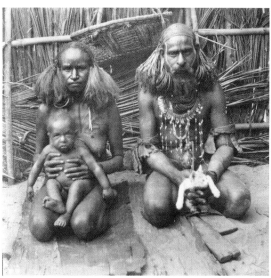

This young family group sports traditional exotic hairstyles and proudly show off their child and a kitten. Cats were treasured and adorned with beads or shiny mother-of-pearl shards.
Photographer unknown. Ca. 1915. SP Merauke-023b

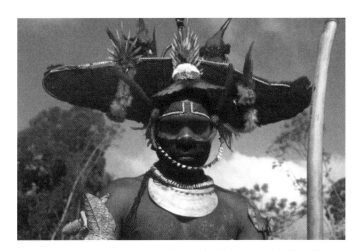

Pongera man wearing his traditional *kembena* 'bullock-horn' hair wig. Enga Province, PNG Highlands. **CB 1996**

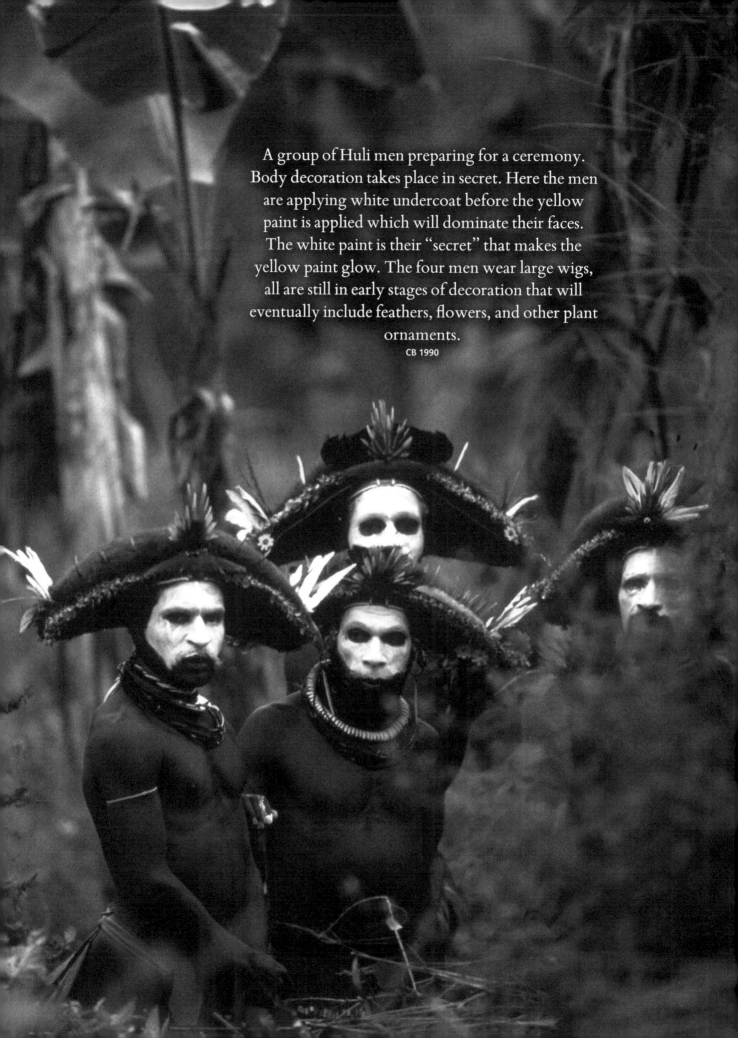

A group of Huli men preparing for a ceremony. Body decoration takes place in secret. Here the men are applying white undercoat before the yellow paint is applied which will dominate their faces. The white paint is their "secret" that makes the yellow paint glow. The four men wear large wigs, all are still in early stages of decoration that will eventually include feathers, flowers, and other plant ornaments.

CB 1990

Human hair

The Huli Wig Men

In New Guinea, the best example the use of human hair as adornment is undoubtedly the fabled Huli Wig Men, who, together with their elaborate wigs, were first discovered by Europeans in November 1934.

Huli boys live with their mothers until they are seven or eight years old, then they go to live with their fathers until their teens, when they enter 'bachelor school' and are forbidden to have contact with women, including their mothers. During this time, a combination of a special diet and magic helps the boys' hair to grow. They must sleep on their backs with special neck rests that can be raised as the volume of hair increases. It takes 18 months to grow a wig before they are clipped off close the scalp and woven into a traditional Huli wig by a Wig Master. Additional adornments are then added to the wig making the final elaborate constructions. Some boys will grow up to six wigs – but wig production must cease once they marry.

A young Huli man wearing the white undercoat face paint, before the final colours are applied for a ceremony. He is still growing his hair and it is carefully combed out. **Photo CB 1990**

The breast shield of the Superb Bird of Paradise *Lophorina superbais* is an integral part of the male bird's spectacular mating display, and forms the centrepiece for many Huli wigs.

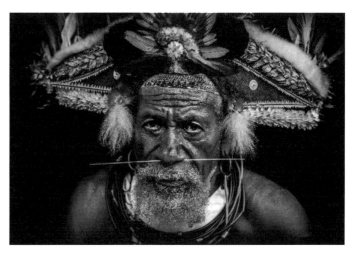

A Huli elder wearing his elaborate headdress trimmed above with cuscus fur. Above his forehead is the prized iridescent blue/green breast shield from the Superb Bird of Paradise *Lophorina superba* and the red and yellow fan of feathers from the Orange-Billed Lorikeet *Neopsittacus pullicauda* – also seen in all the wigs opposite. **Photo OF 2015**

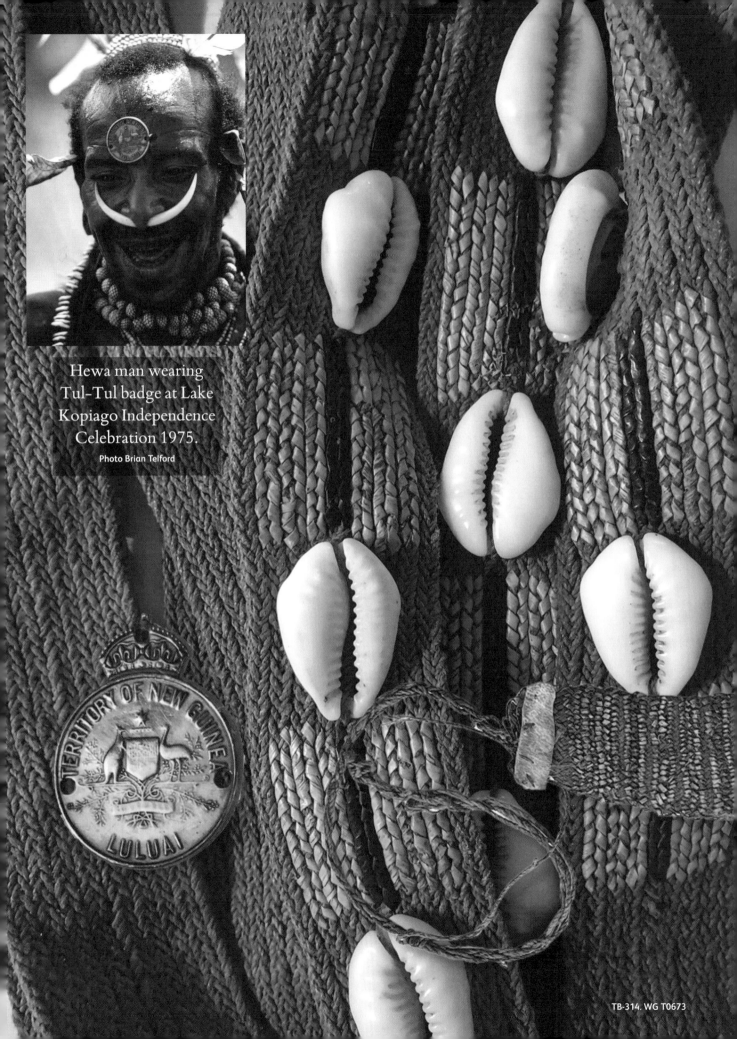

Hewa man wearing
Tul–Tul badge at Lake
Kopiago Independence
Celebration 1975.

Photo Brian Telford

TERRITORY OF NEW GUINEA

LULUAI

TB-314. WG T0673

Orchid Fibres

Orchid leaves and stems are split, strung and woven, on their own and integrated with other natural fibres, to create utilitarian and ceremonial objects, or simply to add highlights and a delicate beauty.

The large picture on the facing page is of a finely-woven 'herringbone' belt called *yerak* or *jerak* from the Dani people in the Baliem Valley in the Papua highlands. It is made of natural fibres with orchid stem highlights and halved cowrie shells. The belt was given to Todd Barlin after the funeral of the Dani Chief Kurulu in 1986. Length more than 1,500 mm.

Below is a heavily-worn headband woven from orchid stems and other natural fibres, with leather ends and displaying a brass medal inscribed *Territory of New Guinea – Tul-Tul*. These brass badges were produced for the local New Guinea tribes under Australian administration. Struck by Amors in Sydney, they were worn attached to a headband by village 'Committee Men' from the 1940's as a sign of their authority. The chiefs themselves would have worn a similar *Luluai* badge featuring a crown to designate additional prestige.

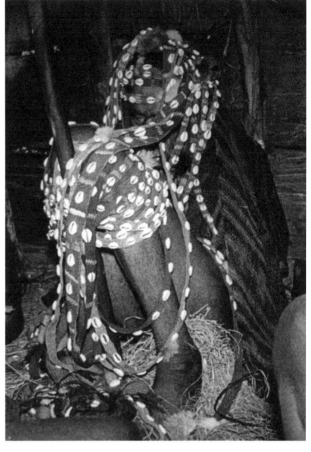

A Dani chief adorned with belts decorated in cowrie shells and orchid fibre, before cremation. **Photo: SP Baliem-afdrukken-031**

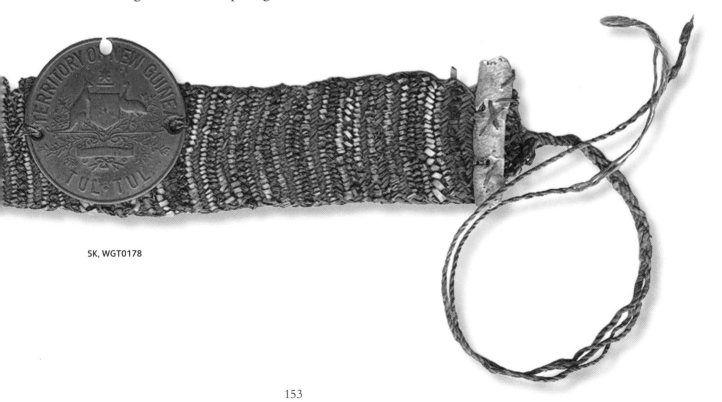

SK, WGT0178

153

This magnificent *beron* initiation apron is made from *tapa* cloth and includes a long *tapa* apron together with elaborate adornments of Nassa and cowrie shells. Watam Lagoon, Sepik area. Size 520 mm x 310 mm. The apron at the back opens to 1300 mm long. Early to mid–20ᵗʰ Century. **EP-41, CB**

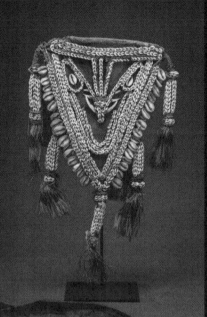

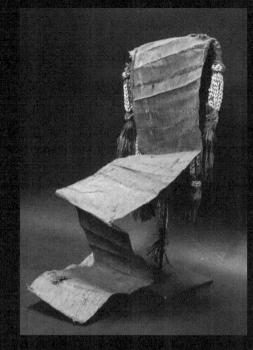

A bark belt deeply carved with abstract designs. Simbu (Chimbu) Province. PNG. **UK Mead181**

Ceremonial bark belt decorated with deeply carved abstract triangles, dyed with red and blue pigments and with *Conus* shell ties. Wahgi Valley, New Guinea Highlands. Size 160 x 300 mm rolled up. **CB**

The bark armband from the Papuan Gulf displays abstract faces and symbolic motifs highlighted with white lime. Size 120 x 230 mm rolled up. **CB**

Tree bark

The primary use of bark in the South Seas is to make Tapa cloth (or simply *tapa*). The paper mulberry tree *Broussonetia papyrifera* has become the most popular source of raw material. The bark, smoked, stamped and dyed, was primarily used as clothing, but it has long since been replaced by imported cotton and modern textiles that are much more able to survive moisture.

This *beron* initiation apron shown opposite, is an excellent example of the traditional use of *tapa* cloth. It includes a long *tapa* strip which opens to 1300 mm long. with elaborate adornments of Nassa and cowrie shells. This apron is used in a male initiation ceremony called *kandinbung* which takes place at puberty in these villages near the mouth of the Sepik River. The face represents a powerful spirit whose power is revealed to the initiates, and the hanging tassels are referred to as fish forms.

Thick-cut tree bark is used to produce elegant ceremonial belts, decorated with deeply carved abstract designs and symbolic motifs, dyed with pigments or white lime.

These bark belts are wide and strong but flexible enough to be unrolled to fit tightly around the waist. In the New Guinea Highlands, *bilum*-like loincloths are hung over the belt, with grass tucked in at the back.

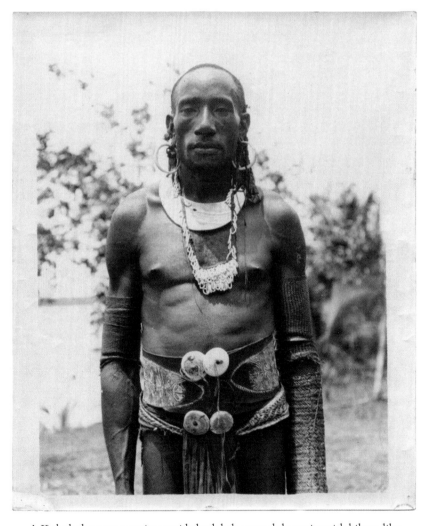

A Kukukuku man wearing a wide bark belt around the waist with bilum-like loincloths hung over the belt. Morobe Province, New Guinea Highlands. 1900–1930. **BM Oc,B139.4**

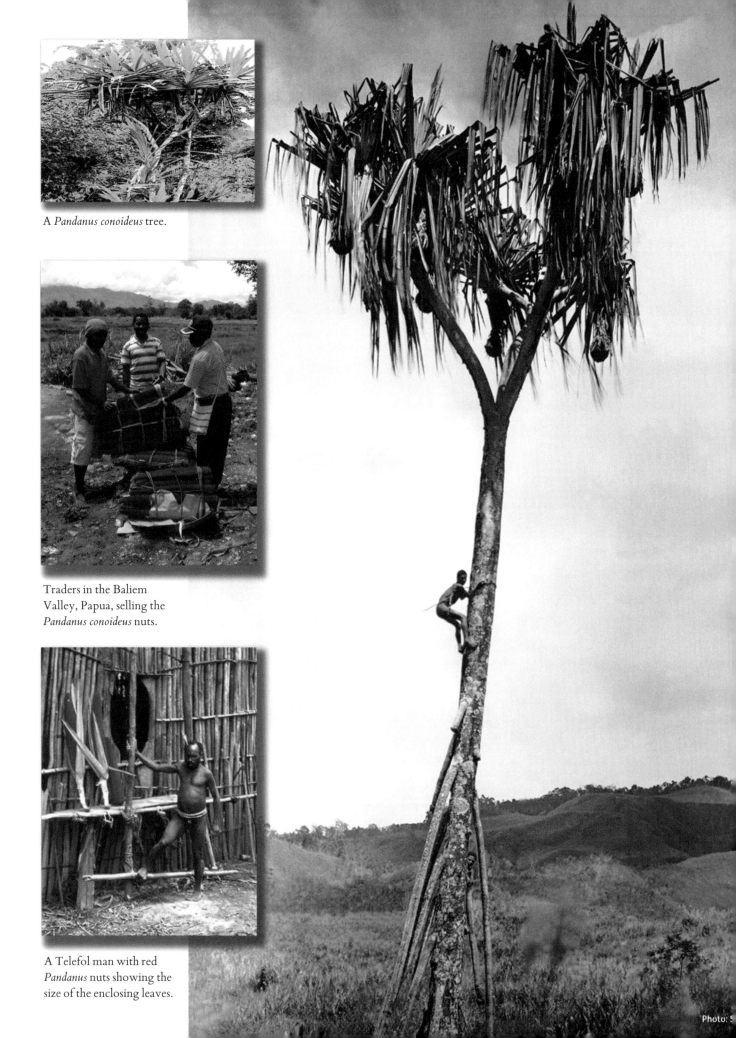

A *Pandanus conoideus* tree.

Traders in the Baliem Valley, Papua, selling the *Pandanus conoideus* nuts.

A Telefol man with red *Pandanus* nuts showing the size of the enclosing leaves.

Seeds, nuts and leaves

Pandanus is a genus of palm-like trees with around 750 accepted species, of which the greatest number are found in the South Seas – with two dominant species.

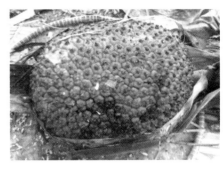

Whole *Pandanus julianettii* nut

The nut of *Pandanus julianettii* (locally called *karuka*, with more than 45 cultivars and many other local names) is a very important food crop in New Guinea. The nuts are extremely nutritious and villagers in the highlands may move their entire households closer to trees for the harvest season. As you can see from the image of two boys climbing a *Pandanus* tree in the Central Highlands, the trees can grow up to 30 m tall.

The long red fruit of a *Pandanus* variety, *Pandanus conoideus*, is a traditional delicacy and of great economic value. It is is typically prepared by splitting it, wrapping it in leaves, and cooking it in an earth oven.

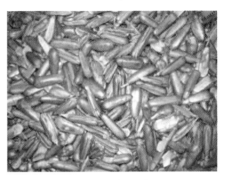

Pandanus kernels

The nuts are not used in adornments but the large leathery leaves (3–4 m long) are frequently used for wrapping precious adornments and heirlooms before storage – such as the *kina* shells. *Pandanus* bark is used to make *kina* wallets, which are discussed in the *Precious Objects* chapter.

A whole *Pandanus conoideus* fruit with *bilum* bag and spades for size.

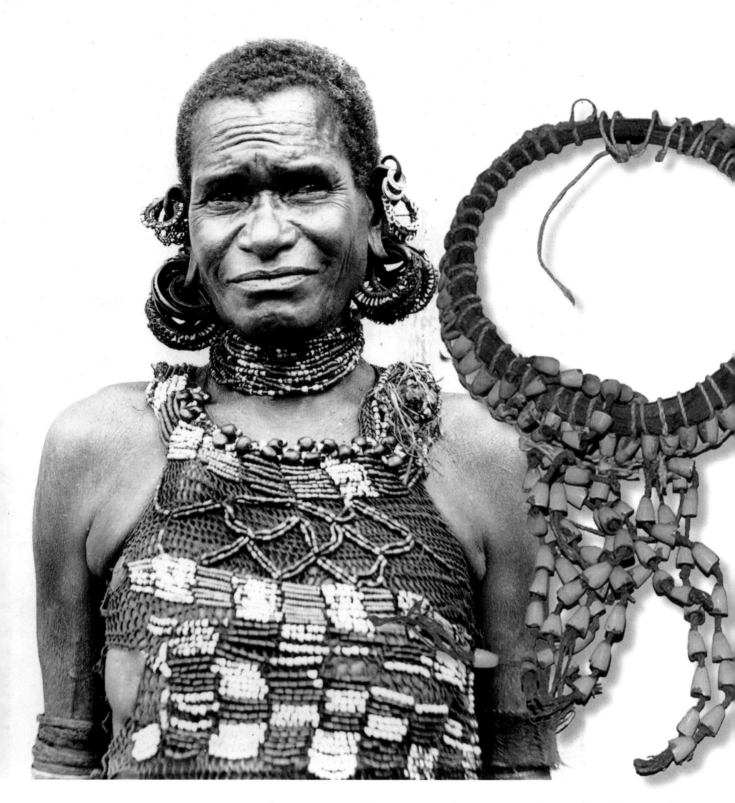

Kapaia Bousimai, a Binandere woman from Mambare Bay, the wife of Binandere Chief Bousimai, wearing a *bilum* dress adorned with Job's Tears seeds (a design called *boera bari*, that originated in Oro Province in the early 1900s). Her necklaces and ear adornments also include Job's Tears seeds, wound into natural fibre rings. She is also wearing natural fibre woven armbands, *kau* and *kambo* shells, *sipa* coconut shell, *kepore* turtle shell and *daima* shell money which is used even today.

Information: Maxine Anjiga. Main photo: Captain Barton at Cape Nelson, ca. 1901.
Ear adornment detail: Collingwood Bay 1890s. **BM Oc1990,07.124**

Seeds

Job's Tears

Coix lacryma-jobi is a tall, grain-bearing tropical plant. The seeds are popularly called *Job's Tears* and are said to represent the tears shed by the biblical Job during the challenges he faced.

They are small, pea-like, and begin grey-green in colour and can ripen to a grey or tan-brown. They grow ready-to-use as beads with a hole through the middle, and have a hard, shiny coating. Their use is common in Melanesian adornments and functional items, such as this elaborate necklace worn by the woman in the image below. Job's Tears have been added to functional *bilum* bags, to add some status, for thousands of years.

Coix lacryma-jobi seeds, commonly called *Job's Tears.*

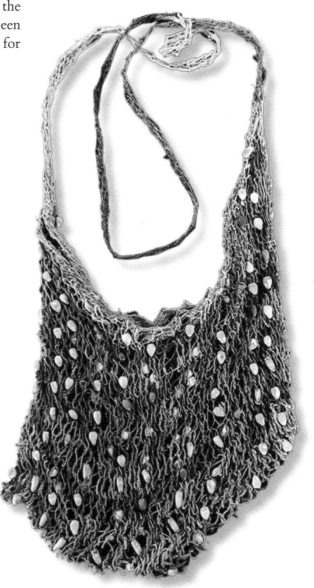

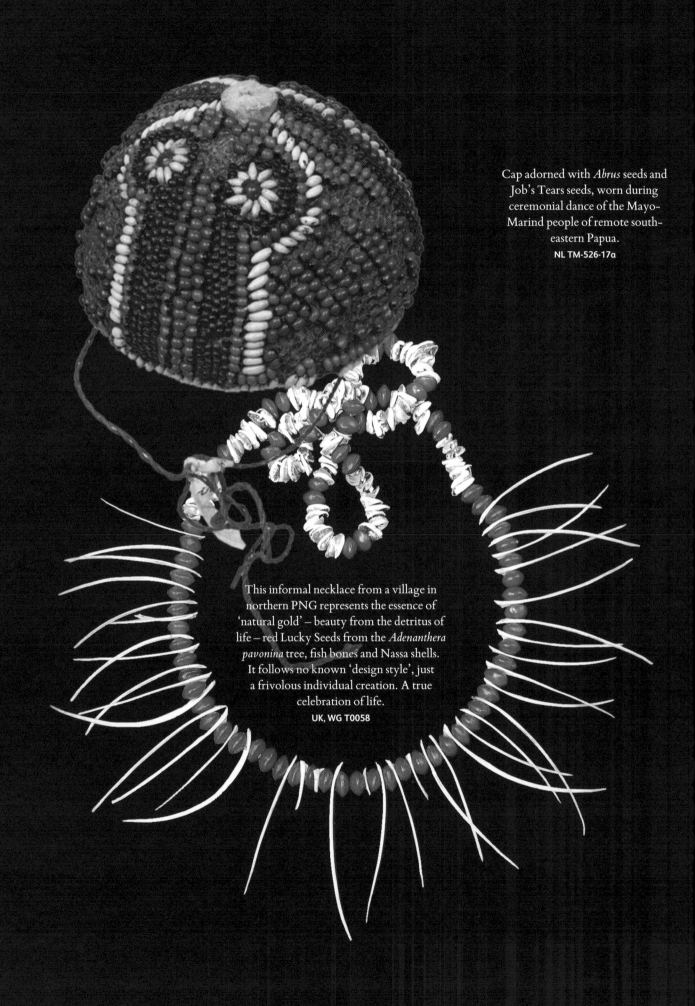

Cap adorned with *Abrus* seeds and Job's Tears seeds, worn during ceremonial dance of the Mayo-Marind people of remote south-eastern Papua.

NL TM-526-17a

This informal necklace from a village in northern PNG represents the essence of 'natural gold' – beauty from the detritus of life – red Lucky Seeds from the *Adenanthera pavonina* tree, fish bones and Nassa shells. It follows no known 'design style', just a frivolous individual creation. A true celebration of life.

UK, WG T0058

Seeds

Red seeds are frequently used in South Seas adornments. There are two similar seeds, but from different plants – *Abrus* seeds with a distinct black spot (and highly toxic) and 'Lucky Seeds' or 'Love Seeds' that are pure red.

Abrus precatorius, commonly known as the Rosary Pea, is a herbaceous flowering plant in the bean family Fabaceae. It is a slender, perennial climber with long, pinnate-leafleted leaves that twine around trees and shrubs. It is best known for its seeds, which are used as beads in adornments and in rattles. The seeds are toxic and a single seed, well chewed, can be fatal.

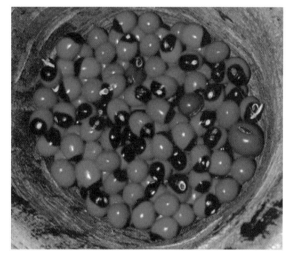

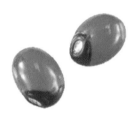

The common red Lucky Seeds or Love Seeds come from the *Adenanthera pavonina* tree. The curved hanging pods split open into two twisted halves to reveal the hard, scarlet seeds. Its seeds have long been a symbol of love and are widely used as beads for adornment and jewellery. Like the *Abrus* seeds above, Lucky Seeds are known to be almost identical weights to each other and historically have been used as units of weight for precious items, such as gold in India.

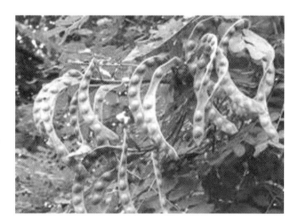

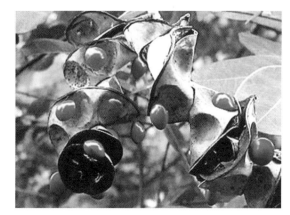

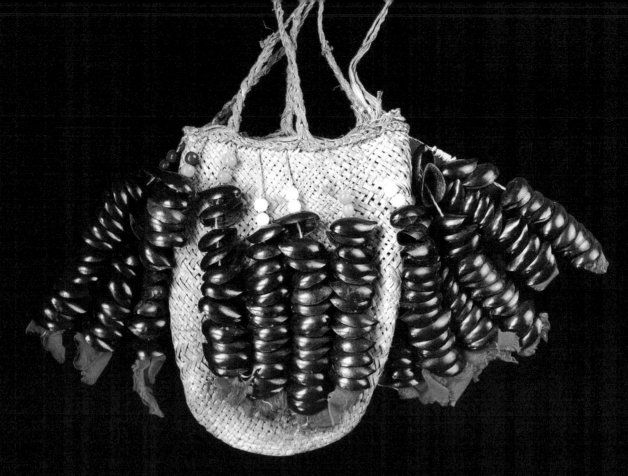

Halved seed pods from a *Palaquium* sp. tree adorn this magic amulet bag from Manus Island, Admiralty Islands, northern PNG. The bag is also decorated with red fabric bindings and a few plastic beads – demonstrating the intersection of traditional and modern culture. This is a rarely seen item made in the mid–20th century. **WG T0432**

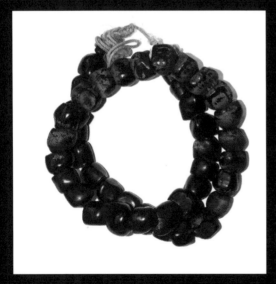

A complete necklace of banana seeds, collected in Milne Bay Province, PNG.
SM, WG T0513

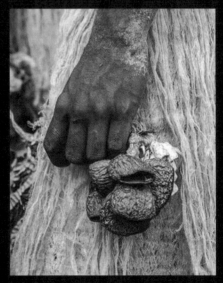

A cluster of *Pangium* nuts used as a rattle during the National Mask Festival in Kokopo, East New Britain Province, PNG.
Photo OF 2012

Seeds and nuts

The hard dark brown seeds from the tall evergreen trees of the genus *Palaquium* are used in many adornments, especially halved, at the ends of tassels on bags, skirts and aprons. There are several local varieties, and many local names are given to the seeds. The example at right is of *Palaquium gutta*.

Large *Canarium* nuts from *Canarium indicum* trees have been important in South Seas diets and in traditional medicine. Dried nuts are hollowed out and used for ear decorations in the south-eastern Solomon Islands. See the *Precious Objects* chapter for further examples.

Fruit and seeds harvested from the *Pangium edule* tree, found in mangrove swamps, are deadly poisonous if consumed without prior preparation. They are boiled and then buried in ash with banana leaves for a month or more during which time they turn dark brown to black. The kernels can then be eaten, while the husks are used to make shakers for dancers, tied to arms and legs for dramatic effect. See an example opposite.

Bananas originated in Southeast Asia and the Pacific region. Those you buy in supermarkets have been specially bred over the years to be seedless. Wild bananas contain large seeds that, in the South Seas, are dried and used as beads in adornments. Most often only one or two seeds will be integrated with other beads, but occasionally one comes across a complete necklace made from banana seeds, as shown on the facing page.

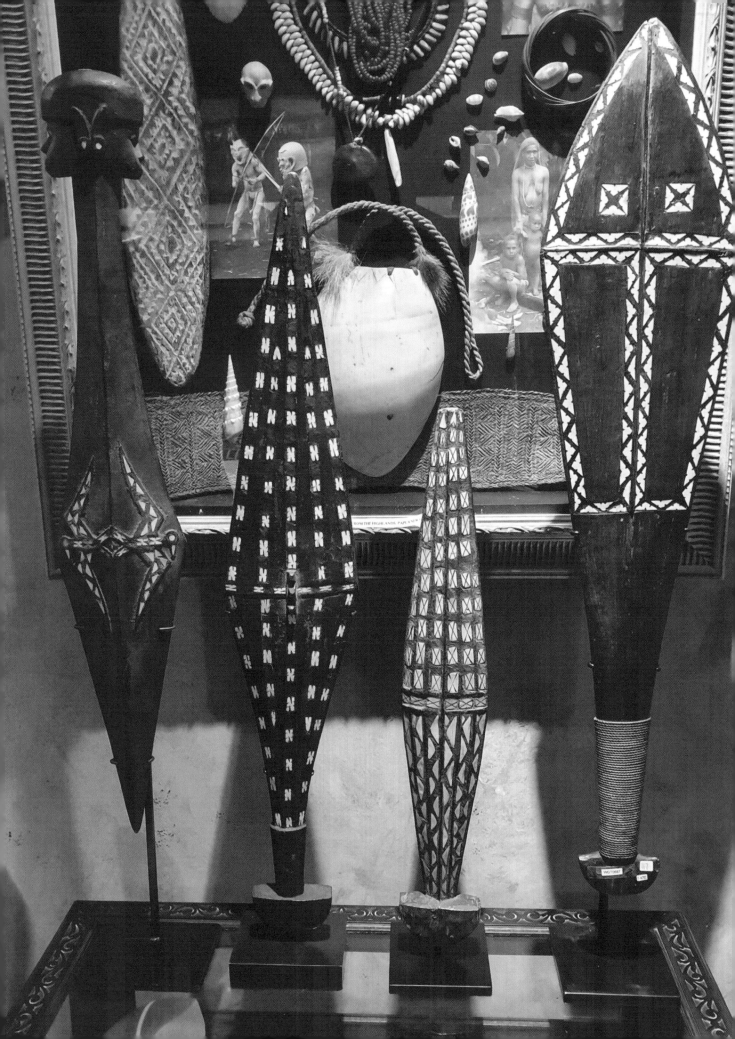

Parinarium nut paste

Whenever you see South Seas ceremonial prestige objects inlaid with shell, it is likely that the description will say that the inlay has been fixed with '*Parinarium* nut putty', sometimes incorrectly spelled *Paranarium*. In fact, that now common name is derived from the outdated synonym *Parinarium hahlii* for the *Atuna racemose* tree. It should now, correctly, be called *Atuna* nut putty.

The fruit of this tree is grated and made into a putty that has been used for caulking canoes across the Pacific islands for thousands of years. The fatty acid content of the nut allows it to be used as a binding medium.

Especially in the Solomon Islands, it is used extensively for fixing *Nautilus* shell inlay to many ceremonial objects and adornments. This inlay-effect is most often seen on shields, clubs and sticks from Malaita and around Makira Island (previously known as San Cristobal), ear adornments from Malaita and bowls from Roviana Lagoon. The paste is sometimes coloured with black or red pigment. Examples of *Nautilus* shell inlay in *Parinarium* nut putty are shown below and on the facing page, all from the author's collection.

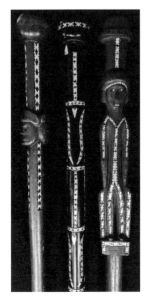

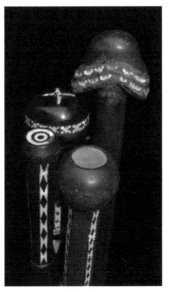

Nautilus shell being cut into strips and tiles for constructing mosaics in ceremonial objects.

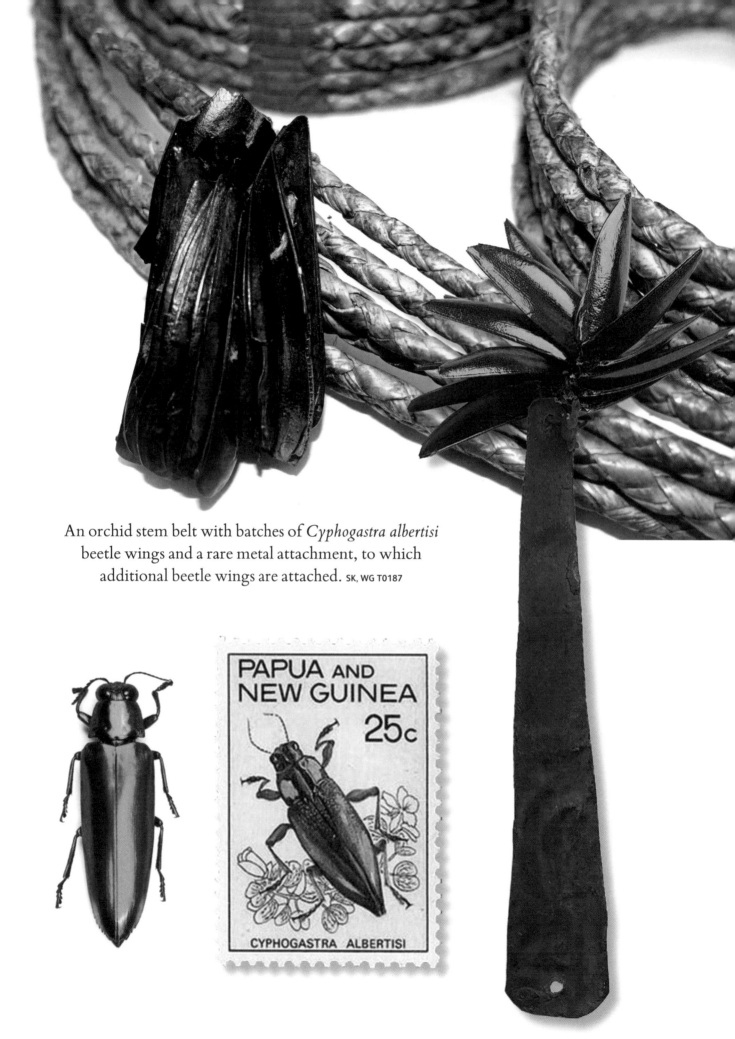

An orchid stem belt with batches of *Cyphogastra albertisi* beetle wings and a rare metal attachment, to which additional beetle wings are attached. SK, WG T0187

PAPUA AND NEW GUINEA

25c

CYPHOGASTRA ALBERTISI

Beetle wings

Chrysochroa is a genus of metallic-coloured wood-boring beetles. The iridescent wings of *C. fulminans* made attractive additions to adornments in New Guinea – see examples opposite, the wings pierced and strung at the upper ends). These 'wings' are not the actual wings used in flight, they are modified, hardened fore-wings, and are correctly called 'wing cases'. Also, necklaces were made from their legs, bored lengthwise.

In the 19th century, European ladies of high standing would have dresses covered in these iridescent beetle wings – creating a fashion sensation wherever they appeared.

In the Wahgi Valley of the Western Highlands Province of PNG, *mormi* is the local term for the green *Chrysochroa* beetles. They are trapped by laying out ripe bananas to which the beetles are attracted. Depending on the species, they live for just one or two days, or up to about two weeks – overall a very short life in which to produce such long-lasting jewels.

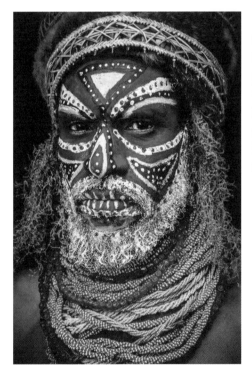

John Singer Sargent's painting of Ellen Terry playing Lady Macbeth, wearing the renowned dress adorned with beetle wings.

At left, a Tambul tribesman in the Wahgi Valley is wearing the traditional facial adornments giving him the required fearful, warlike expression, surmounted by an impressive headband made from orchid fibre with beetle wings woven into it.
Photo: OF 2015

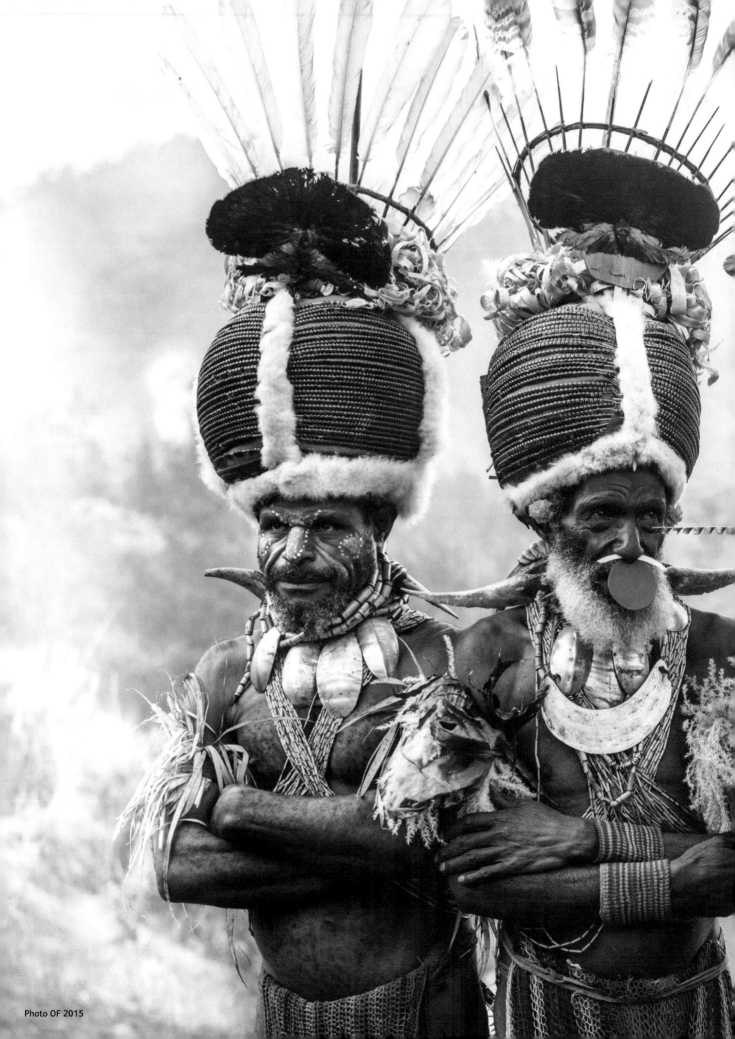

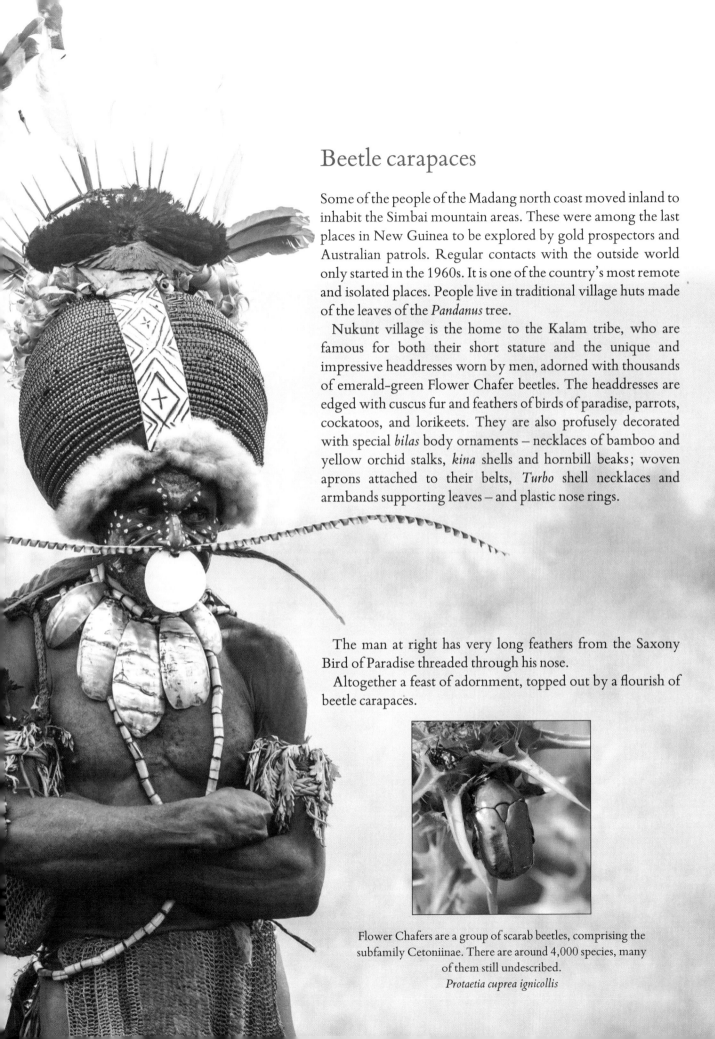

Beetle carapaces

Some of the people of the Madang north coast moved inland to inhabit the Simbai mountain areas. These were among the last places in New Guinea to be explored by gold prospectors and Australian patrols. Regular contacts with the outside world only started in the 1960s. It is one of the country's most remote and isolated places. People live in traditional village huts made of the leaves of the *Pandanus* tree.

Nukunt village is the home to the Kalam tribe, who are famous for both their short stature and the unique and impressive headdresses worn by men, adorned with thousands of emerald-green Flower Chafer beetles. The headdresses are edged with cuscus fur and feathers of birds of paradise, parrots, cockatoos, and lorikeets. They are also profusely decorated with special *bilas* body ornaments – necklaces of bamboo and yellow orchid stalks, *kina* shells and hornbill beaks; woven aprons attached to their belts, *Turbo* shell necklaces and armbands supporting leaves – and plastic nose rings.

The man at right has very long feathers from the Saxony Bird of Paradise threaded through his nose.

Altogether a feast of adornment, topped out by a flourish of beetle carapaces.

Flower Chafers are a group of scarab beetles, comprising the subfamily Cetoniinae. There are around 4,000 species, many of them still undescribed.
Protaetia cuprea ignicollis

solomon Islands
Stone axe head. once used
as currency. WGT0070

Large stone blade: **SM, WG T0072**
Small stone blade on top: **WG T00070 A**

Above: **WG T00070 B**

Purchased 18/1/1940. from
Mr. Jas. T. Hooper $25/=
Croxley Green. Herts.

New Guinea. Stone Adze Blade
used as money in S.E New Guinea
6" × 4".

A nephrite jade bead necklace strung on
a plant fibre cord with long braids spun
from flying fox hair. This would have
been worn by a wife or daughter of a
chief. Length 810 mm. Collected by
Emma Hadfield in the Loyalty Islands,
late 19th century. BM Oc1928,-.13

Stone

Prestige, wealth and currency

Hard green stone used for axe and adze blades have been important trade and prestige items throughout the South Seas for thousands of years.

Far left is a large 160 mm blade from the Massim people around Milne Bay, southeast Papua New Guinea. The two smaller greenstone adze blades, at 60 and 80 mm, are from the Solomon Islands. These stones have the patina of ages and will have been handled, used and traded over many generations. Those illustrated here were all collected before 1945.

Precious stone blades were sometimes bound to carved wooden handles and, even though the handles were magnificently carved, their sole purpose was to show off the beautiful stones. Right is a Massim blade haft made of hardwood with typical Massim carved pattern incorporating a stylised snake, collected around Milne Bay in 1886 by Hugh Hastings Romilly. The stone blade is missing but the cane binding remains. BM Oc1981,Q.1794

New Caledonia stone beads

In New Caledonia, hard green stones of serpentine or nephrite (commonly included in the generic term 'jade') are especially valued as beads in adornments, in addition to their use in tools and weapons. The nephrite necklace shown opposite, called *meciwe* in the Kanak language, would have been amongst the most prestigious riches, held by women and daughters of chiefs. A *meciwe* was also an important currency: the longer the skein of flying fox hair, the greater its value.

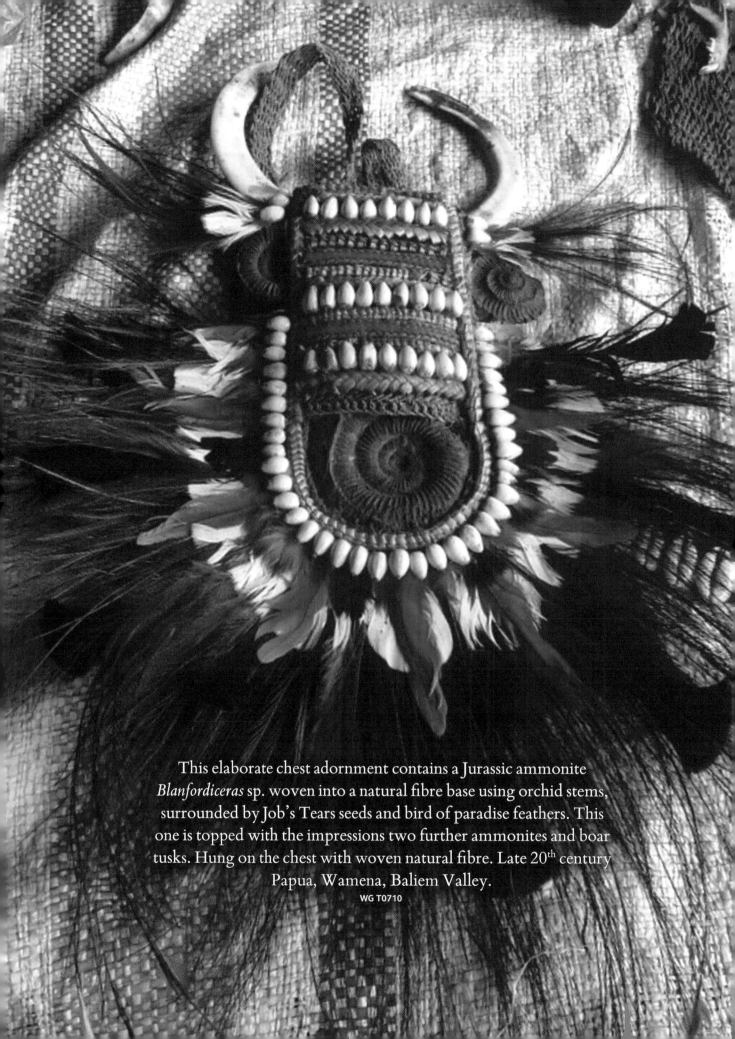

This elaborate chest adornment contains a Jurassic ammonite
Blanfordiceras sp. woven into a natural fibre base using orchid stems,
surrounded by Job's Tears seeds and bird of paradise feathers. This
one is topped with the impressions two further ammonites and boar
tusks. Hung on the chest with woven natural fibre. Late 20th century
Papua, Wamena, Baliem Valley.

WG T0710

Fossils

Across New Guinea, unusual natural objects have always been associated with magic. The rivers in the Highlands yielded many 'magic stones' – the most highly treasured were those displaying spirals. These are actually fossil ammonites, extinct shelled ancestors of squid and octopus, several hundred million years old, washed down the rivers from fossil deposits upstream, especially during floods. In markets in Goroka in the New Guinea Highlands, we were able to find some 'magic stones' that were parts of really unusual uncoiled heteromorph ammonites, treasured by fossil collectors, such as this one at right, shown from two angles.

Traditionally, these 'magic stones' were kept for their supposed magical powers in small amulet bags or used by magicians as part of their powerful rites.

The Dani people of the Baliem Valley in the Papuan Highlands are the only New Guinea tribe that are known to have integrated these fossil 'magic stones' into their adornments. The earliest ones known were simply tied with natural fibres into a necklace, but in the 1980s, likely with the encouragement of entrepreneurial dealers, more elaborate adornments started to appear, such as the one illustrated on the facing page.

The ammonites are found in nodules in the Jurassic deposits of the upper Baliem River, are about 160 million years old and are washed down the river in the annual floods to be collected by locals and used as charms or integrated into various adornments. The photos below show us recovering ammonites on a 2012 expedition down the Baliem River.

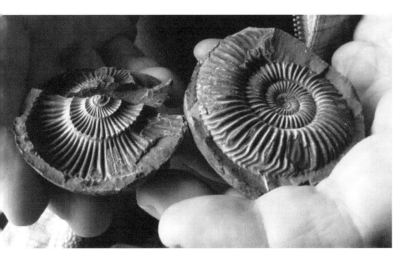

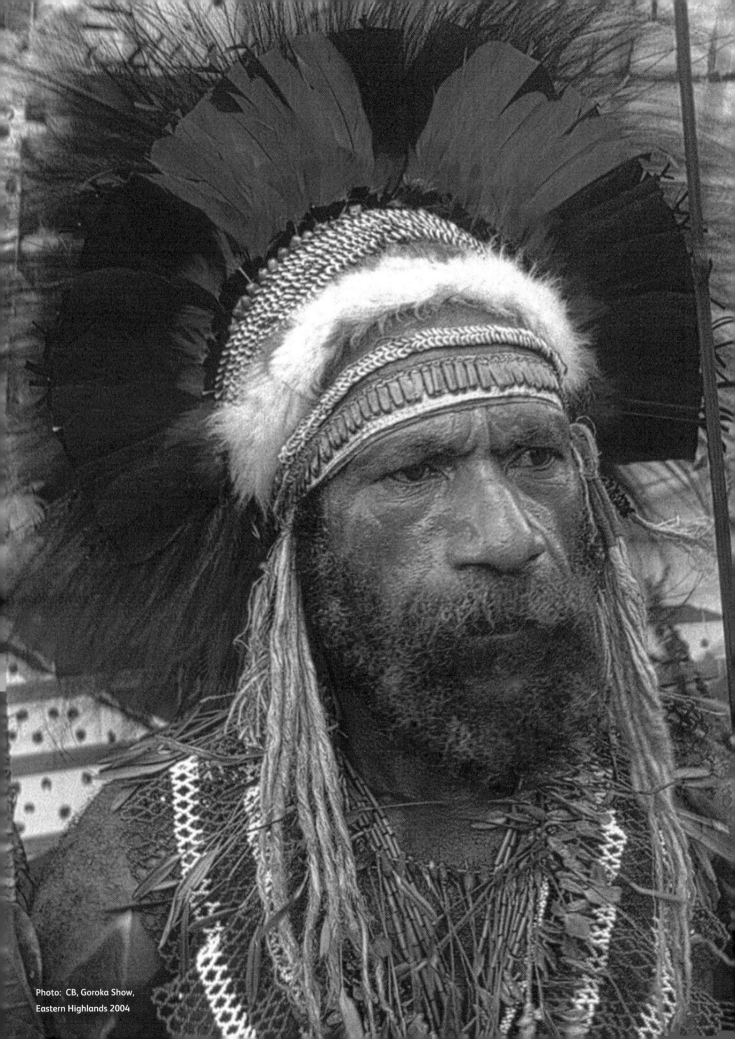

Pigments and paint

Colour is an essential aspect of adornment. Most traditional pigments came from natural clays in yellow, white and rust colours. Because these materials were usually reduced to powders, plant saps and oils were used as binding agents. Sometimes the powders were baked in leaf packets to intensify the colour. Other common sources were vegetable dyes, insects, charcoal and oils to make black paint, and powdered white lime from shells. To apply colours, bamboo sticks were used or twigs with the end chewed to make a paintbrush. Everything, from ochre to brushes, was traded.

Once European trading stores arrived, they sold packets and bottles of commercial paints which were favoured for their ease of use and more brilliant colours. In the late 19th century products such as Reckitt's Blue, a laundry whitening powder, became popular for adding a previously unobtainable bright blue colour. It is the saturation that is of great importance, not the blue colour per se. Generations later, typewriter white-out fluid was used for painting highlights and body adornment.

The photo of a Benabena man decorated for a ceremony, on the facing page, shows a stark combination of the old traditional forms – the red feather headdress, the Nassa shell and cuscus fur headbands – and the impact of modern materials such as Reckitt's Blue to colour his face.

The base for the large headdress is made of imported cotton cloth (rather than natural *tapa*) and the headband of green beetle wings uses yellow nylon rather than the traditional yellow orchid fibres. Of course, the glass beads used to make the pectoral were introduced by missionaries and traders in the late 19th century.

Which takes us neatly from *Naturalia* to *Artificialia* in materials used in South Seas adornments.

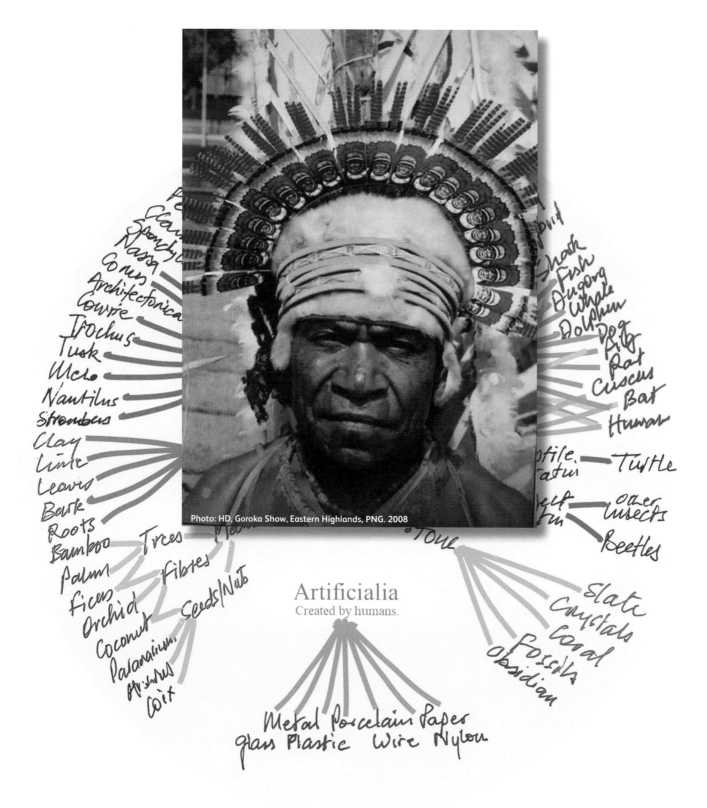

Peucu
Clams
Spondylus
Nassa
Conus
Architectonica
Cowrie
Trochus
Tusk
Ucro
Nautilus
Strombus
Clay
Lime
Leaves
Bark
Roots
Bamboo Trees Me
Palm
Ficus Fibres
Orchid Seeds/Nuts
Coconut
Paranium
Hisabus
Coix

pua
Shark
Fish
Dugong
Whale
Dolphin
Dog
Pig
Rat
Cuscus
Bat
Human

ptile. — Turtle
ratu
elf other
 Insects
 Beetles

Tour
 Slate
 Crystals
 Coral
 Fossils
 Obsidian

Artificialia
Created by humans.

Metal Porcelain Paper
glass Plastic Wire Nylon

Artificialia

As we saw earlier, in the context of the *Wunderkammer*, natural materials would be classed as *Naturalia*, and man-made items would be classed as *Artificialia* – objects made from materials created by humans.

Anything new and unusual that washed up on South Seas shores, or arrived with traders or missionaries, was welcomed, given a high status and eventually integrated into adornments. Glass beads and buttons brought in by traders and missionaries were the start of a plethora of things that were utilised.

Locals even found the colourful plastic insulation around electrical wire quite irresistible. Soon they would be 'harvested', cut and used to replace or supplement natural materials.

The shell money-bead makers of Langalanga in the Solomon Islands began to use nylon string to tie their strings of beads as soon as it became easier and 'cheaper' than weaving their own natural fibres.

In the photo on the facing page, the traditional feather headdress of this dancer from the Benabena Valley has been re-worked using bubble-gum wrappers. This mimics the style of the red and yellow feathers of the Orange-Billed Lorikeet *Neopsittacus pullicauda* almost exactly. The man also wears a traditional headband of cuscus fur, embellished with narrower headbands made of green and yellow nylon.

This is the story of *Artificialia* – and it's not a recent phenomenon.

Orange-Billed Lorikeet
Neopsittacus pullicauda.

A modest bracelet in which tubes, insulators and bits of brass pipe have become 'treasures' and added to flying fox teeth, all strung on modern string and wire. Solomon Islands. **WG T0094**

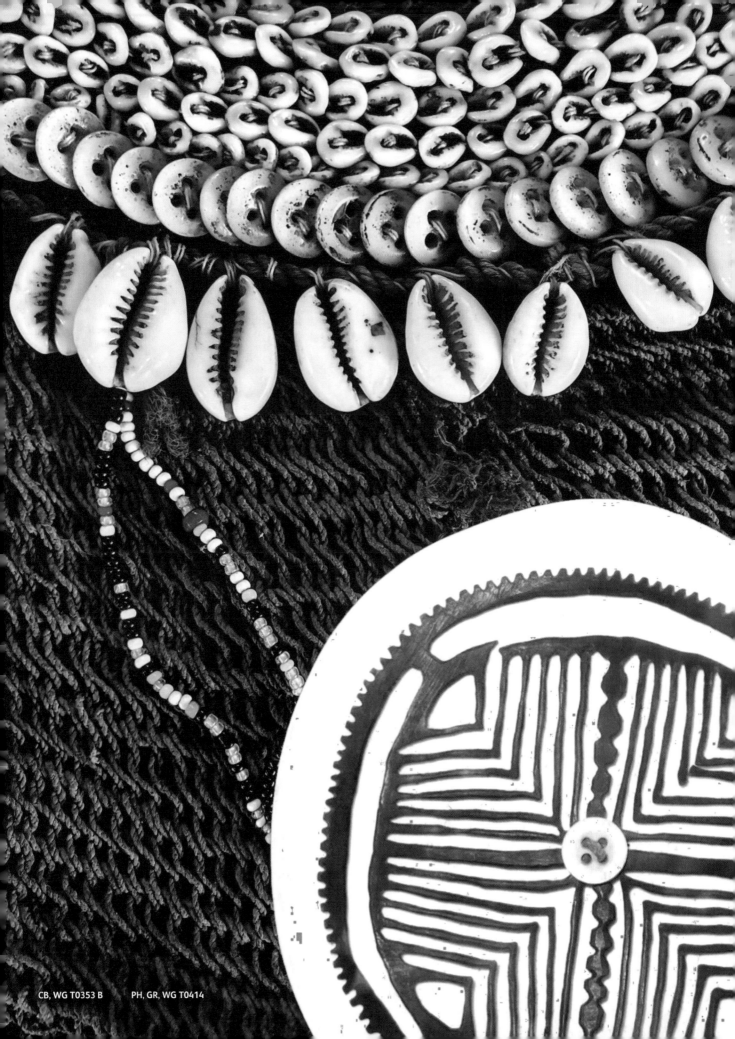

Glass beads and buttons

Traders and missionaries brought beads and buttons to exchange. Such items have often been listed in trade inventories and contemporary accounts since the mid-19th century and were welcomed by locals as cheaper and brighter alternatives to local money-beads. Ever since, both have been enthusiastically integrated into traditional adornments – the woven *bilum* bag at left has buttons integrated amongst the natural materials, and the *kapkap* adornment from the Mekeo people in the Papuan Gulf, facing page bottom, uses a button to tie down the traditional turtle shell carving to the *Melo* shell back.

In New Caledonia, the *Trochus* sp. molluscs were a highly prized food for the Kanak people, and the discarded shells were shipped to France since the 19th century and transformed into 'pearl shell' buttons. By the early 20th century, trade reached its peak with up to one thousand tons of *Trochus* shells being exported per annum.

Meanwhile a similar industry in buttons had developed in the United States – but these buttons were being produced from the shells of local freshwater molluscs. A German button manufacturer named John Frederick Boepple came to the United States and found that the bend of the Mississippi River near Muscatine, Iowa, caused shells to accumulate – perfect conditions for the mother-of-pearl button industry. There was a time when almost half of the world's buttons came from this single manufacturer.

Many of the French and American buttons made their way back to the South Seas over time.

We came to anchor next morning, and soon were surrounded with canoes, and our deck swarmed with natives trading their curios, yams, coconuts, and fish – for our glass beads and iron goods.

The Project Gutenberg eBook, *Adventures in New Guinea*, James Chalmers 1886

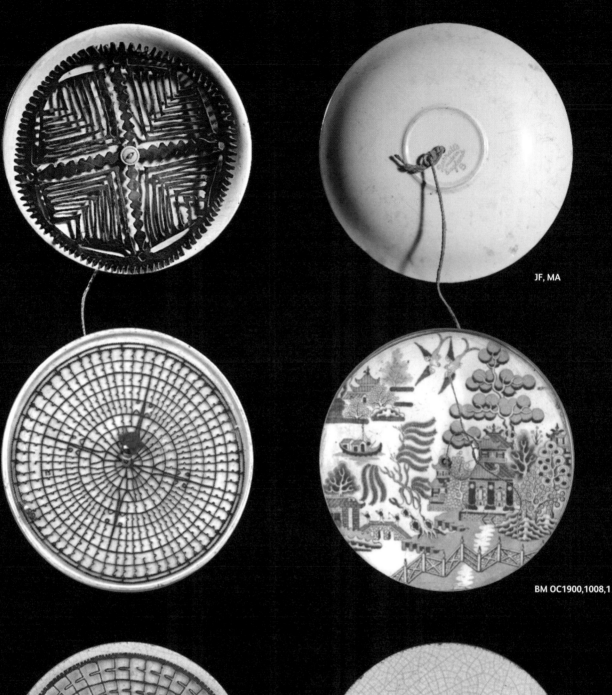

JF, MA

BM OC1900,1008,1

BM OC1900,1008,2

Porcelain and ceramic

Manufactured *artificialia* was even integrated into the most valuable of objects found in the South Seas – the adornments broadly called *kapkaps* – highly detailed filigreed turtle shell discs mounted on shell bases – we'll meet these beautiful items in some detail in the next chapter. The three examples illustrated on the facing page and shown both front and back, serve to illustrate the introduction of imported porcelain splendidly – possibly making the objects even more attractive in the eyes of their owners.

Top is an example of a Papuan Gulf *kapkap* on which the traditional shell base has been replaced by a British porcelain plate. The plate was undoubtedly obtained in trade during the British occupation of that part of New Guinea in the late 19th century. Size 140 mm.

The two examples below are Solomon Islands *kapkaps* (there called *dala*), where the turtle shell fretworks have been mounted on two different ceramic bases. Charles Woodford, who collected both of these along Roviana Lagoon, wrote a letter to the British Museum on 4 March 1900, recounting how he acquired these objects: "*Two very fine examples of the tortoiseshell fretwork on discs ground down from old plates. I took them myself from an island in the Rubiana (sic) Lagoon when administering punishment for the last, and I hope and think final, head-hunting raid from that locality.*"

The first of these two examples has been mounted on a cut portion of a thick Chinese ceramic plate, perhaps from a shipwreck. Size 135 mm. The second of these examples has been mounted on a disc cut from an English Staffordshire China plate. Size 115 mm.

Ceramics and porcelain are both made from clay, the difference being mainly in the heating and solidifying process. Porcelain is made at a higher temperature than ceramics, making it denser and harder, but more expensive to produce.

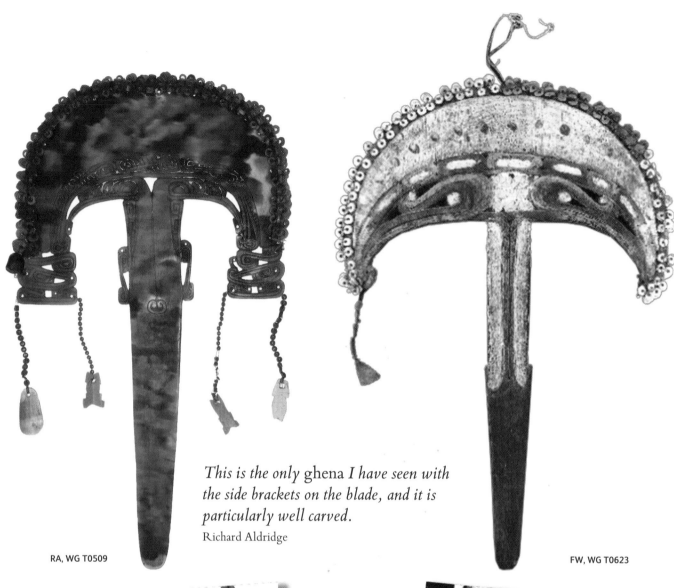

This is the only ghena I have seen with the side brackets on the blade, and it is particularly well carved.
Richard Aldridge

RA, WG T0509

FW, WG T0623

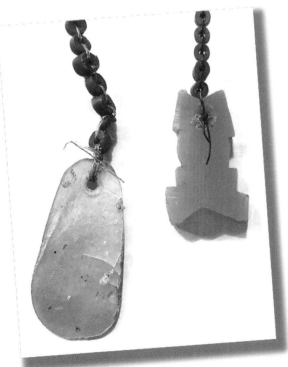

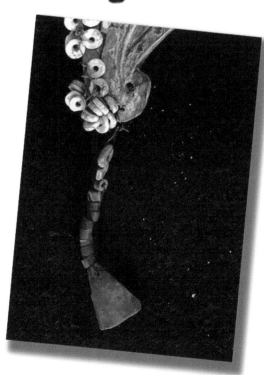

Plastic

Towards the middle of the 20th century, when bits of plastic started washing up on island shores, they became a highly desirable addition to traditional adornments.

Plastic is sometimes seen appended to even the most valuable heirloom items – seemingly an anachronism in our pursuit of 'genuine' ethnographic items. Like it or not, anything different for integration into adornments was fair game.

The two ceremonial *ghenas* shown on the facing page are excellent examples of this. Collected on the Trobriand Islands and Sudest Islands respectively in the 1980s, they were originally made in the late 19th century. Both have plastic 'dangles' added at a later date. On the wooden *ghena* they have been attached with fine old *Spondylus* shell beads, but on the turtle shell *ghena* they have been attached with sheaths cut from plastic-coated wire. The turtle shell *ghena* still has the original *bagi* shell-money discs, made of precious *Spondylus* shell, attached on the top, but it is interesting to note that several have been replaced with plastic discs, The detail of the wooden *ghena* shows that about half the *bagi* have been replaced with 'inferior' white shell discs.

The dramatic New Guinea Highlands head adornment at right is made of cassowary feathers mounted on a coconut fibre headband. It has a plastic star integrated into the traditional materials, adding immediate dramatic impact and prestige to the wearer. Collected in the 1970s on the Fly River estuary, the plastic was likely added in the 1950s.

The most precious *daveri* currency from Sudest Island, wrapped in natural fibre and adorned with shell-money beads – and with plastic added much later. **KK**

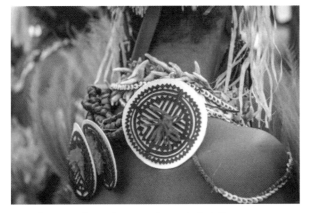

Kapkaps cut from plastic with simplified filigree pattern. Mekeo festival. **OF 2014**

Cassowary feather head adornment with plastic star. **GR, WG T0445**

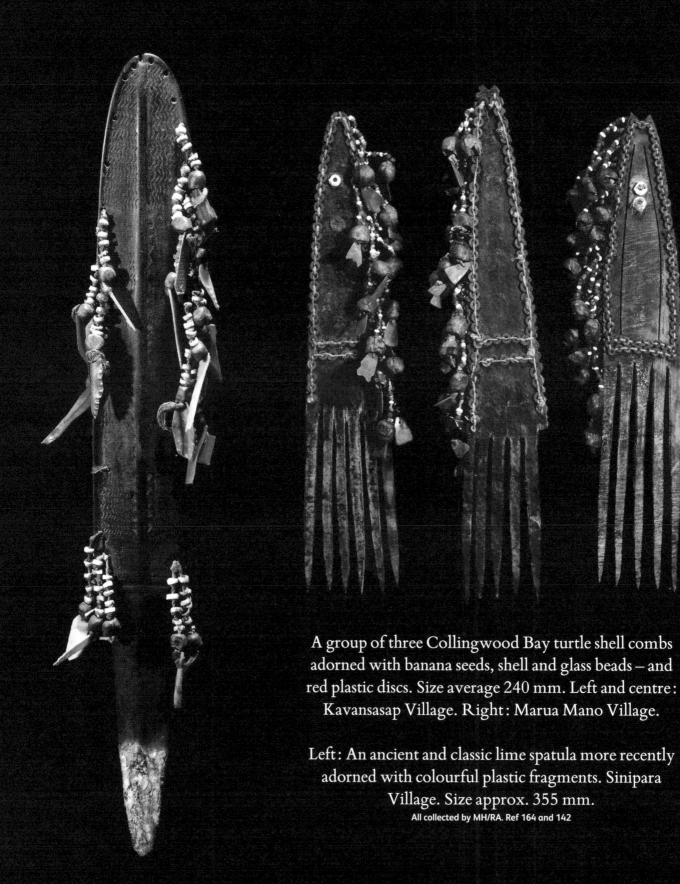

A group of three Collingwood Bay turtle shell combs adorned with banana seeds, shell and glass beads – and red plastic discs. Size average 240 mm. Left and centre: Kavansasap Village. Right: Marua Mano Village.

Left: An ancient and classic lime spatula more recently adorned with colourful plastic fragments. Sinipara Village. Size approx. 355 mm.

All collected by MH/RA. Ref 164 and 142

Plastic

Collingwood Bay, Eastern New Guinea

Here are further examples of how priorities and values change over time and how readily new materials are integrated into traditional objects.

The ancient and classic lime spatula at far left has evidence of old repairs and much usage. The traditional seeds and shell bead attachments are boldly supplemented with new brightly coloured plastic gathered on local beaches.

In the image below, an elder of Kavansasap Village on Collingwood Bay wears two turtle shell combs tucked horizontally into the back of the hair so that the carved shell pieces, banana seed and glass bead attachments dangle downwards. The red *Spondylus* shell beads that would have previously been tied to the combs have all now been replaced by beads cut from the plastic covering of wires.

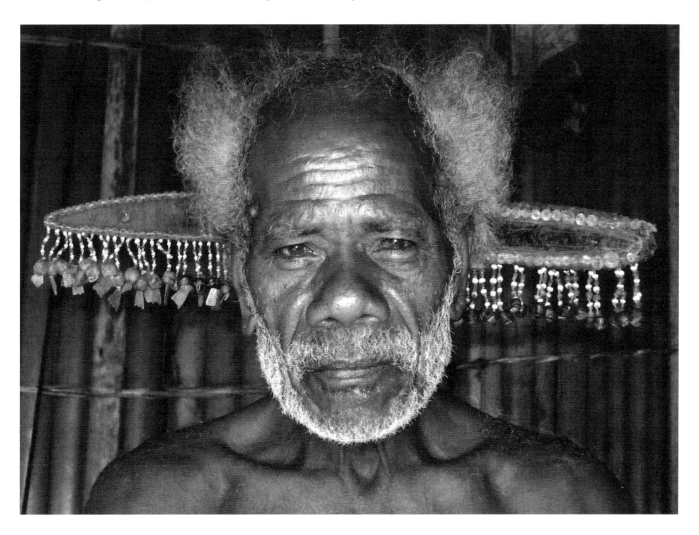

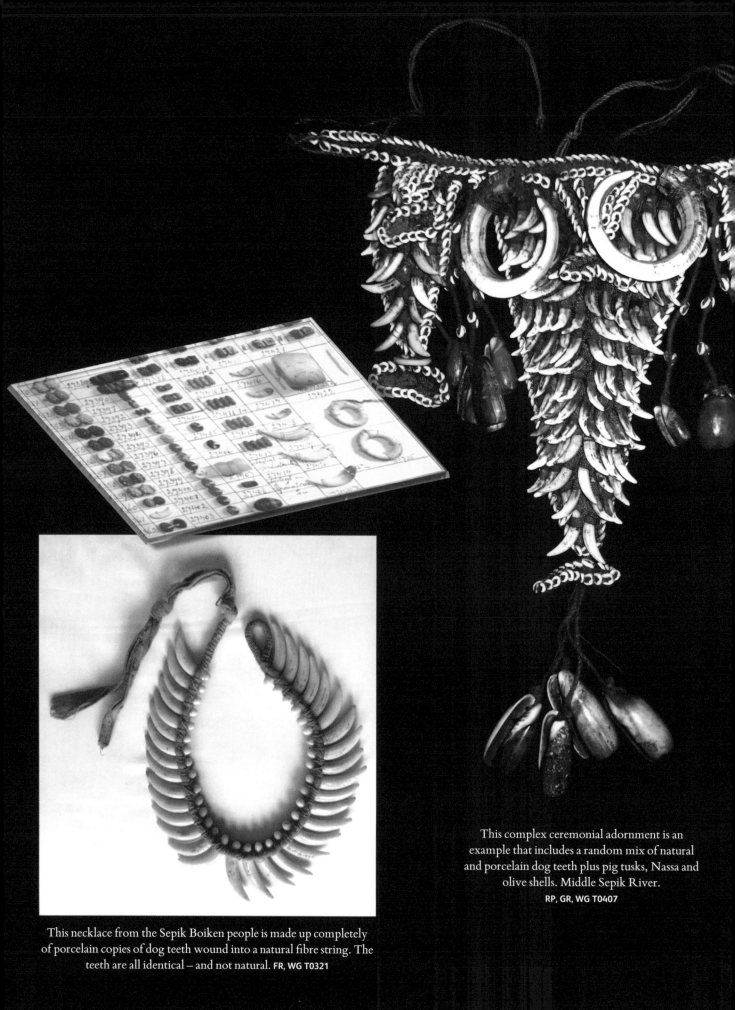

This complex ceremonial adornment is an example that includes a random mix of natural and porcelain dog teeth plus pig tusks, Nassa and olive shells. Middle Sepik River.
RP, GR, WG T0407

This necklace from the Sepik Boiken people is made up completely of porcelain copies of dog teeth wound into a natural fibre string. The teeth are all identical — and not natural. **FR, WG T0321**

Colonial replicas

Dog teeth

During the German occupation of the north-eastern part of New Guinea from 1884, the colonial authorities engaged the thriving porcelain industries in Germany and Bohemia to make porcelain and ceramic copies of several much-used traditional currency items, such as dog teeth and the smaller rings. The material was sometimes referred to as 'milk glass' and the replica items were primarily used by German companies to pay locals for working on plantations. It was hoped that this way the colonial administration could better control the local economy.

Contracts were assigned to traders to import a plethora of items from Europe. Although these replicas are often cited as being 'Made in Germany recent research by Maria Wronska-Friend has tracked down prolific manufacturers to Bohemia, including Albert Sachse's factory in Jablonec, in what is now the Czech Republic. An example of their catalogue is shown far left. By the early 1900s these replica items were already being accepted as part of brideprice payments. It is said that manufacturers even tried to copy Nassa shells – but without success.

The large canine teeth of dogs were highly valued, all of similar size and relatively straight forward to copy. The necklace at bottom left, from the Sepik Boiken culture, is made up completely of porcelain copies of dog teeth wound into a natural fibre string. It is clear that the teeth are all identical – and not natural.

While these replicas were soon accepted by the local people, they have been largely frowned on by ethnographic collectors – with the noted exception of the Pitt-Rivers Museum which include these 'trade goods' as an integral part of their collections.

Over time these porcelain teeth became mixed in with real dogs' teeth and are occasionally seen mixed in adornments from New Guinea.

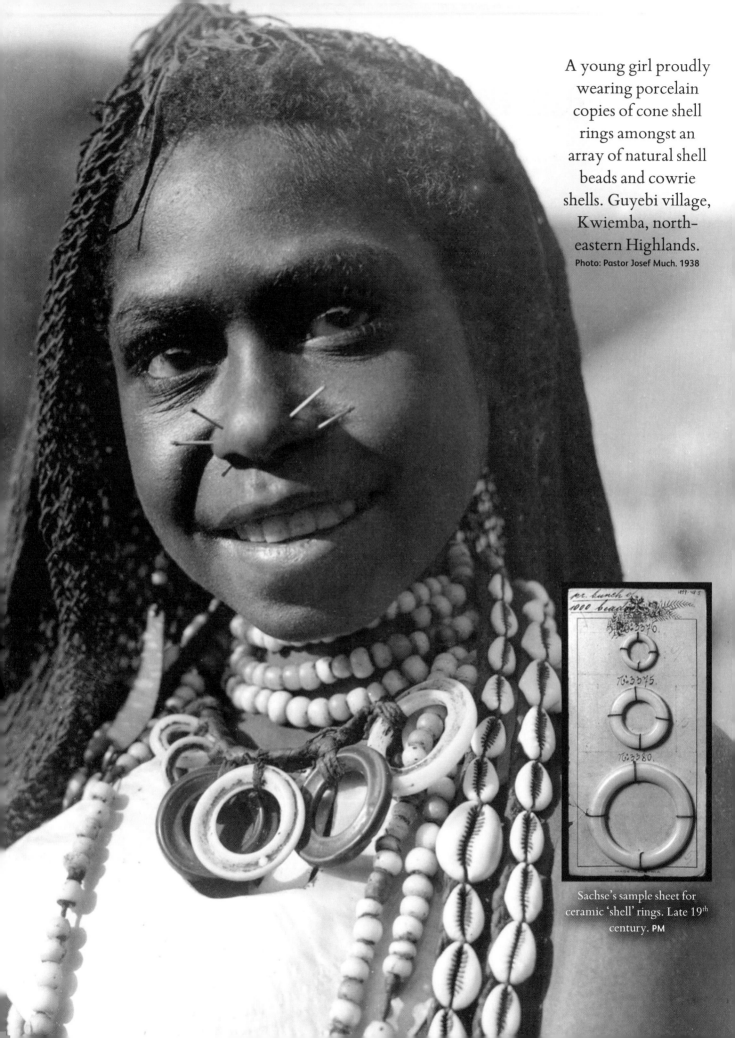

A young girl proudly
wearing porcelain
copies of cone shell
rings amongst an
array of natural shell
beads and cowrie
shells. Guyebi village,
Kwiemba, north-
eastern Highlands.
Photo: Pastor Josef Much. 1938

Sachse's sample sheet for
ceramic 'shell' rings. Late 19th
century. PM

Colonial replicas
Clam and cone shell rings

The other target for German colonial reproductions were the ubiquitously popular clam shell and cone shell rings.

At right is an example of a 'clam shell' armband about 100 mm across, made from ceramic. This one was found being used amongst the Boiken people in East Sepik.

Copies of the smaller cone shell rings were made in great numbers in both ceramic and porcelain varieties and in a variety of colours – as shown in this selection – then shipped to traders in both the Pacific and African markets.

Replica rings soon became commonly mixed with the real things in many adornments. On the facing page a young girl proudly wears a string of porcelain cone shell rings along with cowrie and shell bead necklaces. Even in this black and white image you can see that the porcelain rings are in several colours.

The two images below reflect the same mix of genuine cone shell rings and coloured replicas in Sepik adornments – worn by the woman below right and on the arm ring, below left, with a variety of dog teeth and cone shell rings attached – some genuine and some porcelain replicas.

Ceramic 'clam shell' armband, 100 mm. Boiken people, East Sepik. **FR 1980s, WG T0317**

Below, several examples of ceramic ring replicas made in several unnatural colours for the colonies.

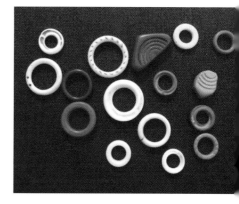

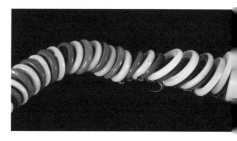

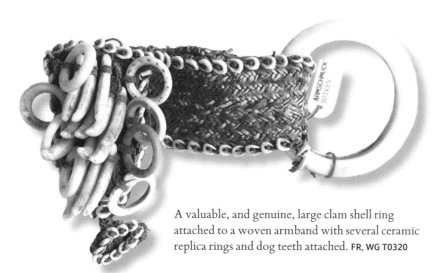

A valuable, and genuine, large clam shell ring attached to a woven armband with several ceramic replica rings and dog teeth attached. **FR, WG T0320**

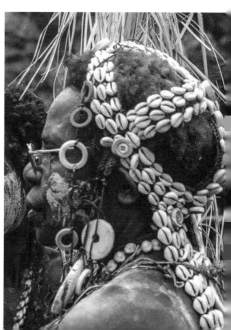

Photo OF

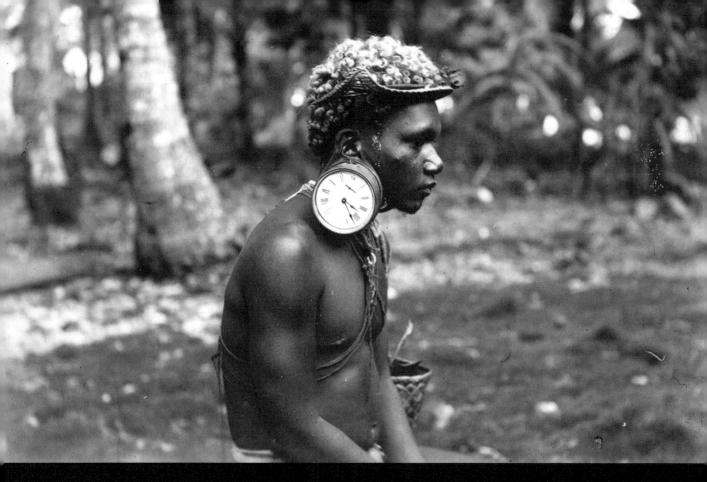

Above: The caption that accompanies this photo says: "Man with clock placed in the lobe of his ear, to show size of the orifice." Solomon Islands. Photo: Rev Dr George Brown 1880s. BM Oc,Ca42.49

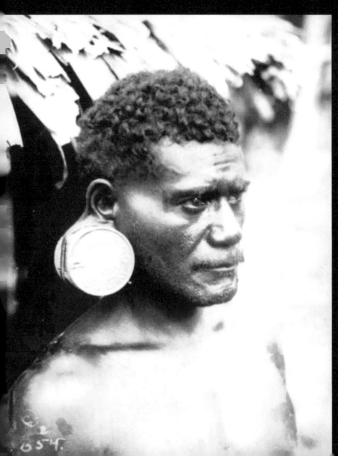

Left: Man with tin can in his ear lobe. Solomon Islands, 1920. AM MEL.SOL.072.JPG

Almost any Artificialia will do!

Cardboard, tins and clocks

This set of images from the Solomon Islands shows the unparalleled fascination for manufactured objects that the early contact with them must have inspired.

The group below posed for a photographer at the Marist Mission on Buka Island in the 1930s, wearing celebratory adornments, including belts woven from orchid fibres and what appear to be large circular *kapkaps*. You'd be right that they appear to be unusually large – they were in fact cardboard cut-outs, likely used to impress while the real things were not available to them or, in that size, to anyone.

The somewhat bizarre images on the facing page show objects inserted into extended ear lobes, replacing the traditional ear adornments. One can only suspect that this was more as a result of the photographers' creativity than a genuine desire to use these objects of *Artificialia* as adornments.

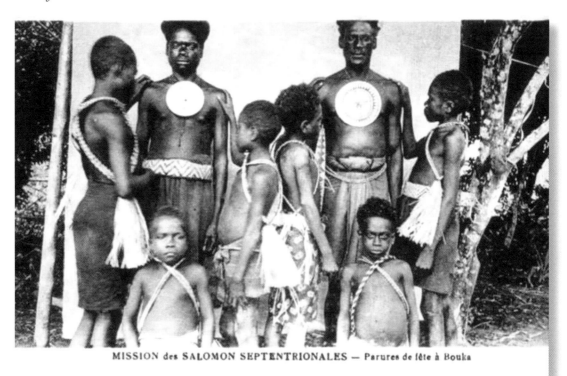

MISSION des SALOMON SEPTENTRIONALES — Parures de fête à Bouka

Photo: *Early photography in the Solomon Islands* by Allison Huetz. November 2014. **AM**

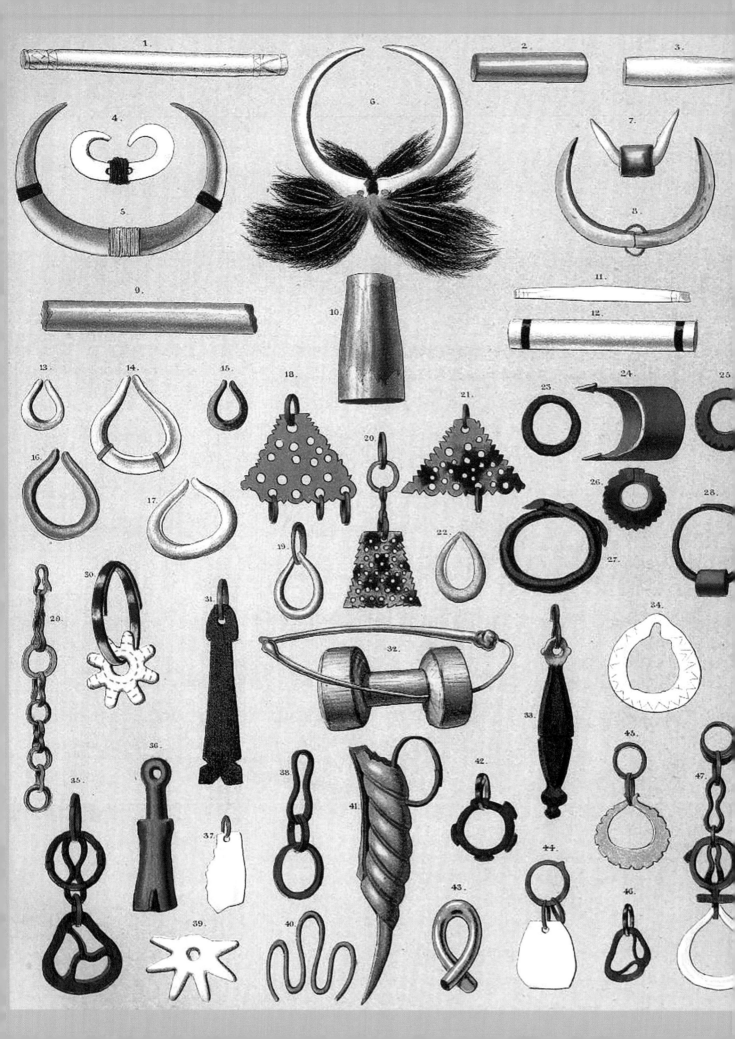

PRECIOUS OBJECTS

The Transformation of Value

The value of things beyond utility

This fabulous illustration from a 1893 study by De Clercq featured nose and ear adornments from the north coast of Papua, all made from natural materials found locally, apart from the coloured glass rings which were traded from far-off lands – more about these later in the *Value Networks* chapter.

At a basic level, all these things are just functional adornments, but in the local context they are also a source of prestige, magic and ancestral power. Just by creating such visual assemblages, De Clercq elevated these functional 'things' into important pieces of material culture, perhaps unintentionally making them sought-after and highly collectable 'objects'.

When *Things* become *Objects*

In his article on *Thing Theory* in 2001, Bill Brown, a professor in visual arts, said that a 'thing' becomes an 'object' when it is no longer used for the purpose for which it was intended, or when it breaks down or stops working. A car abandoned at the roadside would soon become no more than an object of interest, of social detritus, a potential bargain – but no longer a useful thing – a 'car'.

This is particularly so for the objects that are the subject of this book. As we have already seen, most of these objects start off having a specific purpose – either physical or spiritual – they are utilitarian 'things'.

PLATE V. NOSE & EAR ADORNMENTS
De Clercq, F. S. A. 1893 *De Ethnographische beschrijving van de West- en Noordkust von Nederlandsch Nieuw-Guinea (Ethnographic description of the west and north coasts of Dutch New Guinea)*

A picture of Irobaoa, the great leader of Su'uafa, and chief of the sea people on Malaita, Solomon Islands. He wears his adornments with pride: On his head a mass of palm strips stained red and fixed to a comb, two cowries and a large *dala* on his forehead; ear adornments of turtle shell rings, one with a *Conus* shell ring, and a fine nose-pendant carved from *Tridacna* clam shell. His necklace is made of hundreds of the most valuable dolphin teeth. The bands on the top of his arms and his belt are of glass beads. He also wears arm rings of clam shell or cone shell, shell rattles at his knees and rattan bands at the ankles. He wears his calico in a characteristic Malaitan style and holds an *alafolo* club. Re-imagined in colour by C. W. Collinson (in a 1929 Grolier Society publication) from black-and-white photos in the Edge-Partington collection at the British Museum taken ca. 1910. Many of these adornments are discussed in this chapter.

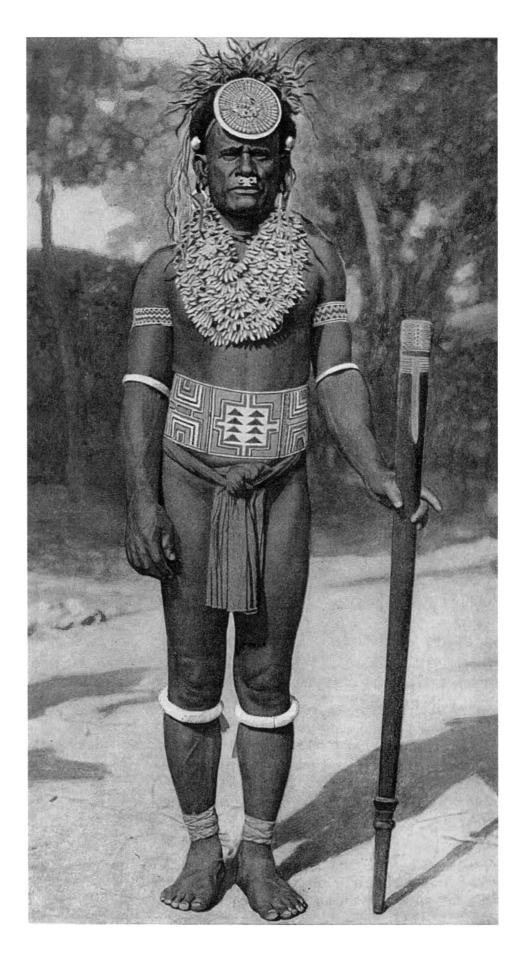

Things were used and exchanged variously as adornments, gifts, commodities, heirlooms and/or currencies, depending on the social or economic context. In each situation, rules and traditions specified the things to be exchanged plus the process to be adhered to – the attendant social relationships and their mythical underpinnings.

Even though currencies may end up being adornments, used in rituals and as part of brideprice and finally hidden away as heirlooms, they continue to be 'things' – they have not yet become 'objects'.

The transformation of value

Once we remove a 'thing' from its useful environment, once we put a collector's label on it, display it in a museum or put it up for sale, then the original 'thing' becomes an 'object'. They have value only insofar as they are observed, understood, discussed, and shared. And only, in my view, when this is done actively and passionately.

So, according to Brown's definition, all things in museums or collections are objects. Perhaps even more profound, is the way an object is seen by different observers throughout its later life.

Once removed from its original context and put up for auction somewhere in the West, the *thing* will have become an object – its verbal history most likely lost, and its *provenance* will have become what Ben Burt evocatively calls "*the history of its Whitemen owners*". With each new perspective it has become a different kind of object, each with a different kind of value.

Let's start this section with one of the simplest things – and the most common utility – a *bilum* bag.

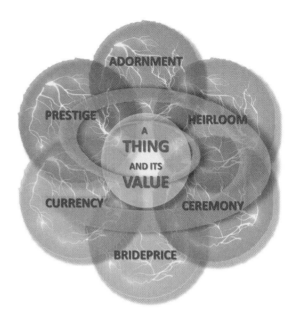

Collecting is the process of actively, selectively, and passionately acquiring and possessing things removed from ordinary use.

Russell Belk 1995

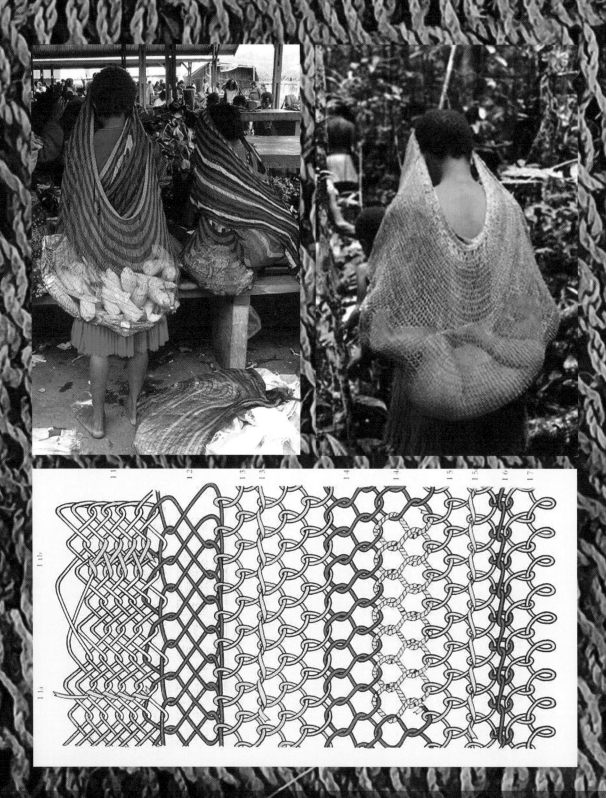

Women using their *bilum* utility bags in two Papuan locations: Dani women in Wamena market in the Baliem Valley, carrying the week's supply of maize and a Kombai woman with her baby in a *bilum*.
At right: Various styles of New Guinea knotless loop weave used in *bilums*. Le Roux 1950 *De Bergpapoea's van Nieuw-Guinea en hun Woongebied* (*The mountain Papuans and their habitat*)

A *Bilum*

Simple bag, complex utility

A *bilum* is a hand-made string bag that is ubiquitous in everyday use in New Guinea. To its users, this utilitarian object goes beyond its obvious functionality – it can enhance well-being and be an integral part of transcendental rituals – so precious is the *bilum* that it also the Tok Pisin word for 'womb'.

Constructed from hand-made natural fibres (often from the *Ficus* tree and ornamented with orchid fibres), *bilums* are woven in a knotless looped figure-of-eight weave that allows for almost infinite expansion. They are both strong and flexible. Other varieties are made of 'bush rope' and *cuscus* fur.

Bilums are manufactured only on mainland New Guinea, with the best ones coming from the Highlands. On average, each bag takes from 80 to 100 hours.to make and some will become an ideal base for added adornments.

Bilums are specifically tailored for a variety of uses. Marc Assayag, writing in his book *Bilum*, identifies four main types:

THE 'INFINITELY' LARGE UTILITY BAG: Equivalent to suitcases for heavier loads, for firewood and cradling children. Women carry these over their foreheads, so they fall down their back. These are seldom adorned.

UTILITY/SHOPPING BAG: Mainly used for food (equivalent of our plastic bag). The specialised bags such as those used by medicine men take these modest bags to extraordinary heights of ornamentation and spiritual content. Men usually carry these over their shoulders.

NECK BAG: The equivalent of purses for precious small items.

ARTEFACT/AMULET/MAGIC BAG: These small bags are receptacles for charms and 'personal magic'. In one example it is used to store a baby's umbilical cord until the baby has grown strong, at which time it is buried.

The photos on the facing page give just a few examples of 'infinitely' large utility *bilums*. Further *bilum* examples follow overleaf.

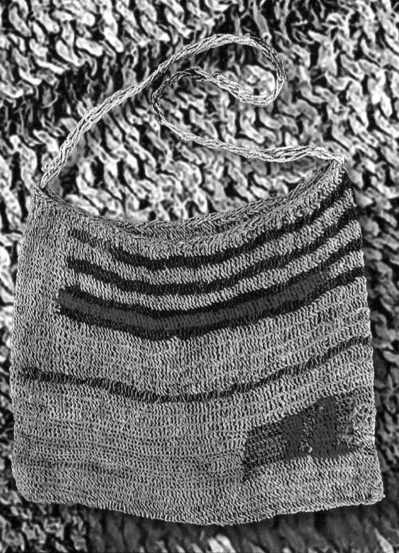

A rare small *bilum* with interesting asymmetrical and abstract design elements. Yilli Village, Torricelli Mountains, Sandaun Province (formerly West Sepik Province), PNG.

GR 1970s, WGT0458

Bold colours & promises

Illustrated here is a pair of 'Promise *bilum*s' that are made by the Kwoma and Nukuma people who dwell in the Washkuk Hills region of the Upper Sepik River. The bags are woven by women, before a man decorates it with shells and tassels for presentation to a man friend as a statement of their friendship – hence the name 'Promise *bilum*' – a promise to stand beside his friend at all times.

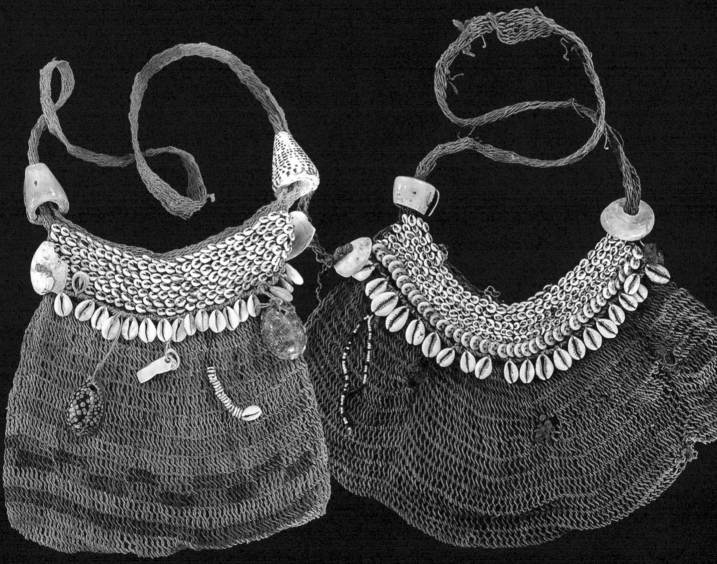

A woven fibre 'Promise *bilum*' from Washkuk village, Kwoma people. Local name : *Mako*. Owner : Peter Ausomb ; presented to him by Colin Kujom.

CB B624, WG T0353A

A woven fibre 'Promise *bilum*' from Warise village, Nukuma people. Local name : *Ayerkupo*. Owner : Paul Molikupa ; presented to him by Pius Amol.

CB G766, WG T0353B

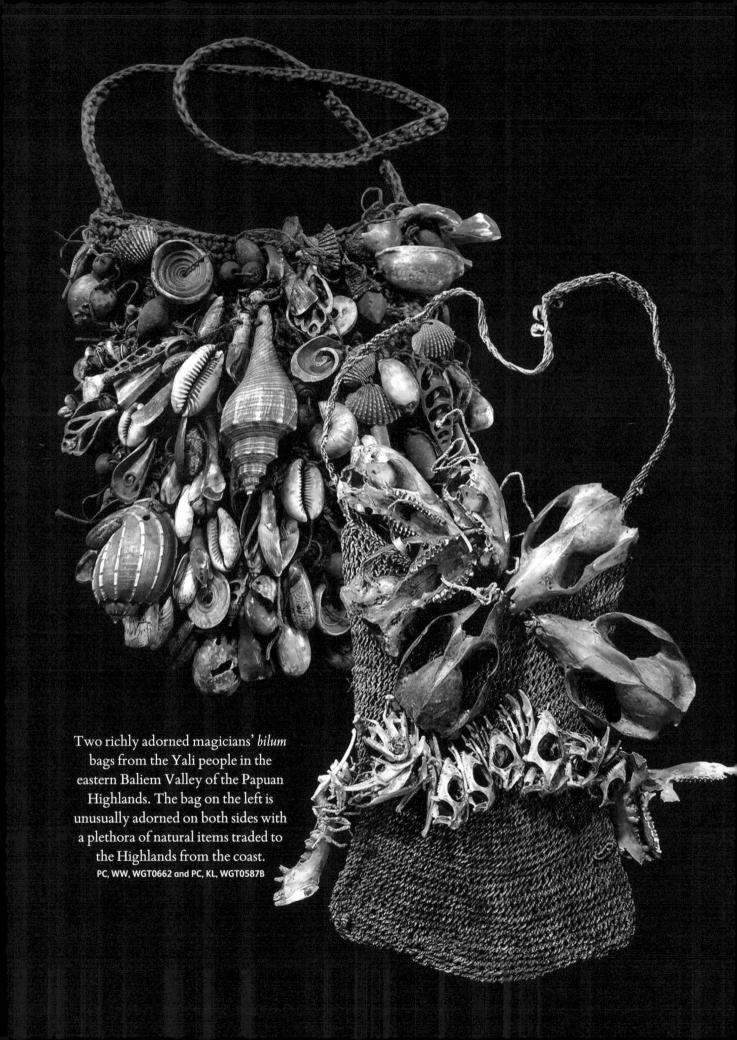

Two richly adorned magicians' *bilum* bags from the Yali people in the eastern Baliem Valley of the Papuan Highlands. The bag on the left is unusually adorned on both sides with a plethora of natural items traded to the Highlands from the coast.
PC, WW, WGT0662 and PC, KL, WGT0587B

Magicians' bags

Some *bilum* bags are covered with a plethora of seemingly random objects and charms. They started out as simple bags that evolved with the magician over time into bizarre complex objects that are *beyond utility*, and are said to *carry magic*, perhaps the ultimate adornment.

They are imbued with a ritual potency and contain the means of their owners' magic and healing powers. These were the only men's *bilums* to be worn hung from the back of the head. Their attractiveness was enhanced because the loose objects rattled when walking and would announce the imminent presence of an important man. When not in use, they were hung inside the *Men's House*.

During the conversion to Christianity these bags were special targets for destruction and many burnings of sacred bags took place.

The two bags on the facing page are examples from the Yali people, a major tribal community in Papua. 'Yali' is the Dani word for *lands of the East* and they live in the eastern Baliem Valley of the Papuan Highlands. Their villages are only accessible by walking for several hours.

The bag at far left is one of the most prolifically adorned bags I have ever seen. Unlike most magicians' bags, it is totally covered on both sides, and must relate untold stories of a lifetime spent gathering these charms. It includes a fabulous variety of teeth, seeds, a crystal mounted in fibre weave, a giant clam shell disc, sea urchin spines, bones and shells of land-snails and marine molluscs. There are also fragments of porcelain, likely washed up on some remote beach from a shipwreck, which will have been traded along tortuous routes from the coast – each one regarded as an important prestige item.

The profusion of skulls in the right-hand example will have been collected locally from a variety of mammals, including the upper and lower jawbones of various cuscus species.

Every bit of *Naturalia* and *Artificialia* is treated with great respect and highly valued.

Galia – money-beads cut from white cockles, ribbed bivalves, usually *Anadara* sp.

Romu – money-beads made from red *Spondylus* or *Chama* shells.

Safi – brown/red money-beads made by heating black mussel shells of *Beguina* sp.

Kofu – fine white money-beads made from the tops of small cone shells.

Kurila – large black mussel beads, perhaps *Atrina* sp., with *galia* and *safi*.

Fulu – black seeds with a natural hole in the middle, with *galia* and *safi*.

Drawings by Ben Burt. Descriptions expanded by the author.

Solomon Islands shell-money

The shell-money of the Solomon Islands has been ubiquitous in the region for hundreds of years. Shell-money was used as currency, as a part of brideprice and in compensation payments. It remains a powerful symbol of reconciliation and was even used as such during the civil conflicts at the turn of this century.

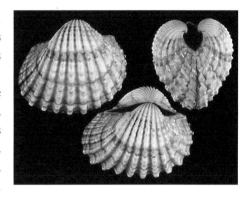

The essential ingredients are beads cut from various shell species, such as the ribbed white bivalve mollusc *Anadara granosa* – which is also an important food source – plus others as shown in the examples opposite.

Production of the shell-money beads is mainly by the sea people of Langalanga on the west coast of Malaita, who call them *bata* – a generic term for shell-money. The Langalanga community takes great pride in these economic activities and their output is traded right across the Solomon Islands and beyond. Today, Langalanga shell-money has gained new value as a symbol of national identity, made into ornaments for dancers, national sports teams, beauty queens and political leaders, gifts for foreign dignitaries as well as tourist souvenirs. Different areas of Malaita and the neighbouring islands have their own preferred kinds of Langalanga shell money and some also make their own.

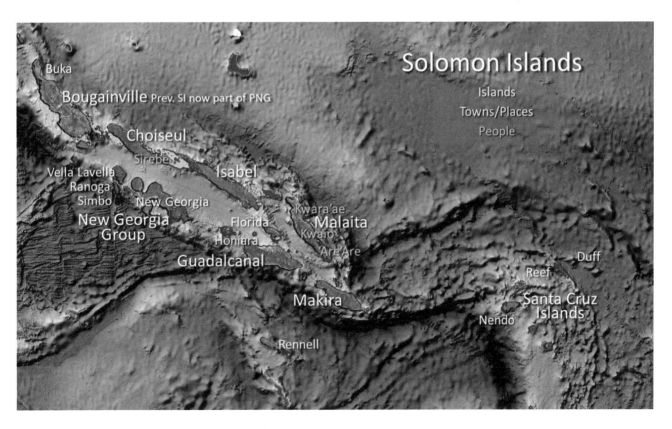

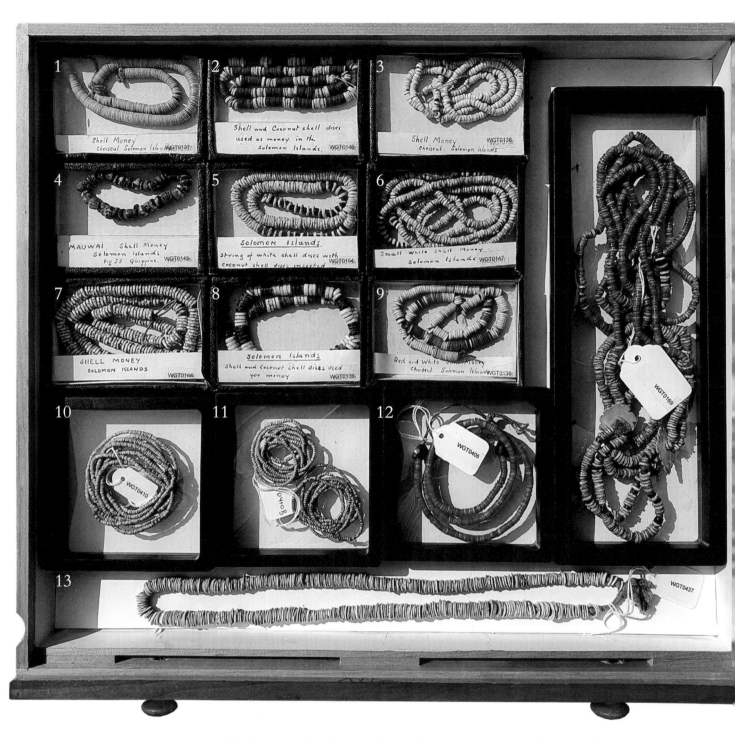

An assortment of Solomon Islands shell-money beads and adornments (numbered 1-12) made in different combinations of beads, seeds and coconut shell, all strung on natural fibres and, below (numbered 13), on a woven band.

SM, WG various

Collected by Charles 'Meyer' Adams from soldiers returning from the war in the Pacific in the 1940s. Several of these (1, 3 and 9) are from Choiseul, the northern-most island of the Solomon Islands – regarded as the least studied of their shell-money forms; 2 and 8 feature coconut shell beads interspersed with cone shell top beads; 5 and 7 are *galia* beads and 6 is string of *kofu* beads, all from Langalanga; 10 and 11 are much finer shell beads called `afi`afi from the Kwaio people of Malaita; 12 is a string of red *Spondylus* shell beads called *romu* with banana seeds at the end; 13 is a strand of *som* shell money-beads made of the polished tops of *Strombus* shells (discussed in detail on page 101). The tall box at right contains a chaotic mix of Langalanga shell-money beads made up with carved shell spacers.

Shell beads are strung into various money denominations and some are strung or woven into adornments. One exception seems to be the Kwaio people's *kofu* – if you see a photo of *kofu* money being worn by the Kwaio, it is only for convenience, it will be worn as a wallet, not as adornment.

The Kwaio used techniques similar to the Langalanga people to make much finer shell beads called `*afi`afi*. The standard value of `*afi`afi* is double that of *kofu* but today most remaining `*afi`afi* strings are heirlooms and worn only as jewellery – examples are shown numbered 10 and 11 on the facing page.

In the western Solomons, shell-beads were also made and used in valuable adornments, rather than as currency – shell rings were the main currency there.

There are two major kinds of shell-beads and there is a subtle difference in the way they are made:

TYPE ONE: BEADS HAND-CARVED FROM SHELL FRAGMENTS

In Langalanga, making shell-beads starts with tasks performed by women, who chip shells into rough beads. Each bead is then drilled as required, formerly with simple pump drills but now with mechanical tools. After this, men take over, stringing the rough beads on a cane to grind and polish the edges smooth.

TYPE TWO: BEADS MADE FROM SHELL TOPS THAT HAVE NATURAL HOLES

Shells such as *Conus* and *Strombus* do not require drilling to make a suspension hole – for more information, see the detailed shell descriptions in the *Natural Gold* chapter.

These two types of beads are discussed on the following pages.

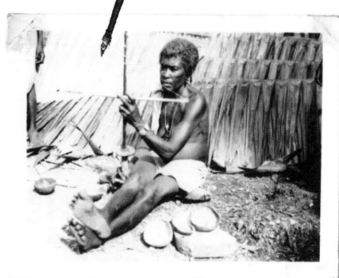

A simple pump-drill.

TYPE ONE: MONEY BEADS CARVED FROM SHELL FRAGMENTS

After they have been used as food, shells such as the cockle *Anadara* sp. would be broken up, drilled with a pump-drill, threaded on cane and the strings polished smooth using water and sand. The beads would then be removed and mixed with beads made from a variety of shell material to make up various forms of shell-money and adornments.

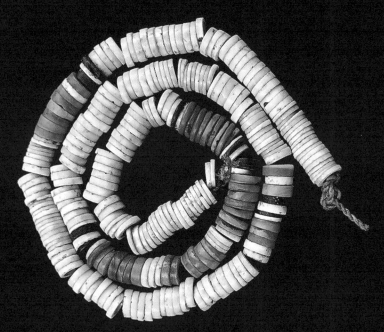

These money beads are carved from various shell types including the bivalves *Anadara* sp., *Spondylus* sp. and black mussel. From Choiseul. Bead diameter 5-6 mm.

SM 1940s, WG T0136

Extremely fine graduated shell beads from Choiseul, carved from unidentified shell species and then carefully polished into thin discs. Bead diameter 5-7 mm.

SM 1940s, WG T0137

TYPE TWO: MONEY BEADS MADE FROM SHELL TOPS
THAT HAVE NATURAL HOLES

Shells such as those of the *Conus* and *Strombus* genera do not require drilling to make a suspension hole. The centres are easily knocked out and the interior spiral of the shell is clearly visible on one side of each bead. The quality ranges from superb to crude.

Image: Quiggin 1949

These extremely fine `afi`afi money beads, from the Kwaio people in southern Malaita, are cut from the tops of tiny cone shells and beautifully polished before being strung on natural fibre. Bead diameter average of 2.7 mm.
SM 1940s, WG T0406C

This strand of shell money beads is from Makira in the southern Solomon Islands and is called *mauwai*. They are made from the tops of small speckled cone shells (*C. sponsalis* or *C. ebraeus*) roughly broken into almost square pieces and not polished. According to Schneider they "look like weather-beaten flotsam". These are rarely seen. Bead diameter 7–8 mm.
SM 1940s, WG T0145

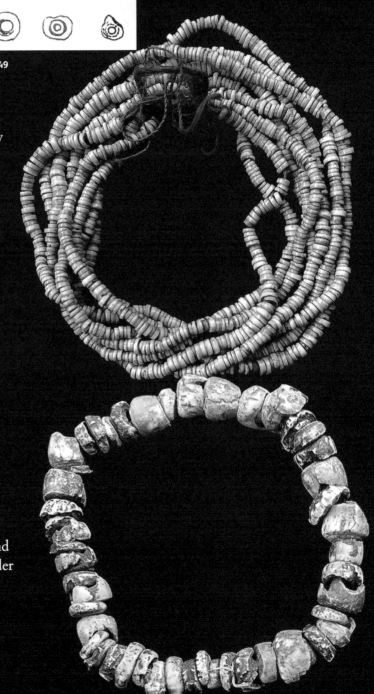

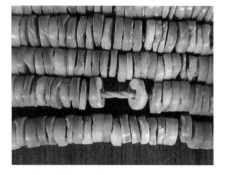

Reconstructing shell-money

Shell-money can be used and exchanged for all of life's necessities – it is essentially treated as cash. When one deconstructs the Solomon Islands shell-money into its basic elements, each one can be seen as a 'ring', 'disc' or 'bead', with each one between 2–8 mm across.

Seen this way, unlimited possibilities emerge to re-construct these money-beads into new objects – it's literally an infinite crafting palette to create a dizzying variety of adornments and exchange items.

Several types of shells are combined into strings with a plethora of natural materials, such as seeds, teeth or turtle shell added for additional value. The modest example at left has just a single flying fox tooth added. MA 1940s, WG T0119

Spacers to manage complexity

When beads are combined to make up larger objects, they can become quite complex with many separate shell strings added, and significantly more valuable than the sum of their individual parts.

To prevent these complex objects from getting entangled, the crafters use spacers called *bala*, carved from turtle shell or wood. This would also keep the valuables looking good as they were carried onto the feast site, with each valuable dramatically hung from long lengths of bamboo. The *bala* spacers are very much functional as well as decorative.

Plain spacers are found in many day-to-day items (they are called *balaodoodo* – *odoodo* meaning 'straight'), but more elaborate ones are sometimes used in valuables given at important feasts – typically for five- or six-string valuables. In the following examples, made in the 1970s/1980s, the number of holes in each spacer indicates the style of valuable it was intended for. The ten-string money *tafuli'ae* is the epitome of these important shell-money valuables and is discussed on page 211.

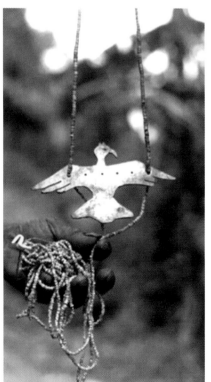

Bird *bala* on a shell-money string made by Nene`au So`ogeni. Kwaio, Malaita, 1996. **Photo: DA**

David Akin, who worked with the Kwaio Cultural Centre and spent nearly seven years living amongst the people of Malaita, relates the story of these spacers: "Malaitans are always borrowing art styles and ideas from each other, and other Solomon Islanders, and did so long before Europeans arrived. *Bala* is also a generic term for turtle shell, and you may see *dafi* crescent ornaments adorned with turtle shell referred to as *bala*. Many *bala* shell-money dividers now are made of plastic. One would not normally use a fancy *bala* in an object given as part of any compensation payment, even though a large valuable might be given in such a payment."

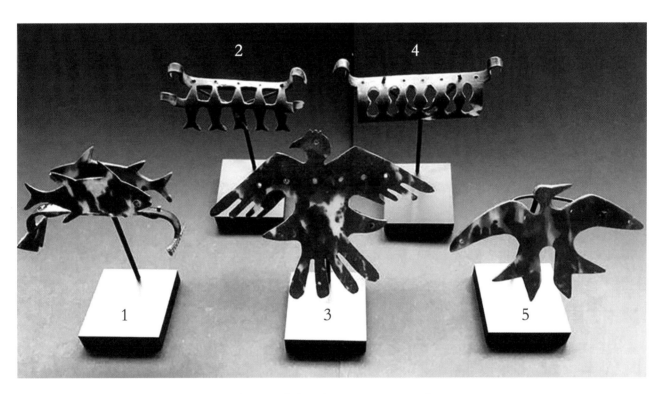

1. A two-fish shape called *balai'a*. Made by John Aniwa`i Laete`esafi. **CD, WG T0528**
2. A row of five fish, called *fai`a*. Made by John Aniwa`i Laete`esafi. **CD, WG T0524** (Note *i`a* is a generic term for fish in Kwaio and several other Malaitan languages.)
3. A large bird, the Sanford Eagle *langasi ba`ita*, sacred on Malaita. Made by `Ita Foolamo. There is a photo of him plaiting a comb in Ben Burt's *Malaita Ornaments* book." **CD, WG T0527**
4. A six double diamond shape, with birds' heads and is named *founikwarikwari*. This is a style from western Kwaio. Made by John Aniwa`i Laete`esafi. **CD, WG T0524**
5. The common sandpiper *sisifiu*. Made by Alasiaboo from a design by Laete`esafi. **CD, WG T0526**

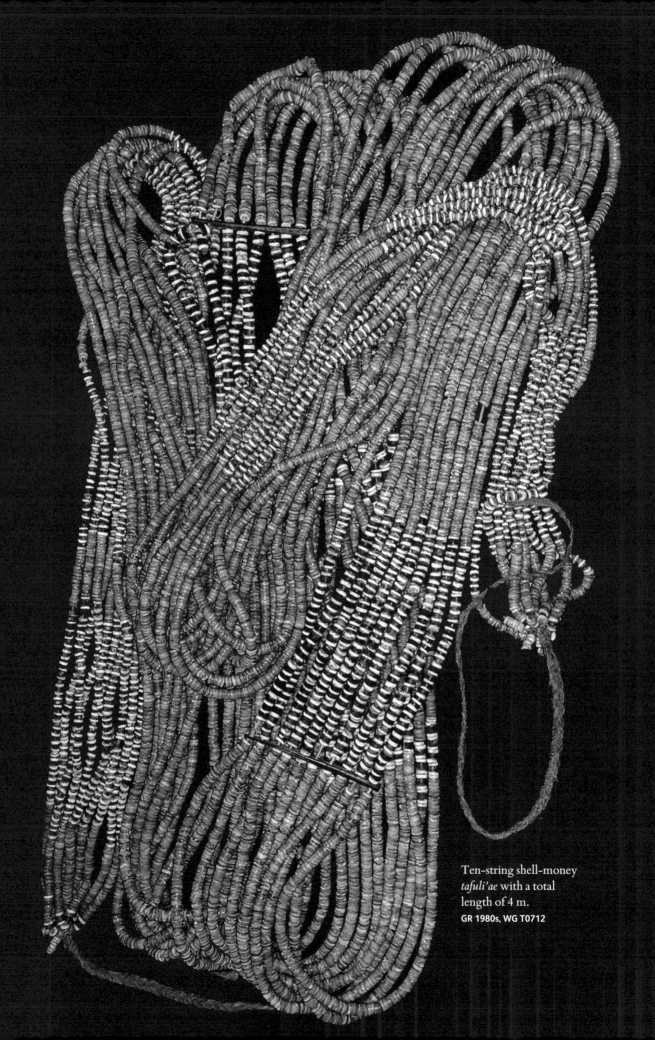

Ten-string shell-money *tafuli'ae* with a total length of 4 m.
GR 1980s, WG T0712

Solomon Islands

Multi-string shell-money

Amongst the most iconic of the shell money-bead valuables from the Langalanga people of western Malaita is undoubtedly the ten-string *tafuli'ae* – the example on the facing page is more than 4 meters long – and would be used for large-scale exchanges and brideprice.

These are great prestige items and are now often regarded as a symbol of peace, the red cloth tied at the ends representing the bloodshed they aim to prevent. It is now a traditional way to honour esteemed visitors, even though in the past *tafuli'ae* may have been given as part of payment for killings.

David Akin has a useful shorthand for explaining the fundamental difference between the concepts of gift exchanges and commodity exchanges:

In a *Commodity Exchange* the relationship serves primarily to facilitate the exchange.

Commodities ← Relationship → Commodities

In a *Gift Exchange* the exchange is primarily to facilitate the relationship.

Relationships ← Gift → Relationships

There are a multitude of similar designs and variations used in 'smaller' valuables such as necklaces, belts and other adornments, such as a ten-string *torisusu* worn across the chest, a six-string *baani'au* and a four-string *fa'afa'a*.

These smaller valuables are strictly used as currency and exchange, but they are by no means of 'low value' – for example, one could exchange a good-sized pig for a *fa'afa'a* or a *baani'au*.

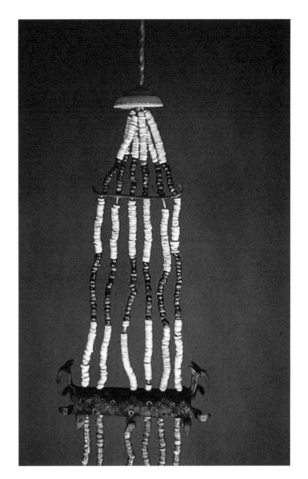

A six-string *baani'au* with complex turtle shell spacer.
Photo: DA 1985

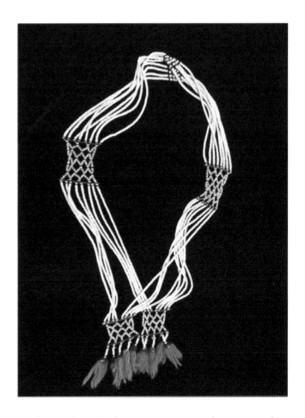

A breast-fastening ten-string *torisusu adornment* made primarily from white shell-money beads. **RD, WG T0223**

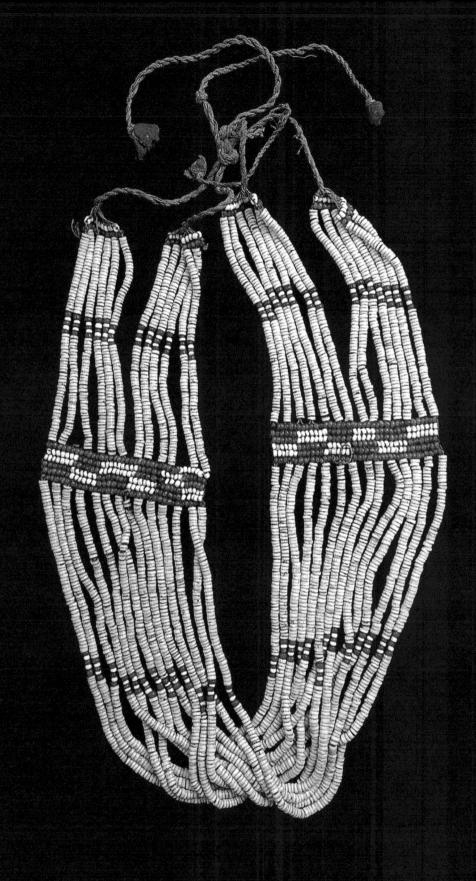

A 12-string white shell-money necklace from Malaita – length 560 mm – primarily made of very fine small beads *'afi'afi* (tiny, polished cone shell tops) and several woven segments of glass beads *kekefa*.

GR 1970s, WG T0427

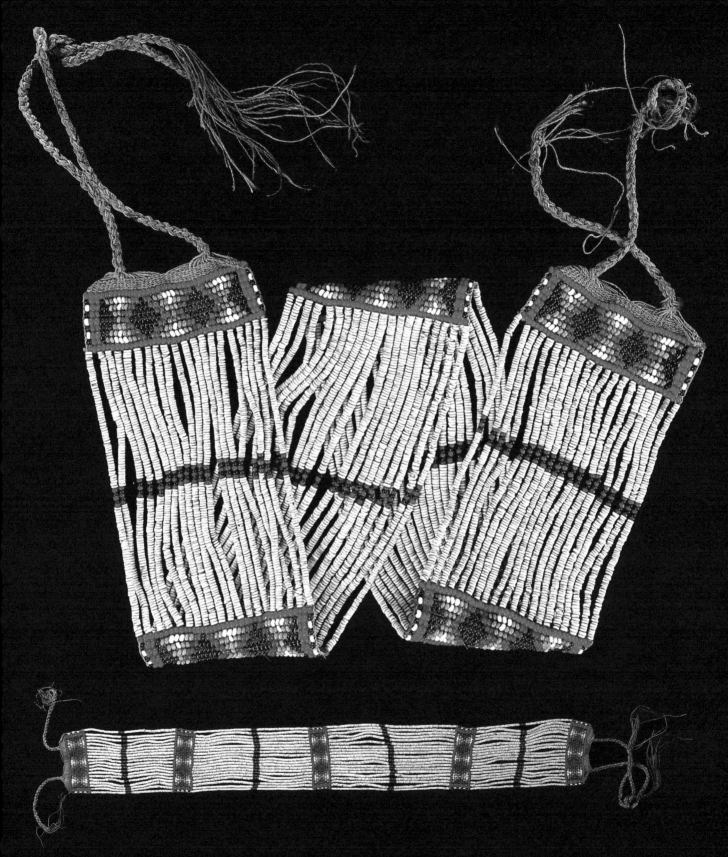

A superb 20-string waistband *fo'o'aba* from Malaita – length 720 mm – primarily
made of very fine small beads *'afi'afi* (tiny, polished cone shell tops) and several woven
segments of glass beads *kekefa*. In the examples of necklaces and belts shown on this page
spread, the turtle-shell spacers have been substituted by woven glass bead clusters.

GR 1970s, WG T0386

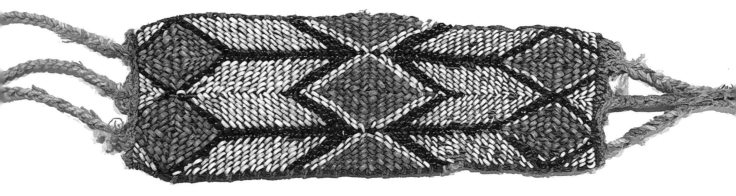

A fine *'abagwaro* arm band from the inland Kwara'ae people, Malaita. GR, WG T0363

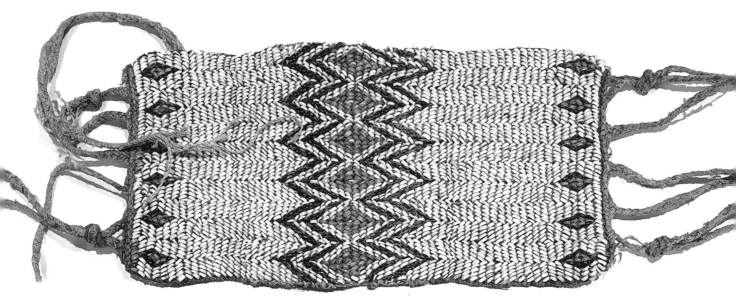

A fine *'abagwaro* arm band in the style of north Malaita. GR, WG T0364

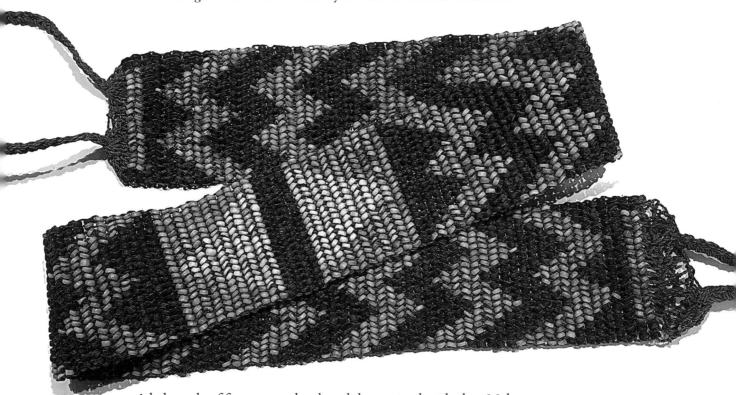

A belt made of fine money-beads and then stained with clay. Malaita. RD, WG T0220

Solomon Islands

Up-cycled money-beads

These fine and valuable shell money arm bands and a belt were made on a simple bow loom with the technique shown below so that the beads/discs lie diagonally on edge. A large variety of zig zag and lozenge designs were made, and the arm bands were usually made in pairs.

They were made from fine quality shell money beads – either old, well-used ones originally made by coastal people, or re-ground to produce thinner and more polished beads – making them significantly more valuable. The black beads are *fulu* seeds that have a natural hole in the kernel. The seeds are obtained from two different shrubs, *Gesneriaceae* that grows inland and *Cyperaceae* that grows amongst the coastal mangroves.

Fine old Malaita arm bands **GR, WG T0277**

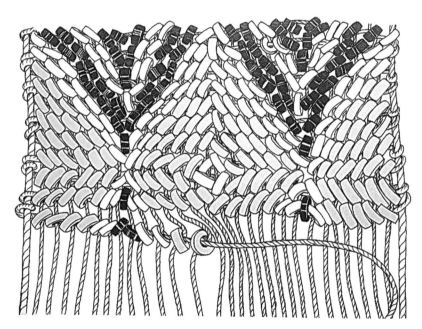

Drawing by Ben Burt

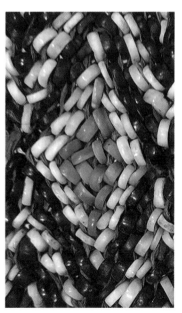

Close-up of bead structure
GR, WGT0363

215

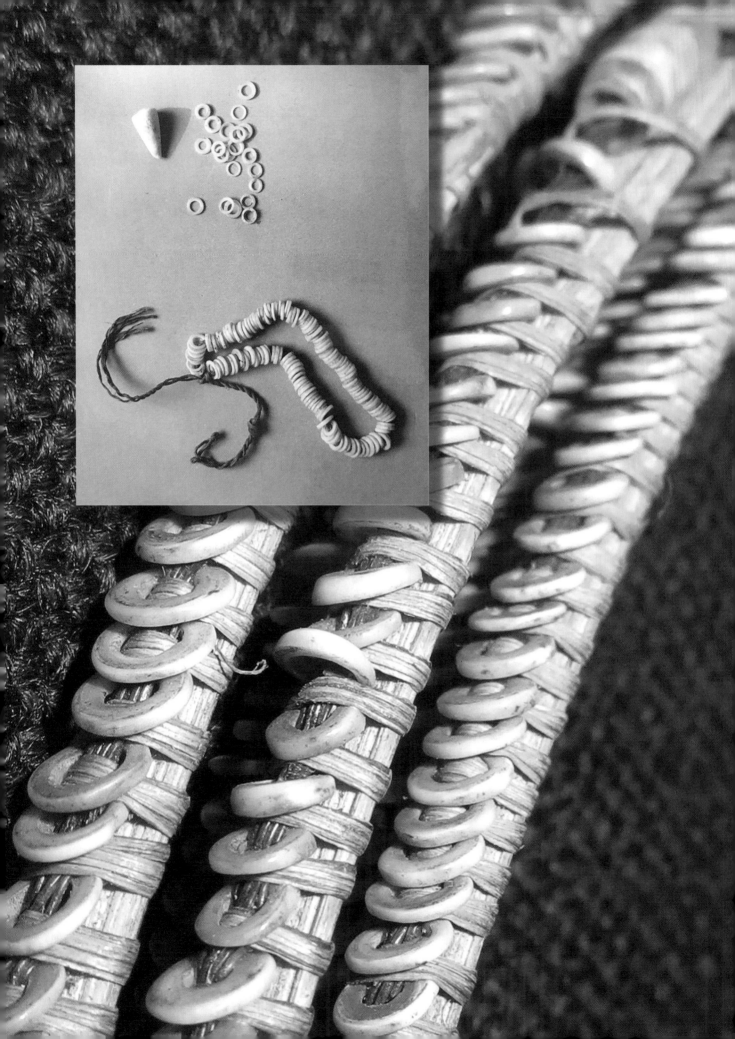

Solomon Islands

Fine currency necklaces

These valuable *barafa* currency necklaces were primarily made in Langalanga and used as ceremonial adornments worn around the neck, as currency and as part of brideprice in north Malaita but apparently never by the Kwaio or in southern parts of the island.

Tiny cone shells, *Conus emaciatus* and likely other similar species, are broken up and the tops polished to make these extremely fine *soela* rings – each just approximately 4 mm across and often less than 0.5 mm thick (or perhaps one should say 0.5 mm 'thin'). Each disc is meticulously polished to have uniform large centres. They are delicately bound in overlapping form onto a rattan vine strip using natural fibres.

Kurt Koschatzky, writing in *Der Primitivgeldsammler* in 1991, recounts a personal visit to Langalanga on Malaita where he was shown examples of loose *soela* rings and the cone shells they were cut from – see his photo top left on facing page.

The *soela* rings were also used in superb ear adornments that are discussed later in this chapter.

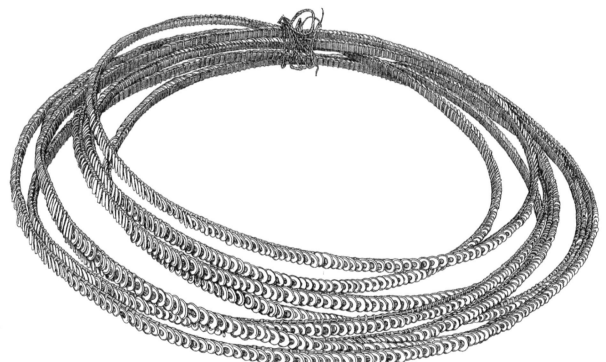

Drawing of *barafa* by Ben Burt.

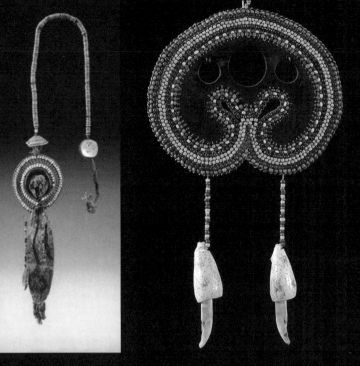

Far left: A *mis* currency string with an elaborate terminal attachment made of glass beads, seeds, shells, a dog's tooth, natural fibres and a large cocoon of the bagworm moth (Psychidae). RA, AM

Left: Detail of an elaborate terminal attachment of a *mis* currency string. This one is made of glass beads strung on a turtle shell centre, with cone shell and dog teeth dangles.

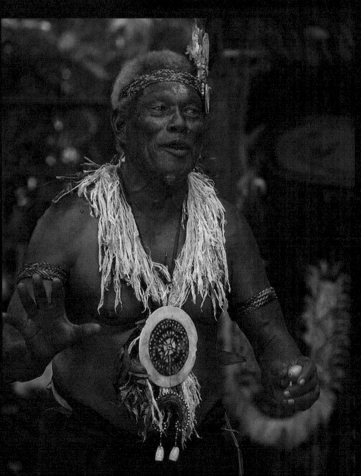

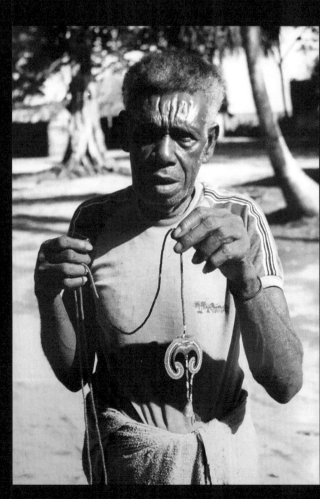

A Malagan chief wearing a *kapkap* chest adornment and a *mis* string with turtle shell terminal beneath; and a Lihir Island man displaying a similarly adorned *mis* currency string. Photos: New Ireland Tourism and L. van Bussel, *Primitivgeldsammler* 1988

New Ireland

Mis currency-strings

Orange-mouthed Top Shells *Chrysostoma paradoxum* are gathered in the Tigak Islands west of Kavieng, the capital of New Ireland, and on some remote islands, such as Lihir, situated north-west of Tanga. They are used in and around the islands to make shell–money beads.

The shells are crushed, drilled and then strung on a strong cane strip for polishing with coral and stone – see images bottom right. The finished beads are placed in a fire to darken the colour.

When complete, the beads are strung together to make a string called *mis*, which is used as currency and brideprice. The *mis* strings are sometimes further adorned with elaborate symbolic terminals and worn as prestige objects, such as the strings shown on the facing page. These have a powerful ceremonial and symbolic status.

The New Ireland process of making *mis* beads is similar to that used to make the Solomon Islands 'Type 1' shell-money, which was discussed earlier.

Photo: GP

Polishing money-shell beads on Lihir Island.

Photos by L. van Bussel from Primitivgeldsammler in 1988

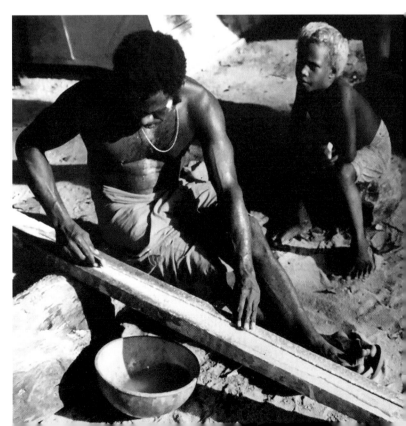

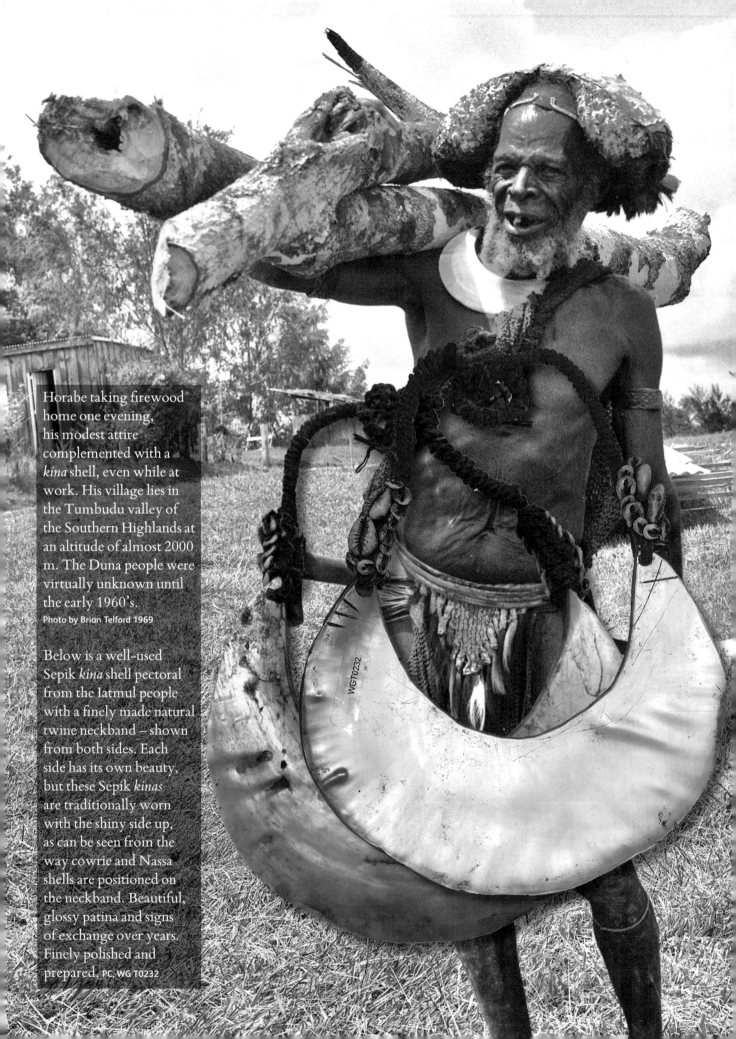

Horabe taking firewood home one evening, his modest attire complemented with a *kina* shell, even while at work. His village lies in the Tumbudu valley of the Southern Highlands at an altitude of almost 2000 m. The Duna people were virtually unknown until the early 1960's.
Photo by Brian Telford 1969

Below is a well-used Sepik *kina* shell pectoral from the Iatmul people with a finely made natural twine neckband – shown from both sides. Each side has its own beauty, but these Sepik *kinas* are traditionally worn with the shiny side up, as can be seen from the way cowrie and Nassa shells are positioned on the neckband. Beautiful, glossy patina and signs of exchange over years. Finely polished and prepared. PC WG T0232

The ubiquitous *kina* pectorals of New Guinea

It's easy to regard the bright crescent-shaped *kina* shells primarily as adornments, but they have also been important currency and exchange items in New Guinea for several hundred years. Gold-lipped pearl shells, *Pinctada maxima*, were widely traded amongst the South Seas islands and then inland from the coast on treacherous journeys along the Markham and Ramu Rivers in the north, up into the remote Highlands of New Guinea. Here they were exchanged for locally-quarried stone axe blades – initially one polished stone blade could be exchanged for one *kina* shell. The inland people had no concept of the sea, but they prized the bright, glowing shells and kinas took on spectacular value and popularity amongst the local tribes.

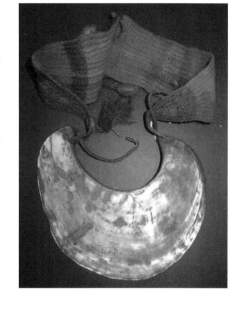

The natural pearl shells are usually encrusted with marine growths. To be 'fit for purpose' they were scraped clean, and the outside was then polished to a high gloss. The hinge part of the shell had to be cut to make the desired crescent-shape. Some were left quite broad, while others were cut more delicately, as a waning or waxing moon. In the New Guinea Highlands, many *kinas* were stained with red ochre to enhance their brilliance. In the southern Highlands many were additionally adorned with abstract lines and dots – making some *kinas* appear like a galaxy of red stars in a golden sky. Yet others had shell pieces attached with resin.

In the Sepik River area, the inner, silver side was worn facing outwards, and the fibre ties decorated with cowrie and Nassa shells as shown in the example opposite.

The kina *is a good example of an adornment and currency that was worn for work and ceremony, crossing cultural boundaries and ethnic groups. It ended up becoming the name of the modern currency of Papua New Guinea.*

A highly adorned elder of the Chimbu people (occasionally spelled Simbu) in the eastern Highlands of New Guinea. *Photo from a 1930s commercial postcard.*

Below that is a well-worn and cracked *kin*a pectoral from the same area, decorated with dots. Early explorers commented that many *kina* shell pectorals they saw in these early days were broken and carefully repaired. PC, WG T0622

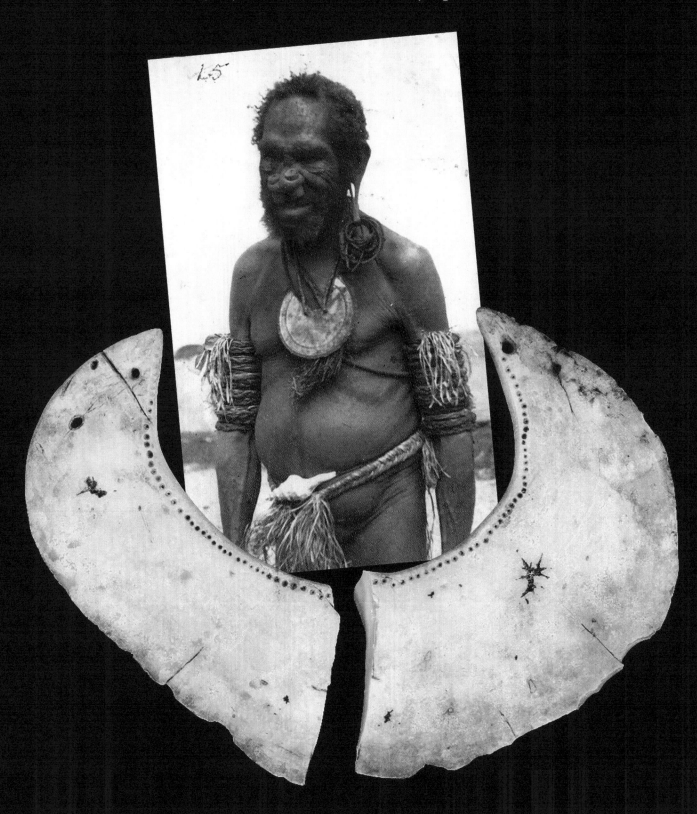

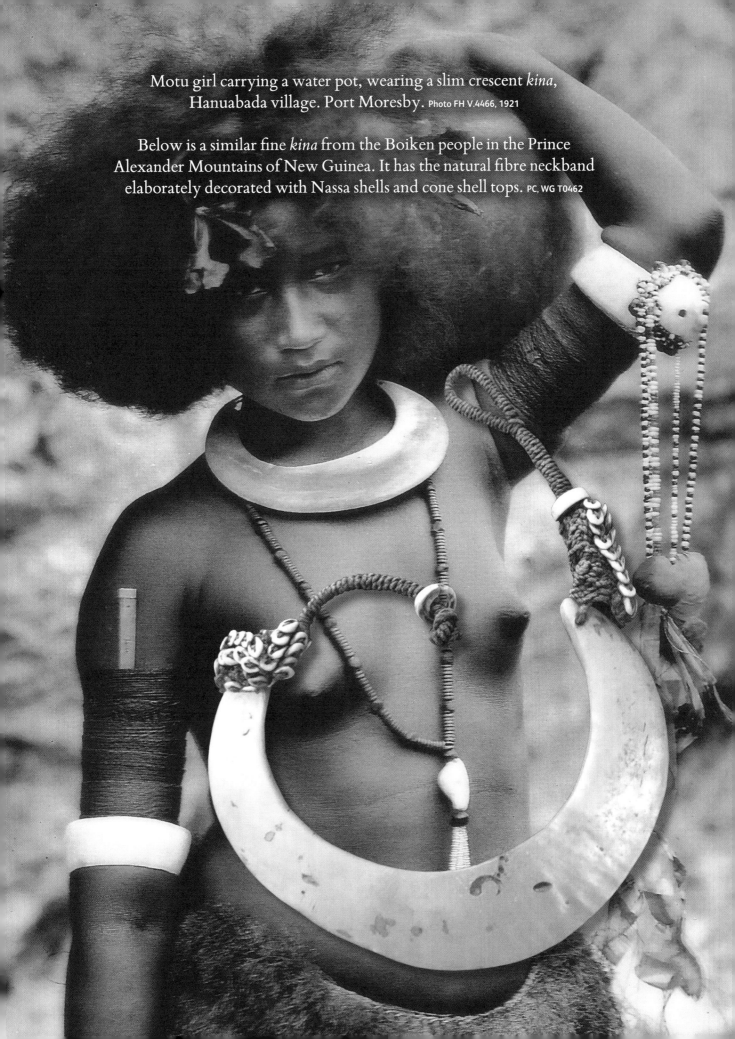

Motu girl carrying a water pot, wearing a slim crescent *kina*,
Hanuabada village. Port Moresby. Photo FH V.4466, 1921

Below is a similar fine *kina* from the Boiken people in the Prince
Alexander Mountains of New Guinea. It has the natural fibre neckband
elaborately decorated with Nassa shells and cone shell tops. PC, WG T0462

TB, WG T0697

WG T0696

TB, WG T0694

Kina wallets and bands

Protection, mobility and display

Decorative bark wallets were used to store the precious *kina* pectorals until dramatically revealed at the appropriate time in a ceremony. The *kina* shells were first wrapped in a generous padding of leaves and plant detritus and then placed into the bark container – often with parts of the *kina* protruding. It is rare to find this original padding with a bark container. Below left is one such example that shows the great care taken to protect these precious objects – a fascinating slice of cultural history.

The top two wallets shown opposite were collected in the 1950s and subsequently sold in the Paulian Lay Missionaries' long-gone *New Guinea Arts* co-operative in Sydney. They were hand-sewn from *Pandanus* bark and stained or painted with whatever was available – either natural pigments or trading store paint. Typically, the wallets were smaller than the *kina* shell itself, and at least two, often four wallets were used on a single shell, regularly packed also with soft fern, then tied together with copious amounts of string. The designs seem to vary enormously according to the maker's own preference. The zigzag designs are the most common; occasionally an abstract human figure is used.

On the New Guinea Highlands, elaborate woven bands are used to suspend the *kina* pectorals around the neck, and are in themselves objects of great beauty, made with enormous skill and variety. RP, GR, WG T0442 (right) and DE, UK, WG T0236 (below)

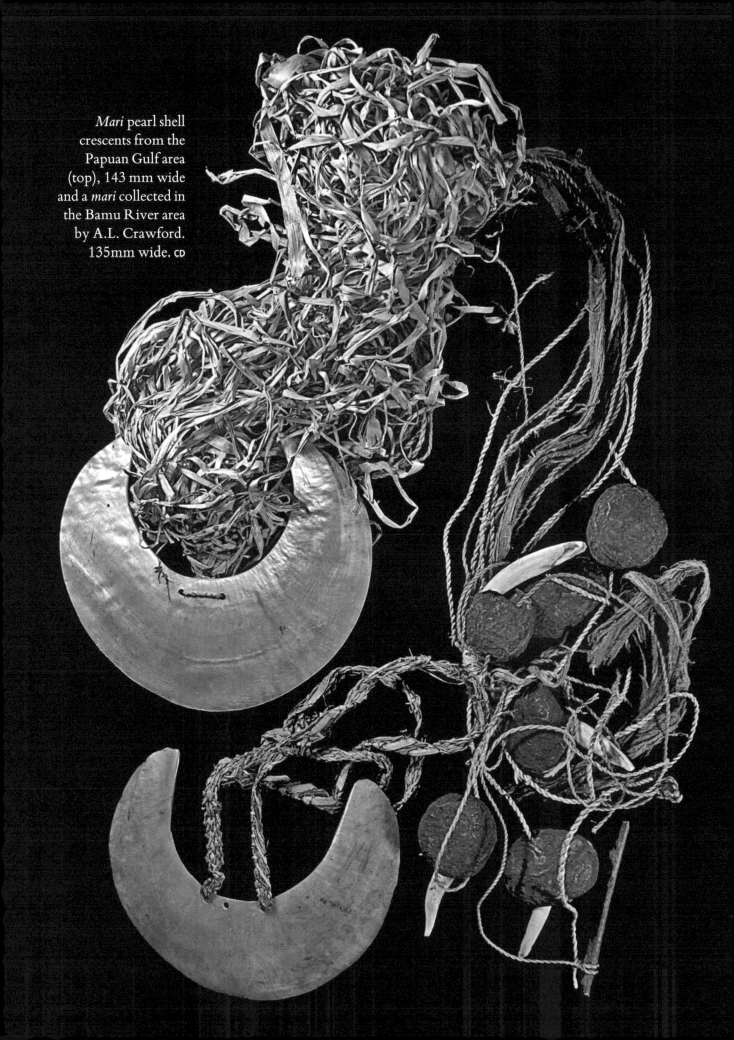

Mari pearl shell crescents from the Papuan Gulf area (top), 143 mm wide and a *mari* collected in the Bamu River area by A.L. Crawford. 135mm wide. CD

The *mari* of the Papuan Gulf and Torres Strait

Crescent-shaped chest ornaments made of pearl shell were in common use as adornments and trade items throughout the Papuan Gulf area and the Torres Strait islands.

The Torres Strait islanders called theirs *mari* or *mai* (literally meaning 'pearl shell') and they were also called *danga mai* or *danga mari* which means 'pearl-shell tooth'. From this it appears that the shells were originally seen as representing valuable boar tusks, or perhaps two tusks fastened together at their bases.

What makes a *mari* from the Torres Strait area different from a *kina* of Highlands New Guinea, is that the attachment holes are in the centre rather than at each end. As shown in the image opposite, the *maris* are often adorned with natural fibres, leaves and bark string (mixed with more modern string). They have also added bell-shaped *toca* seed pods (harvested from the *Pangium edule* tree in mangrove swamps), each with the tip of a pig tusk inserted in them, just like the clapper of a bell.

Locals believed *mari* to be worn by mythical heroes. Remains of similar pearl shell adornments have been found in archaeological digs on Pulu Islet, off Mabuyag Island in the centre of the Torres Strait, dating back more than 550 years, and clay pottery that dates back between 1,500 and 2,500 years.

Right: A *mari* pearl shell crescent from the Torres Strait, likely from the *Chevert* expedition in 1875, on which the top edge of the shell is delicately engraved and displays the traditional central attachment holes. MM A1975

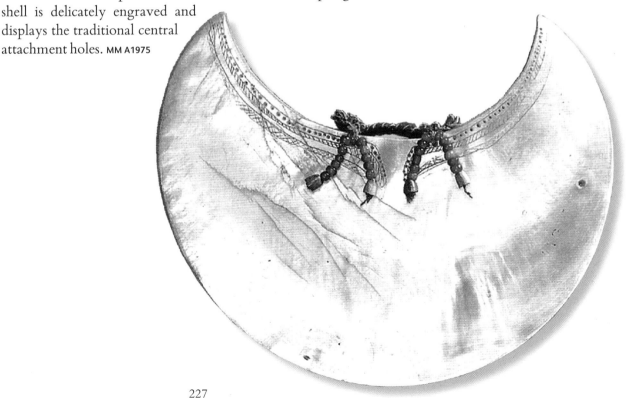

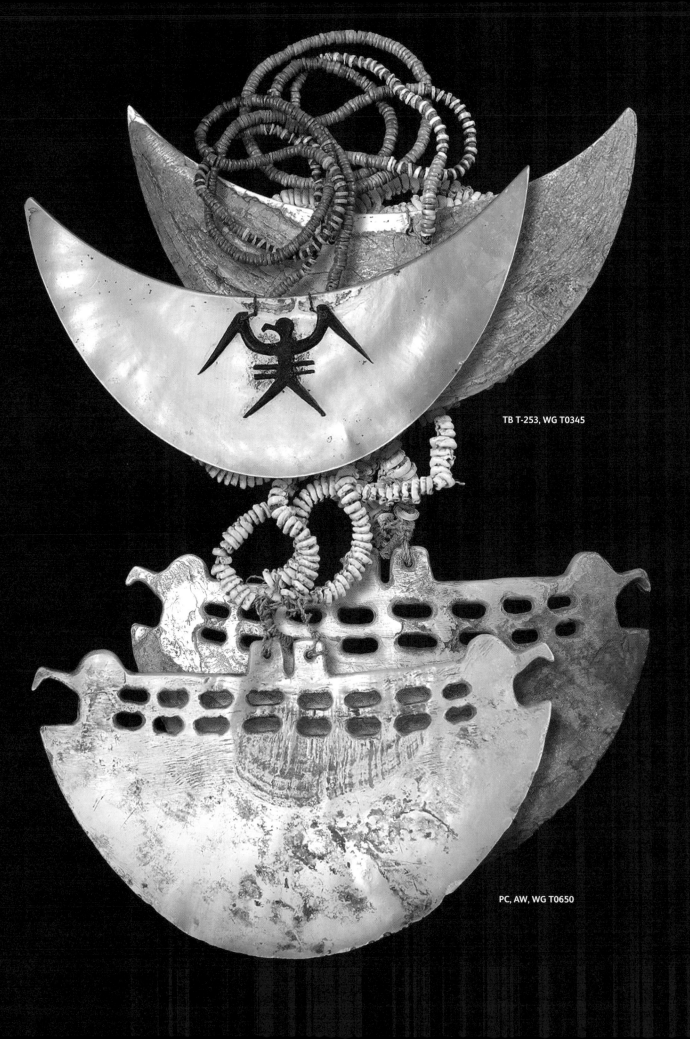

TB T-253, WG T0345

PC, AW, WG T0650

The *dafi* of the Solomon Islands

In the Solomon Islands, pearl shell was mostly used for *dafi* crescents – suspended from central attachment holes – highly valued adornments that were worn around the neck, primarily by men. Although traditionally made on Malaita, *dafi* were traded widely and used on other islands. The designs are highly varied and often include stylised frigate birds cut from turtle shell, such as the example at top left. One aspect that differentiates the Solomon Islands *dafi* from New Guinea *kina* shell pectorals is that *dafi* are often polished only on one side, with heavy shell material remaining on the back, as is shown on the two examples on the facing page – both shown front and back. Many include abstract representations of frigate birds which follow schools of bonito, helping fishermen sight the fish. They are important symbols of good fortune and help avert the influence of evil spirits.

Facing page – top: This superb *dafi* from Malaita includes a carved turtle-shell frigate bird and has a necklace of miscellaneous shell-money beads – including white, black and red *Spondylus* shell beads. Late 19th, early 20th century. Size 170 mm.

Facing page – bottom: This *dafi* is made from an unusually thick and heavy pearl shell and originates from the western Solomon Islands. It has typical frigate icons carved on the tips of the crescent. The double strand necklace is made of cut-down Nassa shells, likely traded from New Guinea. Size 155 mm.

Below right: With the increasing availability of pearl shells in the 20th century, designs evolved rapidly and were subject to many outside influences – as shown in this example collected on Rendova Island in the Western Province in the 1970s. The attachment holes (unusually not positioned centrally) and the spiral designs have been drilled right through the pearl shell. Size 150 mm. SK, CD TMA Journal 1994 Vol 13 No 1, WG T0535

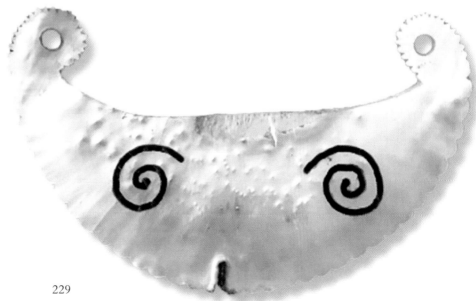

The small disc at the centre of the large ring is also enlarged for detail at the top of the page. It is just 30 mm across and weighs just a few grams. The giant *wenga* ring is 380 mm across and weighs 4 kg.
They are both cut from fossil *Tridacna gigas* giant clam shell.

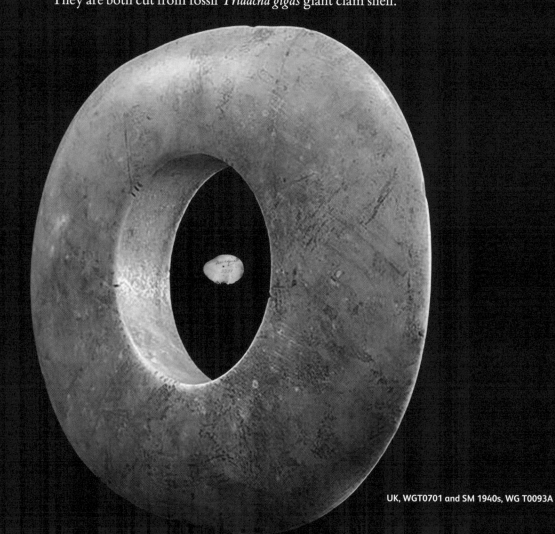

A PLETHORA OF RINGS

Because of its unique symmetry, a 'ring' or a 'circle' is often considered to be the perfect shape. A ring worn on a finger is a ubiquitous symbol of authority, a token of marriage, engagement or just pure adornment. Not surprising then that the circle or ring is a shape that is ubiquitous in South Seas adornment and exchange valuables.

Without metal tools, objects of this shape were also amongst the simplest to make. With a section of bamboo, sand, water and a lot of patience, a circle could be cut from the hardest shell material. With a simple bow drill holes could be cut and constantly enlarged with bamboo strips.

The two objects shown opposite (the smaller one also shown enlarged to reveal the detail) are both cut from fossil giant clam shell and are essentially the same constructs, just at a different scale, each with their own special purpose, beauty, and value.

One is a modest token of exchange for a Solomon Islands islander, the other represents immense value, purchasing power or the ability to settle a large debt for a chief in the East Sepik Province of Papua New Guinea.

In this section we will look at the immense diversity of rings that appear in the South Sea cultures, and how the most common ones were made and used.

- Northern New Guinea – the clam shell rings from the Sepik and surrounds.
- Bismarck Archipelago – especially the islands of Tanga and Nissan
- Solomon Islands – focused on the prolific rings of the New Georgia Group

The circle is a shape consisting of all points in a plane that are a given distance from a given point, the centre.

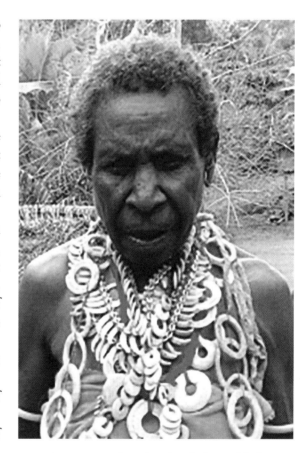

A Boiken woman adorned with a plethora of shell rings demonstrating status and prestige.

Photo: Didier Zanette from the book Tridacna gigas

Top left: Two partly-finished clam shell rings. These were cut out with bamboo, quartz sand and water, and evidence of this method of shaping can still be seen from the marks left on the surface and edges. Collected by Ron Perry in Koboibus Village, East Sepik Province, PNG, between 1964 and 1973. RP, GR, WGT0514

Top right: The discarded core of a drilled clam shell ring. Simbo Island. Solomon Islands. PR 1900.55.545

Right: Drawing of a partially completed ring fixed within a cleft stick for sawing with a strip of fibre.

Below: A variety of irregularly-shaped *yua* clam shell rings attached to a woven natural fibre string necklace. East Sepik River area. PNG. CH, WGT0280

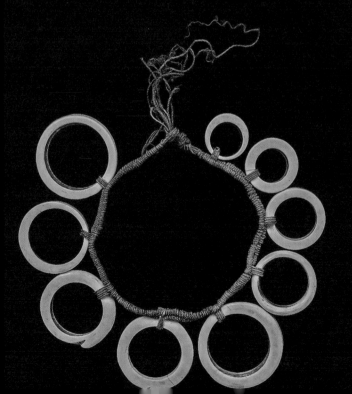

Making rings out of clam shell

Fresh, fossil and sub-fossil giant clam shells (typically *Tridacna* sp.) have been used as raw materials for carving precious objects for thousands of years.

The aragonitic material of fresh giant clam shells is extremely hard, brittle and difficult to carve. For that reason, craftsmen have preferred fossil and sub-fossil giant clam shells found in land-based deposits on many Pacific Islands.

René Gardi commented in his 1956 book *Tambaran*: "The priest told us that when he travelled (from the mountains) to Wewak once a year, he always brought back from the coast a few giant shells, to the great delight of his neighbours, whom he was saving a ten-day journey."

The large shells would be roughly knocked into shape and firmly wedged between posts rammed into the ground. The sawing would be done with strands of toughened bamboo shoots – with large bundles used up for every cut. A mixture of fine quartz sand and water would be dripped into the cut to work as abrasives. They would likely work for about a month to complete the cutting of one large shell, and another month to cut the shell into slices, before the drilling of the central hole could begin, using bamboo sections about 100 mm across. A long arduous task with constant replenishment of water and sand, and regular replacement of the bamboo 'drill'. Only then could the detailed polishing work to fashion an individual ring begin.

There were significant differences in overall styles: while the carvers of the wider Sepik region preferred vaguely rounded shapes for their *yua* and *wenga* rings, the Solomon Islands carvers preferred regular round shapes – consistently across rings of all sizes.

By the end of 19th century, steel tools came to be used and according to many reports, large rings ceased to be made during the 1920s.

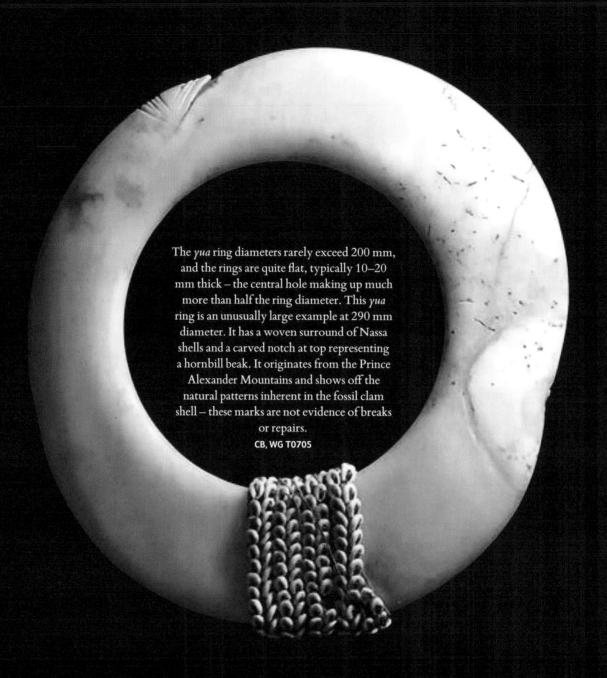

The *yua* ring diameters rarely exceed 200 mm, and the rings are quite flat, typically 10–20 mm thick – the central hole making up much more than half the ring diameter. This *yua* ring is an unusually large example at 290 mm diameter. It has a woven surround of Nassa shells and a carved notch at top representing a hornbill beak. It originates from the Prince Alexander Mountains and shows off the natural patterns inherent in the fossil clam shell – these marks are not evidence of breaks or repairs.

CB, WG T0705

Yua rings would be used during male initiation, the dedication of men's ceremonial houses, brideprice negotiations and other occasions, as symbols of the strength and wealth of the community.

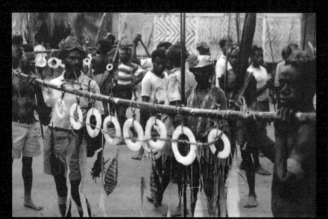
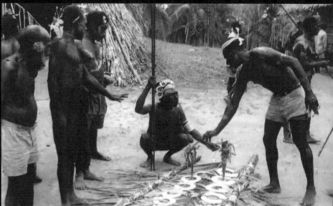

Yua rings being used during a male initiation. Ilahita village, East Sepik. 1971. Photos: Bryant Allen

Yua and *Wenga* rings of New Guinea

These roughly circular rings were used extensively amongst the Boiken and Abelam people of the Prince Alexander Ranges, north of the Sepik River. They were popular exchange and trade items through much of the Sepik and Ramu River regions. The typical names used are *yua* (for the smaller rings) and *wenga* (for the large rings). These rings were mostly made from fossil *Tridacna* giant clam shell, but some reports indicate that fresh shell material was also used, even if it was more difficult to work

Yua Rings

Yua rings were displayed and exchanged as part of most major rituals and rites of passage – and have significant spiritual significance. The Metropolitan Museum of Art in New York relates their purpose eloquently: "At birth, a *yua* ring would be presented to a maternal uncle, who later would help guide him through the complex male initiation cycle. At marriage, the groom might present a *yua* to the bride's parents, the number he was able to give becoming a lifelong source of pride. At death, gifts of *yua* to relatives would help ease the passage of the spirit to the afterlife. Shell rings also play an integral role in ceremonial life."

Yua rings often have characteristic notches and shapes carved into them that represent a hornbill's beak or a shark's profile – as symbols of virility, aggression and power). The latter styles are known to have been made to imitate valuable full-circle pig tusks.

The yua *rings are so important that a man, wishing to emphasise another man's status and his affection for him, will address him as* wuna yua *(my ring).*

Yua ring with carved notches said to represent a hornbill's beak. **RP, GR, WG T0450**

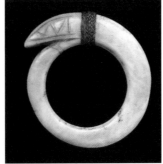

A *yua* ring with a shark profile and a woven natural fibre band. Astrolabe Bay, southeast of the coastal Sepik-Ramu area. Others believe that these forms are not meant to be sharks, but carved imitations of even more valuable full-circle pig teeth. **RP, GR, WG T0446**

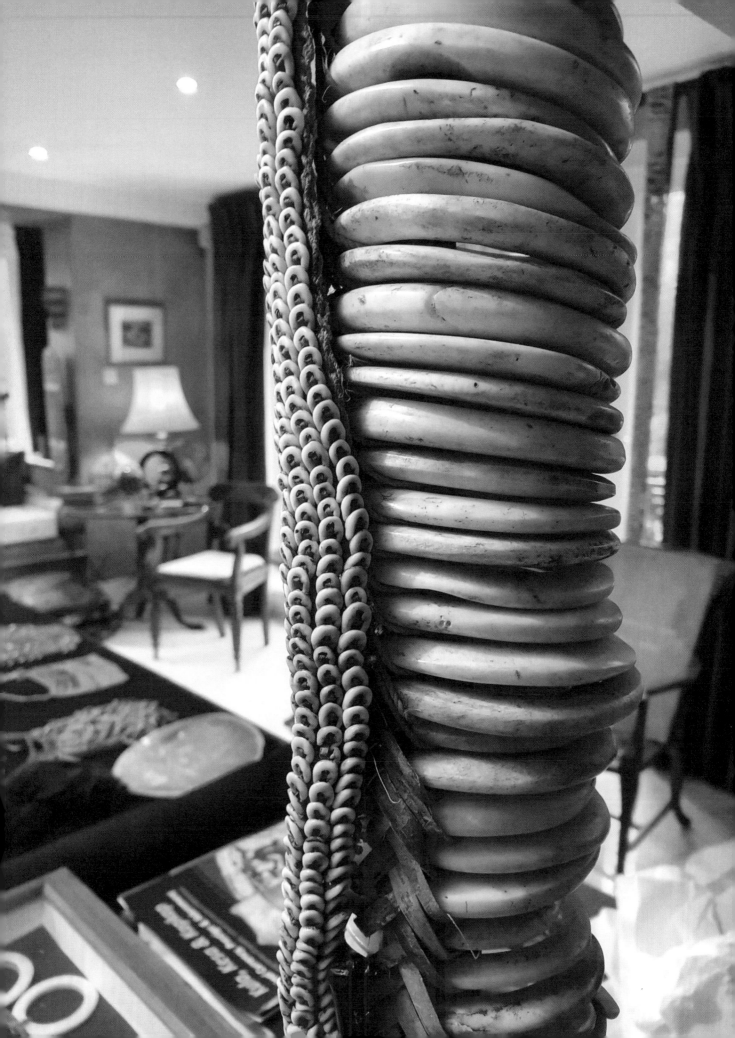

Yua sticks of the Lumi

In the Torricelli mountains, the Lumi people have a custom of threading many *yua* clam shell rings to a stick of black palm wood. According to Michael Hamson writing in *The Art of West Sepik*, the resulting *yua* ring-stick is called *mangou*, *tabe* or *aifungu*.

On the *yua* stick in these images, the diameter of the fossil rings varies from 30 to 100 mm, the widest rings being arranged in the centre, forming a biconical structure. The total length is 1055 mm, incorporating a superb stack of 106 clam shell rings. It also retains its original carrying strap made of sennit coconut fibre, expansively adorned with Nassa shells, likely traded from the Gazelle Peninsula in New Britain. MH, WG T0700

The number and quality of the rings attached constitutes the value of the object. The *yua* sticks were carefully stored in protective boxes and wrapped in cloth.

There is a wonderful photo of multiple *yua* sticks being used in a healing ceremony in William Mitchell's 1978 book *The Bamboo Fire*, one the few books written about this culture (photo below).

Recently-constructed sticks come onto the market from time to time and they are typically made with cheaper shell materials such as *Trochus* and *Conus* rings intermixed with vertebrae and other decorative materials.

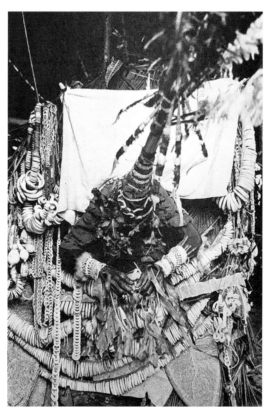

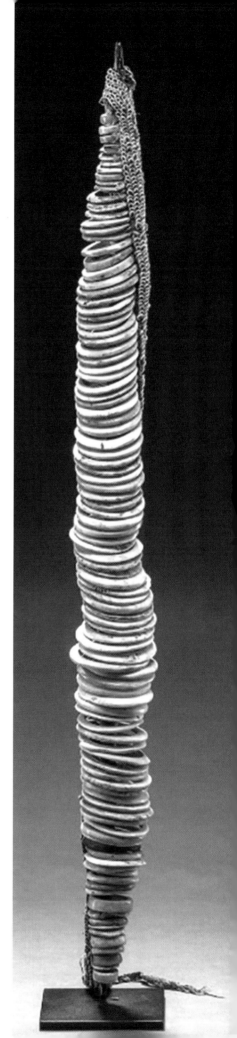

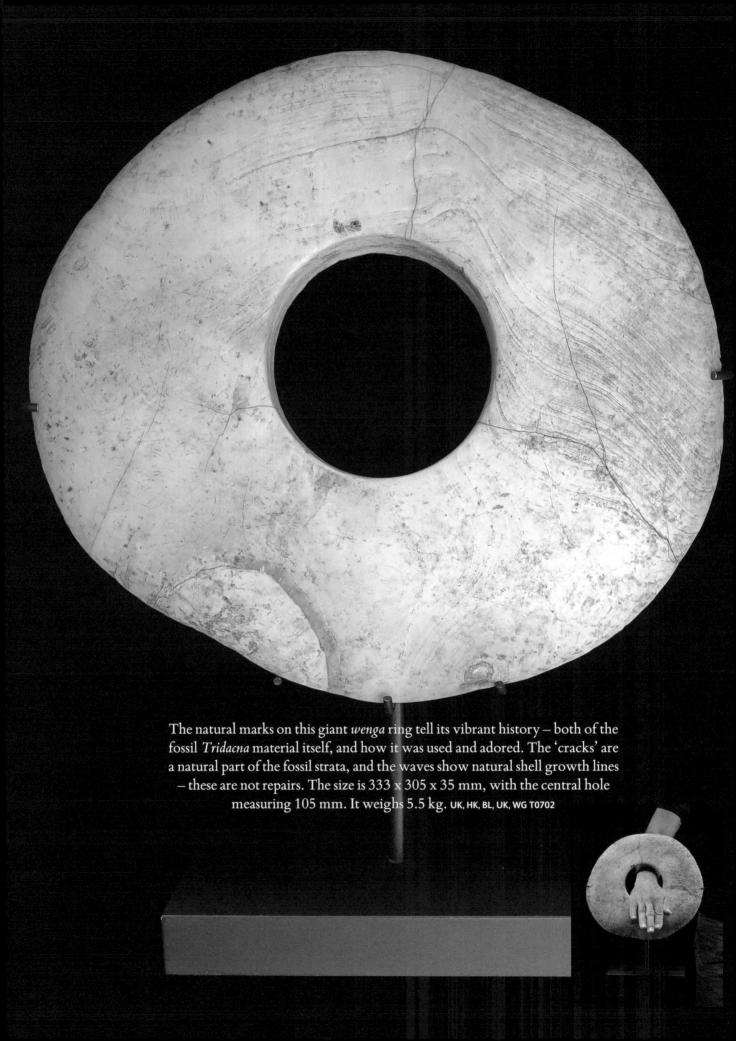

The natural marks on this giant *wenga* ring tell its vibrant history – both of the fossil *Tridacna* material itself, and how it was used and adored. The 'cracks' are a natural part of the fossil strata, and the waves show natural shell growth lines – these are not repairs. The size is 333 x 305 x 35 mm, with the central hole measuring 105 mm. It weighs 5.5 kg. UK, HK, BL, UK, WG T0702

Wenga Rings of the Boiken people

The *wenga* rings are the largest of the *yua*-style rings, and some of these are real giants. It becomes difficult to imagine how such large objects can be carved from the shell of a clam.

Although some rings are apocryphally said to have been "from seven to fifteen kilos in weight", such dimensions have never been verified in any collection. The largest *wenga* I can personally vouch for is 370 x 340 mm, 50 mm thick, has a central hole of about 100 mm – and it weighs in at 7.8 kg. The *wenga* rings illustrated here are amongst the largest and heaviest.

These rings can be quite brittle and require extreme precautions when being transported. To improve handling, some rings have a rope wound around the top and are wrapped carefully to avoid damage. Flat indents may be carved in the shell at the point where these suspension ropes are attached. The ring at right weighs in at 5.7 kg and has dimensions of 315 x 270 x 45 mm. Although these *wenga* rings are large and heavy, they are generally not as thick as the largest Solomon Islands rings.

Wenga rings are said to date mainly from the early 19th century to the 1950s and many have been cared for and handed down from generation to generation. They are carefully stored in boxes, protected by several layers of linen, away from prying eyes. Some old wenga have slight ochre coloration. It is said that, in pre-contact times, when warfare was more common, valuable *wenga* were buried for safety from enemy raids.

For the clans of northern New Guinea, these giant clam shell rings are their most valuable assets and venerated because of their rarity. The Australian ethnologist Bryant Allen, who worked in the Dreikikir region (East Sepik between the Arapesh and the Lumi) in the 1970s, reports that there a 'cargo cult' destroyed most of these giant rings in the 1950s.

EL 1990, WG T0494

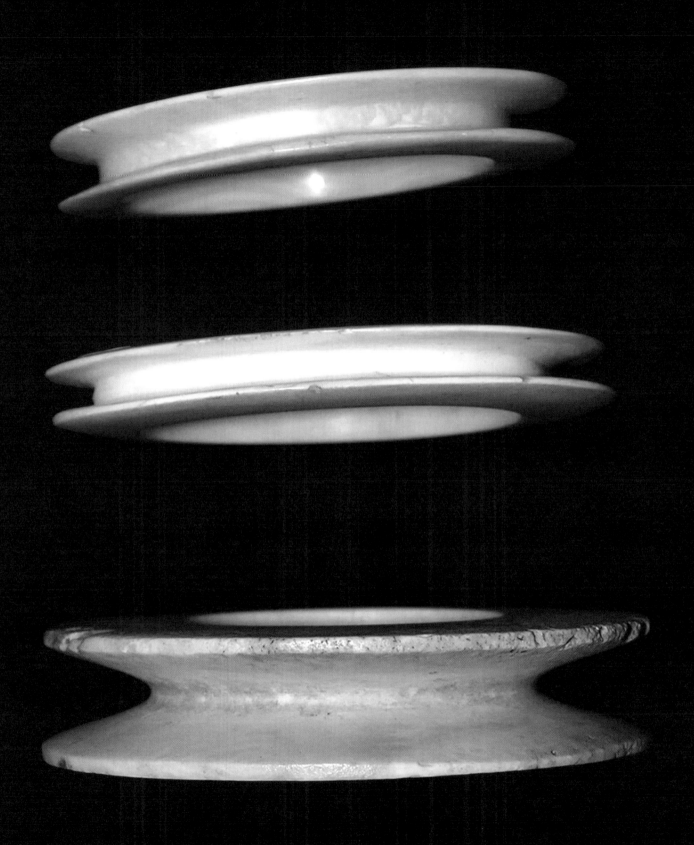

Three Sulka spool rings collected by Todd Barlin. Diameter 120–105 mm. TB T-330

Spool rings of the Sulka people

The Sulka people who live in eastern New Britain consciously sought to achieve magnificence and visual impact with their adornments. They wore enormous, vividly coloured headdresses and dance paraphernalia – much of these used only once.

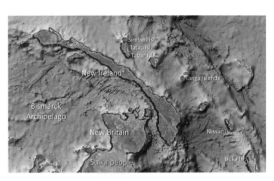

They were also renowned for their unique spool-shaped rings, called *tintol*, that are both currency and wealth items. The *tintol* spool rings were rarely worn except on special occasions but were primarily important exchange items and used for brideprice. They have been found widely traded around the islands of the Bismarck Archipelago and the New Guinea mainland.

These distinctive objects were made the traditional way of using bamboo, sand and water to cut and shape the fossil clam shell fragments – literally months of hard work for each ring. None seem to have been made from the 20th century onwards – all known examples are believed to be from the 19th century.

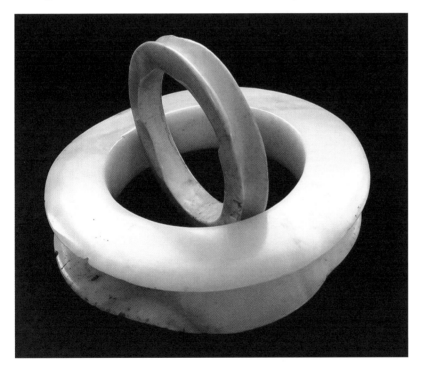

Two Sulka spool rings.
127 x 25 mm and 80 x 11 mm.
TB, WG T0242 and TB, WG T0512

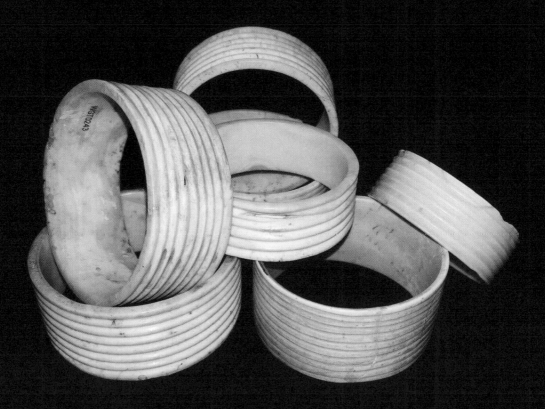

The characteristic Tanga/Nissan rings with distinguishing parallel grooves are called *amfat mil* and are the most valuable wealth items on the islands. **WG from various old collections**

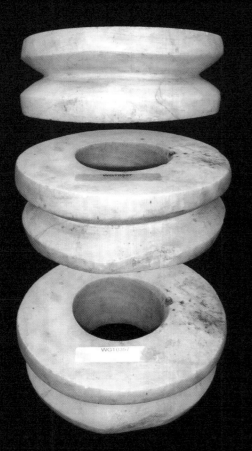

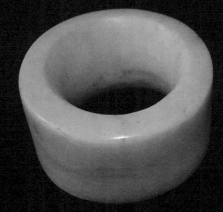

A large and extremely heavy ring known as *kuamanu*. Perfectly polished and many years of handling have given it a patina not unlike old ivory. It was an important wealth and currency item also used on neighbouring Buka Island, part of Bougainville. Size 100 x 56 mm and weighs almost 1 kg. **GR, WG T0245**

Left: This heavy ring with a groove around the circumference with a V-shaped cross-section, shown in three perspectives, was another important currency. "This type of ring would be regarded as occupying the deepest (most important) part of a money basket", says researcher Eric Lancrenon. An inscription on the inside of ring says 'Tanga Island'. Size 135 x 42 mm and weighs 1250 g. **PC CM19, GR, WG T0357**

The rings of Tanga and Nissan Islands

To the east of New Ireland, Papua New Guinea, lie the Green Islands that include Tanga and Nissan. Situated north of Bougainville, they are culturally closely related to the Western Solomon Islands. Bougainville was itself previously part of the Solomon Islands until it was incorporated into Papua New Guinea in 1975.

Tanga and Nissan are considered to have been a centre of the shell carving industry until the early 20th century and some of the finest and most valuable clam shell rings come from these islands. The rings were traded widely across the Bismarck Archipelago and down to the Solomon Islands.

The general term for clam shell ring appears to have been *amfat*, and *amfat mil* was used for rings with these distinguishing parallel grooves – known to be the most valuable wealth items, currency and could be worn as adornments. The rings are extremely thin (less than 5 mm is usual) and the depth and width of the grooves vary enormously. There clearly was no 'standard' design for craftsmen to follow but making the multi-grooved rings would clearly have required special skills.

Other heavier rings were also made in these islands but drilling of rings using large bamboo sections, as has already been described for the *yua* and *wenga* rings, was apparently unknown here. Their process involved shaping the central hole in rough clam shell with corals and rocks, slowly developing it from both sides until a hole is broken through. Then the polishing with sand and water would begin. Such heavy rings are quite rare from the Tanga and Nissan islands and seldom seen.

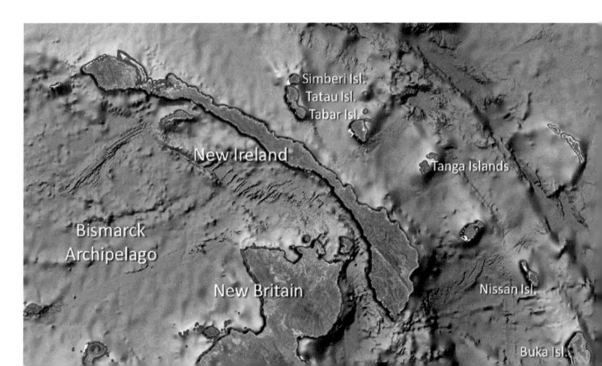

CH, WG T0284

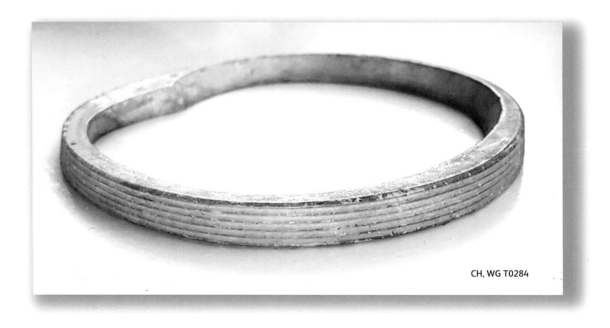

CH, WG T0284

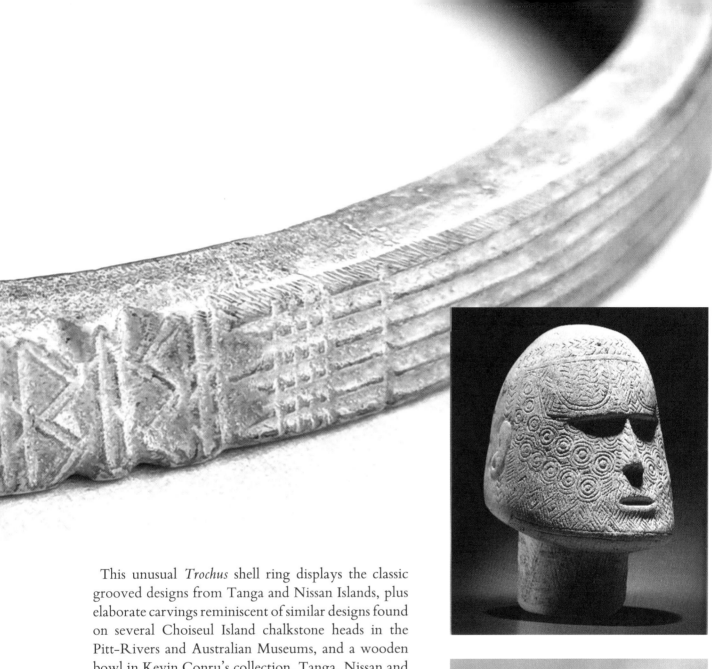

This unusual *Trochus* shell ring displays the classic grooved designs from Tanga and Nissan Islands, plus elaborate carvings reminiscent of similar designs found on several Choiseul Island chalkstone heads in the Pitt-Rivers and Australian Museums, and a wooden bowl in Kevin Conru's collection. Tanga, Nissan and Choiseul Island are within easy sailing distance and this rare and iconic object may be a classic example of stylistic diffusion between them.

This *Trochus* ring first arrived in Europe via the famous collection at Charterhouse School's purpose-built museum founded in 1874. For over a century, Old Carthusians and friends of the School donated artefacts from all over the world. Some of the most valuable artefacts, including this one, were sold in 2002 to pay for building refurbishments.

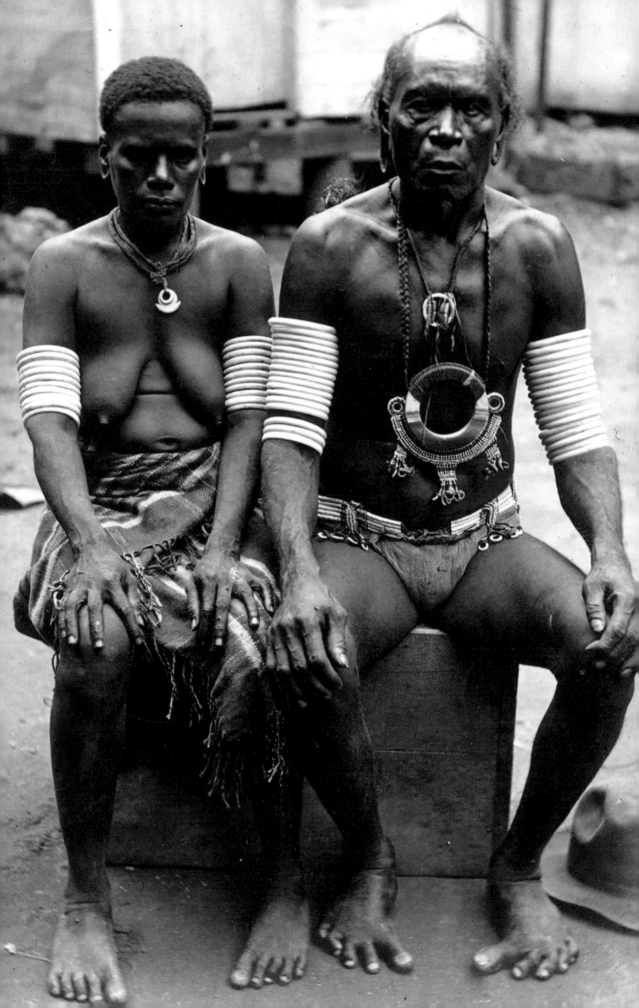

Solomon Islands Rings

By comparison to the somewhat irregularly-shaped rings from New Guinea, the Solomon Islands rings are a delight of Euclidian geometry.

Their makers, primarily on New Georgia, Malaita, Choiseul and Makira, clearly prided themselves on more regular designs. As utilitarian and currency objects they preferred arm-size rings, with the larger and more valuable combinations worn as pendants. Then there are the 'giant' clam shell rings, too big to ever be adornments, that are used as land title deeds and heirlooms, variously called *titi* or *mau lavata*. Having said that, throughout the Solomon Islands there are many different local names for what appear to be identical ring designs.

Roviana and Marovo Lagoon in the New Georgia group (see maps on the book's inside covers) were renowned centres of production, from where, in pre-contact times, raiders in large, fast canoes captured enemies to increase the workforce making rings.

The Solomon Islands rings are almost always carved from clam shell and many of those were from fossil clam deposits. The fossil material was certainly easier to work with than the harder and more brittle fresh clam shell. Also, the fossil shells were said to be discarded on land by the god Tamasa, so articles made from this material had strong spiritual and magical properties.

There is a large range of rings, each with its own purpose and value. Many are used in exchanges, as wealth items and worn as adornments or prestige items. As a rule, big rings are almost always clam shell, narrow section rings (worn on arms) may be *Conus*, clam or *Trochus* shell.

Arm-size money rings were worn above the elbow by men and women as a demonstration of wealth and status. This photo taken on New Georgia shows Roviana Chief Ingava and his wife both wearing a plethora of thin *hokata* arm rings. He is also wearing a *bakiha* clam shell ring bound with red pandanus braid onto a turtle shell base, adorned with teeth and shells.
Photo: George Brown 1902. BM Oc,Ca42.52

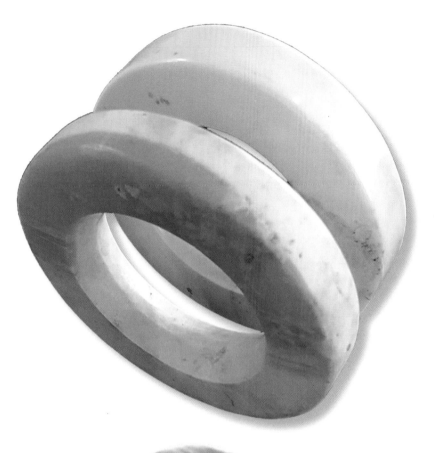

The highest quality Solomon Islands clam shell rings have a distinct ridge around the inside, as is shown in these examples. This pair of rings makes an interesting comparison. They are identical in shape and dimensions and were collected together, so it is likely that they were carved by the same hand. One was carved from a fossil giant clam shell (it shows the highly-valued orange tinge from the hinge of a fossil shell), while the other has a very high lustre that indicates it was carved from a recent sub-fossil or live-collected clam shell. Both are of superb quality and are 108 mm in diameter. Auction records indicate that these were collected on "New Georgia Island, Roviana Lagoon" in the early 20th century.
WG T0665 and WG T0666

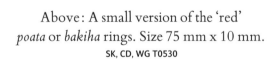

Above: A small version of the 'red' *poata* or *bakiha* rings. Size 75 mm x 10 mm.
SK, CD, WG T0530

Right: Two round-edged *njava* rings. 105 and 125 mm. **WG T0653 and WG T0654**

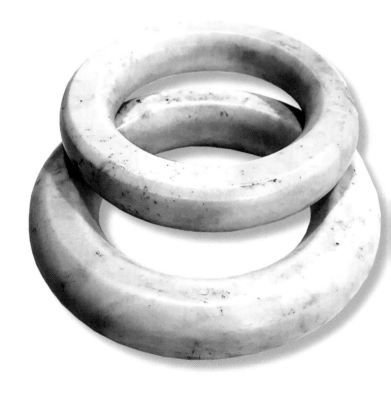

Solomon Islands Rings

Poata and Bakiha

Poata and *bakiha* are general terms used interchangeably in the western Solomon Islands for mid-size money rings made exclusively from clam shell. *Bakiha*, and its different spellings, mostly referred to the orange tinted rings – sometimes called 'true *bakiha*'. These rings have an external diameter of 80–200 mm, internal diameters of 40–100 mm and are typically 10–30 mm thick.

Poata and *bakiha* rings occur in 'white' or 'red' versions. The 'red' variety have an edge with a distinctly orange tinge (even though they were called 'red'). The rare colour is highly prized and is carved from the hinge of the fossil clam shell. In some cases, only one or two could be carved from a single giant clam shell. These rings are a powerful statement of wealth and prestige. Their size means that they can be worn as arm rings.

These rings were occasionally integrated into pendants called *tarkola*, bound with red pandanus braid onto a turtle shell base and adorned with teeth and shells.

Smaller versions of these money-rings are sometimes seen but they are clearly too small to be used as adornments, except by children. This small 'red' ring shown at far left was originally collected by a missionary around Morova Lagoon in the 1960s.

Njava

Theses rings are similar in size to *poata* rings, but the sharp edges have been smoothed down and rounded on all sides. Their typical external dimensions are 100–125 mm, internally 60–70 mm, and they are 15–30 mm thick.

These rare rings are specific to the east coast of Vella Lavella, New Georgia. They are an important currency, and some are still in use today. The people of Vella Lavella say that these rings cannot be refused during an exchange.

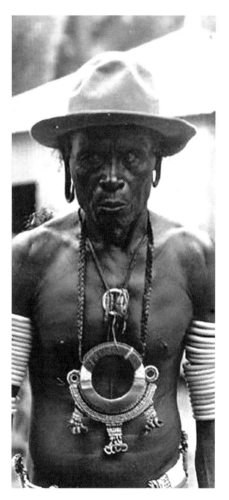

Roviana Chief Ingava wearing a *tarkola*. **Photo: George Brown 1902**

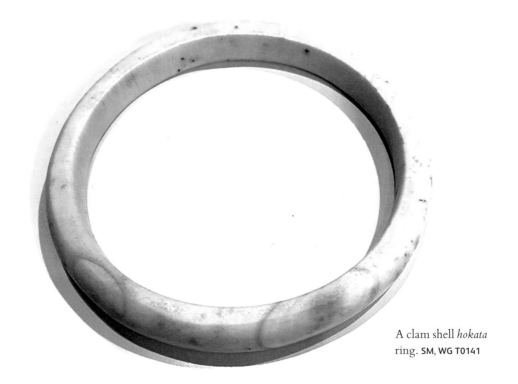

A clam shell *hokata* ring. SM, WG T0141

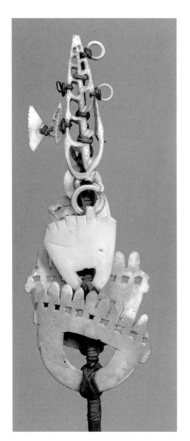 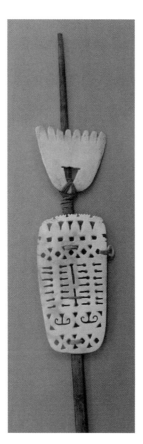 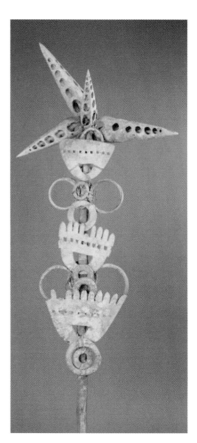

Vosovo sticks with shell charm-pendants attached, all from Roviana Lagoon. The first two were collected on graves by Admiral Edward Henry Meggs Davis before 1901. **BMOc1904,0621.3** The one on the right was likely assembled from old charms in the second half of the 20th century. **WW, WGT0254**

Solomon Islands Rings

Hokata

These are relatively thin, highly-polished rings, typically 90 mm in diameter, closely resemble bracelets and are carved from clam shell or cone shell tops. The image at right compares them to the much thicker *njava* rings.

They are used as adornments worn at the top of the arm and serve as a currency for small transactions, with ten *hokata* (sometimes called *mbokolo*) worth one *poata*. These shell arm rings were already mentioned by Spanish explorers in 1568 when they visited Santa Isabel.

Ovala

These are small thin rings, typically just 30–50mm in diameter, made from clam or cone shell for various mortuary ceremonies. An *ovala* might be tied to each orbit of the skull and on the eyes. They became part of the respectful representation of a deceased relative.

Ovala rings were also placed on *vosovo* sticks to personify the wealth and status of the owners and were positioned near skull shrines, or on war canoes. Other shell objects such as the spiral *ragos*, carved from *Terebra crenulata* or *T. maculata* shells, were also tied and mounted on the wooden post with *asama* vine binding. The vines used to tie the objects were less durable than the shell objects and would have decayed and been replaced several times on older pieces, while the shell objects were re-used. Ben Burt recalls that *vosovo* sticks were being assembled by Betty Afia from old shell objects in Bruce Saunder's craft shop in Honiara at the end of the 20th century.

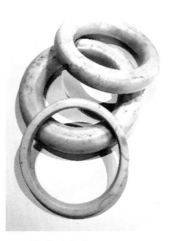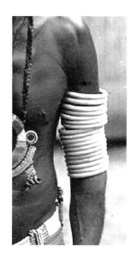

Left: A hokata ring compared to the much thicker njava rings. Right: Roviana Chief Ingava wearing a hokata arm rings.
Photo: George Brown 1902

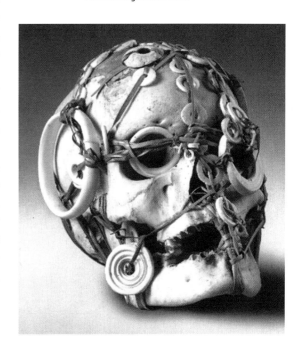

An ancestor skull with *ovala* rings placed on the temples. Solomon Islands, Western Province, 19th century. South Australian Museum A.37681

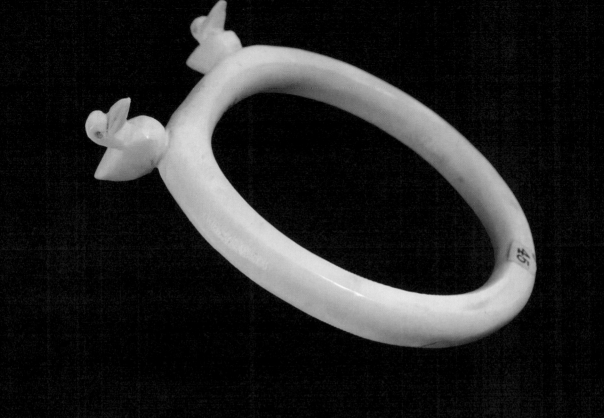

Main image and above: A magnificent double-bird clam shell ring with a label *Armlet Chief's clam shell Choiseul Solomon Is. 1901.* MV X8075

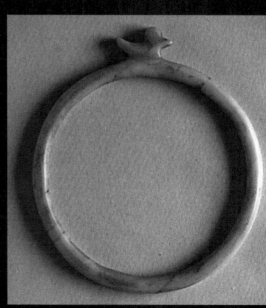

Above: A single-bird smoke-stained ring collected by Sir Mariano Kelesi who recalled: "I obtained the shell ring from a chief on the island of Santa Isabel". SK, CD C1500, WG T0647

Solomon Islands Rings

Hokata with birds

These rare and important carved clam shell rings featuring birds have been recorded from Choiseul and Santa Isabel islands, in the northern Solomon Islands. They are similar in shape to the *hokata* rings, but feature either one or two birds carved on the edge of the ring, at varying angles.

There is also some debate about what exactly these bird carvings represent – pigeon, hornbills, kingfishers, frigate birds – or perhaps megapodes, birds that are abundant in the north of Santa Isabel and on the islands of the Strait of Manning between Santa Isabel and Choiseul.

The megapodes are stocky, chicken-sized birds with small heads and large feet. They are also known as *incubator birds* or *mound-builders*, because, unlike most birds, megapodes incubate their eggs by burying them deep in beach sand. They are also known to bury them in warm lava at the base of volcanoes.

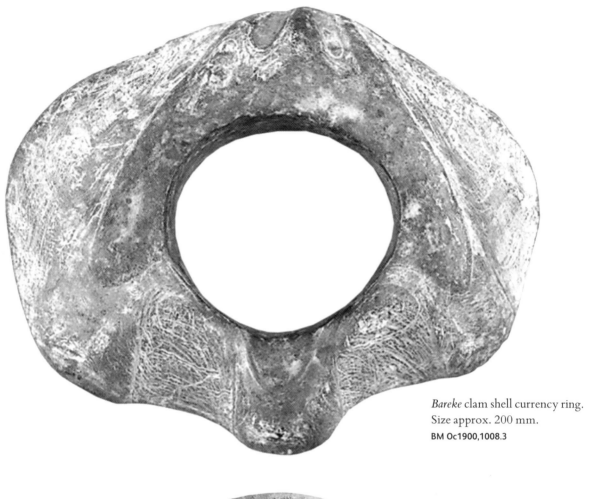

Bareke clam shell currency ring.
Size approx. 200 mm.
BM Oc1900,1008.3

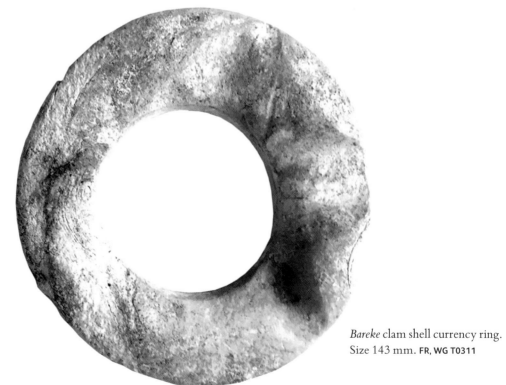

Bareke clam shell currency ring.
Size 143 mm. **FR, WG T0311**

Solomon Islands Rings: New Georgia

Bareke & kassia

Bareke is the general New Georgia name for large shell currency rings made from the lip of fossil clam shells. These roughly-polished 'rings' are made following the natural contours of the lip of the shell. They are typically quite large, 150–250 mm in diameter.

 Bareke are considered the oldest rings of the archipelago and have been found on ancient graves in New Georgia and are estimated to date from between 1200 and 1600. They are believed to have been used in rituals to dedicate selected children to become head-hunters and leaders in future, and as a symbol of claims to land. They were never worn as adornments. Many consider their origin to be 'unknown', possibly made by *tamasa* gods.

 The top specimen on the facing page is from the British Museum Collections. It was one of six objects collected by Charles Woodford on 21st January 1900 on a punitive raid to the Roviana Lagoon. Woodford was in the Solomon Islands between 1888 and 1914, first as a naturalist, and later as British Resident Commissioner.

Kassia 'Rib-breaker' rings

Large solid arm-rings worn on the lower arms and used in hand-to-hand combat, grabbing the enemy around the body with both arms, so that the rings would break their ribs, are referred to in the Solomon Islands as 'rib-breakers'.

 The distinctive examples shown below are from New Georgia are known as *kassia* and carved from fossil limestone – likely from the same deposits where fossil giant clam shells were found. The sharp projecting edges would certainly have done the trick. Additional references to these can be found in *Pacific Jewelry and Adornment* page 127.

Kassia 'rib-breaker' rings. **WG T0615**

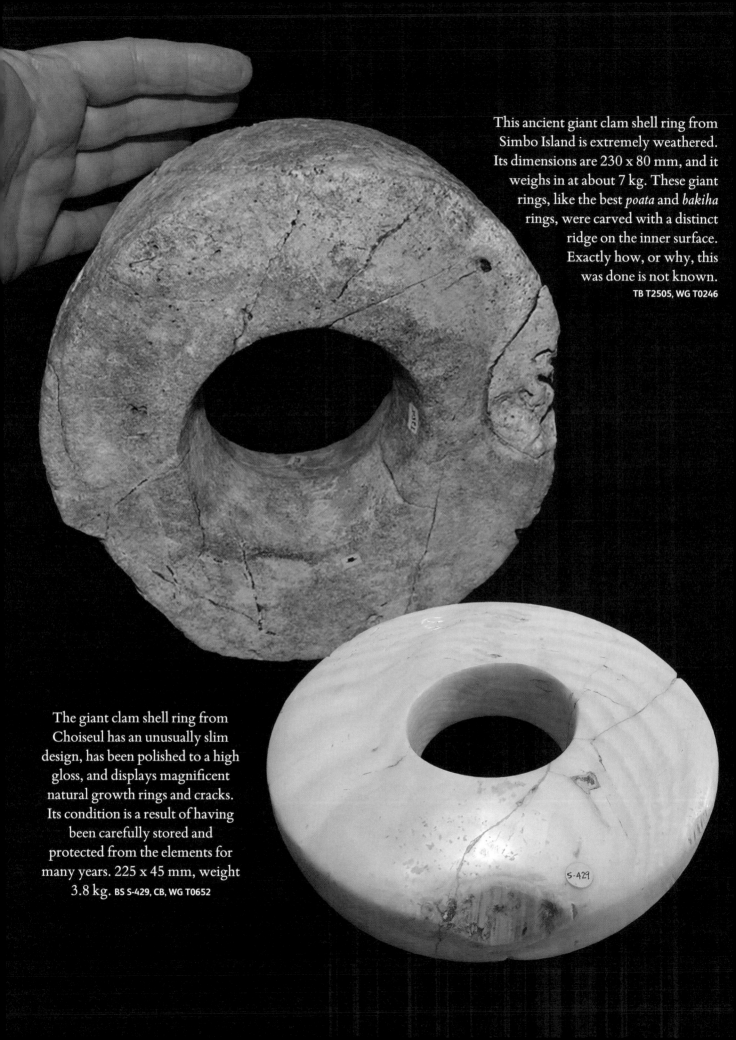

This ancient giant clam shell ring from Simbo Island is extremely weathered. Its dimensions are 230 x 80 mm, and it weighs in at about 7 kg. These giant rings, like the best *poata* and *bakiha* rings, were carved with a distinct ridge on the inner surface. Exactly how, or why, this was done is not known. **TB T2505, WG T0246**

The giant clam shell ring from Choiseul has an unusually slim design, has been polished to a high gloss, and displays magnificent natural growth rings and cracks. Its condition is a result of having been carefully stored and protected from the elements for many years. 225 x 45 mm, weight 3.8 kg. **BS S-429, CB, WG T0652**

Solomon Islands Rings: Western Islands

The Giants: known as *titi* (on Simbo), *tinete* (Marovo Lagoon) and *mau lavata* (Choiseul)

These giant rings have only been attributed to the above areas. Although also classed as currency rings, their purpose was quite specific, primarily used as Land Title Deeds. These rare items would perhaps only have been used a few times, spending most of the time hidden, perhaps even buried – as the surface condition of the specimen on the facing page shows. Because of their importance they were never to be touched except by the most senior chiefs. They were dedicated to deified ancestors and kept in important shrines.

The ancient ring shown opposite is one of the largest and oldest known. It was brought to Australia in the 1930s from Simbo Island (known to early explorers as Eddystone Island) and eventually ended up in Todd Barlin's personal collection. "This ring left the Solomon Islands at a time when these objects were considered *curios*", commented Todd. "I have had a few of these over the years – some were published in *Art of the Solomon Islands* by Waite and Conru. You can just touch and feel the age of these ancient objects. This one is certainly several hundred years old."

At right is a similar ring displaying the same iconic design. The material displays beautiful wavy lines of the clam shell and its condition confirms that it has been exposed to weathering but was not buried. 19th century or earlier. The collection inventory number Z–35 on this object may indicate that it was originally in the Cambridge University Museum of Archeology and Anthropology. Dimensions 200 x 60 mm. WW, WG T0563

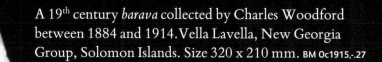

A 19th century *barava* collected by Charles Woodford between 1884 and 1914. Vella Lavella, New Georgia Group, Solomon Islands. Size 320 x 210 mm. BM 0c1915,-.27

A more recent *barava* plaque likely made in the second half of the 20th century. New Georgia Group, Solomon Islands. Size 500 x 380 mm. WG T0612

Solomon Islands
Barava heirlooms

Barava is a general term for clam shell plaques used as a tribe's mark of ownership of its land, their *kastom* rights, and ancestor heirlooms. Ring-shapes are included in the designs as symbols of value. *Baravas* are regarded as one of the truly iconic works of art in the Pacific, analogous to the Benin bronzes of Africa, and they reign supreme over all the South Seas objects sculpted from clam shell.

The process of making a *barava* is interesting. After cutting and polishing a slab of fossil clam shell, the edges left rough, a small hole was drilled through which some tough natural fibres were pulled up and down, using sand and water as an abrasive in the process. Slowly the figures were formed as the process was repeated over months and even years.

The magnificent fretwork *baravas* illustrated on the facing page were both sculpted from a single large slab of sub-fossil *Tridacna* shell, incorporating anthropomorphic figures with bent knees, linked hands, and over-large ears. Both feature two large rings and leave the rough surrounding fossil shell borders. The one at left was acquired by the British Museum from Charles Woodford in 1915 and was likely used for a century before that. The one at right was likely made in the second half of the 20th century.

Baravas were important heirloom objects, never used as adornments and seldom seen in public. They were stored in tombs and shrines, and possibly broken up and distributed on the death of the owner. Some consider this practice to have been widespread, since most often only fragments of these fragile *baravas* are found. On the large *barava*, there are multiple obvious fractures repaired over the years by different methods. I obtained this *barava* in a box of more than 20 pieces and had weeks of 'fun' restoring this jigsaw.

Smaller New Georgia *baravas*, like those shown at right, sometimes called *pangosia*, have a basic U-shape with a 'comb' along the upper edge. These were used as charms, or combined with other shell valuables on *vosovo* sticks, mounted with 'combs' upwards.

Small *baravas* called *pangosia*. **WG T0247**

259

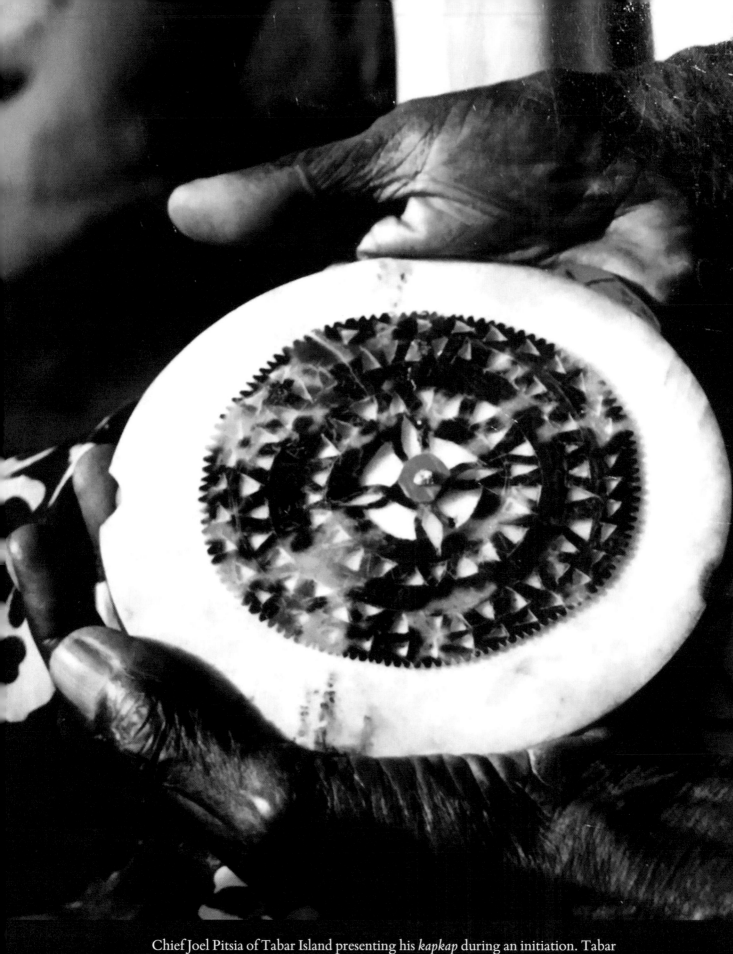

Chief Joel Pitsia of Tabar Island presenting his *kapkap* during an initiation. Tabar Island, New Ireland, part of the Bismarck Archipelago of Papua New Guinea, is widely renowned as the 'home of the carvers'. Despite that, items actually identifyable as coming from Tabar Island, such as this one, are extremely rare. MC, WG T0597

UBIQUITOUS *KAPKAPS*

In the realms of 'Tribal Art', the term *kapkap* is used to describe a wide variety of finely-decorated body ornaments made from filigreed turtle shell mounted on a variety of contrasting shell bases, ranging from marble-like fossil clam shell to *Melo*, *Cymbium* and pearl shell. They are worn either on the head or on the chest tied with a band around the neck, depending on local custom. The brilliant contrasts create an almost hypnotic effect that has entranced islanders and visitors alike. *Kapkaps* have been traded amongst the islands of the South Seas as prestige items for hundreds of years, and the place where they are collected often gives no clue as to where they were originally made.

Kapkap is said to be a Melanesian pidgin term and is now popularly used as a general term for any of a wide range of similar objects including those discussed in this section, the *dala* of the Solomon Islands, the *tema* of the Santa Cruz Islands, the *uhikana* of the Marquesas Islands and various Sepik and Papuan Gulf adornments that don't appear to have specific local names.

All of these are loosely referred to as *kapkaps* in the popular literature.

"The completed kapkaps, composed of contrasting dark turtle shell fretwork hanging over white clam shell creates a kind of figure ground reversal effect, so that the patterns function as an optical movement of geometric shapes. The tying together of the two gendered elements of the kapkap by the carver symbolically binds skin, blood and bone, a process that mirrors local understandings of the composition of the social body composed of male and female substances."

Graeme Were, 2001

Making a *kapkap*

While some *kapkaps* are beautiful in their simplicity, others are so detailed and complex it is difficult to imagine a human hand in their making. They would be extremely difficult to make even using modern metal tools.

Turtle shell fretwork

Turtle shell is quite easily worked and shaped, once heated. The shell was cut and polished into fine discs. The thinner the disc, the older the specimen is likely to be. Recently made *kapkaps* tend to have thicker turtle shell discs.

It is popularly said that the designs were cut using sharks' teeth, but the same effects might have been achieved using a strip of vine inserted into drilled holes to saw out small sections. Some *kapkap* examples, especially from the Admiralty Islands, the Papuan Gulf and the Marquesas Islands, show evidence of tiny, drilled holes and cuts between them to join up the holes.

The example below, in the Pitt Rivers Museum, collected during the Cook Expeditions in the Marquesas Islands in 1777, shows distinct drill marks. Some of the oldest kapkaps show no evidence of drill holes, so one can assume that these were cut directly into the smoothed–down turtle shell discs, perhaps using shark teeth.

Since the late 19th century metal tools have widely been used to make *kapkaps*.

Three unfinished and/or broken turtle shell discs that were collected in New Ireland in the 1980s. **MC, WG T0598-600**

The bases

It is easy to tell the difference between the materials used for the base of the turtle shell fretwork on *kapkaps*. The bases made of clam shell (often fossil clam shell) are flat, polished, heavy and have a marble-like quality. Those made of bailer, *Melo*, *Cymbium* or pearl shell are lighter, thinner and slightly curved.

There is some debate as to whether straight edges on clam shell discs indicate older or newer objects. What is clear from the many examples that I have seen is even hundreds of years ago there were excellent, good and bad craftsmen. Age alone is no guarantee of good *kapkap* craftsmanship.

Exchange, trade and sale of kapkaps

An enormous number of *kapkaps* have been made in the last two centuries. In his 2001 study, Graeme Were identified more than 500 in thirteen museum collections around the world. Very few had reliable collection data, but even when they did, it is well-known that *kapkaps* were frequently traded around the area so that even if the collection data was correct, it would give no positive idea of where it was originally made. Were estimates that less than 5% of the provenance information in museums he studied was correct or complete.

Also, the turtle shell carvings and shell bases were often reworked when more status was achieved or repaired when broken, so one can never assume that the pairings are original, no matter how early they were collected.

In any event, *kapkaps* were dynamic adornments shaped by prestige and ceremony. There were no immutable design standards across the South Seas, although one can discern high-level local clan styles. All one can do is make approximate groupings, as I have done here on the following pages. But these are observations made with our Western perspectives, largely unsubstantiated by the experts who made them.

> *"The carvings of turtle shell patterns is an expression of both individual and societal concepts of style. It's an indigenous knowledge system."*
>
> Graeme Were, 2001

263

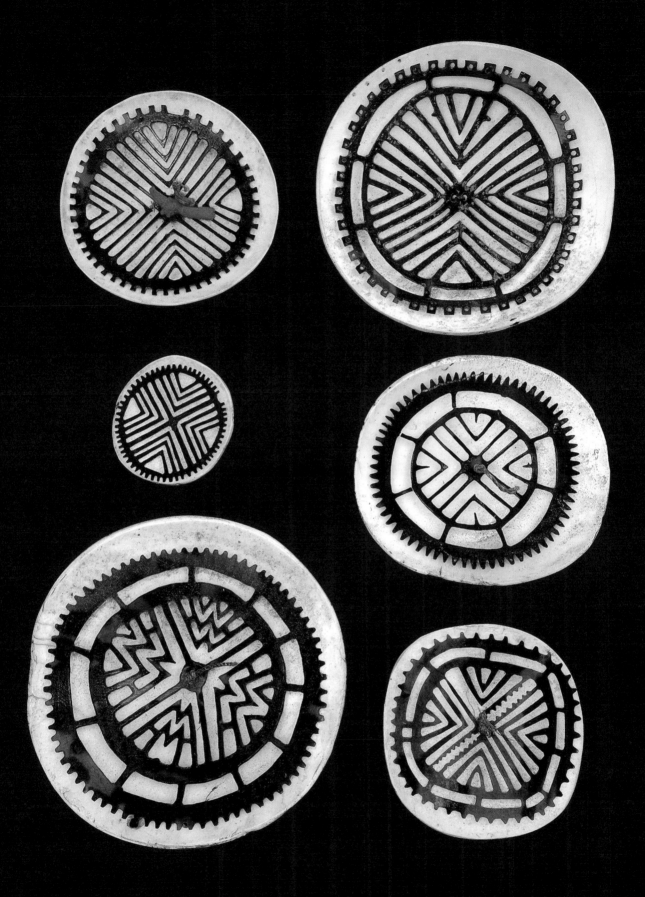

This variety of Papuan Gulf *kapkaps* was collected by Richard Aldridge in the 1980s between Orokolo Bay at the mouth of Purari River and east Kerema, Gulf Province PNG. All are filigreed turtle shell on bailer shells. Size 30 – 140 mm. RA,WG T0538 - 0542

Kapkaps

Papuan Gulf

The *kapkaps* from this area are usually round or oval in shape. Bases are usually made of bailer shells and are slightly concave, topped with turtle shell cut into chevron designs radiating from the centre, often in four sectors, with the outer edge in toothed design. They were attached using natural fibre or woven bands.

Around the northern shores of the Papuan Gulf, single *kapkaps* were mostly worn on the side of the head, such as those illustrated on the facing page.

The most impressive use of *kapkaps* is found amongst the Mekeo-speaking people who live in village communities on the coastal plains along the eastern Papuan Gulf in the Central Province of PNG. Here *kapkaps* are integrated into elaborate headdresses for important celebrations. Up to 20 can be seen used in a single headdress – with relatives and friends asked to lend some of their own to allow an individual to complete her own construction.

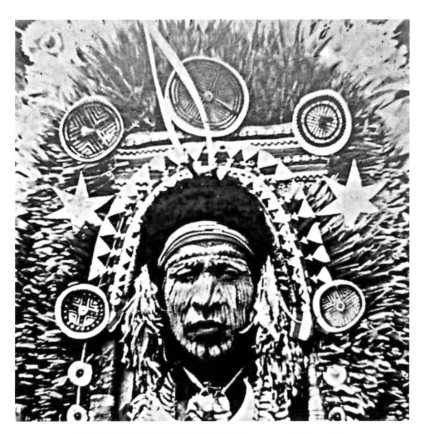

Original photo by Guy Spiler 1960s. Digitally processed by the author

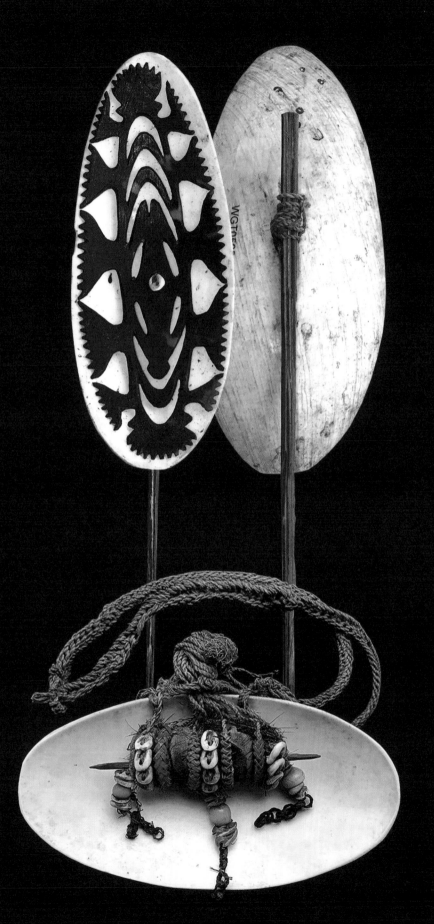
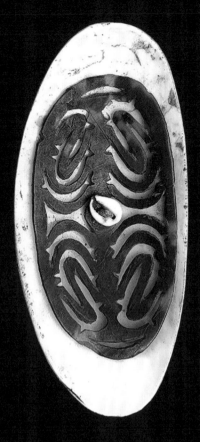

Top left: *Kapkap* mounted on a black palm stick. Murik Lakes region. Size 140 mm. RA 1980s, WG T0505

Right: A *kapkap* with an elegant design motif from Marangis village, coastal Ramu River. Size 105 mm. CB 1998, WG T0352

Left: An elaborate *kapkap* with unusual design elements mounted on a stick and hung on a natural fibre band, likely worn as a pectoral adornment. Size 140 mm. Yangoru Boiken people, East Sepik Province. GL, WGT0547

Kapkaps

Sepik area

The *kapkaps* from the Sepik area are generally elliptical in shape. The filigree overlays are carved from turtle or coconut shell and are tied onto a base made of concave bailer shell. Clam shell bases are almost never used here. The designs and shapes are reminiscent of flowing Sepik wood carvings, some with elliptical and apparently anthropomorphic designs. Sepik area *kapkaps* are often worn in the hair attached on a long black palm stick, such as the examples at top of these pages. They have turtle shell overlays and are tied on with Nassa shells and fibre.

The unsual example shown at the bottom on the facing page does not have a turtle shell carving at all, but instead has elaborate design elements mounted on a stick and hung on a natural fibre band, likely worn as a pectoral adornment.

The rare *kapkaps* at right are from the Yangoru Boiken people of the Prince Alexander Mountains and feature designs of lizards and geckos carved from coconut shell, on bases made of bailer shells. Both have intricately woven natural fibre 'chains' attached.

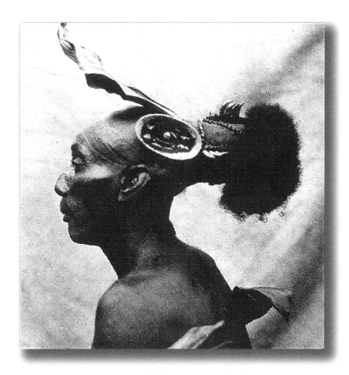

Man wearing *kapkap*. Wageo Island, East Sepik Province. Early 20th century.

Top right, shown front and back : Size 120 mm. **TB T-898, WGT0346**

Below right : Size 90 mm. **TB, WGT0347**

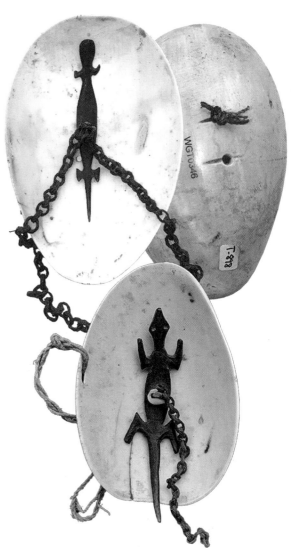

267

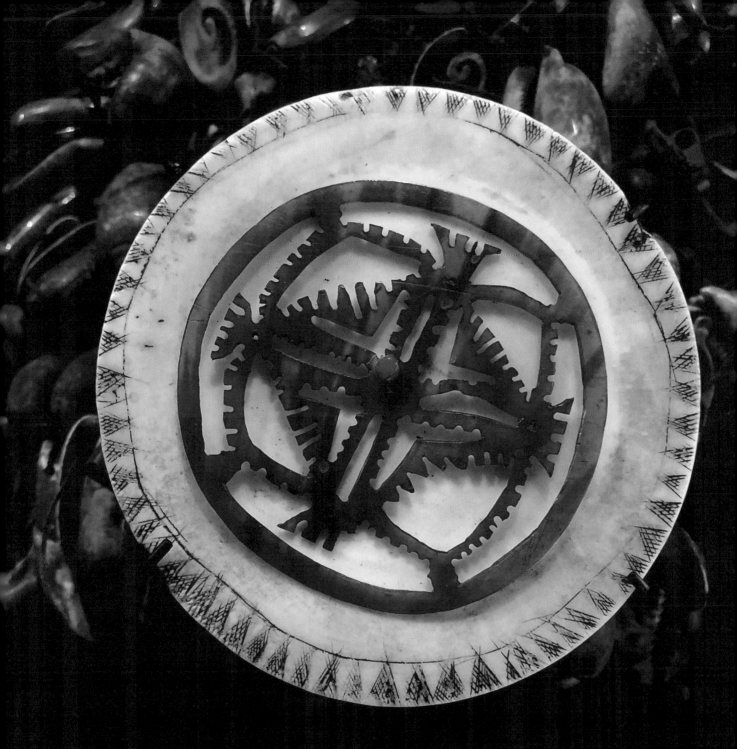

A superb Admiralty Island *kapkap*. The base is a heavy polished clam shell disc with an incised chevron edge, overlaid with a filigreed turtle shell disc with stylised palm and bird designs, tied to the base with natural fibre and glass bead. Diameter 93 mm. From the collection of Matthias L. J. Lemaire, Amsterdam. GL, WG T0664

"*Kapkaps* are the most valuable ornaments in the Admiralty Islands."

Art of the Pacific Islands in the Met 2002

Kapkaps

Admiralty Islands

The Admiralty Islands are a group of 18 islands in the Bismarck Archipelago, to the north of New Guinea. The capital is the town of Manus and many of the islands are uninhabited atolls.

The *kapkaps* from the Admiralty Islands are made from clam shell bases with turtle shell overlays often depicting what appear to be stylised palm fronds or bird shapes, and usually divided into four quadrants. Here *kapkaps* are used as breast ornaments worn around the neck on string.

What is distinctive about the Admiralty Islands *kapkaps* are the incised chevron motifs along the circumference of the shell base, as is evident in these two superb and unusually large examples below – both have a diameter of 130 mm.

Left: A *kapkap* with an unusually thick turtle shell overlay which appears to combine typical Admiralty Islands designs with others reminiscent of the Papuan Gulf *kapkaps* we saw previously. The whole is tied together with a fabric band. From the collection of Aaron William Goode, and the Chris Hemmeter Gallery in Hawaii in the 1980s. **WG T0689**
Right: A *kapkap* with stylised leaf motifs from Manus Island and is tied together with woven natural fibre cord and an opossum tooth, **AW, WG T0649**

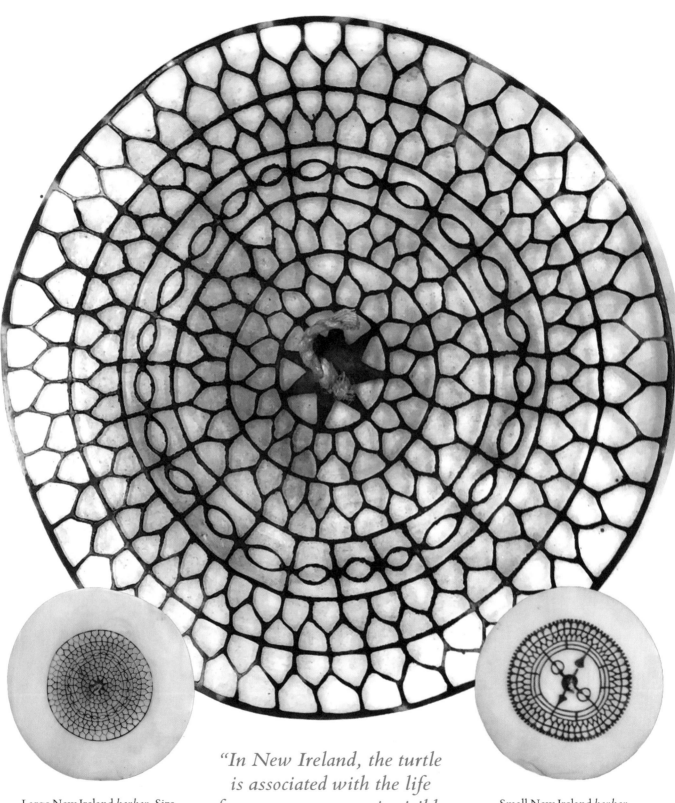

"The Melanesians believe that persons and objects are conceptually alike, and this is embodied in the kapkap, giving the wearer the capacity to act within specific constraints."

Were 2003

"In New Ireland, the turtle is associated with the life force amuzum, an invisible substance that emanates from the sea to enrich the land."

Graeme Were, 2003

Large New Ireland *kapkap*. Size 140 mm with enlarged centre shown above. **CR, WGT0468**

Small New Ireland *kapkap*. Size 75 mm. **CR, WGT0468**

Kapkaps

New Ireland

New Ireland is part of the Bismarck Archipelago in northern Papua New Guinea. The *kapkaps* from this area are amongst the most delicate and finely-carved of all. Here, the only people who can wear kapkaps are family or clan leaders who have earned the right to be called *maimais*, because of their depth of knowledge of traditional culture and customs.

At right, three Malagan *maimais* on Tabar Island – Mekun, Noah and Walik – display heirloom *kapkaps* on their chests, proudly retained from generation to generation. The *kapkaps* affirm their reputation for orchestrating dealings with the ancestral realm and their specialised skills in rain or love magic. As a *maimai* gains in power, a more complex turtle shell carving is made with more rings. Each additional ring indicates a level of authority. The old *kapkap* is then discarded. When a *maimai* dies, his *kapkap* also dies. It is unfastened to represent the departure of the soul and is placed with him when he is cremated or drifts out to sea in a canoe to 'the ancestral realm'. More recently the *kapkap* components have been known to be reused.

Their bases are cut and polished from clam shell or pearl shell, with a turtle shell overlay featuring concentric circles emanating from a central 'flower' or star motif. The finest of these have honeycomb shapes integrated into the designs – see the large image opposite. This design seems to appear only in *kapkaps* from New Ireland.

The *kapkap* on the facing page demonstrates an important differentiating characteristic of the best New Ireland *kapkaps* – the base extends far beyond the turtle shell overlay, often twice the diameter of the turtle shell carving. It also comes with a leaf pouch containing a hand-written label *Kapkap Neumecklenburg* (the German term for New Ireland during the German occupation in the late 19th century),

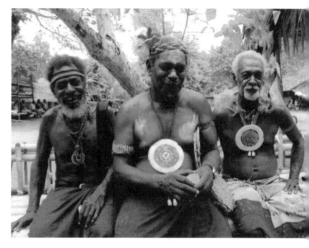

Photo ML

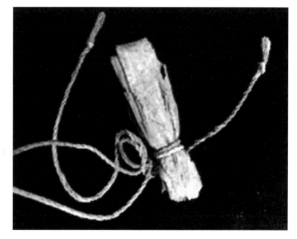

271

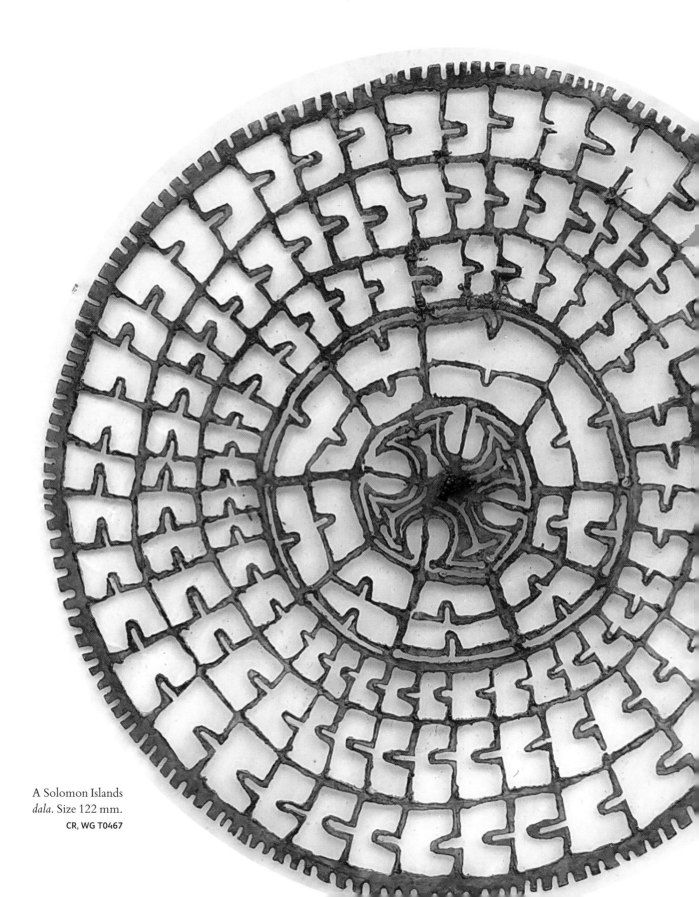

> *"The motifs are a representation of the tribal society conceived as an endless succession of individuals."*
>
> Schuster, 1964

A Solomon Islands *dala*. Size 122 mm.

CR, WG T0467

Kapkaps

Dala – Solomon Islands

On the Solomon Islands a *kapkap* is known as *dala* and is the staple adornment for senior clansmen, typically worn on the forehead by high-ranking warriors and chiefs. *Dalas* are attached by a woven braid around the head and sometimes adorned with shell and glass beads. The best ones were considered heirlooms and passed from generation to generation.

Designs are said to have a strong affinity with the worship of the bonito fish, and the best are those with U-shaped or 'dorsal-fin' motifs, as shown in the two examples on this page. They are similar in style to the Admiralty Islands *kapkaps* with their symmetry radiating from a central motif. Together, the 19th century examples from these two island groups are amongst the most detailed and superbly carved items in the Pacific (or anywhere). Even their bases are exquisitely polished – feeling like the best porcelain in the hand.

A superb Solomon Islands *dala*, collected by Jeff Vanderstraete, Belgium in the 1960s. Size 90 mm. KL, **WG T0336**

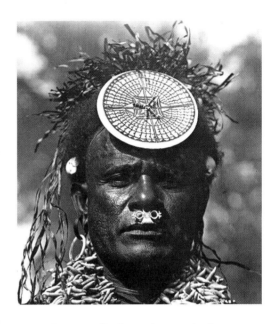

Portrait of Irobaoa, the great leader of Su'uafa, Malaita, Solomon Islands, wearing a dolphin teeth neck ornament and a *dala* shell ornament on his forehead; Early 20th century.
BM Oc,G.T.2611

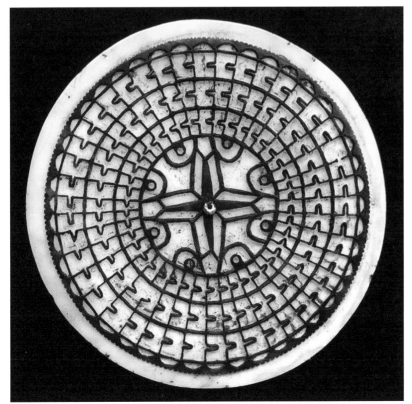

A superb Solomon Islands *dala*, collected by Jeff Vanderstraete, Belgium in the 1960s. Size 90 mm.
KL, WG T0336

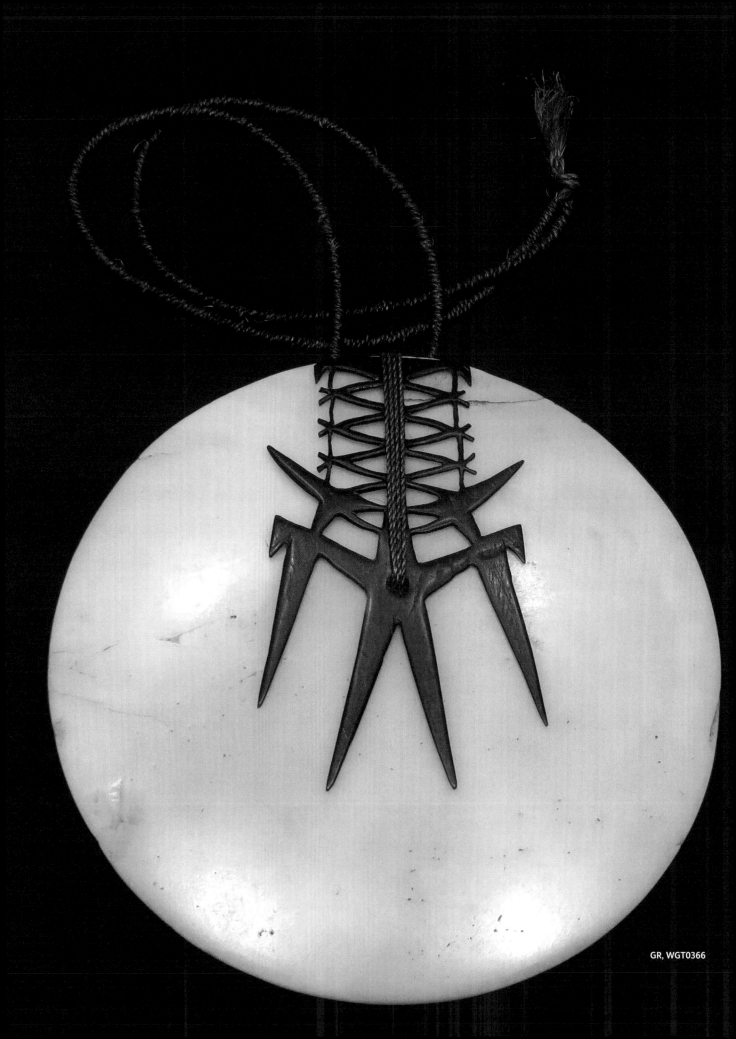

Kapkaps

Tema – Santa Cruz Islands

The Santa Cruz Islands are the remote outliers of the Solomon Islands Group located 400 km to the southeast.

Their *kapkaps*, locally called *tema*, are worn on the chest by important men in ceremonies and previously, during battle. The one on the facing page is a particularly fine 19th century example, made from a sliver of fossil giant clam shell, polished to a fine high gloss and adorned with finely-carved turtle shell and a plant fibre cord. It is relatively large at 170 mm, similar in size to those worn in the image below.

The designs carved into the turtle shell are stylised and abstracted forms variously said to represent frigate birds, bonito fish and sharks – even caterpillars. The whole is sometimes said to represent a stylised ancestor figure… but there are endless other interpretations.

KL, WG T0335

"These motifs represent the caterpillar that infects banana plants, hanging head down."

SI cultural publication 1979

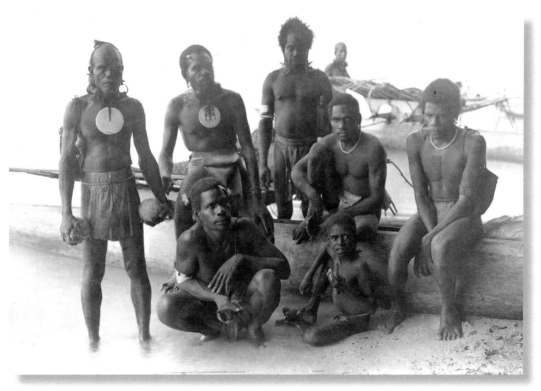

A group of men on a Temotu beach, some wearing *temas*. Reef Islands, Santa Cruz.
Photographed by: John Watt Beattie, 1906 BM Oc,Ca41.150

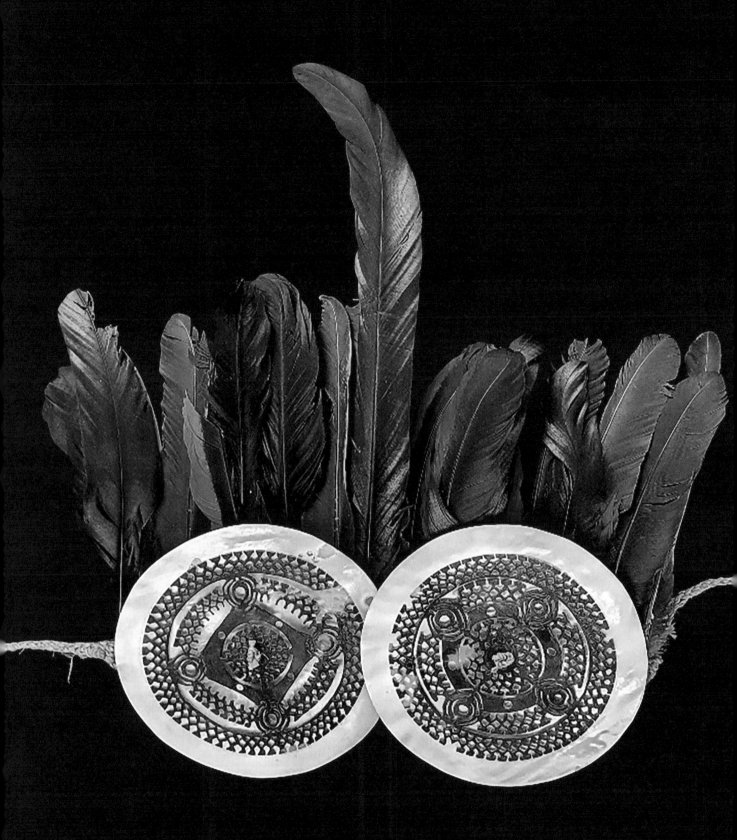

A dramatic feather and shell headdress, called *uhikana*, made of two elaborate turtle shell carvings mounted on pearl shell bases, with cocks' feathers mounted on a band made of plaited coconut fibre. The style of this *uhikana*, although made in the Marquesas Islands in Polynesia, is consistent with the *kapkaps* of the South Seas. PG, WG T0496

Kapkaps:

Uhikana – Marquesas Islands

A particularly unusual *kapkap* head adornment, called *uhikana*, was illustrated in the 1777 accounts of Cook's second voyage, as worn by the Chief of Tahuata in the Marquesas Islands, one of the most remote islands groups, in Polynesia. The Chief has tattoos on his face and is wearing a dramatic headdress, made of an elaborate turtle shell carving on a pearl shell base, with cocks' feathers for dramatic effect. The turtle shell carvings are certainly reminiscent of South Seas *kapkaps*.

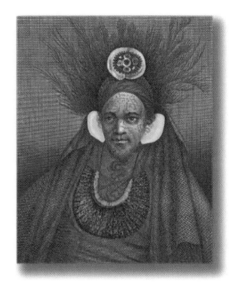

A second engraving in the publication shows an even more elaborate version of the *uhikana* with two pearl shell discs, an object which is now displayed in the Pitt-Rivers Museum in Oxford – see the engraving and the actual object below right.

There appear to be about ten examples of the single-disc head adornment in museum collections. Of the double-shell design, the only one known was in the Pitt-Rivers Collection. Carol Ivory called this "The most spectacular example from the Cook expedition, and from the entire early contact period".

Before I was aware of these Marquesas objects, I came across one in a Belgian auction some years ago – see image on the facing page – completely misidentified as a Solomon Islands object.

We have since compared the drilling and cutting styles with the Pitt-Rivers example and the two objects are entirely consistent. So, this beautiful, strange and extremely rare object almost certainly dates from the 19th century or earlier. It was given to a Belgian family by Paul Gardissat in the 1990s. Gardissat was a renowned collector based in Vanuatu and he collected in the 1960s and 1970s. He died in 2013 and his remaining collection was acquired by The European-Vanuatu Foundation in Vanuatu.

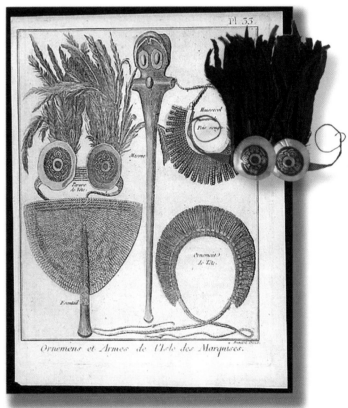

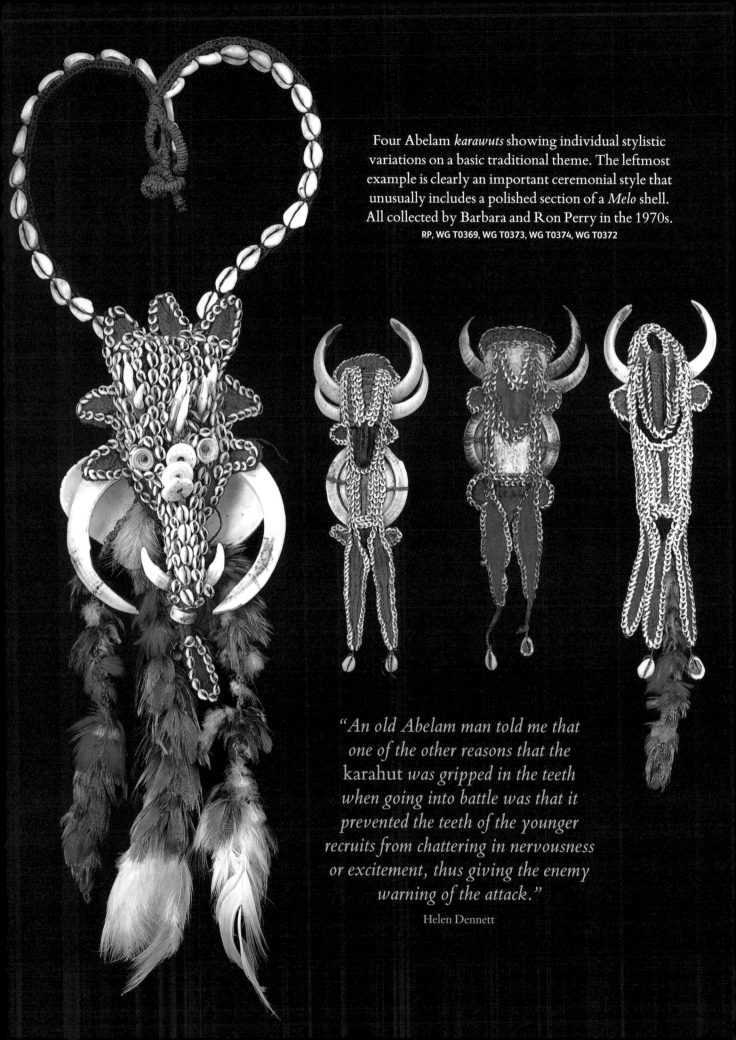

Four Abelam *karawuts* showing individual stylistic variations on a basic traditional theme. The leftmost example is clearly an important ceremonial style that unusually includes a polished section of a *Melo* shell. All collected by Barbara and Ron Perry in the 1970s.

RP, WG T0369, WG T0373, WG T0374, WG T0372

"An old Abelam man told me that one of the other reasons that the karahut *was gripped in the teeth when going into battle was that it prevented the teeth of the younger recruits from chattering in nervousness or excitement, thus giving the enemy warning of the attack."*

Helen Dennett

Mouth adornments
To protect and intimidate

The Abelam, above all else, are renowned for their weaving of both cane and fibre into their important ritual objects and body ornaments. One such object is the *karawut*, having three distinct functions: a mouth ornament, a pectoral, a back ornament – depending on the circumstances. *Karawut* were held by Abelam warriors in the mouth, appearing almost as wild pigs, and amply demonstrating their ferocity in battle. They were also used in a similar way at the important rites of passage by the young male initiates. To become a fierce warrior was one of the core elements of male initiation. During the ceremony, males who had reached certain levels of initiation wore the *karawut* on the chest. At all other times, and by lesser initiated men, the *karawut* was worn on the back.

The *karawut* consists of a human body shape made from hand-rolled, finger-knotted bush string and edged with a border of Nassa shell beads. There is at least one set of pig tusks inserted on either side of the face, and often more tusks inserted into the mid-torso area. The completed object is then painted in dramatic colours, with natural ochres supplemented with red, black and yellow, and sometimes with 'Reckitt Blue', introduced by the colonials to make their washing whiter. Finally, a small cowrie shell is sewn to each leg and feathers may be added for additional opulence.

Each *karawut* is as individual as its maker. The name is derived from two words – *kara* meaning pig tusk, and *wut* meaning a womb, or the hand knotted *bilum* bag of similar shape. *Karawut* literally means *hand knotted twine object with pigs' tusks*.

Similar men's adornments are found in several cultures throughout New Guinea – to protect and intimidate in equal measure. Amongst the Wosera people, their *andakara* typically had a strong woven 3-dimensional face, very much like a tiny yam mask, as shown at right.

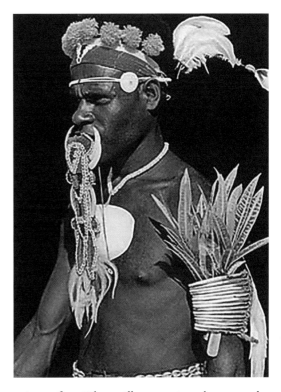

A man from Ulupu village wearing a *karawut* and *Trochus* rings with brightly coloured croton leaves. Photo ca. 1956 from: *Tambaran: An Encounter with Cultures in Decline in New Guinea*. Gardi, Rene

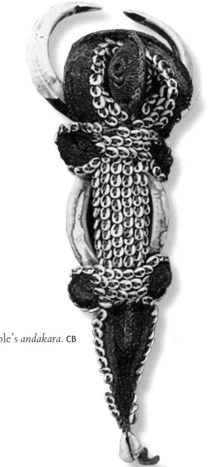

An example of the Wosera people's *andakara*. CB

279

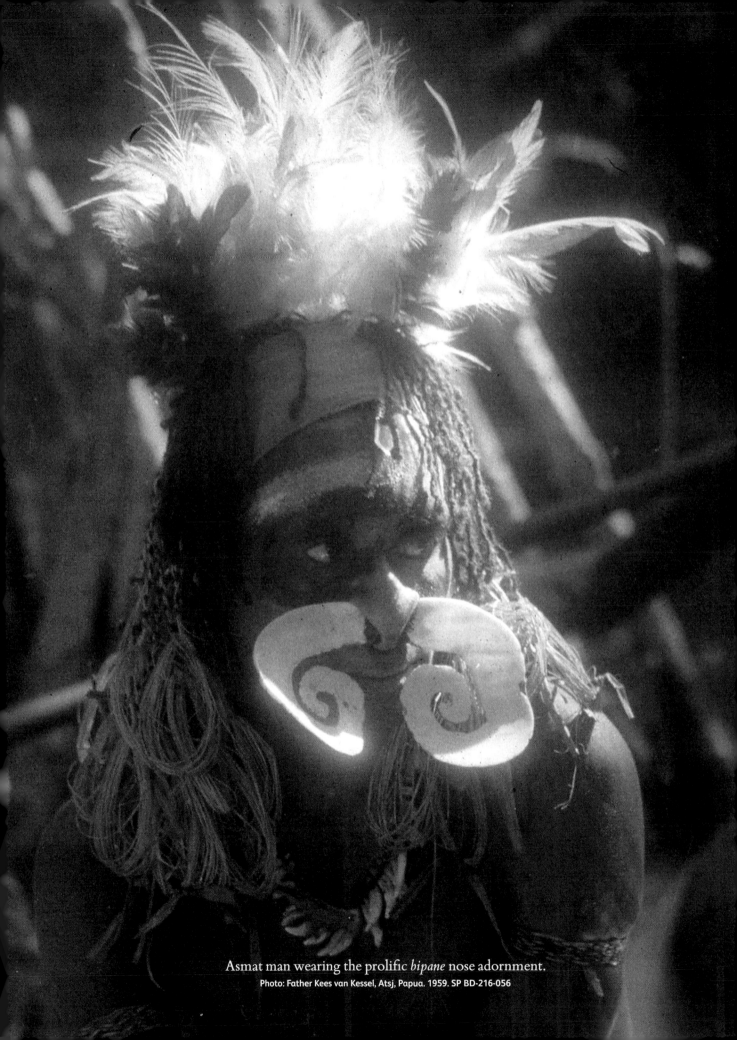

Asmat man wearing the prolific *bipane* nose adornment.
Photo: Father Kees van Kessel, Atsj, Papua. 1959. SP BD-216-056

Nose Adornments

Across the South Seas, it was common for the septum of the nose to be pierced, and a variety of objects inserted for adornment – the choice driven by local custom and limited only by the wearer's imagination.

The objects worn in or on the nose ranged from the modest to the most elaborate, and beyond to the almost unimaginable – such as the *Melo* shell 'tusk' adornments of the Asmat people of Papua – shown on the facing page. They are called *bipane* and are always intended to create a profound dramatic impression.

The image on the facing page was taken by Father Kees van Kessel in Papua in 1959. He was stationed at Atsj but had to return home after the disappearance of Michael Rockefeller in this area in November 1961. Before then van Kessel had also helped Pierre-Dominique Gaisseau and his team shoot the renowned movie *The sky above – The mud below*, released in 1961.

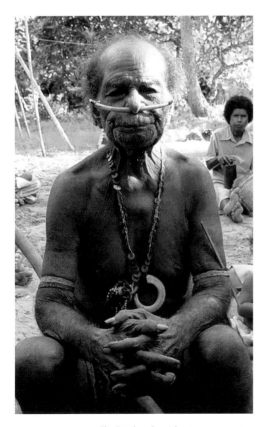

A man on Woodlark Island, Milne Bay, PNG. wearing a dramatic clam shell nose pin and a *dogadoga* imitation pig tusk necklace (also carved from clam shell). **Photo: RA**

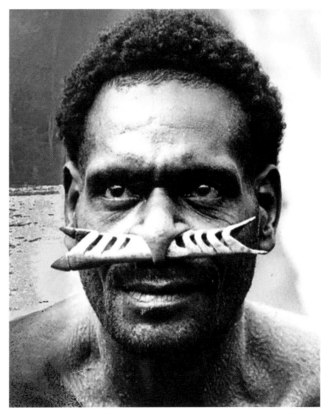

Carved bone nose adornment often seen in Papua adornments.
Photo: Antoon van der Wouw 1950. SP 20188

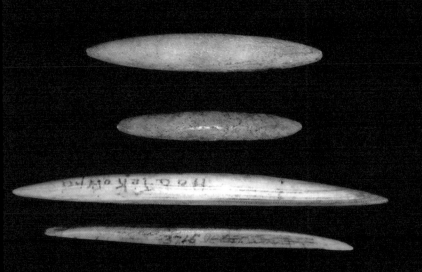

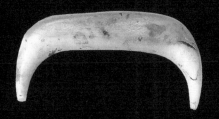

A nose pin carved from a fossil *Tridacna gigas* giant clam shell. These are highly valued for the yellow streak that is only found in the fossilised hinge of the clam shell. Rossel Island, Massim area. PNG. Size 55 mm. **RA**, **WG T0565**

From top, two nose pins made of stone, another carved from clam shell, size 138mm, **DI**, **WG T0312** and one carved from bone. 85 mm. **SA**, **WG T0134**

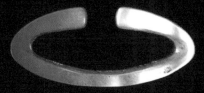

Pearl shell nose ring. Ramu River area, PNG. Size 50 mm. **GR**, **WG T0420**

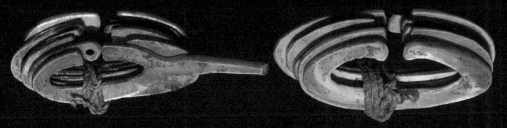

Graduated sets of pearl shell nose rings which were commonly worn in pre-contact times in the Ramu River area, PNG. **TB TB-2485 and TB-2484**

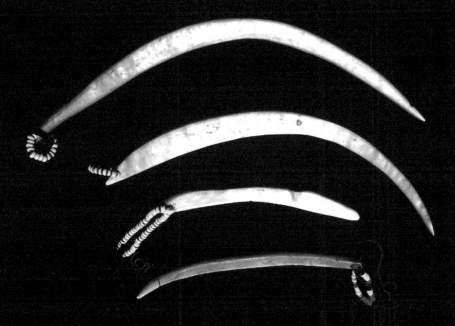

Four women's nose pins made of polished pearl-shell, ornamented with glass beads. Malaita, 'Are'are people, Solomon Islands. Size 80–180 mm. **GR**, **WG T0419**

Nose adornments

The adornments opposite illustrate the wide variety of styles and materials from which the nose adornments were made. Included here are examples made from stone, bone, clam shell, pearl shell and turtle shell.

Some nose pins were such important objects that they required their own bamboo case, such as these fine examples, both bound with natural fibres at each end, collected by Marion Clark in the late 1970s from Santa Cruz, the group of outlier islands of the Solomon Islands Group.

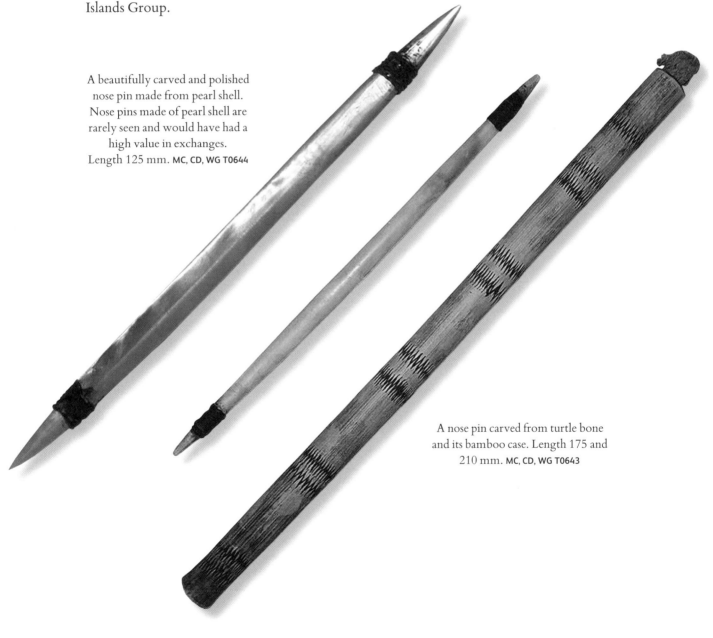

A beautifully carved and polished nose pin made from pearl shell. Nose pins made of pearl shell are rarely seen and would have had a high value in exchanges. Length 125 mm. **MC, CD, WG T0644**

A nose pin carved from turtle bone and its bamboo case. Length 175 and 210 mm. **MC, CD, WG T0643**

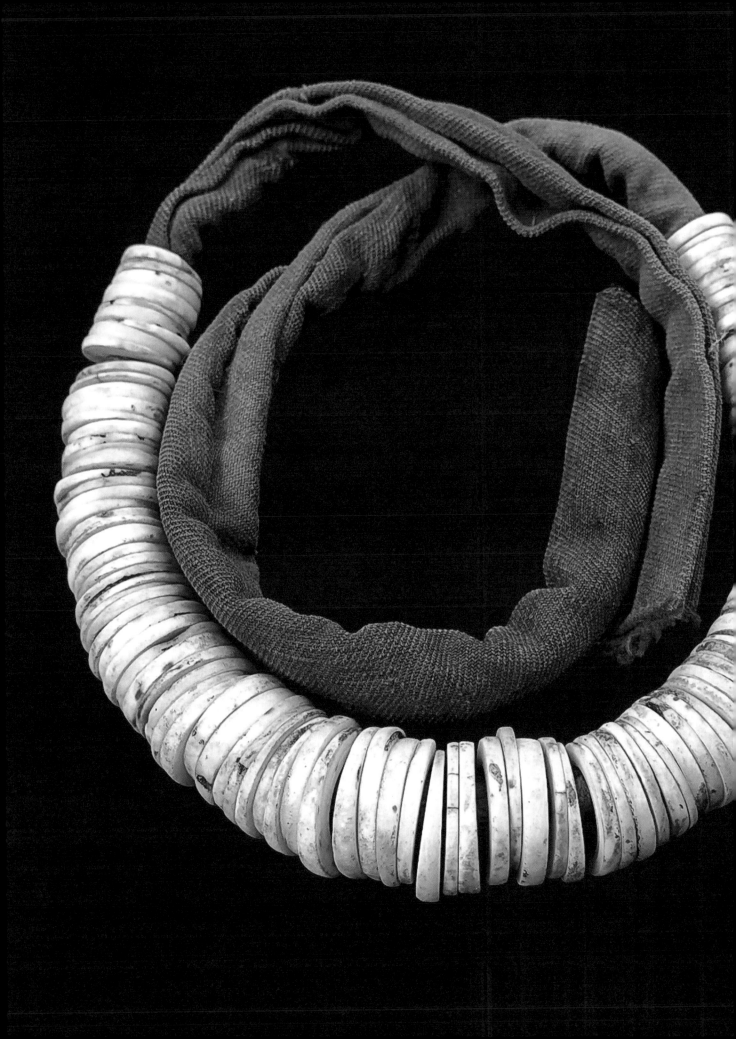

Leg adornments
Malaita, Solomon Islands

One of a pair of leg rattles, called *kete'ekome*, worn just below the knee by celebrants in Malaita, Solomon Islands. The rings are carved from the tops of large cone shells. Many are quite roughly made as in the example below, in the British Museum Collection. BM Oc1980,Q.348

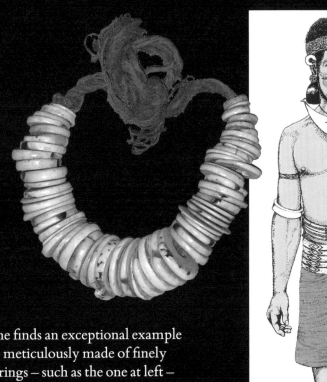

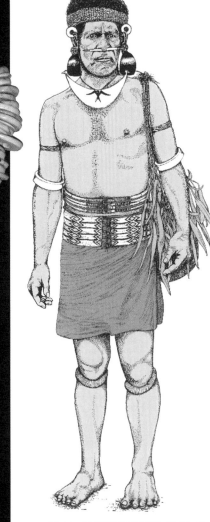

Occasionally one finds an exceptional example that has been meticulously made of finely polished shell rings – such as the one at left – each ring carefully tapered and cut with a large central hole to take the wide woven band. Length of ring section 270 mm. GR, WG T0480

Drawing: Ben Burt

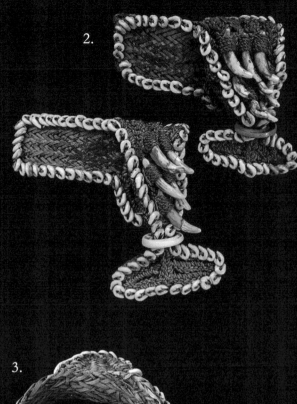

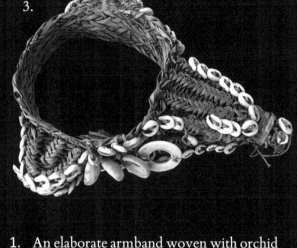

1. An elaborate armband woven with orchid fibres and Nassa shells – shown front and back. Huon Gulf. Size 390 x 190 mm. CB

2. Woven with dog teeth and Nassa shells, both have porcelain copies of cone shell rings attached. From Waresei Village, Washkuk Hills region of the Upper Sepik River. WG T0713

3. Woven with Nassa shells and polished cone shell tops. The armlet is said to represent the mouth of a crocodile (*bilong puk-puk*) as it moves up and down during dances. Boiken people, Yangoru District, East Sepik Province CH, WG T0276

4. Elaborate armbands made from cone shell sections bound onto sticks. Sometimes described as 'bowman's armbands' they are in fact more likely used in a ceremonial context than in warfare. Papuan Gulf. CB, WG T229

Arm adornments

New Guinea

Apart from the 'rings' used as armbands, which we have already discussed in this chapter, the variety of arm adornments made in the South Seas is truly astounding – from simple bunches of leaves to the most elaborate shell constructions – the additional adornments determined as much by tradition as personal choice. The examples on these pages illustrate typical New Guinea designs.

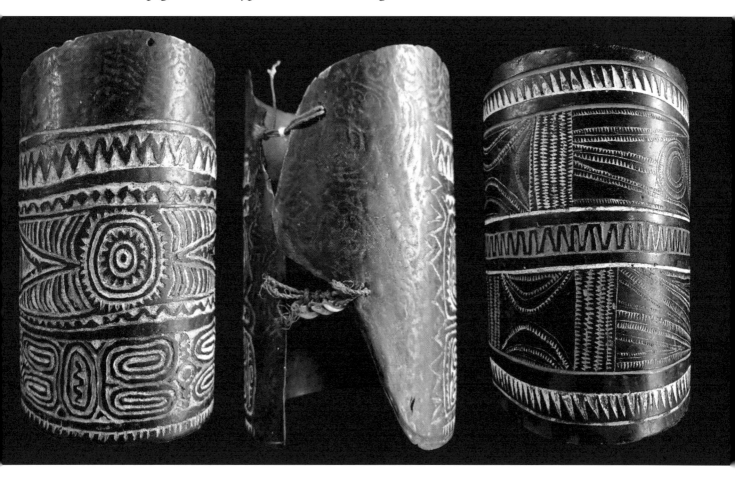

Carved turtle shell armbands from East Sepik Province filled with natural lime paint.
Left: Front and back view. RP, GR, WG T0394
Right: An armband additionally stained with red pigment. RP, GR, WG T0339

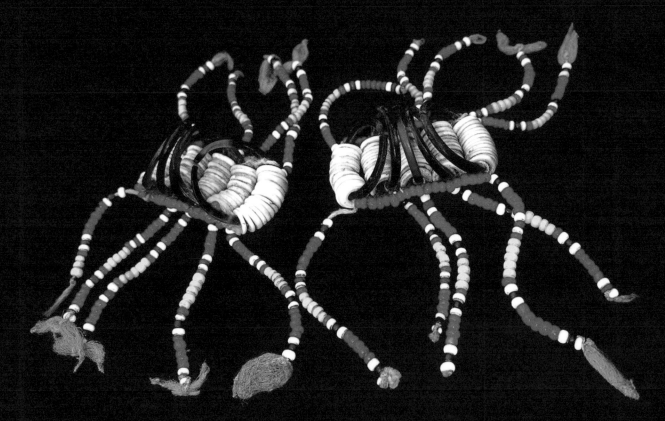

In these ear adornments each group of *soela* shell discs is
bound onto a turtle shell ring, with attached beads and
tufts of fibre. **WG T0417 and WG T0607/8**

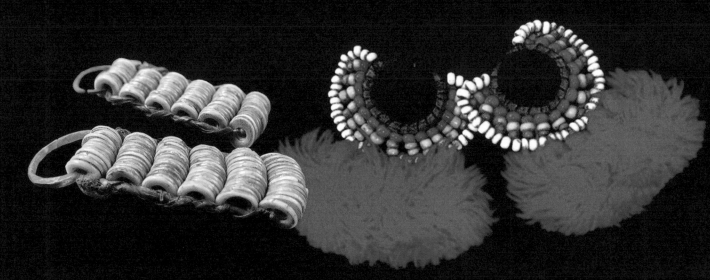

Ear adornments made of plain groups of *soela* discs
bound with orchid fibre and fitted with a turtle
shell ring for attachment to the ear. **WG T0489**

Decorative ear adornments based on turtle-
shell rings and glass beads and modern fibre
attached with fishing line. **GR 1970s, WG T0416**

Ear adornments Malaita, Solomon Islands
Turtle shell hoops and fine shell discs

To say that the people of Malaita have a fascination with ear adornments would be an understatement. The plethora of these discussed on the following pages gives just a sense of how prolific they were. Most seemed to have been made simply for the pleasure and prestige of adornment – without much spiritual emphasis – and subsequently used as exchange and currency items.

The ear adornments on this page feature the finest *soela* shell money beads that have been polished to make extremely smooth, flat discs with large centres, which are then bound with orchid fibre onto turtle shell rings.

A close-up of this highly decorative ear adornment reveals that the turtle-shell rings and glass beads have been attached with modern nylon fishing line and recent fibres have been attached to add colour.

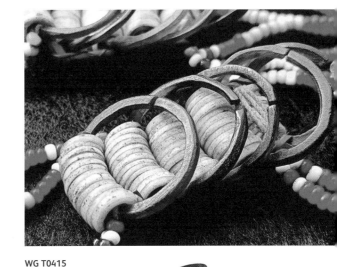

WG T0415

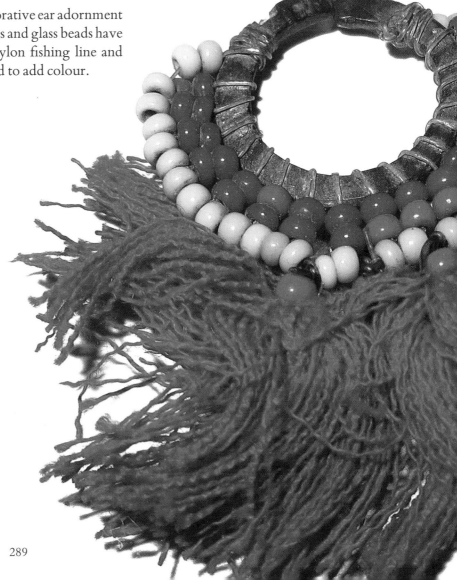

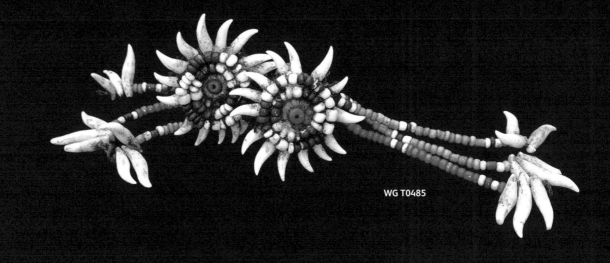

WG T0485

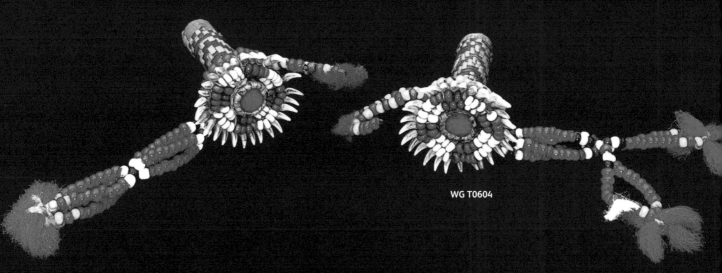

WG T0604

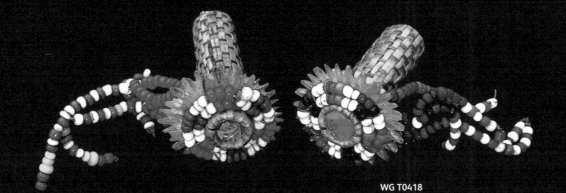

WG T0418

Ear adornments Malaita, Solomon Islands

Bamboo-trees

These bamboo-tree ear adornments are called *'ai'au* or *malenii`au* and are made on a bamboo stick base adorned with plaited orchid vine, occasionally coconut palm skin and other materials dyed red, orange or black. Finally, glass beads and various teeth have been added.

You can see, from the top two examples on the facing page, the vast difference in the size of the dolphin teeth that have been used, most likely from different species of dolphin. These ear adornments are from the South Seas Evangelical Mission and from the Melanesian Mission collections around the turn of the century.

In the object bottom left on the facing page, and in the drawing bottom right, the dolphin teeth clusters have been replaced by star-shaped shell carvings.

Probably the most iconic of all Solomon Islands ear adornments.

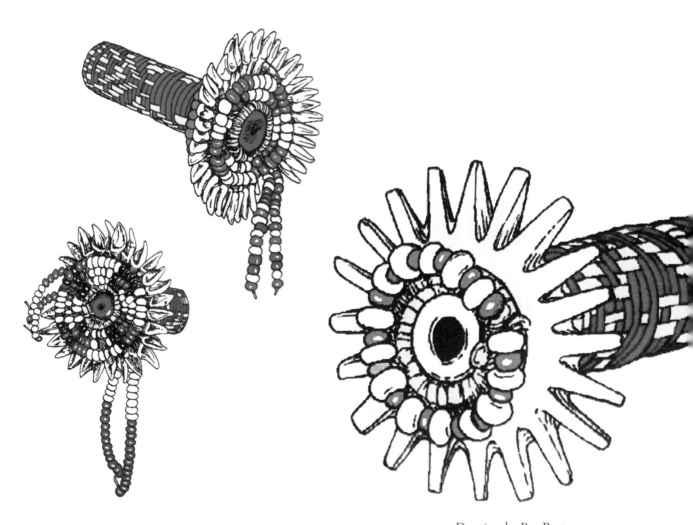

Drawings by Ben Burt

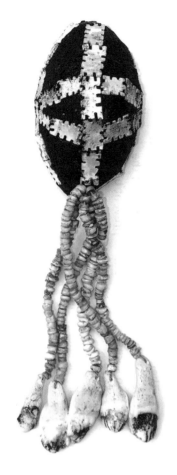

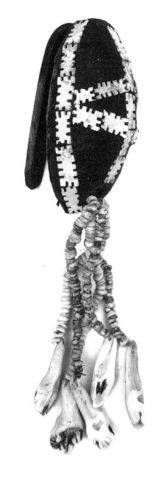

A pair of *ngari* nut ear adornments with typical *Nautilus* shell inlay, strands of *kofu* shell money and split human molars. They are from the 'Are'are people in southern Malaita. There are turtle shell 'hooks' integrated into the back for insertion into the ear.
LL, RD, WG T0211

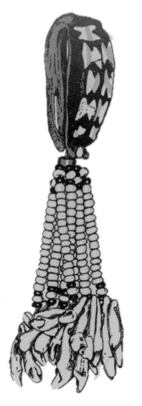

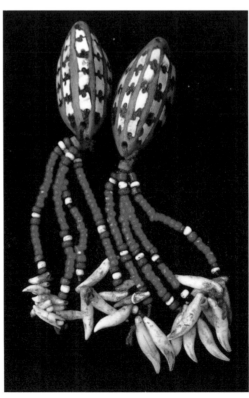

Far left: Ben Burt's drawing features a *ngari* nut ear adornment with glass beads and flying fox teeth.

Left: A recent example of a pair of *ngari* nut ear adornments from northern Malaita that feature glass beads and dolphin teeth. SK, WG T0486

Ear adornments Malaita, Solomon Islands

Nautilus shell inlays

These ear adornments, found only on Malaita, were made from halved *Canarium* nuts (local name *ngari*) with *Nautilus* shell tiles inlaid into *Parinarium* nut paste and adorned variously with teeth of various kinds – as shown in examples on these pages.

These were worn as pairs amongst the Kwaio and 'Are'are people. The Kwaio call these adornments *kwari'ingari* – which literally means 'cut *ngari* nut', but theirs have shorter strings, and they don't use human teeth. Others from the area feature glass bead tassels with various kinds of teeth attached.

Below is an unusual pair of ear adornments from Malaita made of carved turtle shell inlaid with circles of *Nautilus* shell and adorned with dolphin teeth and glass trade beads. According to David Akin these are called *ba'o*.

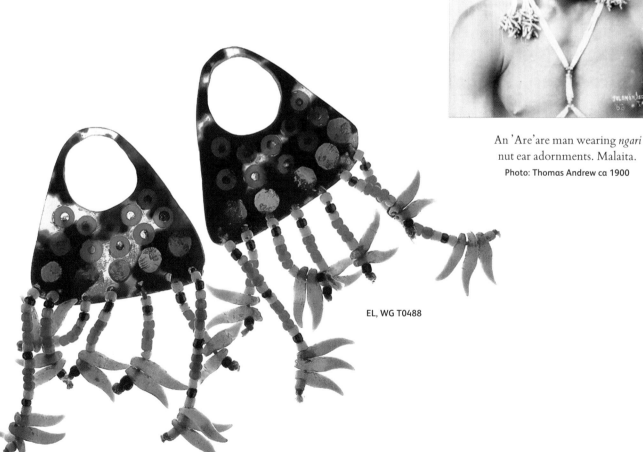

An 'Are'are man wearing *ngari* nut ear adornments. Malaita.
Photo: Thomas Andrew ca 1900

EL, WG T0488

293

Ear plugs carved from a lightweight wood, stained and *Nautilus* shell tiles set into *Parinarium* nut paste.

Below left: BM 1869 Oc.5162 and MM 93.1.15 ca. 1870, both with seed inlays in the centres.

Below right: This ear plug was originally collected by Alexander William Dobbie on Mokasi Island in the Roviana Lagoon, New Georgia, in 1899. Someone, recording details of the item later, incorrectly identified it as the "lid or stopper of a New Guinea coconut bottle", presumably because Dobbie spent more time in New Guinea than the Solomons. CD C1500, WG T0648

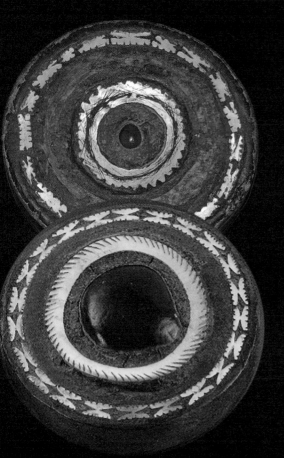

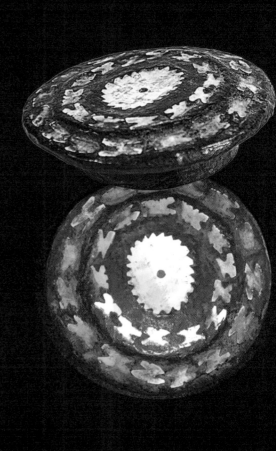

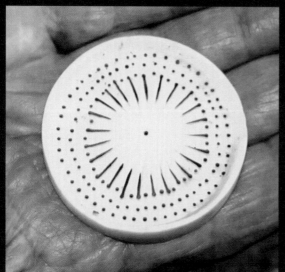

Superb *ulawa* clam shell ear adornment from Makira with fine holes and radiating slits cut into it. FR

Ear adornments Solomon Islands

Adorning extended ear lobes

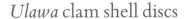

In the South Seas, pierced ear lobes might just be a small hole or the hole in the ear lobes could be gradually enlarged by inserting increasingly larger plugs, such as these simple clam shell plugs shown here, until eventually a substantial ring could be inserted.

This beautifully shaped Solomon Islands ear plug ring, carved from fossil *Tridacna* clam shell, would have been worn by men, women and even children, such as in the image at right.

For a serious statement of prestige, a more substantial adornment might be required, such as these rare earplugs shown on the facing page. Those at the top were carved from a lightweight wood, stained and have carved *Nautilus* shell tiles set into *Parinarium* nut paste.

A young boy wearing a clam shell ear plug. Roviana Lagoon, New Georgia Group. ca. 1900. Wellcome Collection.

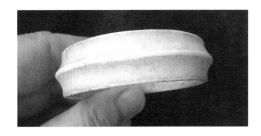

A beautifully shaped ear plug ring from New Georgia, Solomon Islands. Size 71 mm. **WG T0268**

Ulawa clam shell discs

The exceptional ear adornments at the bottom of the facing page were worn on Makira Island, where they were called *ulawa* (after a small island north of Makira where they were likely sourced), and southern Malaita, there called *eho*. They are made from finely polished clam shell discs that have radiating lines and holes cut into them. Examples from various museum and private collections show a remarkable consistency of design.

Ben Burt comments that, as shown in the example from the BM Collection at bottom right, they were worn tied with a string through the central hole and the two ear adornments linked by a string of money beads under the chin. They were sometimes supplemented with flying fox teeth, money beads and glass beads.

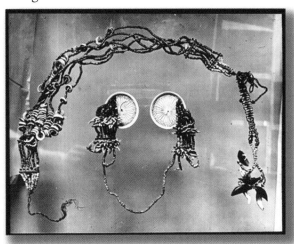

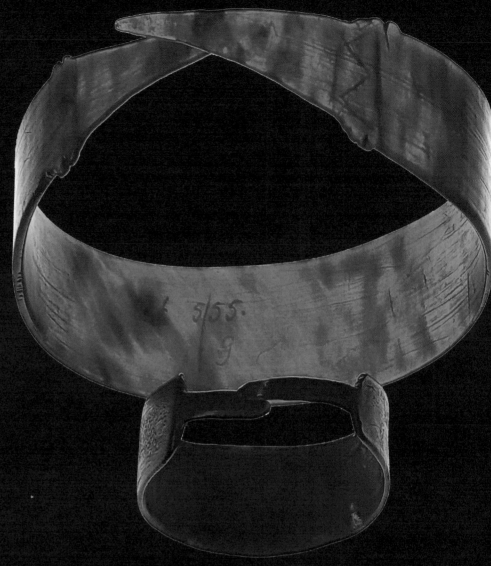

Two *ule`efonu* ear adornments from the eastern Kwaio people, Malaita, Solomon Islands. The larger ring clearly shows evidence of extensive hand polishing. Sizes 80 and 42 mm.

KL, WG T0582

The star-shaped ear adornments below were collected by Todd Barlin in Kaptiau Village, between Jayapura and Sarmi on the Papua north coast in the 1980s. Size 44 mm.

TB, CD C1094, WGT0519 and TB, CD, WGT0520

Ear adornments

Turtle shell was one of the most popular materials for making both ear and nose adornments, plus the attachment rings for many others.

The star-shaped ear adornments on the facing page are carved from clam shell and were attached to the ear with similar turtle shell rings.

Turtle shell was also extensively used across the South Seas to make large hoops used as ear adornments, such as the two Solomon Islands *ule`efonu* ear adornments on the facing page. They have pointed ends that fit through a hole in the ear and are usually worn during ceremonies by both men and women —as seen in the two images below.

Turtle shell hoops used to attach small shell rings.
Malaita, Solomon Islands. **Drawing BB**

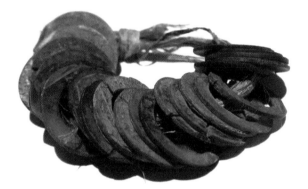

Turtle shell rings also used as currency, Solomon
Islands. **WG T0097**

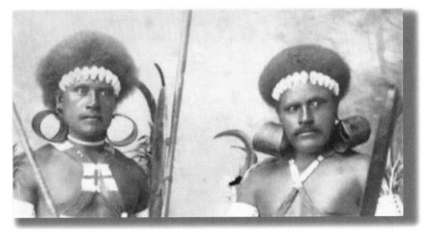

Two men wearing large turtle shell hoops as ear adornments at a ceremony.
Malaita, Solomon Islands. **AM**

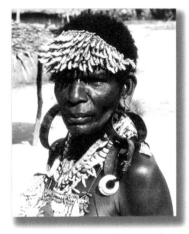

A woman wearing large turtle
shell hoops. Yuo Island (also
known as Guap), off the northern
coast of PNG. **Photo: HD**

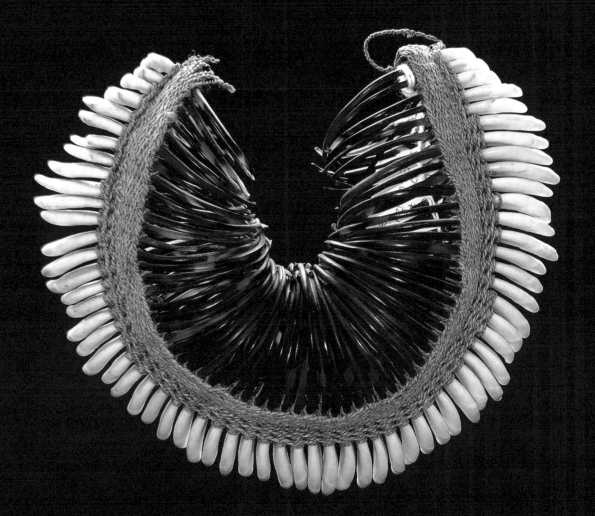

An Extremely rare *avako tapitapi* ear adornment made of turtle shell hoops and dog teeth woven into a natural fibre band. It would have been worn by women on ceremonial occasions. The two ends are said to have been attached and hung on the ear in a loop with the dog teeth pointing outwards as shown in this photo. Diameter : 170 mm. Between Elema (around Orokolo Bay) and Kerema, Gulf Province, PNG. RP, GR, WG T0368

This variation on a *avako tapitapi* ear adornment, the turtle shell hoops are delicately woven onto a thin natural fibre band. The clam shell ring was found with them, and it is possible that they were used together in an impressive delicate adornment, as shown. Alternatively, they may have been unrelated. Papuan Gulf. Diameter 140 mm. PC, WG T0709

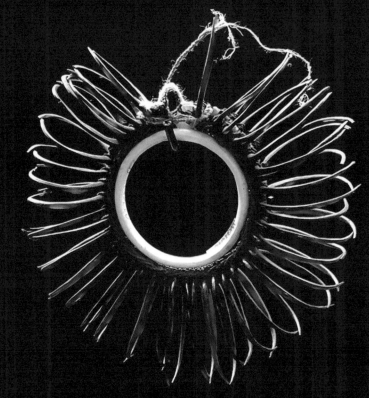

Ear adornments Papuan Gulf

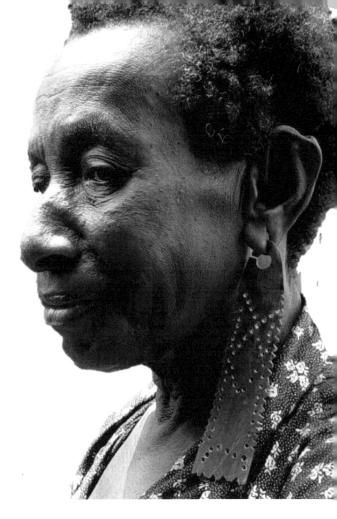

In my view, the adornments found around the Papuan Gulf are amongst the finest objects ever made in the South Seas.

While travelling around the Papuan Gulf, Richard Aldridge took this photo of a woman between Orokolo and Kerema wearing a turtle shell ear adornment that conforms to no known traditional form. It's a practical example of how local creativity in design has never flagged.

The two charming objects illustrated below come from the Papuan Gulf region, and may have been used as ear adornments or perhaps as charms. Both are made of vaguely anthropomorphic figures carved from turtle shell and strung with glass beads.

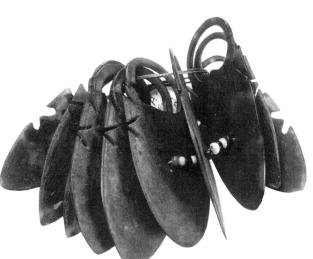

An iconic Papuan Gulf ear adornment.
Size: 65 x 30 x 55 mm. **WM-52713)**

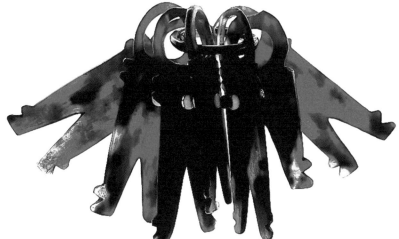

Adornment collected by Richard Aldridge in a small village just east of Kerema, the capital of Gulf Province in the early 2000s.
Size of each figure 50 mm. **RA. WGT0567**

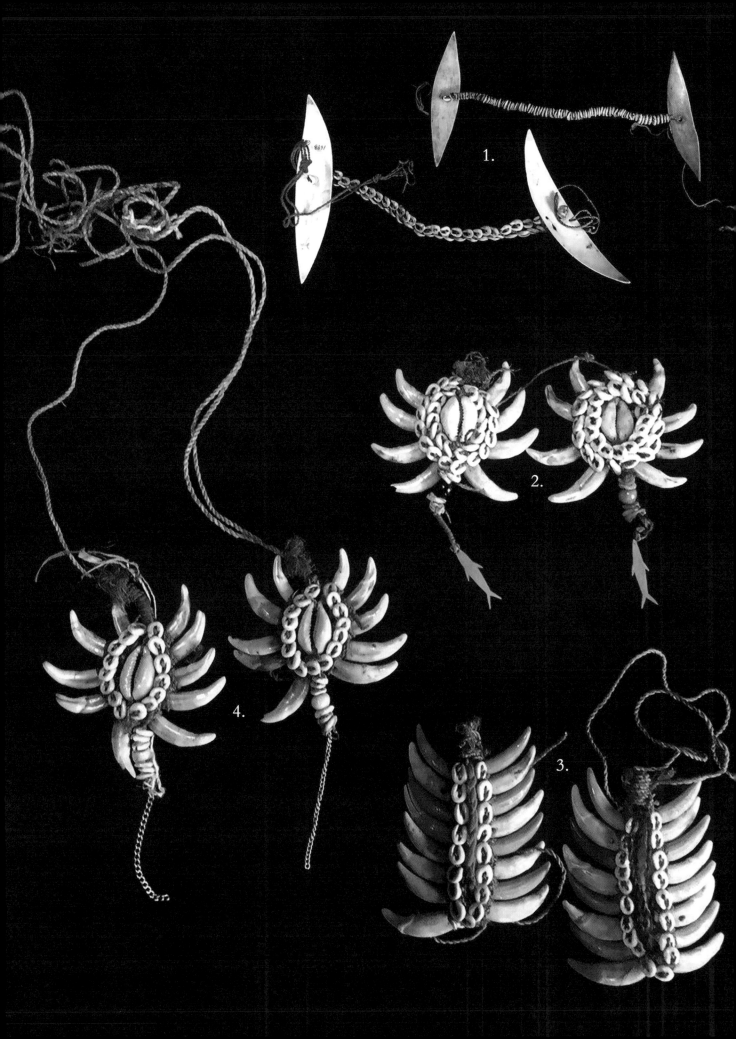

Ear adornments

Sepik River and Murik Lakes

These various ear adornments from around the Sepik River communities utilise shells and dog teeth bound with natural fibres in different combinations.

1. The top two adornments are made of strings of Nassa shells tied to carved bailer shell crescents. The Nassa shell band is worn on the forehead, with the crescents draped over the ears. This ceremonial attire may also be placed on important carved figures. Nukuma people, Washkuk village, Upper Sepik River, PNG. Size large 270 x 150 mm, small: 240 x 90mm. CB

2. A pair of *ara murop* ear adornments with dog teeth, Nassa and cowrie shells. This pair displays two orange fish, carved from plastic, likely added in the 20th century. Size 120 mm including fish. Aramut village, Murik Lakes, at the mouth of Sepik River. WG T0719

3 and 4. Two pairs of *ara murop* ear adornments with dog teeth, Nassa and cowrie shells and including some porcelain teeth imported during the German administration of northeast New Guinea in the 19th century. Size 80 mm and 100 mm. Aramut village, Murik Lakes, at the mouth of the Sepik River. CB

Ear adornments hung by a headband of woven coconut leaves to secure the dog teeth assembly. Note that this adornment also includes fish shapes likely cut from plastic. Aramut Village, Murik Lakes region, PNG. Photo: HD 1988

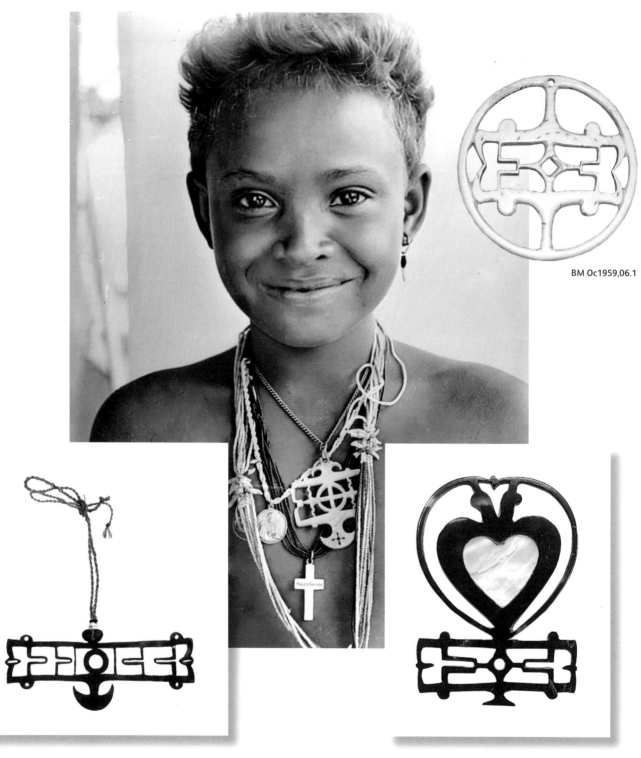

BM Oc1959,06.1

A tortoiseshell *hinuili* from New Georgia. It was collected in the early 20th century and measures 67 x 162 mm. **WG T0707**

The design of this early 20th century turtle shell *hinuili* adornment looks as if it could have been made for a loved one in the 21st century. Size 85 mm. **WG T0667**

Hinuili charms

Openwork shell pendants with abstracted frigate-bird motifs, worn at the neck, are characteristic of the central Solomon Islands, especially the New Georgia group, Santa Isabel and the Florida islands. They are known as *hinuili* in the Roviana language and were made from several different materials. From the early 20th century cross- and heart-shaped designs emerged. Opposite is a portrait of Hilda, the daughter of Melanesian Mission priest Reverend Geo. Gilandi, of Santa Isabel Island, north of Malaita, taken at about that time and showing her wearing several bead necklaces including two that show strong religious influence – a cross containing her name and a clam shell *hinuili* into which a cross has been integrated into the design. BM Oc,G.N.2151

The heart-shaped designs of some of these turtle shell *hinuili* adornments look as if they could have been made as a Valentine's Day gift for a loved one in the 21st century. However, this and other similar designs, such as the one below in Australian Museum Collection all date from the early 20th century.

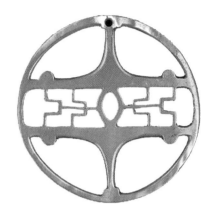

Above is a *hinuili* carved from pearl shell. It is 71 mm across and was collected on Simbo Island in the New Georgia Group. Facing page top right is one carved from *Conus* shell. Collected on Vella Lavella by Rev. Tom Dent 1921-1934. Size 69 mm.
BM Oc1944,02.1780

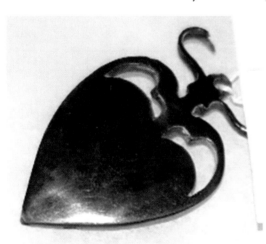

A *hinuili* charm in Australian Museum Collection
AM X 94072

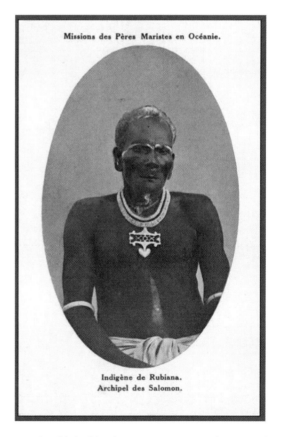

Missions des Pères Maristes en Océanie.

Indigène de Rubiana.
Archipel des Salomon.

A postcard published by the Marist Mission in the 1930s shows a man from Roviana Lagoon (Rubiana) on New Georgia Island wearing a *hinuili* charm. Note the addition of a heart-shaped design at the bottom of the charm.

Ten clam shell discs made into a necklace called *ketesa'ela'o*, which literally translates as a 'shell disc rattle', from the sound made when worn. The shell discs are engraved with abstract designs representing frigate birds and are strung together on natural fibre string with white money-beads laid edge-to-edge. Discs are around 60 x 40 mm each. NM, LL, RD, WG T0208

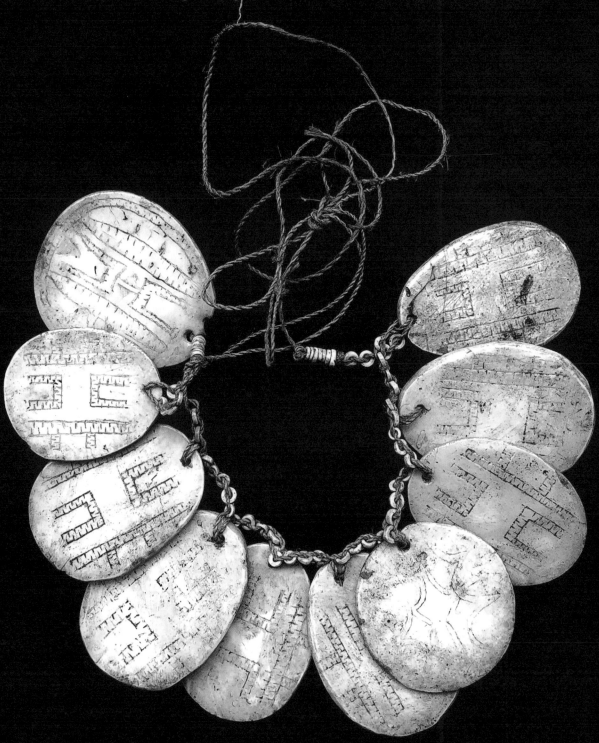

"The ketesa'ela'o *necklace is most interesting. It is a variant of a style from north Malaita in which the three frigate-bird motifs common to Malaita have been reduced to geometric shapes".*

Ben Burt

Sa'ela'o Solomon Islands clam shell discs
Abstract frigate bird designs

Bebe and *sa'ela'o* are the general terms used by the Kwaio and 'Are'are people of Malaita respectively for the clam shell discs worn around the neck.

The discs were cut and shaped from *Tridacna* clam shell, and the designs were cut with flint, primarily as abstractions of frigate birds, then stained with putty nut, ashes or dye from a tree berry. The most realistic designs clearly show two frigate birds diving off left and right, as can be seen in the example at centre below. Others are so symbolic that one can only imagine their origins. The examples on these pages give a hint of the range of designs used. There is also a symbolic link to the bonito, a fish so important in economic and ceremonial life.

The smaller discs could be worn singly, tied into the hair, or combined strung on necklaces, as in the example on the facing page. As with most objects, these engraved clam shell discs were exchanged far and wide.

Examples below: Sizes 76, 55, 50 mm. **WG T0584, WG T0583, WG T0429**

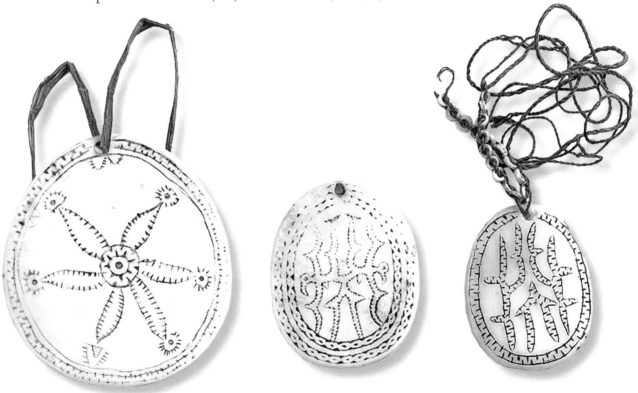

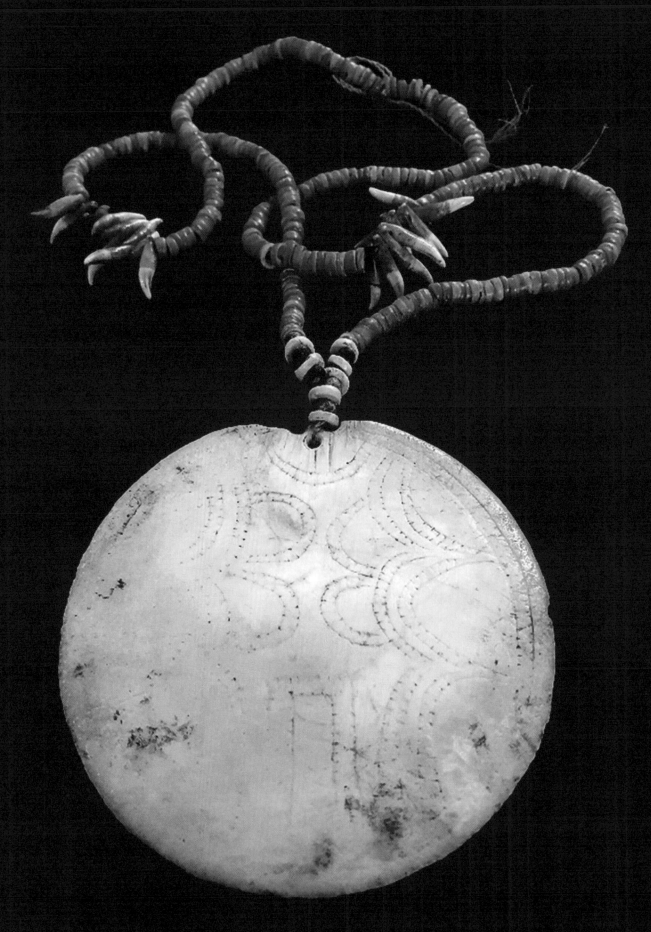

A *sa'ela'o doe* clam shell disc with a necklace of red *Spondylus* shell-money and flying fox teeth. Disc size 80 mm. SK, CD C1041, WG T0533

Sa'ela'o doe Solomon Islands large clam shell discs
Valuable heirlooms in north Malaita

While *dala* is the generic name for the distinctive clam shell discs from northern Malaita (a term also used for the local *kapkaps*), these large clam shell discs are called *sa'ela'o doe* (the words literally mean 'big clam shell disc) and were worn by the people of north Malaita on a band or string around the neck. They were important and valuable heirlooms, often associated with traditional tabu-speakers – the equivalent of preachers in the missionary context – and kept in their tabu-sanctums – the shrines of local clans. These objects were so precious that it was forbidden to treat them disrespectfully.

Again, most are incised with abstract frigate bird and bonito designs, while others feature star motifs.

This *sa'ela'o doe* on the right has a local version of the star design, where the tips of the star represent pairs of fish – a design that is said to have originated with the sea people of north Malaita. The engraved clam shell disc is attached by several strings of finely-made *kofu* shell-money. Originally collected by Barbara and Ron Perry in the 1970s. Disc size 98 mm. RP, GR, WG T0408

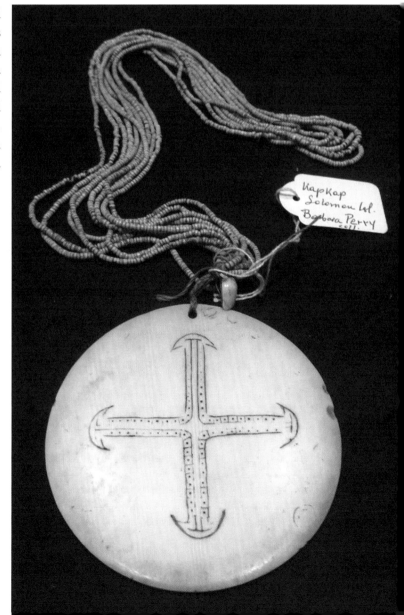

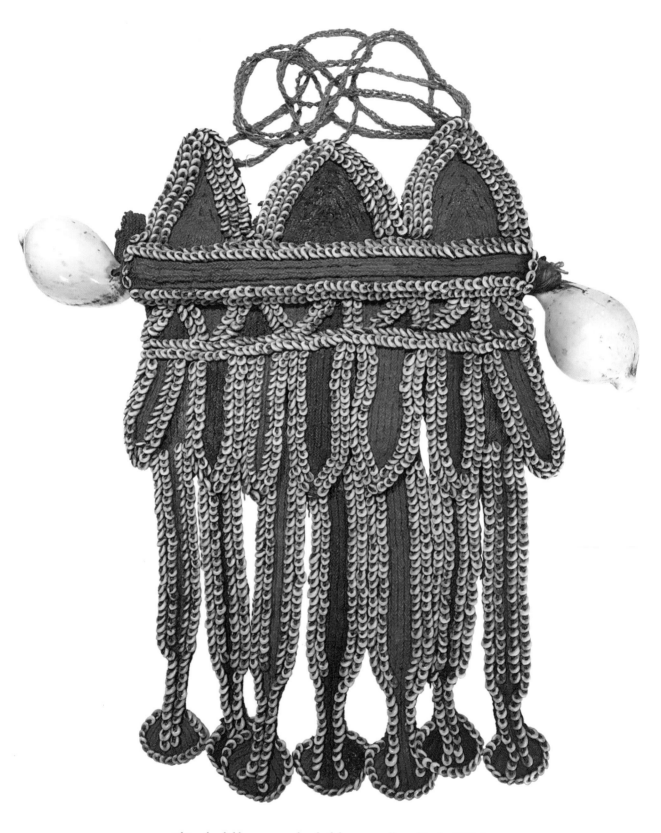

This splendid large example of a *fofana* was collected in the 1970s by
Barbara and Ron Perry. It is adorned with Nassa and *Ovula ovum* shells,
coloured with various pigments and has the added brightness of Reckitt
Blue. It is in exceptional condition. Size 400 mm. **RP, GR, WG T0431**

Chest adornments
New Guinea Highlands

The *fofona* or *siripaya* pectorals were made by the Benabena and Kamano people in the Eastern Highlands of New Guinea (on the Bena River near Goroka), woven by women and given to young men after their initiation. The men then coloured them with various pigments and adorned them with Nassa and *Ovula ovum* shells, the valuable 'egg cowries' that will have been traded from the coast. *Fofona* are an essential part of ceremonial adornment and are also used as a part of brideprice transactions. They are worn on the chest, or sometimes on the back, even occasionally held in the teeth, as shown in the photos at right.

CB 1980s

TB 1980s

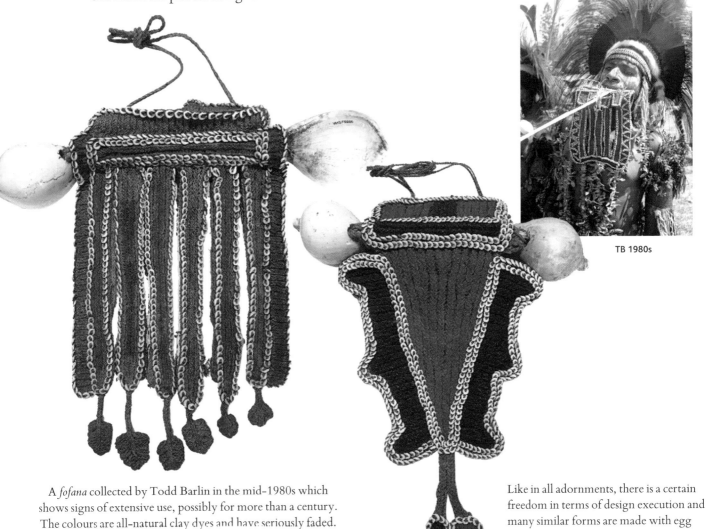

A *fofana* collected by Todd Barlin in the mid–1980s which shows signs of extensive use, possibly for more than a century. The colours are all–natural clay dyes and have seriously faded. One of the egg cowries has been replaced at some time during that period with a new shell. Size 290 mm. **TB, RD, WG T0205**

Like in all adornments, there is a certain freedom in terms of design execution and many similar forms are made with egg cowries central to the design, such as this one at right. Length 250 mm. **GR, WG T0430**

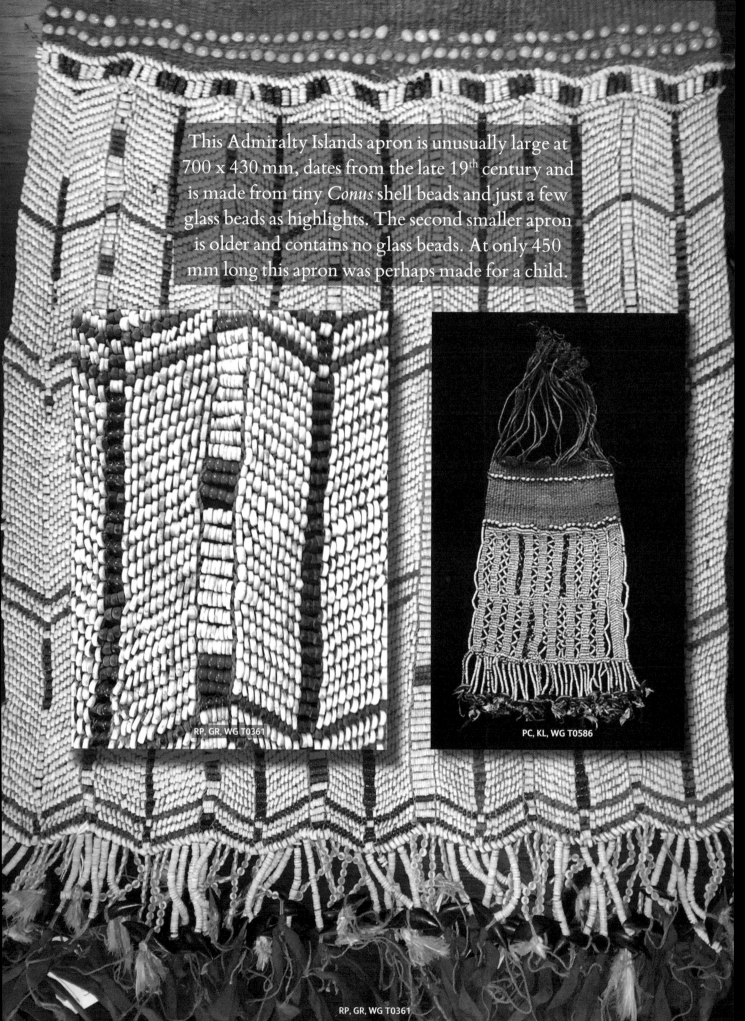

This Admiralty Islands apron is unusually large at 700 x 430 mm, dates from the late 19th century and is made from tiny *Conus* shell beads and just a few glass beads as highlights. The second smaller apron is older and contains no glass beads. At only 450 mm long this apron was perhaps made for a child.

RP, GR, WG T0361

PC, KL, WG T0586

RP, GR, WG T0361

Aprons and skirts
Admiralty Islands

In the northwest of the Bismarck Archipelago lie the Admiralty Islands. Here, magnificent ceremonial aprons called *nai* were woven from local natural fibres and adorned with thousands of almost unimaginably delicate shell beads. To these were added a few glass beads, Job's Tears seeds, cut seeds from the *Palaquium* tree and remnants of cloth and feathers. At marriage two *nai* aprons were part of the bride's wedding attire, one worn at the front and one at the back, secured by a waistband of beads and dogs' teeth (see overleaf for more details).

These shell beads deserve a closer look. Each one was delicately made from the top of a small *Conus* shell and polished into a smooth flat bead. The distinct cone shell spiral is still evident on one side of each of the beads – as can be seen clearly in the detailed image at right.

The time and skill involved in making these *Conus* shell beads was significant. Once 'cheaper' and more convenient European glass beads were brought in by missionaries and traders, they were extensively used to replace shell beads in Admiralty Islands aprons.

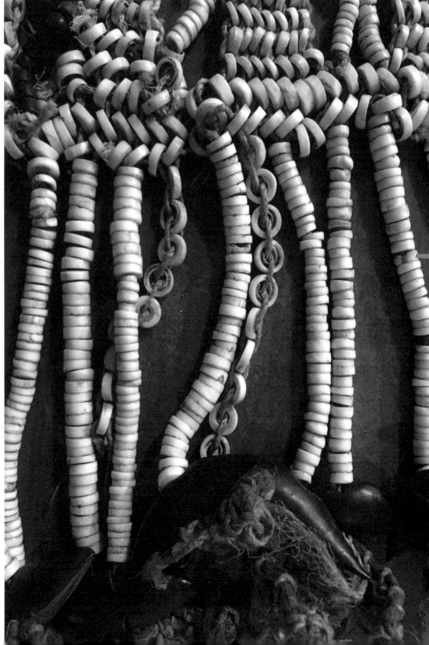

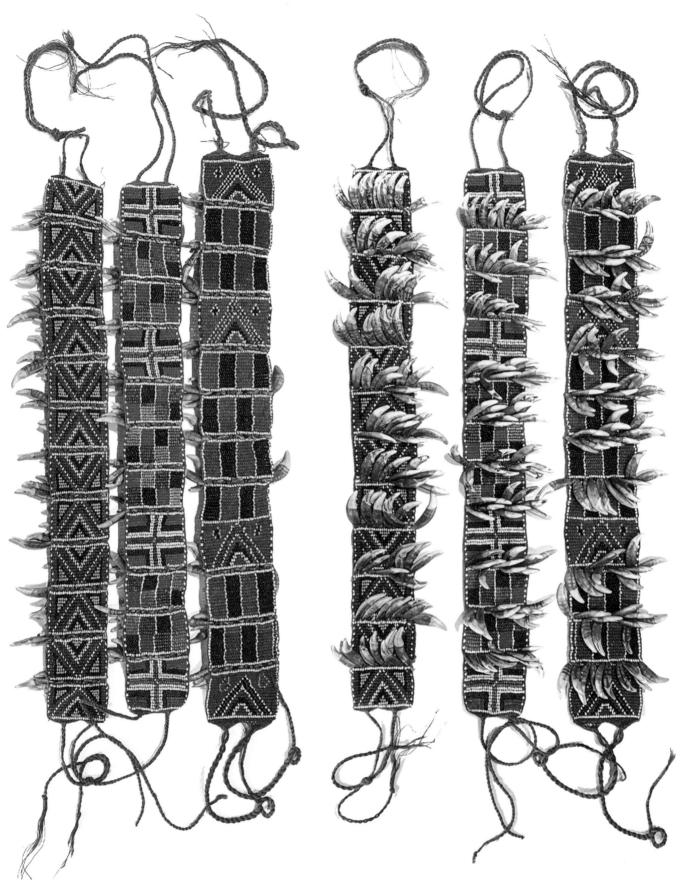

These headbands, likely woven on improvised looms – shown from both front and back –
feature glass beads and are adorned with elaborately engraved dogs' teeth. Traditionally the
teeth were strung in an approximately 10 x 10 pattern creating a fixed monetary value.
Men engraved the patterns onto the teeth and women wove the teeth into the beaded bands.
Size roughly 100 x 480 mm without the ties. RP, GR, WG T0358, WG bT0359, WG T0360

Beaded adornments

Admiralty Islands

If you see engraved dog teeth in the South Seas, then they likely originate from the Admiralty Islands. They were extensively used in the late 19th and early 20th centuries especially in headbands such as those shown opposite – both the teeth and the headbands were used as currency, and were an integral part of brideprice.

The evidence of glass beads is strong in these headbands, and it was a manifestation of the passion with which the Islanders embraced the arrival of these relatively cheap alternatives to hand-made shell beads, as used in the aprons shown on the previous pages.

At the height of this fashion, some adornments were completely covered in glass beads.

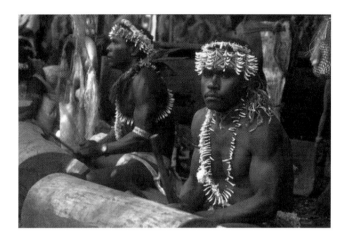

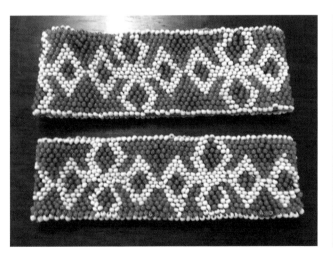

A pair of intricately patterned glass bead bracelets – part of bridal regalia. Size each 120 mm. **RP, GR, WG T0411**

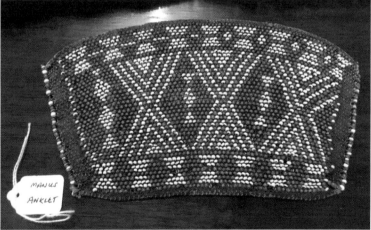

A rare leg/arm ornament made of glass beads woven onto a bark foundation. Size 250 mm. **RP, GR, WG T0412**

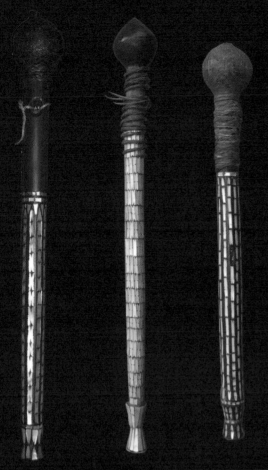

BM Oc1929,0713.87, Oc1914,0317.2, Oc1992,02.5

At left is a selection of 19ᵗʰ century Malaita ceremonial batons showing the variety of designs they encompassed. At right is a 20ᵗʰ century baton that has been made with all the classic materials, including an iron pyrite head encased in woven cane and orchid fibre strands, plus superb *Nautilus* shell tiles inlaid into *Parinarium* nut paste.

DA, CD C0428, WG T0513

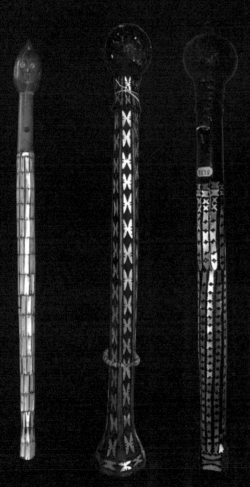

WG T0616, and two from VM

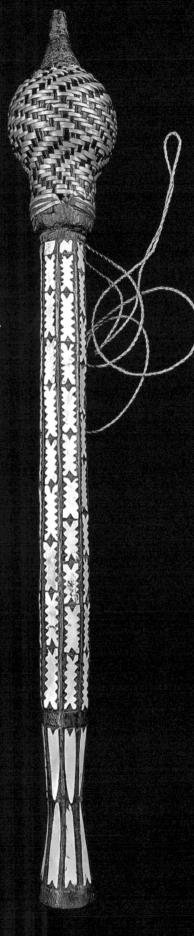

Warriors' prestige batons
Malaita

For the Kwaio people of Malaita in the Solomon Islands, *fou'atoleeleo* batons were a foreboding sight and a reminder of the business of killing and revenge. These ceremonial batons were worn hanging from a neck-cord between the shoulder-blades and only warriors of *lamo* status who had taken a life in battle could wear the baton.

The name *fou'atoleeleo*, sometimes written as *fou'atolēleo* instead of using the double-vowel *ee*, literally translates as 'stone and pearl' and comes from the practice of using a pyrite (iron pyrite, sometimes called *fool's gold*) nodule for the head, encased in woven cane and orchid-fibre strips. It is then attached to a wooden staff covered in finely cut pearly *Nautilus* shell tiles inlaid into *Parinarium* nut paste. The overall effect is quite iridescent. Although the knobbed head is traditionally made of pyrite there are regional differences and some 19th century batons even had wooden tops and were further adorned in a plethora of designs – such as the carved head with shell eyes in the example at right.

Killing ceremonies ceased to be performed after the colonial government abolished reward-killing from the 1920s but the batons continued to be made. According to Ben Burt: "People of Malaita have been making these as curios for visiting Whitemen since the start of the 20th century". The later examples are easily identified by their rather simple shell inlay, thin wooden staffs and plain turned wooden tops.

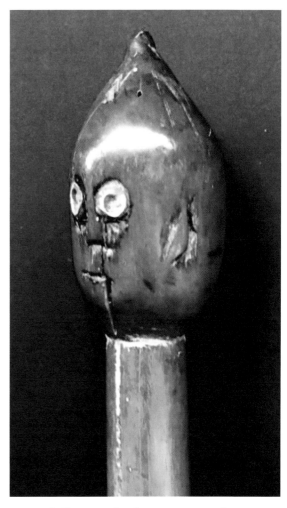

Detail of an unusual 19th century warriors' prestige baton **WG T0616**

Examples of late 20th century warriors' baton with simple designs and turned wooden heads.

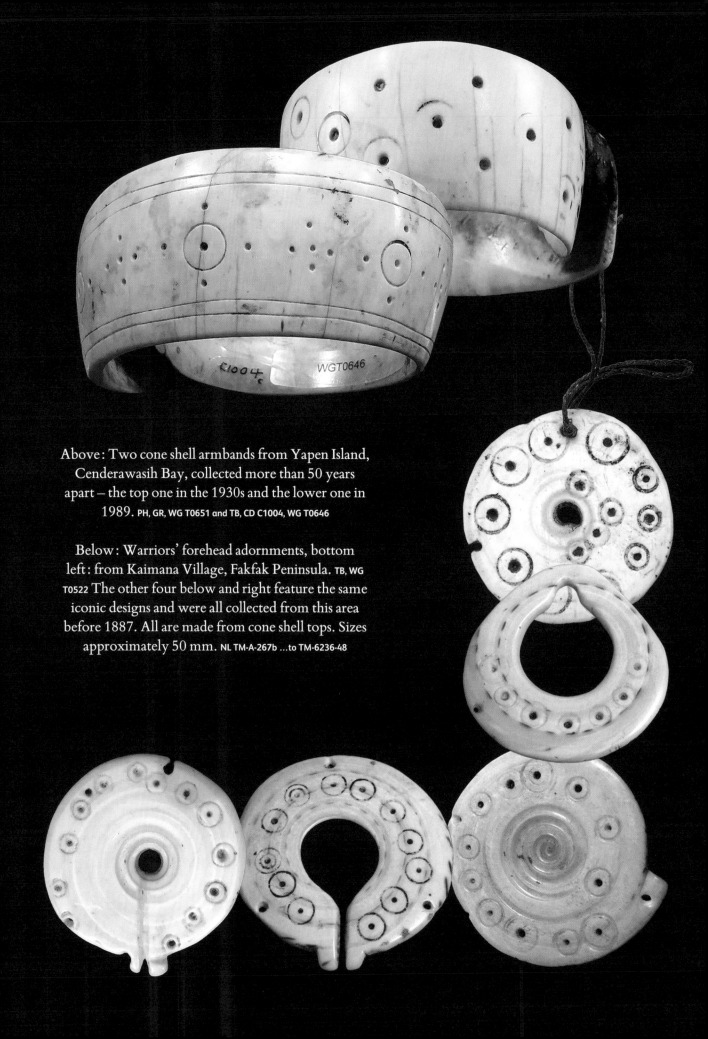

Above: Two cone shell armbands from Yapen Island, Cenderawasih Bay, collected more than 50 years apart – the top one in the 1930s and the lower one in 1989. PH, GR, WG T0651 and TB, CD C1004, WG T0646

Below: Warriors' forehead adornments, bottom left: from Kaimana Village, Fakfak Peninsula. TB, WG T0522 The other four below and right feature the same iconic designs and were all collected from this area before 1887. All are made from cone shell tops. Sizes approximately 50 mm. NL TM-A-267b ...to TM-6236-48

Circumpunct
Ancient symbols used in Papua

These iconic circular designs are repeatedly found on older objects from across western Papua, especially in its two western-most points – the Bird's Head and Bird's Tail (or *Fakfak*) peninsulas.

The *Conus* shell armbands and the warriors' forehead ornaments on the facing page, and the neck adornment below, all exhibit the same circular design style.

All these adornments were renowned as important trade items and the designs may well have been influenced by Malay traders' goods.

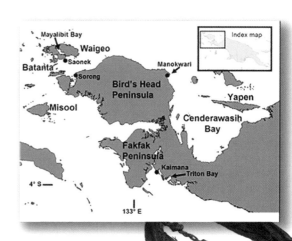

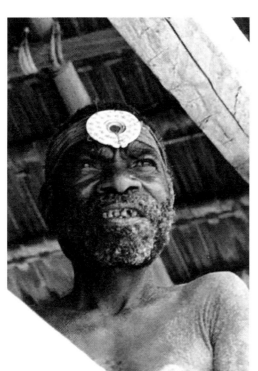

Obet Asentowi, 'the strongest man in Kebar', wearing his warriors' forehead adornment.
Photo: Jelle Miedema 1984

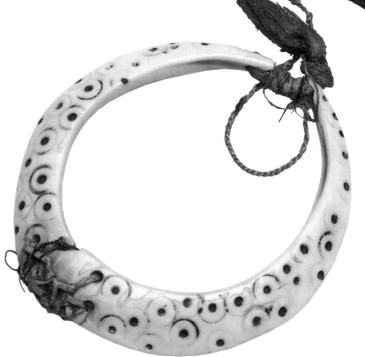

A neck adornment decorated with multiple circumpunct designs. Size 100 mm. **NL TM-A-255**

Circumpunct
The circled dot, or circle with a point at its centre, is an ancient symbol used in many cultures to represent the sun, moon, eternity and a spiritual whole.

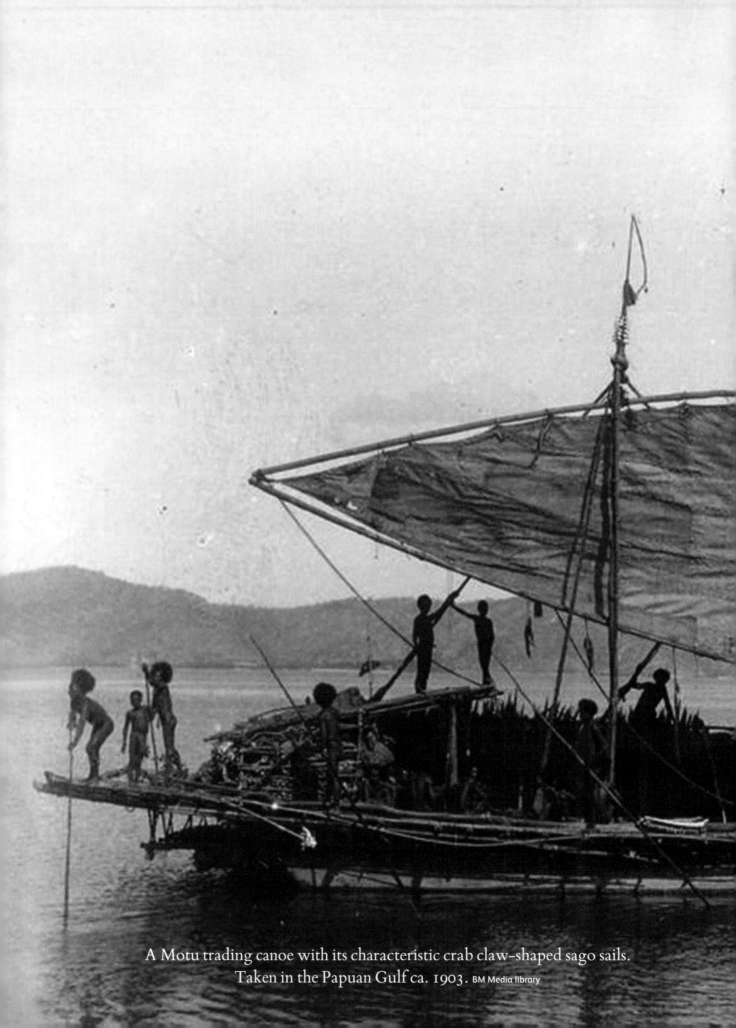

A Motu trading canoe with its characteristic crab claw-shaped sago sails.
Taken in the Papuan Gulf ca. 1903. BM Media library

VALUE
NETWORKS

Trade, currencies, relationships & material culture

The geography of objects

The Euro-centric view of "discovering the Pacific" is a nonsense. Its people were an integral part of extensive trading networks long before Europeans arrived. Networks of large ocean-going canoes sailed for weeks and months, plying the seas and islands in search of natural resources including wood, tropical oils and fabulous feathers for the adornment of royalty. In the 14th Century, royal headdresses of Persian and Ottoman officials were adorned with bird of paradise feathers, traded via Bengali merchants all the way from New Guinea to the Middle East. The kings of Nepal sought out the same feathers to adorn their jewel-encrusted crowns. The Chinese and Romans sought nutmeg and cloves from the 'Spice Islands'. The South Seas were already an established commercial destination long before Europeans even knew the Pacific Ocean existed.

Tiesler 1969

Malay, Arab, Portuguese and Chinese traders frequented the northern coasts of New Guinea, resulting in the locals being in much closer contact with the outside world than the rest of New Guinea. The north-east coasts had an active network of ocean-going canoes – from Tiesler's map you get some idea of the intensity of these trade routes. Continuing these sea-based networks from the coast to inland, precious items including pearl shells were actively traded overland along tortuous routes into the Highlands and the most remote valleys.

The peoples of the northwest coast of New Guinea, especially around Cenderawasih Bay (formerly Geelvink Bay) were seafaring

folk who traded wood, resins and bird of paradise feathers with the nearby Spice Islands.

The glass, shell, beads, textiles, iron objects and ceramics gained from this trade became valuable possessions and heirloom items – including these elegant teardrop-shaped glass objects which the local Waropen people called *dimbo*.

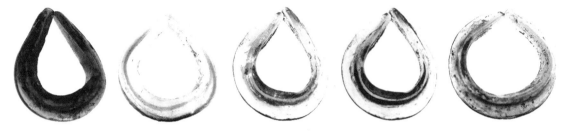

Confirmation that these rings were in fact used as ear adornments came from several glass rings found tied together with a turtle shell hoop – a style commonly used in the South Seas to attach ear adornments. **TB, WG T0668**

The *dimbo* rings were made from glass rods, T-shaped in cross-section, and bent into a teardrop shape with the ends almost touching. The rings typically measure 40 to 60 mm in diameter.

The Bowers Museum in Orange County, California, says that they are based on the glass adornments from the bronze-age culture of Vietnam, similar to those found in an archaeological dig at Lake Sentani, Papua, which unearthed Dong Song bronze age axe heads, kettle drums and ancient glass ornaments dating as far back as the 13th Century. They believe these rings to be more than 1,500 years old.

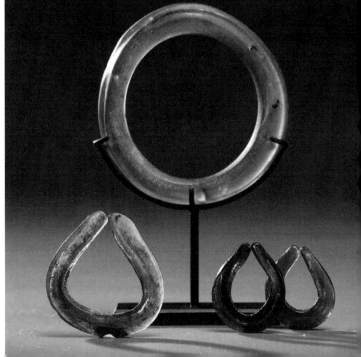

A few larger round rings, such as this example almost 150 mm across, could be of Roman origin and more the 2,000 years old. Collected around Cenderawasih Bay. **CB**

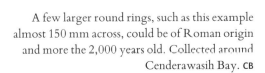

321

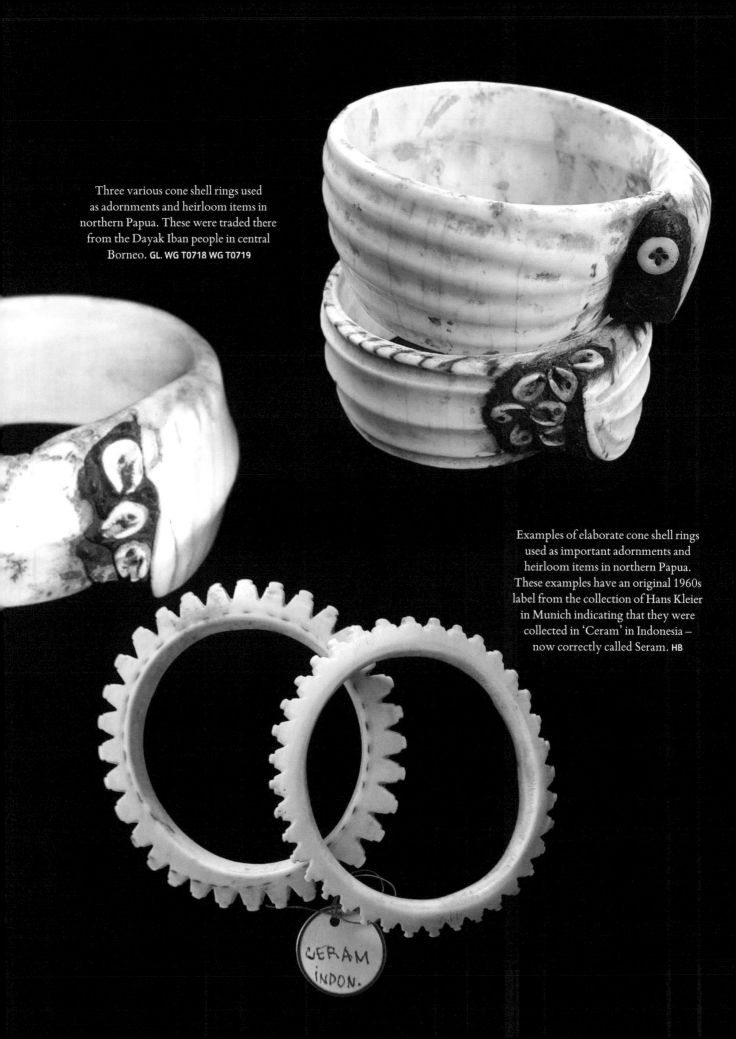

Three various cone shell rings used as adornments and heirloom items in northern Papua. These were traded there from the Dayak Iban people in central Borneo. **GL. WG T0718 WG T0719**

Examples of elaborate cone shell rings used as important adornments and heirloom items in northern Papua. These examples have an original 1960s label from the collection of Hans Kleier in Munich indicating that they were collected in 'Ceram' in Indonesia – now correctly called Seram. **HB**

Amongst trade items found in Papuan adornments and heirloom items are two kinds of beautiful *Conus* shell rings – the iconic design styles immediately hint at origins beyond the local cultures.

The first of these rings have delicately flowing carved ribs (typically two to four ribs, see top of facing page) that converge at the edge of the shell. The gap is filled with a natural putty into which halved Nassa shells are inserted (actually a button has been used to replace the lost Nassa shell in one of the examples). It has been established that these shell rings originated from the Dayak Iban people in the Sentarum Lake region of central Borneo – here they were called *simpa* and worn on the upper arm.

The second type of *Conus* shell rings found amongst precious adornments in Papua are the beautifully carved 'gear-shaped' rings shown at the bottom of the facing page and at right, being worn by a bridal party.

To me, their design appeared to be at odds with Papuan styles I had seen. My first impression was that they came from 'somewhere in SE Asia'. Subsequently, from some examples in a Dutch Museum, it turns out that they may originally have been made at the Pasar Ikan market in Old Batavia, Jakarta, Indonesia.

Such imported trade items were fashioned far away but highly revered in Papua as some of the most highly valued adornments – and used in exchanges and brideprice.

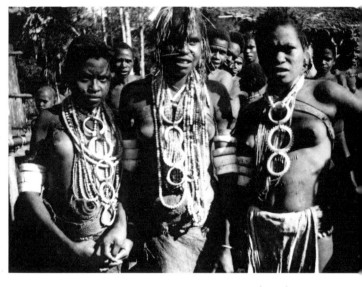

Women wearing gear-shaped rings at a bridal celebration at Aitinyo, Birds Head Peninsula, SP

Armband collected in Boela Bay on the north-east coast of Seram Island, Indonesia, located north of Ambon Island. 1900–1950 Size 85 mm. NL 7082-S-451-915

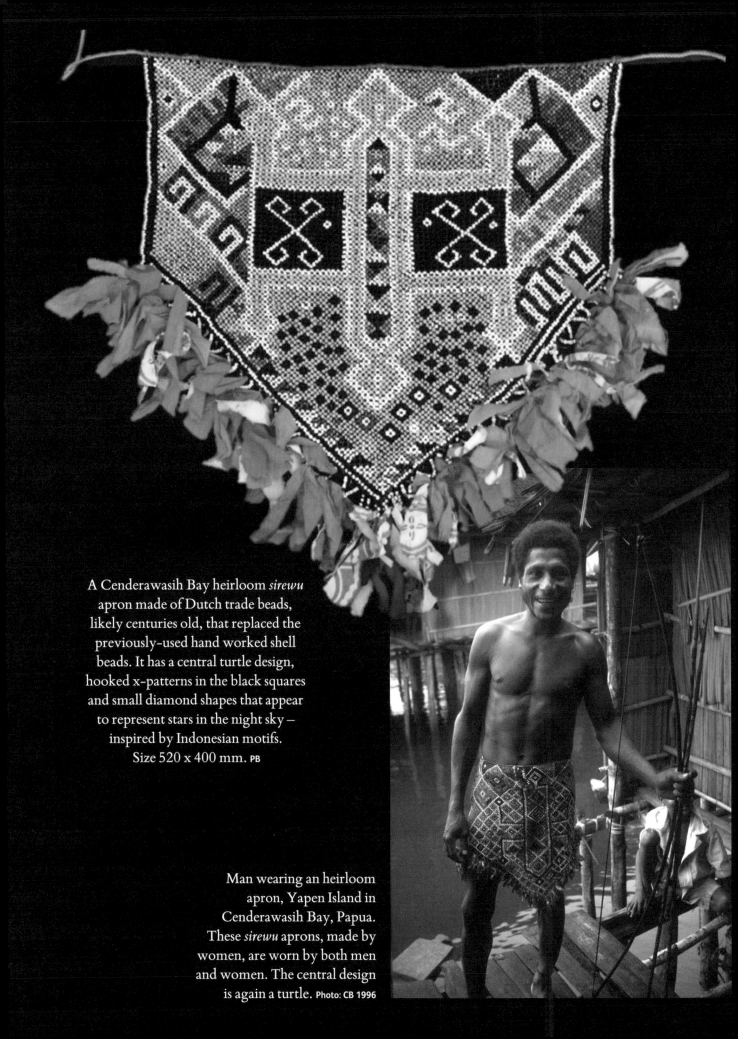

A Cenderawasih Bay heirloom *sirewu* apron made of Dutch trade beads, likely centuries old, that replaced the previously-used hand worked shell beads. It has a central turtle design, hooked x-patterns in the black squares and small diamond shapes that appear to represent stars in the night sky — inspired by Indonesian motifs. Size 520 x 400 mm. PB

Man wearing an heirloom apron, Yapen Island in Cenderawasih Bay, Papua. These *sirewu* aprons, made by women, are worn by both men and women. The central design is again a turtle. Photo: CB 1996

Imported designs and beads

Cenderawasih Bay

Aprons of varying styles have traditionally been worn throughout New Guinea, especially for festive occasions. The aprons of Cenderawasih Bay (formerly Geelvink Bay), in the northern Papua, were unique in having intricate and complex designs likely of Asian origin – and they were made from Dutch glass trade beads and adorned with shreds of imported cotton fabrics.

There has been much debate about the source of the complex patterns seen on the aprons. Are they copied from patterns seen on imported textiles and did these patterns have special meaning to the inhabitants of Cenderawasih Bay?

Certainly, many of the patterns resemble those found elsewhere on the Indonesian archipelago. Peter McCabe, of the University of Adelaide, relates that these 'hooked x-patterns' and 'square spirals' are common in textiles from Timor, Sulawesi and Borneo, so they would have been commonly encountered in trade with the Spice Islands. The inhabitants of Cenderawasih Bay speak a language that is similar to the other maritime-focused areas of northern New Guinea, such as the Bismarck Archipelago, but is quite distinct from the rest of the New Guinea language families.

Rather than just being copies of images borrowed from other cultures, the patterns seen in the aprons of Cenderawasih Bay appear to have had deep meaning for their wearers as they speak of their ancestors and mythologies. The aprons clearly reflect the unique culture and beliefs of the region.

Similarly, the turtle and other sea creatures depicted in the apron designs are so important in the mythology of the area, that many of their houses are built in the shape of turtles.

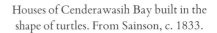

Houses of Cenderawasih Bay built in the shape of turtles. From Sainson, c. 1833.

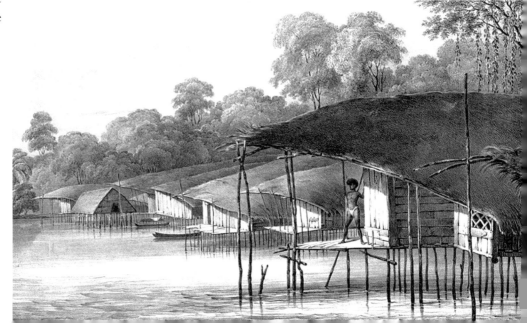

Australia. N. Queensland. 95-250.

Ornament composed of 29 small
rhomboidal & oval plates of nautilus shell
pierced in the centres & strung or tied
edge to edge on two-stranded brown string.
The plates diminishes in size from one end
to the other, though at the smaller end there
is a single larger oval plate.
 Mulgrave Blacks.
Forehead ornament, or fillet.

Presented by
Sir A. W. Franks. K.C.B.
20th. September. 1895

TS
174 IV

This *Nautilus* tile
forehead adornment with
accompanying note from the
British Museum Collection
Collected in Queensland but
likely traded from the Torres
Strait Islands. Oc1895,-.250

Nautilus tile necklace.
Collected in the Solomon
Islands and traded from the
Torres Strait Islands. SK, WG T0273

The *Nautilus* tiles of the Torres Strait

There are only a few records of these fine *Nautilus* shell adornments in New Guinea and the Solomon Islands. The two strands illustrated on the facing page were collected in the Solomon Islands.

The making of these unique adornments appears to be restricted to the Torres Strait and Australia's Cape York Peninsula – so it is likely that these adornments found their way to the Solomons via trade networks.

They are made from simple rectangular tiles cut from *Nautilus* shells and strung on natural fibre – with the shiny nacre of the inside of the *Nautilus* shell creating a startling effect. The other side of the tiles clearly shows the faded orange stripes of the outside of the *Nautilus* shell. Each tile is approximately 10 x 5 mm in size with a hole drilled centrally, although occasionally some are carved into an oval shape as in the British Museum example at far left. The note that accompanies this object records its use as a "forehead ornament". Other examples are much longer, or shorter, and with shorter ties – so likely were also used as bracelets and necklaces.

Monash University researcher Ian McNiven believes that in this case they could be related to the blackbirding industry – the coercion of people through kidnapping to work as slaves. Blackbirders could have obtained the items from the Torres Strait Islanders knowing they could use them as valuable barter objects in the Solomons, where they could have been used as exotic prestige objects by rich merchants.

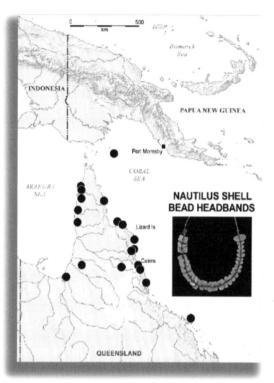

Ian McNiven, Monash University 2021

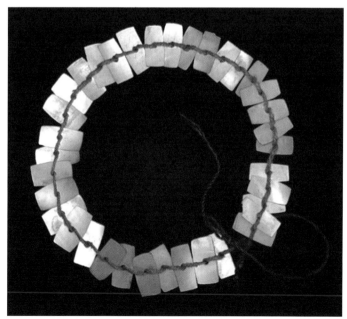

A *Nautilus* tile bracelet. Collected in the Solomon Islands and traded from the Torres Strait Islands. SK, WG T0181

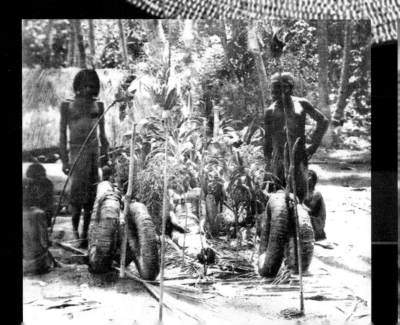

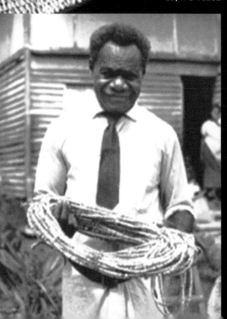

PRIMAL CURRENCIES

Nassa Shell Currency of the Tolai people

On the Gazelle Peninsula and the Duke of York Islands in New Britain, Papua New Guinea, Nassa shells have been the basis of an important currency and value system for centuries, intimately integrated into the Tolai people's culture.

The shells are collected by women on the north coasts, cleaned and bleached. Each shell is then placed into the 'eye' of a coconut and the top is removed by prising it off with a knife, creating a hole through which rattan fibres can be threaded. Value was traditionally measured in 'fathoms' – cane lengths threaded with Nassa shells, 6 feet (1.8 m) long.

When great lengths were accumulated, these were wound into a ring-shaped form called *loloi*. When they reached prodigious size, they were termed *tutuana*, and traditionally comprised 1,000 fathoms of shells, with the ring measuring around one metre or more in diameter – see images on these pages. These large shell currency rings are also shown on the ten-kina banknotes of PNG and on the official emblem of East New Britain Province.

Large *loloi* and *tutuana* wheels represent significant wealth items and are publicly displayed, giving much pride to their owners – as shown in the photos along the bottom of this spread – taken in 1895, 1965 and 1980 respectively.

These large wheels could also be used for settling disputes and 'payback', bartering for produce and in brideprice. It was also a customary method of acquiring land. During funeral ceremonies, rings would be cut up and distributed to family and friends as a way of showing their gratitude.

Smaller Nassa shell strings also found their way into a plethora of adornments, utilitarian and prestige items traded across the South Seas, a long way from their original use as a currency.

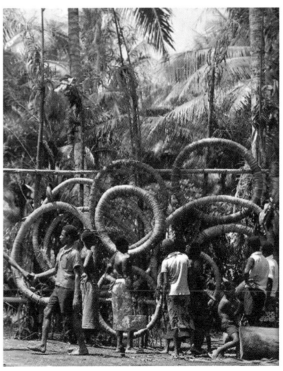

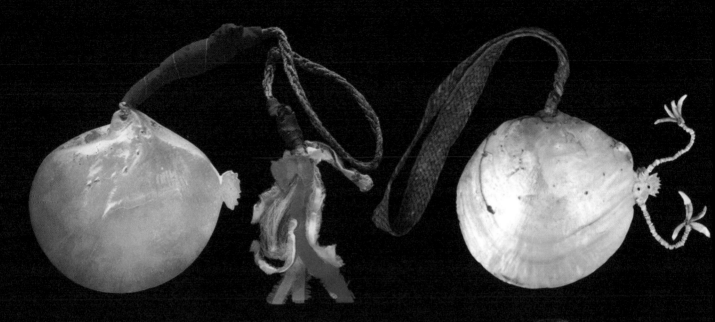

A *tuali* pearl shell currency decorated with colourful fibres on a woven band. Size approx. 190 mm.
EU 1991/33 Collection Bernhard Rabus

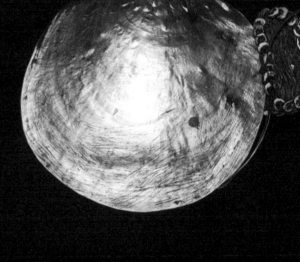

Top right: A *tuali* adorned with teeth, shell beads and woven fibre band. Size 225 mm. Arawe Island, southern coast of New Britain. WW June 2021

Right: This rather simple *tuali* has a woven fibre attachment adorned with Nassa shells. Size: 200 mm. Kandrian Village, Arawe Island, southern coast of New Britain. CD C.0323

Below: Strands of *vula* shell money used by the Kove and Kaliai people of New Britain. EU 2010/83

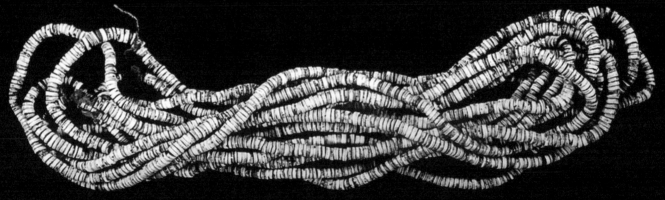

Shell currencies from New Britain

In New Britain, in addition to the ubiquitous Nassa shell currencies, pearl shells and shell money-beads were also used in exchange and worn as adornments.

On Arawe Island, pearl shells would be polished with stone, sand and water and cut to leave a projection, like an 'ear', on the edge of the shell. These were known as *tuali* or *euk* – highly valued as exchange, currency and prestige items. Special magic, only known to certain men, is required to successfully harvest the pearl shells and trade in *tuali*. Some of the most elaborate *tuali* were given names and kept hidden.

The Kove and Kaliai people of New Britain made money-beads from shells much in the style of the Solomon Islands Langalanga people. These *vula* shell beads are made from a variety of shell species, and they appear in brilliant colours, not just shades of brown, and were used primarily as money.

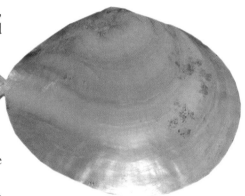

A plain unadorned *tuali*. Size 200 mm.
WG T0257

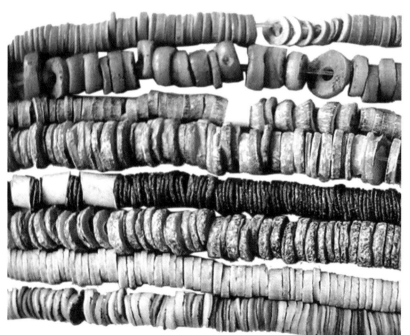

The variety of shell species used to make *vula* shell money. **EU 2010/83**

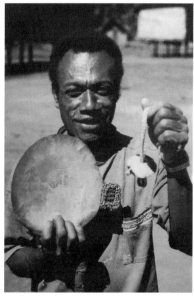

A large tuali proudly displayed in Eseli village.
EU: 1997/50. Photo by Thomas Lautz August 1993

A large *mokmok* stone currency called *singa*.
Size 155 x 140 mm. VK VI54960

Below: Two sides of a small *mokmok*
Size 35mm. SM, WG T0087

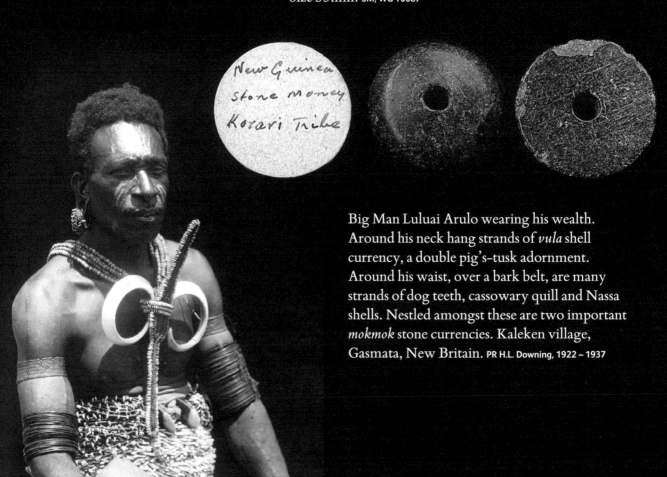

Big Man Luluai Arulo wearing his wealth.
Around his neck hang strands of *vula* shell
currency, a double pig's-tusk adornment.
Around his waist, over a bark belt, are many
strands of dog teeth, cassowary quill and Nassa
shells. Nestled amongst these are two important
mokmok stone currencies. Kaleken village,
Gasmata, New Britain. PR H.L. Downing, 1922 – 1937

Stone currencies of New Britain

Mokmok stone discs are the rarest and most prestigious of the New Britain currencies. The small and large *mokmok* stones were worn to demonstrate wealth and status. Only the *mokmok* stones, *vula* shell beads and *tuali* pearl shells are used in financial transactions in the area and become heirlooms passed down through generations.

Mokmoks were also used in 'special marriages', when the wife comes from another region, but never offered as part of Brideprice. *Mokmok* are owned by the bride's father, used to decorate the bride and then retained by him. *Mokmoks* are so highly prized that they are rarely seen, hidden from view in the forest, but their possession is equated with prestige and power of the highest order.

A 1996 Penn University expedition was "unable to persuade a native to part with a *mokmok* stone". The material from which these *mokmoks* are made is not native to southwest New Britain – their origin and age are shrouded in mystery and locals believe that *mokmoks* appeared to their ancestors in the ground.

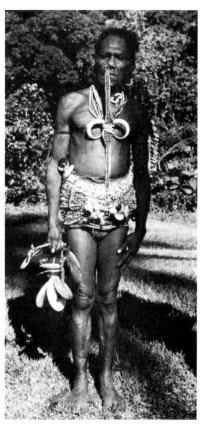

One of the most important Big Men in the Kaulong region carrying large *mokmok* stones in his hand, attesting to his superior wealth. He also wears small mokmok stones together with dogs' teeth and shell beads over a bark loincloth. Photo: Goodale 1962

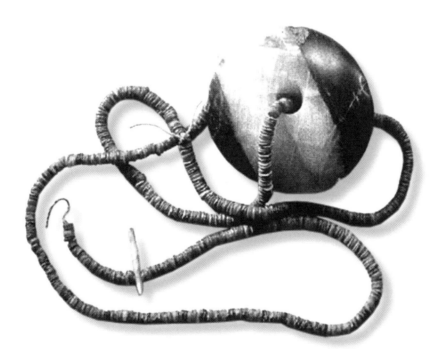

Vula shell money is often tied to the mokmok stone discs. **EU 2010/83**

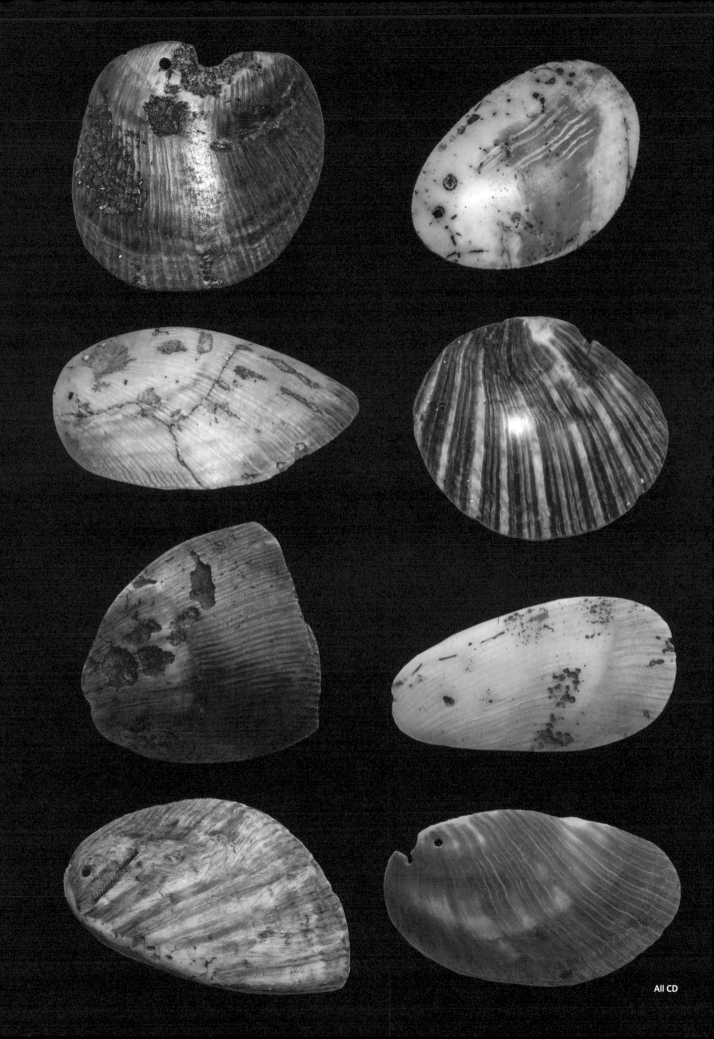

Rossel Island *ndap* currencies

Rossel Island is the eastern-most island in the Louisiade archipelago of far eastern New Guinea, truly a remote outlier. In 1859 a Chinese ship was wrecked on the reef and left 327 crew stranded on the island – two or three survived, the rest were eaten. When the first anthropologists arrived on the island in 1921, they found an isolated population of just 1,500 people with a unique culture and a fantastically complex system of shell currencies.

There are two major forms of shell money that are used for all the usual payments, from small casual purchases to important payments such as Brideprice, canoes, feasts or houses.

The first major form, *ndap*, are cut and polished fragments of *Spondylus* sp. shells (see facing page), shaped into oval or triangular pieces and drilled with holes. There are some 20 classes or ranks, depending on which shells or sub-classes authors decide to include. At the apex of the system is a shell called *Anowö*, which does not belong to any class – it is said to be so valuable that it has not been used in living memory. The classes are also divided into groups depending on their ownership and circulation – some are in free circulation, in payment for products or services, and may only remain with a recipient for hours or days, while others are permanently owned and only change ownership through inheritance.

The higher denominations of *ndap* were considered as sacred, made by the god *Wonajo*. The Islanders believed they were cannibals because *Wonajo* was a cannibal.

The most valuable *ndaps* all have individual names and the history of their ownership, and the recent generations is well known – not unlike some of the *Kula* valuables. The lowest value shells are all in free circulation – they change ownership in payment for products or services. If this sounds like it's getting a little complex, that's just because it is!

The second major form of the Rossel Island currencies, the *nko*, is discussed overleaf.

More intricate than any monetary system operating in modern economies.

Sacred money, made by the god Wonajo, *before man came to Rossel.*

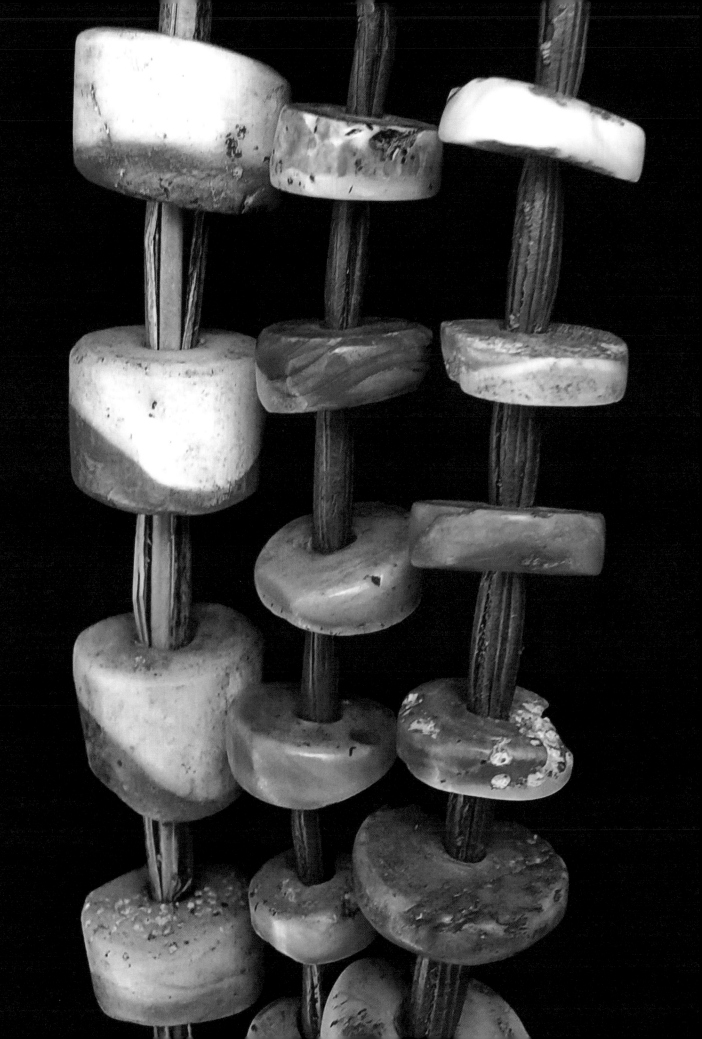

Rossel Island *nko* currencies

The second major form of Rossel Island currency is called *kö*, *kê*, or *nko* by various authors, and consists of strings of ten shell beads laced together, each strand making one *nko*. The rough beads are made from the thick hinge of the oyster-like *Chama imbricata* shells and from *Spondylus* sp. shells.

Nko is of lower value than *ndap* but there are 16 different denominations, each with its own specific weight and name. Six of those are illustrated in a group from my collection below. Armstrong, in his 1928 book on Rossel, estimates that only 800 of the *nko* strands remain, making any *nko* an item of the highest rarity, perhaps only surpassed by the Yap Stone Money.

With only a limited number of *ndap* in circulation, commercial transactions involved a ritualistic social interchange which could take days or weeks to complete, with dozens of people involved. In the early 20th century islanders were said to be unusually preoccupied with borrowing and repaying, dividing and apportioning.

Ndap and *nko* are of course not the only currency and exchange valuables used on Rossel Island. Others include ceremonial greenstone axeblades, red shell necklaces and ceremonial lime spatulas.

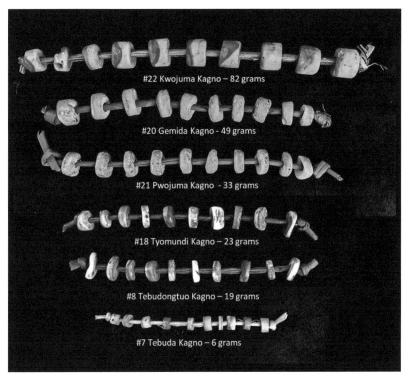

#22 Kwojuma Kagno – 82 grams

#20 Gemida Kagno - 49 grams

#21 Pwojuma Kagno - 33 grams

#18 Tyomundi Kagno – 23 grams

#8 Tebudongtuo Kagno – 19 grams

#7 Tebuda Kagno – 6 grams

RA, WG T0569 and WG T0510

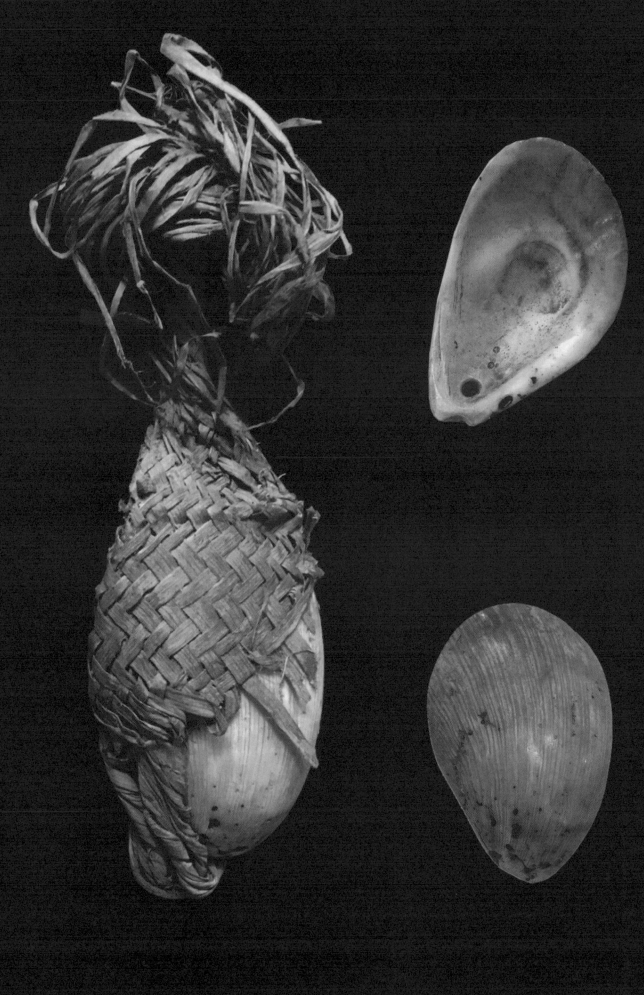

Sudest Island currency

The culture of the Rossel Island currencies escaped to neighbouring islands over time. One example is the *daveri* currency of Sudest Island – a polished *Spondylus* shell bound in a beautifully woven coconut leaf pouch. It was used as a ceremonial valuable hundreds of years ago and any remaining items are far rarer than the Rossel *ndaps*.

There is little difference between the Sudest Island currency and the Rossel Island *ndap* currency, apart from the very distinctive woven covering and sometimes larger shells. It is possible that the shells were originally traded from Rossel Island in the distant past, but little has been written about them.

"Tongue of the snake" Daveri shell money is believed to be the excrement of a mythical snake, and not made by human beings. It is believed it grows larger through magic when placed inside its woven fibre container.

Col Davidson

A variety of wrapped *daveri*. **RA, KK**

The man on the right is from Kimuta Island, part of the Renard Islands between Misima and Sudest in the Louisiade Archipelago. He is wearing an unusual pearl shell '*kina*-style' necklace – Kimuta Island is the only place where this particular style of adornment exists.

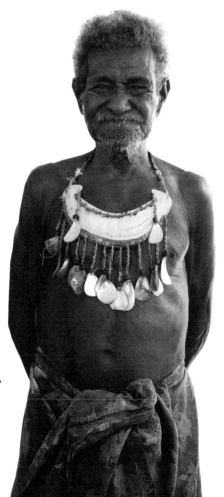

Photo RA

339

Kesa, Choiseul money, was once used all around the island. The people of Choiseul do not know when this shell money was made or who made it. In the minds of the old people, kesa is very valuable, and they have always cared for it like a baby.

Guso Piko, Choiseul elder, documenting *kesa* history in 1976.

A single cylinder carved from fossil giant clam shell is called a *mata* or *lupe*. They have an average diameter of 50-80 mm and a height of 40-60 mm. The walls are slightly convex internally with a thickness of 2-3 mm at the edge and 3-6 mm in the middle. CB, WG T0495

Most cylinders show the undulating growth lines of fossil *Tridacna* giant clam shell, especially when viewed against a strong light source.

Groups of three cylinders were wrapped in ivory-nut palm leaf, making up a *salaka*

Three packets of *salaka* together represent one unit of *kesa*. SK, CD, WG T0517

Although these currency rings from Choiseul are called *kesa* in most modern literature, in the Avasö language of Choiseul these rings are called *kisa*. The word *kesa* actually comes from Katova, an extinct language of Santa Isabel Island in the Solomon Islands. Its last speaker died in 1984.

Choiseul *kesa* currency

These extremely fine and delicate cylinders, made from fossilised giant clam shells, were an important unit of currency, exchange and prestige on Choiseul Island (commonly known as Lauru to locals) in the Solomon Islands in the 18th and 19th centuries. These rings or cylinders were never worn or used as adornments.

Production of these cylinders was limited to the small island of Nuatambu off the east coast of Choiseul. Exactly when and how these were made remains a mystery despite exhaustive research over the last century. In 1911, Reverend Roney reported that no person could be found who remembered anything about their manufacture and by the 1970s, supplies had dwindled and *kesa* was no longer in use as currency. What is clear is that the fossil deposit from which these unique rings were produced was only available locally, and when exhausted there was no other similar material available.

During exchange measurements were taken and checked against the record marks on the owner's war club handle to ensure that the money was the one that they intended to exchange. It was a strong tradition that people always knew how much *kesa* money each chief possessed – a notable case of openness and trust.

Kesa was often buried in the ground or stored in caves for safety from raids and that would explain the weathered nature of some of the cylinders. They were wrapped in ivory-nut palm leaves and the *kesa* parcels were re-wrapped occasionally to keep them safe. This would literally be a time for renewal or *noke* – the ceremony being called *Vinggikisa* in the Avasö language of Choiseul. This would be the time to "pay accounts, settle compensations or to buy a woman" – only experts could handle such an event.

During exchange all nine cylinders had to stand on top of each other quite freely as this 1950s photo shows. They had to fit perfectly, be balanced and level. This made it a *Perfect Kesa*.

Chiefs in the old days had kesa *identity marks on the handles of their war clubs – like the 'Bank Pass Book' of the Europeans. It showed how many* kesa *the owner had, as well as their values.*

Guso Piko, Choiseul elder 1976

PERVASIVE VALUE NETWORKS

Less than one hundred years ago, European explorers could only conjecture at the possibility of people living in the New Guinea Highlands, let alone at the expansive material culture networks that connected these groups to coastal and island populations.

Dylan Gaffney in *The Emergence of Shell Valuable Exchange in the New Guinea Highlands*

In the 18th century, in many South Sea cultures, shell objects were the dominant form of payment. Based on these, complex local exchange structures and expansive economic networks developed, linking disparate groups into powerful, mutually beneficial relationships lasting hundreds of years. Rather than being a barrier, the sea became a highway of exploration, new relationships and exchange for the peoples of the Pacific. Think of value networks building cultural bridges and fostering economic development.

A bit of an aside: I joined IBM in the 1970s when some staffers could still remember the company's original slogan *World Peace through World Trade* – coined by Thomas Watson Sr. before WWII and expressing his personal faith in open borders and free trade. It is fascinating to compare the aspirations of a 20th century company with the traditional economic structures in the South Seas, where a delicate balance was achieved between trading and relationships, gift-giving and reciprocity, all with powerful spiritual underpinnings. In areas riven by tribal wars, these developing aspirations bound together culturally and linguistically heterogeneous groups, replacing violence with mostly peaceful trading relationships.

In the Papua New Guinea Highlands, the great *Moka* and *Te* exchange networks established inter-clan frameworks that turned warlike confrontations into peaceful outcomes via compensations. The *Hiri* voyages across the Papuan Gulf and the *Kula* Ring amongst the Massim people bonded hundreds of islands and go back more than 500 years – with vast social and economic implications. On the Rossel and Sudest islands in the Louisiade Archipelago shell objects were made and used as currencies in a dazzlingly complex economic system for a period spanning more than 2,000 years.

As we have already seen, sophisticated *kapkap* adornments were made and exchanged across the South Seas, especially between the Bismarck archipelago and the Solomon Islands, since the late 18th century.

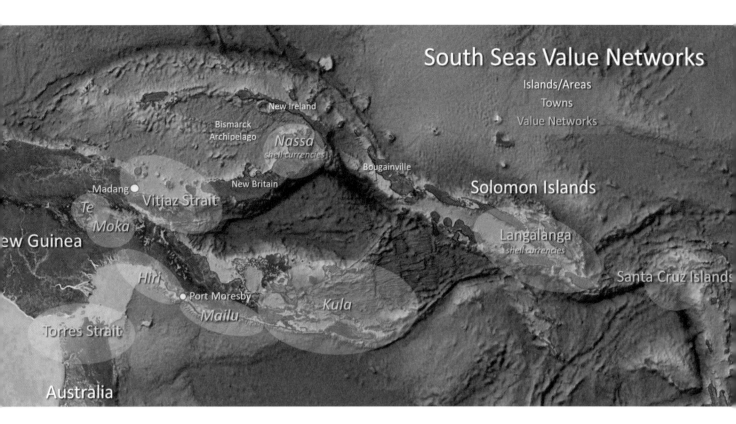

South Seas Value Networks

Islands/Areas
Towns
Value Networks

The pottery makers on the northeast coast of New Guinea established prolific trading networks around Madang and across the Vitjaz Strait. In the southeast, the Motu and Mailu people had similar networks, including the fabled *Hiri* voyages. Along with their pottery they traded in adornments and currency items – this list, from an archaeological survey, shows that trade in adornments was extensive.

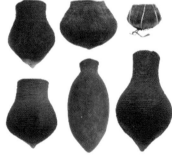

In the Solomon Islands, we have already learned of the makers of shell money around Langalanga, how they traded this widely and still practice their ancient craft to this day. In the outlying Santa Cruz Islands, there developed what is surely the most bizarre economic system, based on feather money, traded on some of the strangest canoes – yet another economic value network bonding remote island populations.

| Turtleshell armbands |
| Turtleshell nose ornaments |
| Shell armbands |
| Woven armbands |
| Armlets |
| Dog teeth necklaces |
| Dog teeth breast-pieces |
| Pig tusk necklaces |
| Fish palatial bones |
| Shell ornaments |
| Hip ornaments |
| Loincloths |
| Grass skirts |
| Combs |
| Red ochre/paint |
| Black paint |
| Red dye |
| Black dye |
| Yellow dye |
| Pig bone tools |
| Lime |
| Lime containers |

A list of adornments and items of currency discovered as part on an archaeological survey, shows that trade in adornments was extensive.

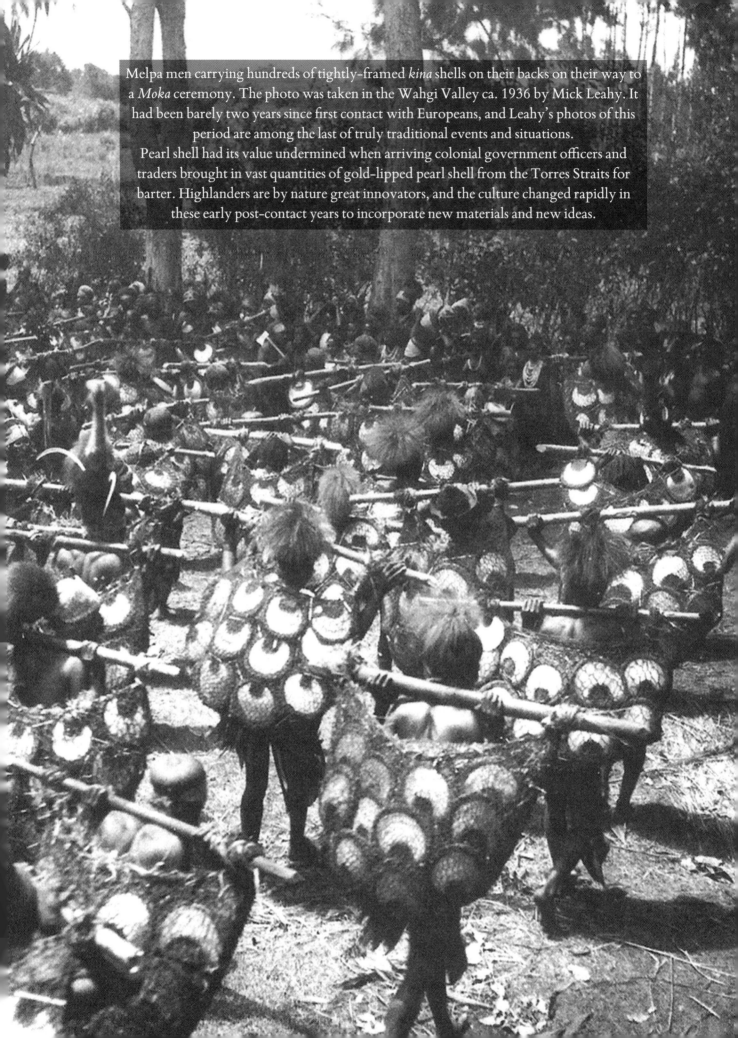

Melpa men carrying hundreds of tightly-framed *kina* shells on their backs on their way to a *Moka* ceremony. The photo was taken in the Wahgi Valley ca. 1936 by Mick Leahy. It had been barely two years since first contact with Europeans, and Leahy's photos of this period are among the last of truly traditional events and situations.

Pearl shell had its value undermined when arriving colonial government officers and traders brought in vast quantities of gold-lipped pearl shell from the Torres Straits for barter. Highlanders are by nature great innovators, and the culture changed rapidly in these early post-contact years to incorporate new materials and new ideas.

The *Moka* and *Te* exchange networks

The people who lived in the large open valleys west of Mount Wilhelm (Papua New Guinea's highest mountain) had been unknown to the outside world until 1933, when the first Europeans arrived in the Highlands. Somewhat to their surprise, they encountered diverse cultures and sophisticated trading networks that crossed the vast Wahgi Valley. These exchange networks were called *Moka* by the Melpa people and *Te* among the Enga people, New Guinea's largest ethnic group, who lived further to the west.

These trade cycles were centred on two valuable products – pigs and pearl shells. The crescent shaped pearl shells were further enhanced for *Moka* by embedding them in a protective base of resin. The shell and resin base were covered in red ochre powder to enhance its vibrancy. In pure Melpa language they were called *Moka kin*, but *Moka kina* is the modern *tok pisin* usage.

The resin was obtained from the hoop pine tree, heated and poured over a prepared circular base of pandanus palm leaves stitched together. The pearl shell was then embedded in the still warm resin. The back was also covered in pine resin to complete the *Moka kina*.

At the eastern end of the Wahgi Valley, around present day Jiwaka, the construction varied slightly, with the base being a thin slab of hoop pine timber, tightly framed around the pearl shell, covered in resin on pandanus leaves in exactly the same process as described above. Later *Moka kina* tended to be larger and, with more Western products available, one might see plywood being used as the base. An *omak* may also be added, inserted into the resin immediately above the pearl shell.

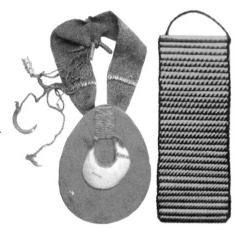

An elaborate *Moka Kina*. Collected in Mt Hagen, Wahgi Valley circa 1980, plus at right, detail of an *omak*. **CB**

Omaks are made of small reed sticks that demonstrate how many times the wearer has given away sets of *Moka kina*. They are not a sign of wealth but of reciprocity owed.

Moka is made between clans, the purpose of which is to cement relationships. Clans will not support clans with whom they do not do *Moka*.

Moka and *Te*, like most Pacific trade systems, are complex. The basic tenet is reciprocity; essentially the notion that what is given away will be reimbursed, and with interest. Through the exchange of valuable objects, they enhance social relationships and strengthen connections within these networks. The contingencies of when and how these objects are displayed and by whom are paramount. These objects visually imply wealth, success and probably most importantly, power relationships.

A Big Man supported by his clan, would instigate a *Moka* cycle entailing the giving away of some of his accumulated wealth to his trade partners, facilitating his rise in status and prestige within the wider community. During the main exchange vast retinues of decorated men and women carry their *Moka kina* in procession to the display grounds, where they are lined up and put on public display. Pigs likewise are brought along, where they are tethered to stakes. Display is a huge component of *Moka*, where every shell and pig is carefully inspected and judged. The pearl shells are given away in an exact and preordained fashion to the trade partners; the pigs are slaughtered, and the meat is divided up.

The *Moka* brings together large groups of people from neighbouring tribes, allies and even groups that may be enemies from time to time. Within *Moka* they attain peaceful co-existence, a process so important that all other activities are put aside. The only activity that could interfere with *Moka* would be warfare.

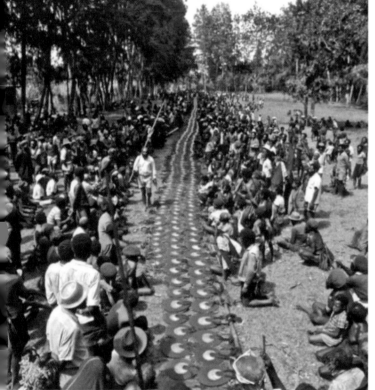

An offering of 7,000 *Moka kina*s laid out on the ground following the death of a chief, near Mount Hagen, PNG. **Photo: Robin Smith 1968**

346

Trade facilitates peace

Moka and *Te* embodied powerful trade politics that became intertwined with warfare reparations. In the fluid Highlands social order, a friend and trade partner today could become an enemy tomorrow. These widespread inter-connections allowed for dialogue to occur, formal requests for cessation of fighting made, and for discussions about compensation for deaths and injuries to begin. Consequently, warfare tended to be formalised among the Melpa and Enga, resulting in swifter peace negotiations and hence fewer deaths. Among the Enga battles took place with sometimes thousands of participants, and even more spectators. But prescribed paths for compensation payments existed, with pigs and pearl shells in readiness so that, even though some warriors died, reparations could start as soon as a truce was declared.

One of the by-products of *Moka* and *Te* was marriage possibilities for both sexes; these infrequent large gatherings brought together people from far-flung isolated communities. Fantastically decorated men showed off their oiled bodies, strength and virility to young women who would almost never leave their own isolated valleys.

The *Moka* and *Te* networks also provided an alternate status pathway for men. Rather than just accruing resources based on pigs, shells and women, these vast trading networks allowed them to establish status and power through reciprocity, relationship building and trading.

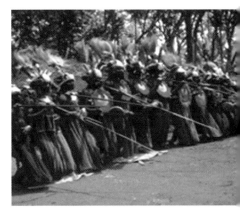

Melpa dancers in a ceremony called *mor*, associated particularly with *Moka* exchange, with many of the men wearing *Moka kina* pearl shells. They form a long line that extends into a horseshoe, drumming, singing, and moving up and down in a graceful genuflecting rhythm. It is a simple dance that shows off the strength and fine body adornments of the dancers to rivals. Wahgi Valley. **Photo: Stan Moriarty 1965**

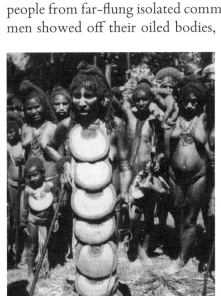

Young bride wearing seven *kina* pearl shells, each carefully protected in *Moka* style; her hair oiled and twisted into braids, her face painted. In the background, all women wear some form of simple, daily adornment, rather than the more spectacular ones used in ceremonies. **Photo: Mick Leahy 1936**

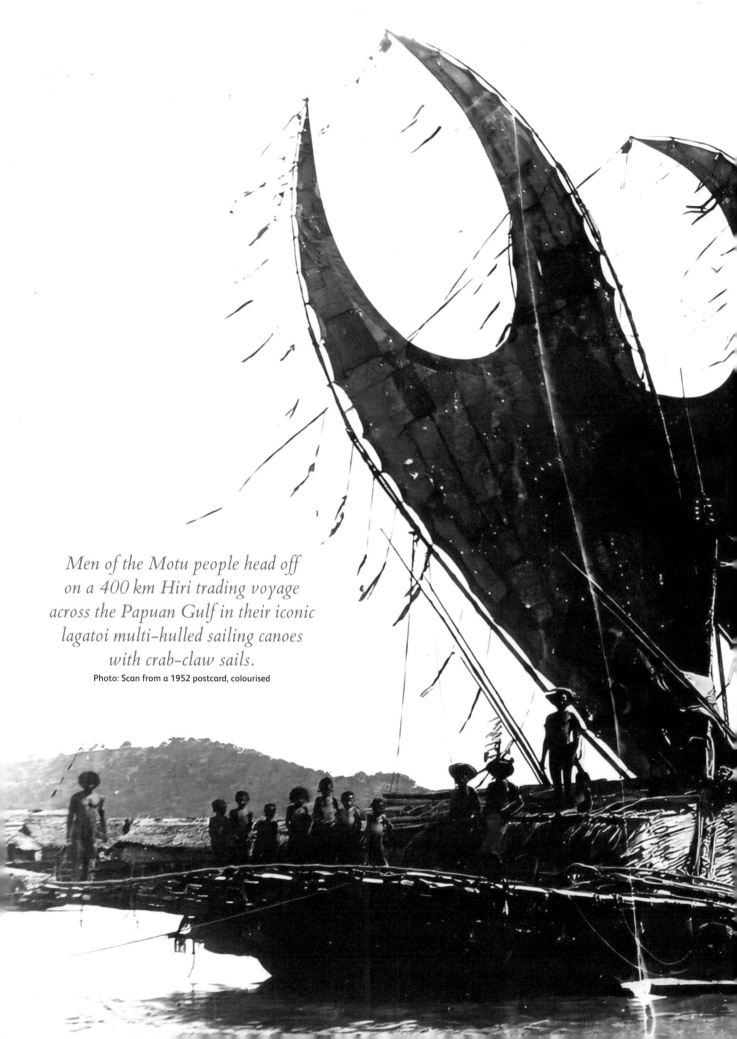

*Men of the Motu people head off
on a 400 km Hiri trading voyage
across the Papuan Gulf in their iconic
lagatoi multi-hulled sailing canoes
with crab-claw sails.*
Photo: Scan from a 1952 postcard, colourised

Papuan Gulf: The *Hiri* trading voyages

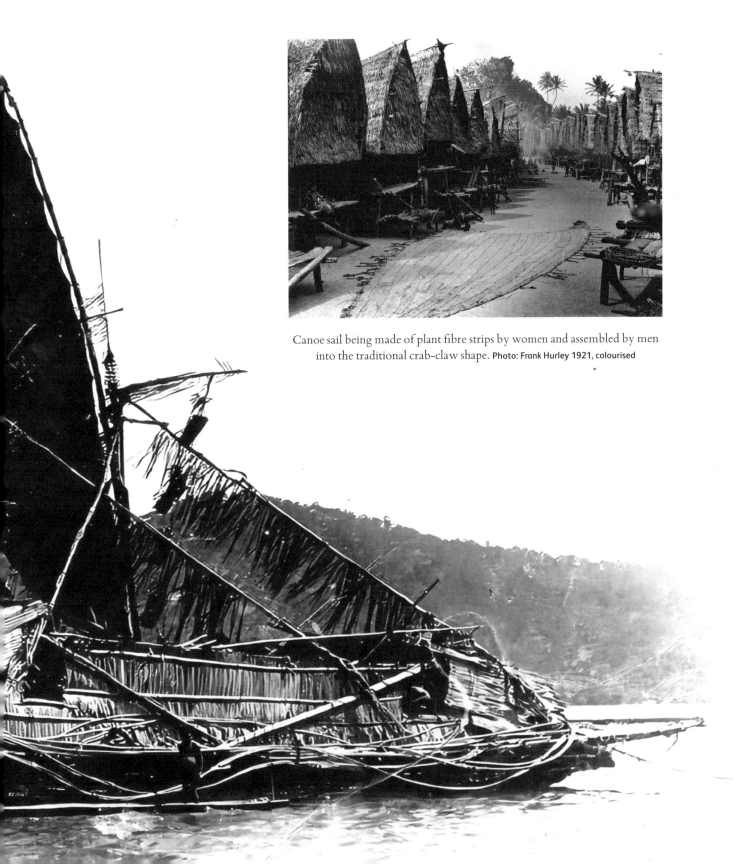

Canoe sail being made of plant fibre strips by women and assembled by men into the traditional crab-claw shape. **Photo: Frank Hurley 1921, colourised**

The *Hiri* trading voyages

For at least the past 350 years, and possibly longer than a thousand years, the coastal Motu people (around what is now the city of Port Moresby, the capital of Papua New Guinea) have embarked on treacherous sea voyages in the Gulf of Papua from their unique marine villages and sandy beaches to lush rainforests some 400 km away.

Hiri voyages were an important part of the culture of the Motu-speaking people. They even established a new kind of trade language, *Hiri Motu*, a simplified version of Motu by which they communicated with other coastal tribes they encountered on their journeys. *Hiri* voyages were adventures in innovative ship-building and entrepreneurship.

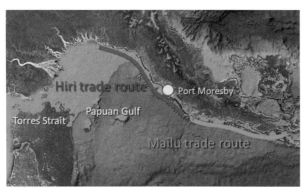

The scale of the expeditions was staggering. At times 20 canoes, each 15-20 metres long, would be laden with a total of 30,000 clay pots and 600 men. They sailed out with the Trade winds in October and November. They stayed at their destinations across the Gulf of Papua for several months – sourcing materials and food, and repairing and rebuilding their ships with locally sourced logs from the rainforest. They would return with the January monsoons. One legend tells that the very first voyage was so long that when the men returned, the women had remarried because they thought their husbands had perished.

Their voyages were not just for food and raw materials; rather as part of a complex culture intertwining coming-of-age, cultural exchange, and exploration, all bound in deeply established social rituals. A similar trading culture existed further to the east, amongst the Mailu people centred around Mailu Island.

A *Lagatoi* canoe with its crab-claw sail up off the island of Mailu,
Photo: FH 1921 BM Oc,B122.32

The Motu economic reality

To understand what prompted the Motu to undertake these adventurous voyages, it's important to understand their social and economic situation. The Motu lived primarily in marine villages on stilts and informal land-based settlements.

The men were accomplished seafarers and boat builders, and their women produced sought-after clay pots – skills that may have been directly inherited from the early Lapita culture in the South Pacific.

They faced an unfortunate economic conundrum. The local trees were too small for the large ship hulls they needed. Their trading partners in the Gulf of Papua, however, had abundant timber and sago palms – which, when processed, produced sago flour, a treasured food.

Hanuabada, Port Moresby, watercolour by Norman Hardy in *The Savage South Seas* 1907

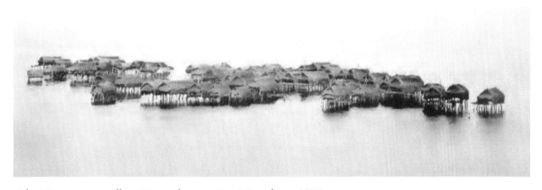

The Motu marine village Tupuselei near Port Moresby in 1887. Photo by J. W. Lindt, from *Picturesque New Guinea*

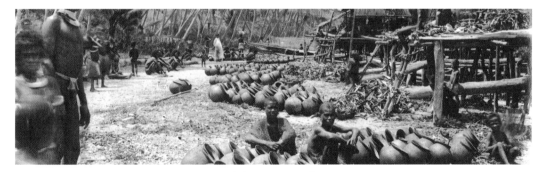

Motu women and their renowned pots. Photo FH 1921

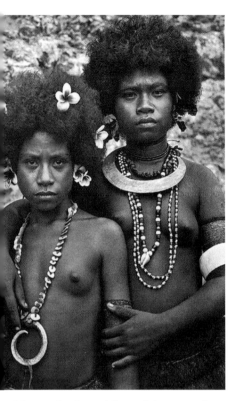

Motu girls adorned for a celebration, of
Elevala village. Port Moresby. **Photo: FH 1921**

How could they sail the vast distances to their trading partners across the Papuan Gulf, and return home with an additional load of timber to rebuild for the next year's journey?

Bruno David at Monarch University describes their elegant solution. *"They dismantled the ships as they arrived in the Gulf of Papua, often in large fleets, and then sailed back with the rebuilt ships and trade load of sago flour. New logs were cut from the rainforest and made into multi-layered rafts upon which the upper parts of the ships were built. They rebuilt the ships from the bottom up. The extra logs became spare hulls, to be used in future voyages."*

When the men returned, it was celebrated with feasting, singing, dancing and great rejoicing. This was a perfect opportunity to display adornments both local and acquired – all excellent trade items to obtain food and materials that were at a premium. A *toea* cone shell arm ring could, for example, purchase 100 kg of sago or a massive log.

The *Hiri* voyages continued until the late 1950s when a heavily laden and storm-damaged *lagatoi* foundered on its return voyage with heavy loss of life. Further voyages were then forbidden by the colonial authorities, although *Hiri* is still celebrated annually in the capital Port Moresby.

*"The Hiri is where young
boys become men."*

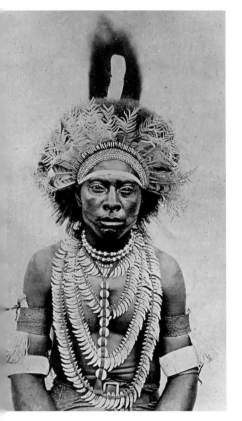

Motu man dressed for a ceremony.
Photo: Rudolf Pöch 1905

How the *Hiri* Voyages originated

Oral tradition has handed down many stories around the Hiri trade, carried down by families across many generations. This is one version:

Edai Siabo, from the village of Boera, was returning from a fishing trip when a great eel The Spirit of the Sea *appeared and dragged him under the water before returning him to the surface and instructing him to build a great* lagatoi *sailing canoe, fill it with cooking pots, and to sail westward, following the* laurabada *south-east trade wind. He named his first canoe* Bogebada *(sea-eagle) and loaded it with pots made by his wife. He gathered some men and sailed up the coast into the waters of the Gulf of Papua.*

For months, he and crew were away. The villagers were convinced they had perished. They mocked Edai's wife and tried to force her to remarry. Before Edai left, he had instructed her to stay within a corner of her house, not to bathe in the sea, to keep a tally of the days the Bogebada *had been gone, to keep her fire burning, and to have her skin tattooed by an old woman. Failure to stick to this routine would endanger the expedition and the lives of Edai and his men.*

One day, a canoe appeared on the horizon and slowly approached the village. It was Bogebada, *laden with vast quantities of sago, timber and new forms of body adornment. Edai arrived home, a hero. His wife jumped into the sea, washed away her accumulated dirt, put on her finest costume, walked out onto the verandah of the house, hit it with a stick, shouted, 'Hedihoroha* Bogebada!' *and began dancing in joy.*

Source: Port Moresby Website

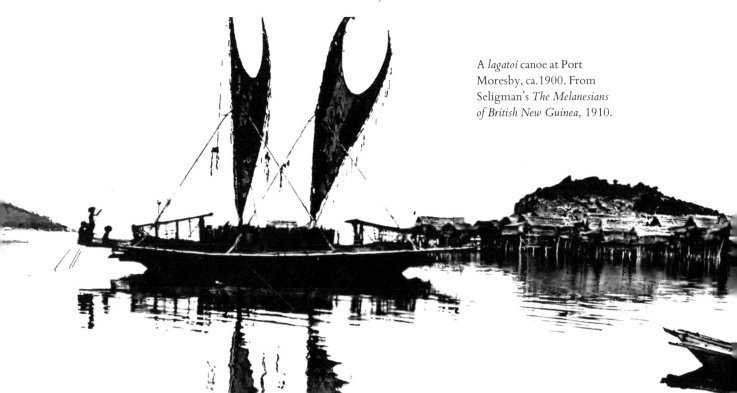

A *lagatoi* canoe at Port Moresby, ca.1900. From Seligman's *The Melanesians of British New Guinea*, 1910.

Santa Cruz navigators established a powerful trading community that may have extended as far as the Polynesian islands. Their canoes-of-choice were the distinctive *Tepuke* or *Tepukei* long-distance outrigger canoes with overhead thatched cabins and crab-claw sails.

The voyagers would navigate using the stars and their unique 'wind compass'. The canoes were made on Taumako Island in the Duff Island group in the Santa Cruz Archipelago based on logs hollowed-out with a shell adze.

Because these canoes were so important in Santa Cruz society, it would take something of great value to buy one. The only currency most would accept was the unique feather-money of the Santa Cruz islands — *toau*.

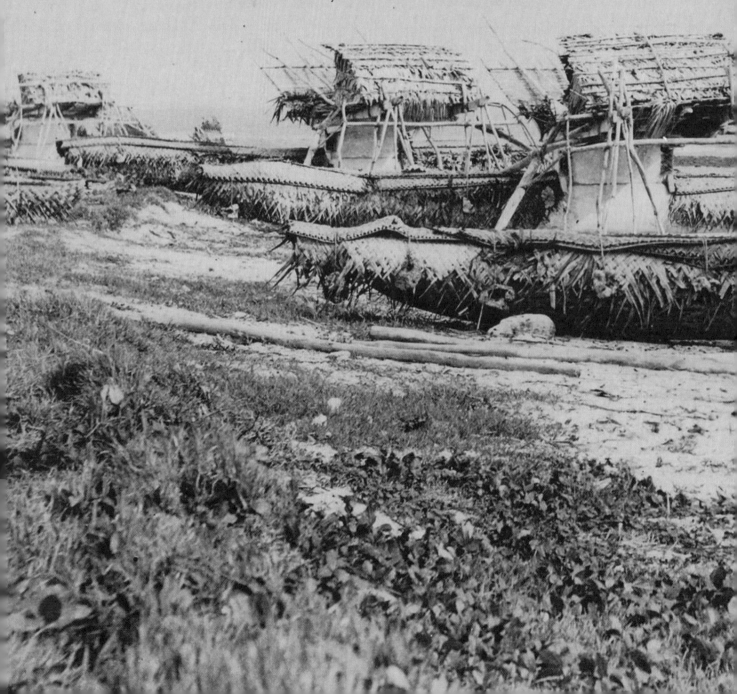

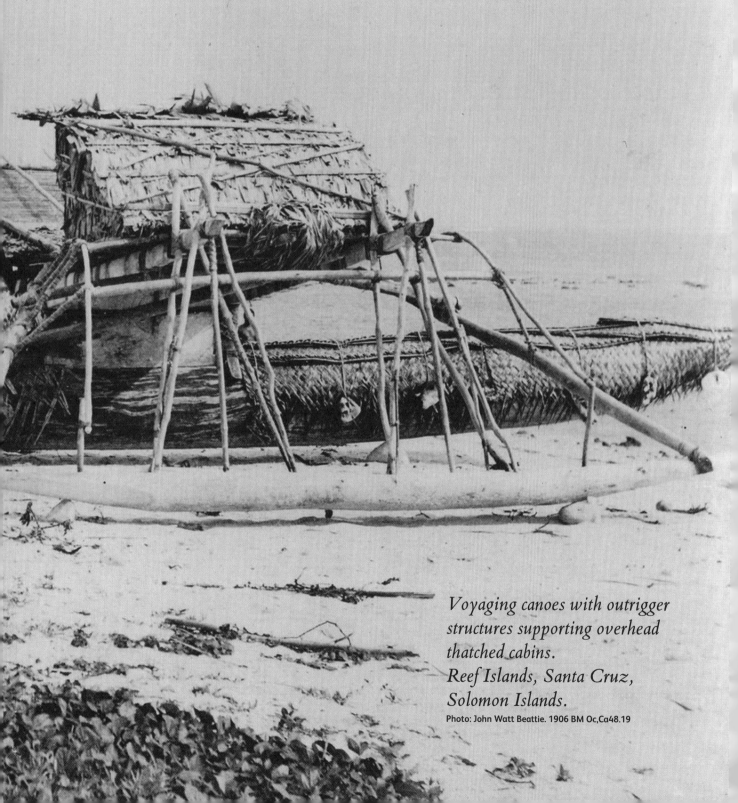

Santa Cruz trading voyages
Facilitated by the strangest feather currency

*Voyaging canoes with outrigger
structures supporting overhead
thatched cabins.
Reef Islands, Santa Cruz,
Solomon Islands.*
Photo: John Watt Beattie. 1906 BM Oc,Ca48.19

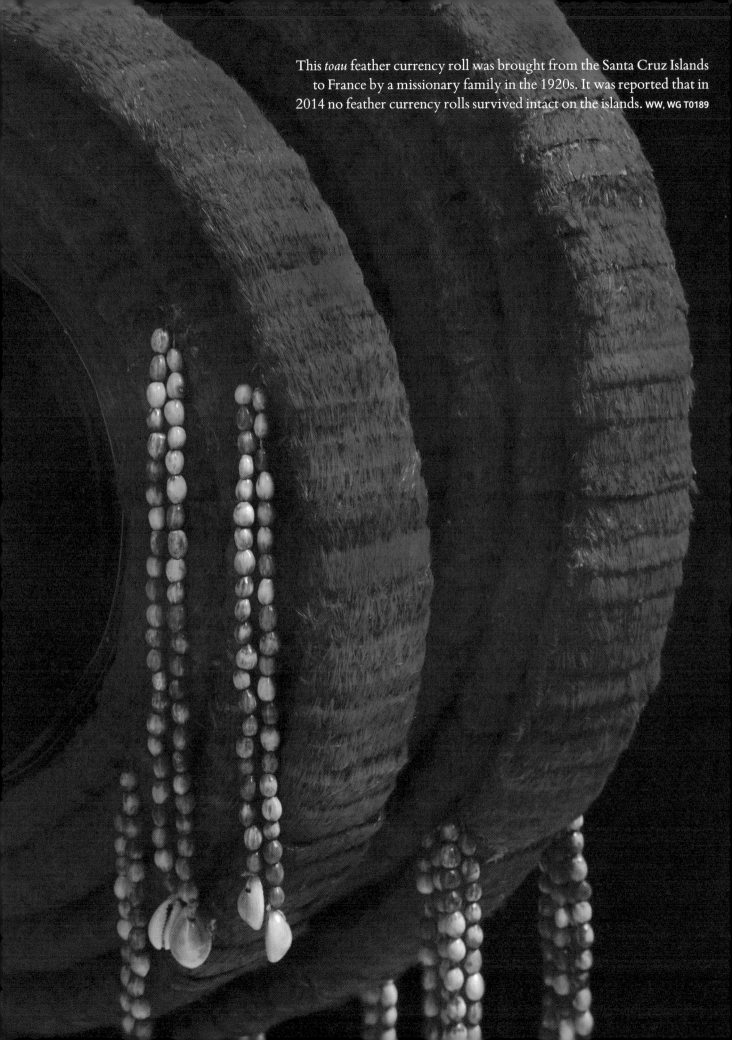

This *toau* feather currency roll was brought from the Santa Cruz Islands to France by a missionary family in the 1920s. It was reported that in 2014 no feather currency rolls survived intact on the islands. WW, WG T0189

Santa Cruz feather currency *toau*

In the far south-east of the Solomon Islands Group are the Santa Cruz Islands. Here the people of Temotu Province on Nendo, produced a rare feather currency called *toau*. Based on elaborate coils of bird feathers, it is amongst the most spectacular of the world's primal currencies and the basis of a complex trading system between neighbouring islands.

While this feather currency is possibly best known as an essential part of brideprice payments, it was also used as the primary currency to trade essential foods, land and canoes. The main island always had good soil conditions for growing the staple crops of taro root and yams, while the smaller islands relied on fishing and rearing pigs. Feather currency was the basis for the trade in these essential commodities between the various island communities. The feather rolls, which can be up to 10 metres in length, were not worn, displayed or used in any decorative way. They were money. Canoes made in the Duff Islands were traded for feather coils.

The story of why and how the feather currency was made reveals much about the culture of these islands. In Pacific societies, feathers and the colour red were especially important. Red materials were rare in nature and the best vibrant red came from the head feathers of the male scarlet honey eater *Myzomela cardinalis,* a common bird in the region.

Red was the colour of the gods. Chiefs, who were the embodiment of the gods, preferred this colour for their personal adornment.

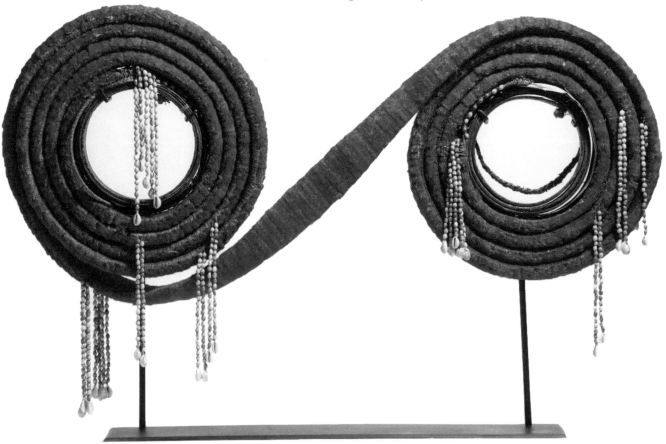

WW, WG T0189

The feather money was manufactured on Santa Cruz Island. Three specialists were needed to manufacture each roll and these skills were restricted to a few families, passed from father to son down the generations, together with various incantations and chants used to endow the currency with appropriate spiritual powers. During manufacture the men lived in a secluded house away from the village to work and practice their magic.

The bird-catcher. The first of these specialist craftsmen caught the birds by spreading a sticky sap from a mulberry tree onto their preferred perches. The feathers were then plucked and packed into coconut shells, the feathers from ten birds in each shell being regarded as a trading unit. A good hunter was said to catch up to twenty a day.

The feather-gluer. A second craftsman constructed a series of small platelets, each 60 x 30 mm, based on the stiff, grey flight feathers of the grey Pacific pigeon *Ducula pacifica* glued together using the same sticky sap from a mulberry tree to form a flexible pad. To each pad was glued a 10 mm band of the small red honey eater feathers along one of the long edges which protruded beyond the edge of the plate to form a red fringe. 1,500–1,800 platelets were needed to make one roll around 10 m in length, using the feathers from 300–500 birds.

The coil-maker. The individual platelets were then passed to the third specialist, who bound them into a long coil, constructed using long strips of bark from the indigenous *Gnetum* tree *Gnetum gnemon*. Two fibre cords were stretched between trees with a spacer made from the wing bone of the flying fox to keep the cords a constant distance apart. The platelets were then bound one at a time onto the cords, with a backing strip of bark. The platelets were overlapped like tiles on a roof so that only the edge of red honey eater feathers was visible.

The underside of the bark roll often contained the hallmark signature of the person who made them, only visible when the feather money was unrolled. The particular one on the page opposite is inscribed with the maker's mark 'W' (or perhaps an 'M'?), and the name '9. HENRY MEPULULE' which could be the maker's or the original owner's name.

Several decorative strings of small shells, plates of turtle shell, beads or pig teeth, were attached to both the mid-point of each roll and the two ends. The finished rolls were spectacular objects, brilliant in colour and luscious in texture.

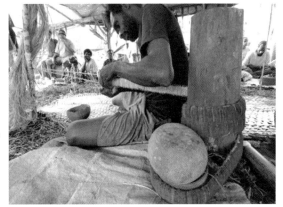

HeritageExpeditions.com

WW, WG T0189

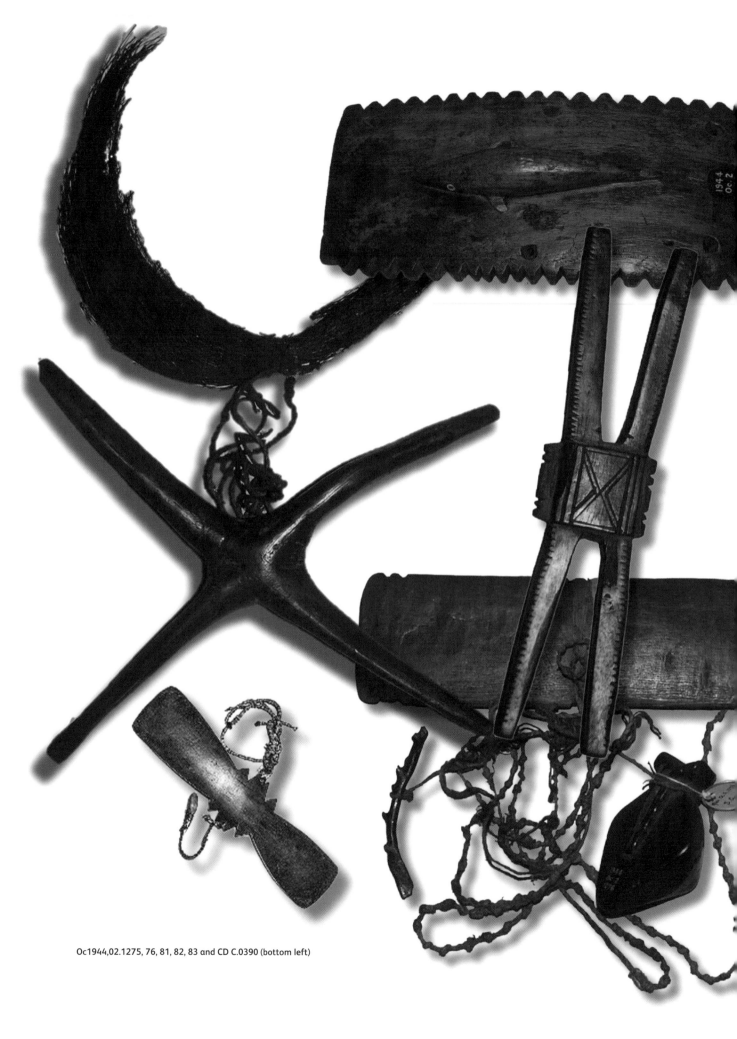

Oc1944,02.1275, 76, 81, 82, 83 and CD C.0390 (bottom left)

Each feather roll would take about a year to make, and a skilled team doing several in parallel would make about five in a year. The value of each would depend on its condition. As the feathers faded so the value of the currency deteriorated. The rolls would become patchy, and eventually bald. In the humid conditions, stored in the smoky atmosphere of a hut roof, the organic bark, glue and feathers is unlikely to remain in good condition for more than a few decades. The more worn the feathers of a roll, the lower its exchange value, and when a roll had lost most of its feathers, it was discarded.

Some *toau* feather currency rolls were accompanied by a wooden 'charm', sometimes referred to as *nomba*, and said to add a powerful spiritual *mana* to the feather roll. These were carved pieces of wood, sometimes including the image of animals. They were placed loosely on top of the rolls before they were wrapped in leaves for storage.

The British Museum has a wonderful assortment of these charms, originally collected by Harry Geoffrey Beasley (1881–1939), a selection of which is shown on the facing page.

The British Museum Collection also has several other charms associated with *toau* feather currency, including these oblong boards. They were made of wood painted with the typical Santa Cruz geometric patterns and tied with vegetable fibre and *Coix* seed strings. They were ended with slivers of pearl shell. The purpose of these charms is not fully understood or recorded.

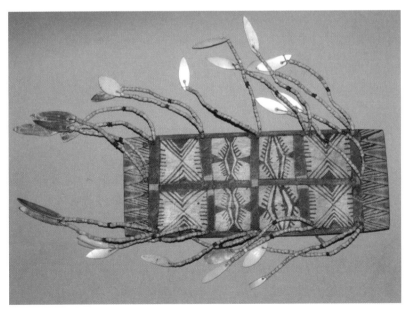

Oc1891,0322.1.c ca. 1891

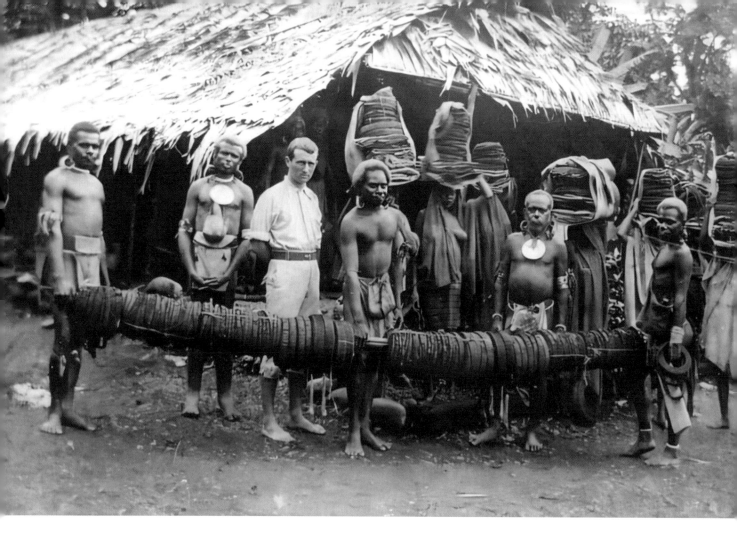

In this evocative photo, a range of feather-money rolls is being displayed at Nelua, Santa Cruz, for a visitor sometime in the 1880s. It is clear that most of the feather rolls are in extremely poor condition. A caption handwritten in pencil reads: "*The price of a wife. Feather money – Santa Cruz*", BM Oc,B117.28J. W. Beattie ca. 1880

The impermanence of feather rolls and the cultural limit on the number of families who were allowed to carry out this work was vital to ensure a limit on money supply, avoiding inflation and devaluation of the currency.

AN ORIGIN STORY OF *TOAU* FEATHER-MONEY.

There were once small forest-dwelling supernatural beings called lemwurbz *who loved song and dance and had a reputation for helping humans. A chance meeting might bestow wealth on you. This happened to one man who was then led to a cave and given a wealth of* toau *feather-money rolls, plus taught the skills to make them. He was told that if he ever revealed this skill to anyone else his luck would be taken away from him forever. Since then, the skills have been passed down only in certain families.*

The average price for a wife was around ten feather rolls, with 'market forces' making some less valuable, and others more expensive. A good wife was said to have had the same value as a small canoe. Women from the neighbouring Reef Islands who were sold as courtesans for sexual services in men's clubhouses in Santa Cruz and fetched about ten times that price. The clubhouses were also the place where most of the feather-money rolls were kept – wrapped in palm leaves or trade cloth and stored over hearths where the smoke from fires probably deterred insect infestation.

These remote islands had been shielded from European influences until about 1920. Within ten years, the trade in courtesans ceased and the clubhouses lost their role as a 'home' for courtesans, men and as a 'bank' where feather-money rolls were stored and traded.

In 1936 it was estimated that the total output of feather-money was less than 20 coils per year. Workers could earn far more from the timber industry. By the 1960's only a few men still demanded the traditional feather money before they would allow their daughters to be married. Salome Samou, a former curator of the Solomon Islands Museum, wrote that Henry Mwenaku, one of the last makers of fine feather-money rolls, died around 2010. The use of feather currency in Santa Cruz has died out – even for brideprice. Many of the rolls in European museum collections are almost completely bald of feathers.

Small feather items, such as reproductions of these mid-20th century hair sticks are still made today on a small scale, but this is all that remains of one of the most remarkable currency systems that human societies have ever developed.

The most extravagant use was the payment for women : wives and courtesans.

Salome Samou 2014

A selection of red feather hair sticks.
CB, WG T0350 A and B

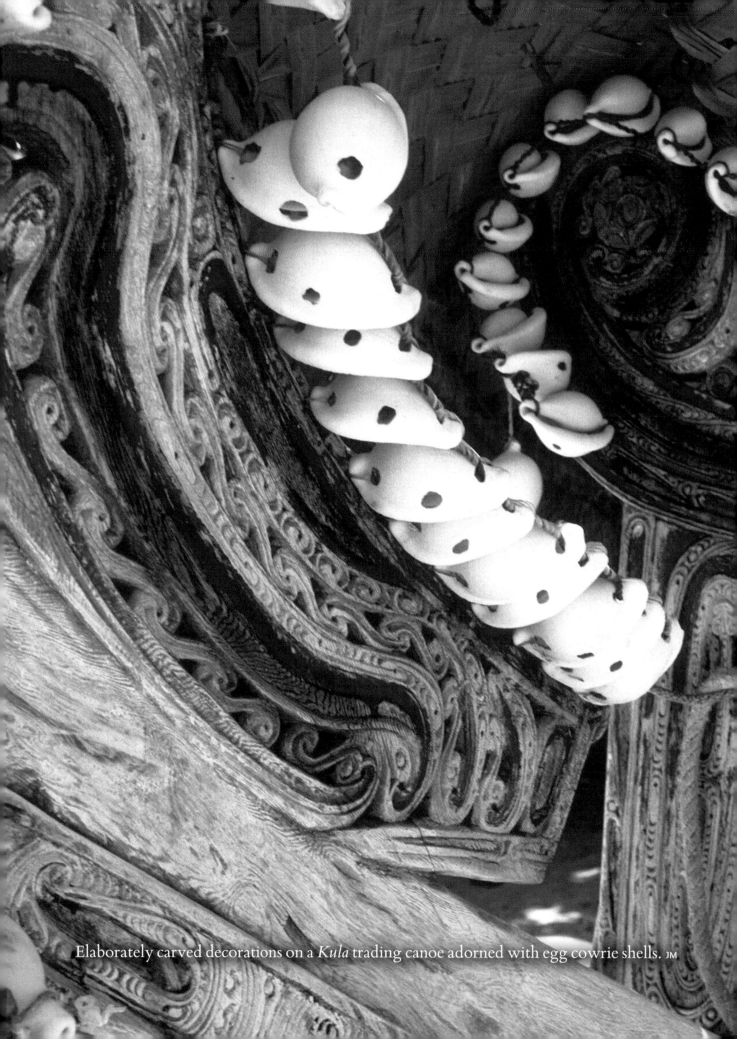

Elaborately carved decorations on a *Kula* trading canoe adorned with egg cowrie shells. JM

The Massim people and the *Kula* voyages

In the southeast corner of the island of New Guinea, the central mountains that run right through its spine drift down into the South Pacific. Here, the more than 600 islands of Milne Bay Province are a combination of steep volcanic peaks and low-lying coral atolls. From most of the islands the next inhabited island is visible on a clear day. This is the home of the so-called Massim people. Although numerous languages are spoken in the area, western anthropologists refer to them in the literature by the encompassing term 'Massim'.

Magic and myth have always played an important part in Massim life – influencing life and death, love, fertility, weather and food production – as well as success in trading, through an age-old system known as the *Kula* Ring.

The region is renowned for its wood carvings and their material culture is dominated by powerfully iconic swirling design motifs, also found on their elaborate canoes.

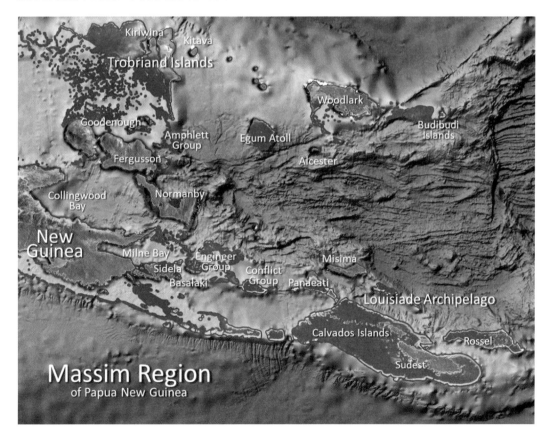

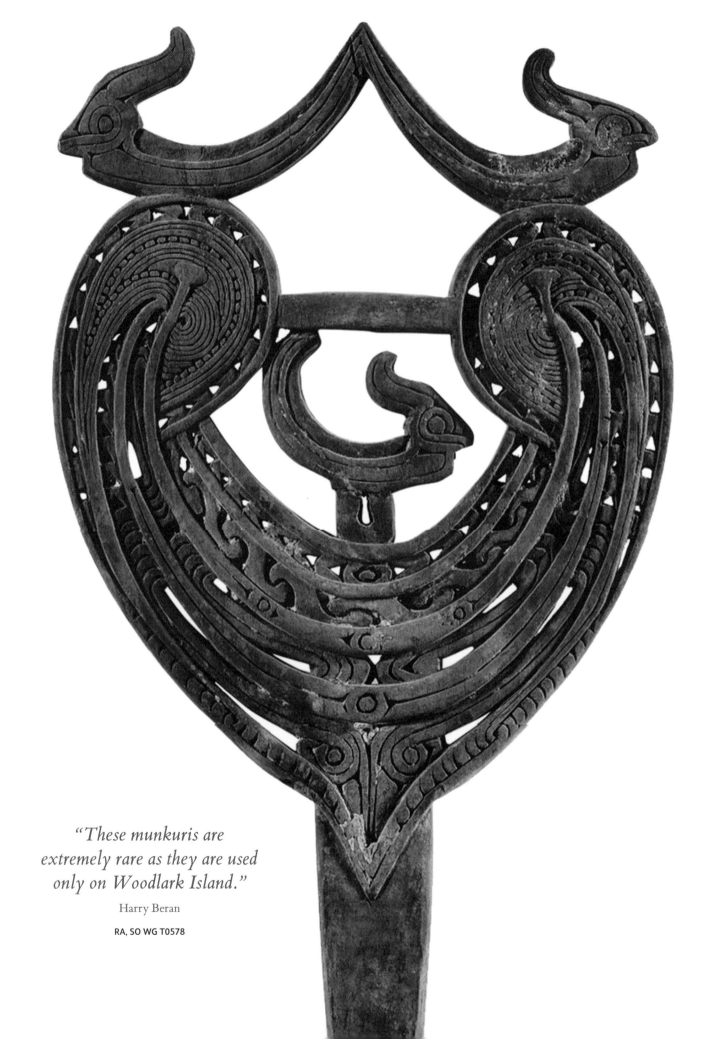

*"These munkuris are
extremely rare as they are used
only on Woodlark Island."*

Harry Beran

RA, SO WG T0578

Massim design

The Massim people have historically been recognised for their decorative carving of wood, turtle shell and whalebone, with mainly two-dimensional designs featuring abstract scroll patterns with deliberately asymmetric features. While these objects have been used and traded for hundreds of years, the Massim have been actively making objects for sale since the late 19th century.

Their elaborately curved abstract and fluid scroll designs adorn everything from lime spatulas and gourds to the elaborate components of canoes. There are few figurative elements and birds, fish and other animals are highly abstracted.

The *munkuri* in the image opposite is a perfect example of such Massim designs. This 'Wave Splitter Filial' would have been attached to the top of the prow boards of a *Kula* canoe. It comes from Wailuyelu Village on Woodlark Island, is 415 mm tall and shows remnants of white lime pigment brushed into the lines to enhance the design. This was collected by ethnographer Harry Beran in February 1999 from an old man named Sabalana, the younger brother of Kia, who carved it and who died during WWII.

While most *munkuris* were used on *Kula* trading canoes, this particular one adorned the front of a turtle and dugong fishing canoe. The design resembles the early style of turtle-shell lime spatulas, and there is an easily discernable face at the base of the openwork section as it joins the handle. Above this are graceful layers of arched curvilinear designs surmounted by three long-tailed birds.

Richard Aldridge comments: "While the individual elements are thin and delicate, they are composed in a series of layers that build upon each other to create a strong and stable overall form. The strength of the composition depends upon the interconnectedness of a number of individual fragile parts."

This iconic Massim design style is seen on many functional and ritual objects from the region.

Tava (or *Tauwau*) the mythological spirit lived in secrecy amongst the Massim people and moved from island to island, always staying on the fringes. At times, *Tava* took the form of a large snake. When *Tava* was in residence, an island prospered. But, if he felt disloyalty, he moved on, taking this prosperity with him. But, *Tava* always bestowed a legacy, which became the essence of the special skills and products of each island – such as carving, canoe-making, pottery, yams, pigs or other foods. Each island retains these legacies, and they are of great importance for trading in the *Kula* Ring.

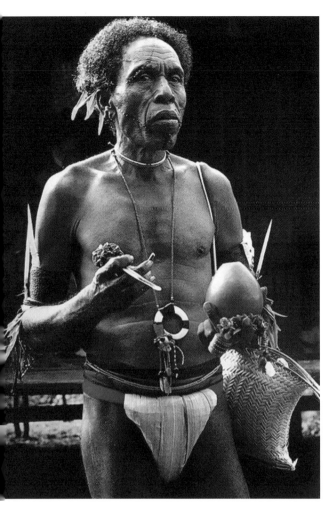

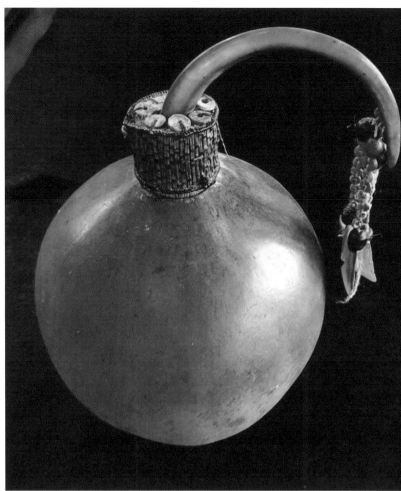

Chief Nalubutau in Okububura village on Kitava Island, one of three large islands in the Trobriand Islands, holding his lime spatula and lime gourd. **Photo: JM 1981**

A modest Massim gourd lime container adorned with an elaborately carved pig tusk stopper, *Spondylus* discs, shells and banana seeds. Sudest Island, Louisiade Archipelago. **RA, WG T0500**

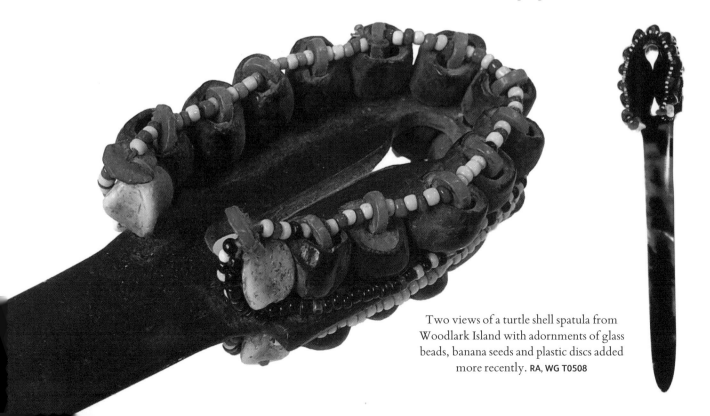

Two views of a turtle shell spatula from Woodlark Island with adornments of glass beads, banana seeds and plastic discs added more recently. **RA, WG T0508**

Massim craftsmanship

The utensils used in betel chewing include some of the finest crafted objects and include both utilitarian and ceremonial lime spatulas made of turtle-shell, wood and whalebone. The carvings include abstracted human figures, animals, or plants.

The simplest spatulas are functional, to carry powdered shell lime from storage gourd to mouth for betel chewing. The most elaborate ones are purely ceremonial or to display status and wealth. Several have glass beads and carved plastic beads that were added to older objects in the 20th century.

Lime spatulas, left to right: Two turtle shell spatulas from Woodlark Island; a hardwood spatula with male figure in hocker position (Beran), from the Trobriand Islands; and a whalebone spatula, from Sudest Island.

RA, WG T566; RA, WG T0501; PC, WG T0663; RA, WG T0507

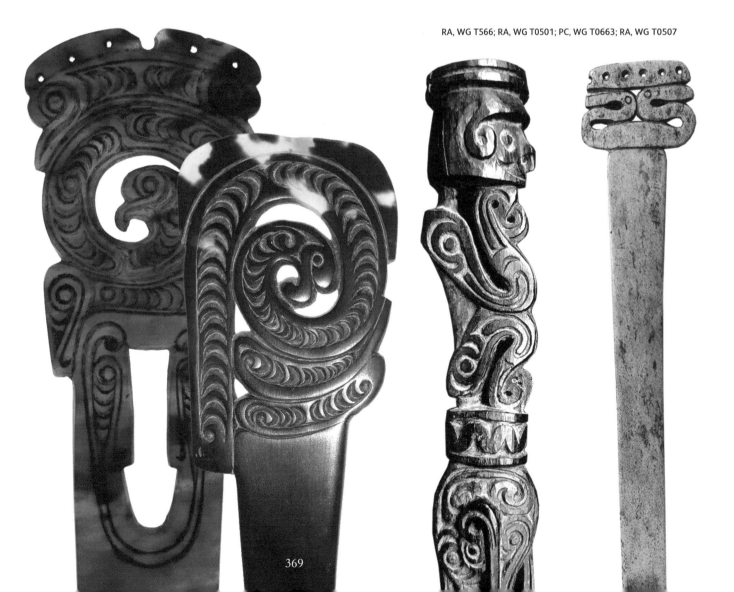

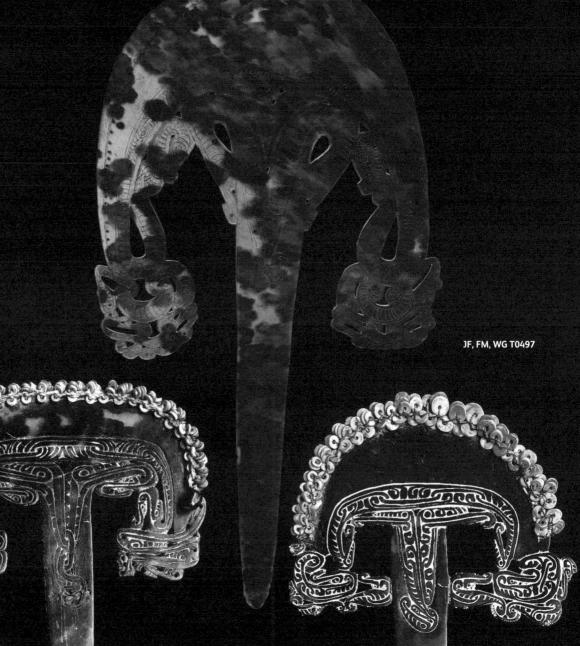

JF, FM, WG T0497

RA, WG T0502

MI, UK, WG T0634

*"Crescent-topped turtle shell
spatulas made in the 19ᵗʰ century
have two bird heads back to back
with more or less horizontal beaks
at the top of the blade."*

Harry Beran

Massim Prestige Objects

Massim craftsmen made beautiful crescent-shaped lime spatulas called *ghena* or *gabaela*, traditionally carved in wood, turtle shell or (on rare occasions) in whalebone. White lime was brushed into the carved design to accentuate the contrast and the deliberate asymmetric designs.

The traditional form of the *ghena* symbolizes several things: With the blade pointed downwards, it can represent a human head, with frigate birds heads standing for the eyes or, alternatively, the whole body, with the long projection representing a leg or phallus. When it is held the other way up, the form could represent a canoe with mast.

Their elaborate shape reveals that they were not designed to be used as lime spatulas. They did however serve as important carriers for the *bagi* shell currency, made up of fine *Spondylus* shell discs. The holes along the top of the crescent allowed strings of this ritual currency to be threaded through and attached to the spatula with fibre. Sometimes, any spent shell currency was later replaced – often with different colour or size shell rings, or even plastic ones, as evidenced on these examples.

JF, FM, WG T498

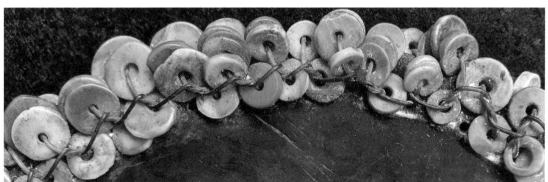

RA, WG T0509

MI, UK, WG T0634

371

These *ghena* presentation spatulas are made of wood. The one in front is painted over with lime and adorned with both red and white *Spondylus* shell discs – the traditional *bagi* shell currency. An additional string made of cut sections of plastic coverings from wires and a plastic fragment were clearly added later. Behind is a fine old stone-carved wooden *ghena nga* from Rossel Island. The wooden *ghenas* were no less valuable in the Massim hierarchy of objects than the turtle shell versions – the overarching purpose of *ghenas* is to carry the important *bagi* shell currency.

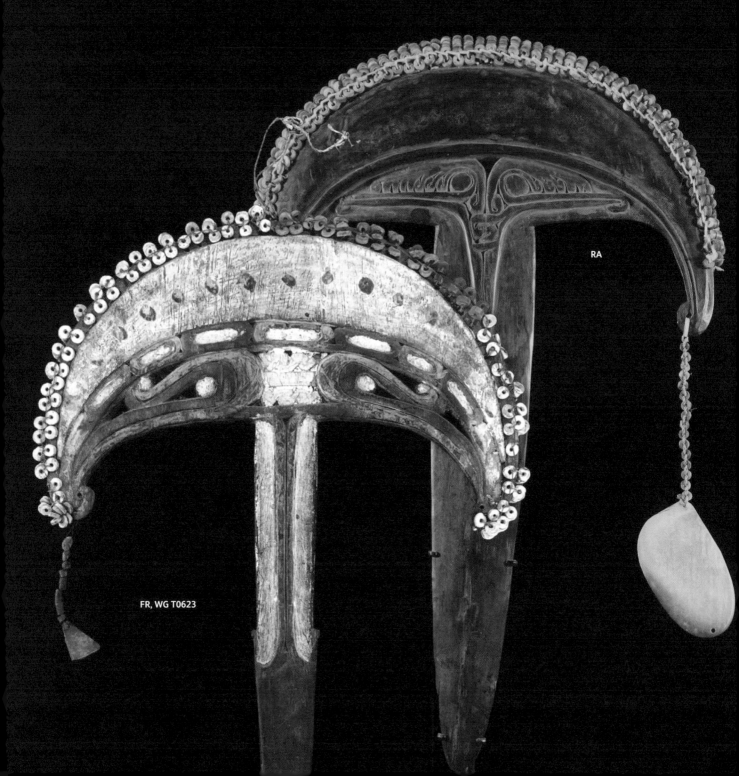

RA

FR, WG T0623

This large and rare whalebone presentation spatula, called *bosu* or *potuma*, is generously threaded with strings of *bagi* currency, pearl shells, banana seeds and cowries. It was collected by Richard Aldridge on Basilaki Island in the southern Massim region, is 440 mm tall and is an early 20th century example.

A man presenting a large whalebone spatula similar to the one at right. Southern Massim region, between Suau and Samarai islands. Photo: RA

These *bosu* spatulas travelled in the same direction as the *mwali* armbands. Harry Beran noted that these are "rare, valuable and restricted to village leaders and wealthy individuals. A good canoe can could be obtained in exchange for one".

A third important *Kula* item was the fabled ceremonial *beku* adzes and axes from Woodlark Island. The blade was made of polished ignimbrite stone, inserted into an elaborately carved wooden handle and held in place with woven fibres. Its sole purpose was to make the valuable greenstone blades more attractive.

The *ghena*, *bosu* and *beku* valuables are essential parts of showing the prestige and wealth of the owner during the *Kula* voyages and rituals.

MI, MH

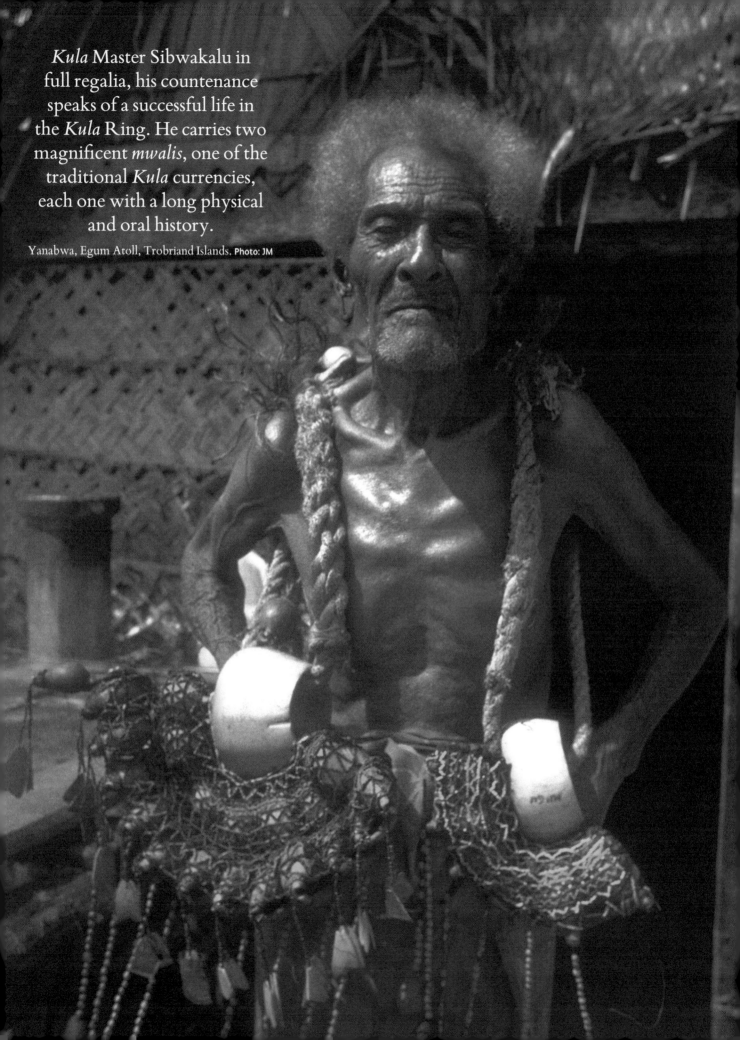

Kula Master Sibwakalu in full regalia, his countenance speaks of a successful life in the *Kula* Ring. He carries two magnificent *mwalis*, one of the traditional *Kula* currencies, each one with a long physical and oral history.

Yanabwa, Egum Atoll, Trobriand Islands. **Photo: JM**

The *Kula* voyages

The Trobriand Islands, in the northern Massim area, were immortalised in a cryptically-titled 1922 book *Argonauts of the Western Pacific*. At a time when economic theories were polarised towards either Karl Marx or Adam Smith, anthropologist Bronislaw Malinowski's findings challenged conventional ideas about the nature of wealth and the role of currencies. He revealed trading networks based on exchanges and reciprocity – an analogy to what French anthropologist Marcel Mauss called 'gift economies' – that build relationships, value and increased morality between groups and individuals.

Malinowski observed a network of regular canoe journeys with shell objects passing around the islands through intricate formal relationships, forming a kind of balanced reciprocity. The act of giving was a display of the greatness of the giver, accompanied by shows of exaggerated modesty. Such partnerships built strong mutual obligations of hospitality, protection and assistance. It had evolved over hundreds of years and proved effective to prevent wars and enhance the status and prestige of its participants.

Known as the *Kula* Ring, it was, and still is, a social and commercial enterprise, with spiritual and mythical purpose, based on the ceremonial exchange of two items, necklaces called *soulava*, and arm bands of cone shell, the *mwali*. These objects, essentially with no intrinsic or utilitarian value but immense spiritual power and effect, move through the *Kula* network without ever 'settling down' or moving outside the ring.

The two ceremonial gifts always circulate in opposite directions: necklaces *soulava* move clockwise and *mwali* armbands move counter-clockwise. Until the early 20th century, the *bosu* whale-bone lime spatulas and *doga* circular pig tusks moved together with the *mwali*.

Jutta Malnic's 1998 book, Kula *is a profound and poetic account of the trading cycle's allure. Her intimate photographs, taken on expeditions between 1981 and 1985, inspired this section of the book.*

"The Kula trade consists of a series of periodic overseas expeditions, which link together the various island groups, and bring over big quantities of armbands and necklets – and subsidiary trade from one district to another. The trade is used up, but the armbands and necklets go round and round the ring."

Bronislaw Malinowski 1922

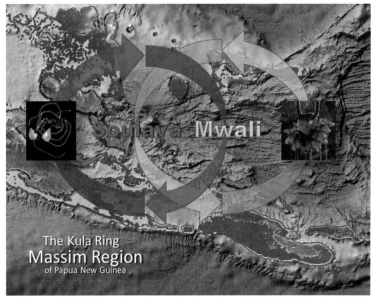

The Kula Ring
Massim Region
of Papua New Guinea

gugu'a – day-to-day objects.
vaygu'a – objects of high value
mwali – armbands of *Conus* shell
soulava – necklaces of *Spondylus* shell
doga – curved or circular pig tusks
bosu – whale bone lime spatulas

"When a canoe arrives on an island, its very arrival is a gift. It is a gift you can't quantify. You are honoured and you must honour in return."

A *Kula* Master 1979

Kula is ceremonially regulated. Twice a year, canoe expeditions are scheduled under the leadership of a *Big Man* or *Kula Master*. The dates are aligned with the prevailing monsoon winds and harvests.

The visitors start the exchange with a small opening gift, a *gugu'a*, which the hosts reciprocate by offering the *Kula* gift, *soulava* or *mwali,* depending on the direction of travel. Only at the later visit do the visitors present their *vaygu'a.*

Another important *Kula* article was a *doga*, a curved or circular pig's tusk, or a copy made of clam shell. Malinowski rated it as almost as important as *mwali* in the *Kula* Ring.

By this delayed reciprocity, each partner remains indebted to the other. No one may keep a gift too long, thereby running the risk of losing his reputation. The exchange builds lifelong partnerships that are transferred to the heirs by mortuary rites symbolizing the stability of the relationship.

Also, one also does not *join* the *Kula*, but is introduced to it by members, usually relatives. This principle of being asked to join the *Kula Club* enhances trust and the stability of relationships. Typically, members know the names of their partners' partners, building strong networked connections, and the idea of being part of a privileged, permanent system is common. In Malinowski's words: "Once in *Kula*, always in *Kula*".

Through public ceremonies, magical rites and conversational skills members try to influence their partners, inducing them to give generously. The principle of delayed reciprocity may be considered open to abuse but is in its essence a self-managing complex system. As one *Kula* Master puts it: "I have become a great man by enlarging my exchanges at the expense of blocking theirs. I cannot afford to block their exchange for too long, or my exchanges will never be trusted by anyone again. I am honest in the final issue." (Fortune 1989).

Vaygu'a objects make their way around the *Kula* Ring of islands, taking as long as twenty years to complete the passage, the value growing with each exchange; often enhanced by the addition of new shells or beads, new stories of exciting ceremonial exchanges, and

"A man who is in the Kula *never keeps any article for longer than, say, a year or two. Even this exposes him to the reproach … and certain districts have the bad reputation of being 'slow' and 'hard' in the* Kula."*

Malinowski 1966

perhaps adorned with the names of the great men whose lives it had passed through. The objects were in constant motion, encircling the islands in a ring of social and magical power, their reputation being constantly enhanced.

For men, the *Kula* provided prestige and status, and enhanced the authority of hereditary chiefs. Their names were associated with the most valuable armbands and necklaces, and it fell to them to organise and lead the voyages. Many months went into the preparation for the next *Kula* voyage and with each passing day the excitement would grow.

For all the spectacular ceremonial context of *Kula*, the ultimate aim was the trade back and forth of utilitarian objects, pigments and dyes, stone axes, obsidian, ceramics, polished ceremonial stones, woven goods and certain foods. However, no dealing or haggling occurs between *Kula* partners themselves, though always within their villages. Trading takes place between the visitors and the locals who are not their partners, but who must belong to the *Kula* community.

Beyond the exchange of 'gifts', *Kula* has facilitated an effective long-term economic trading network, and enabled the spread of peaceful relationships in a part of the world that was riven by constant tribal conflicts. Malinowski saw the *Kula* Ring as a surrogate for war.

The last war between islands in the Massim area was in 1899.

"Kula is simply a human experience of growth and growing through persons engaged in giving and receiving"

Jutta Malnic 1982

As Malinowski suggested, the *Kula* voyagers really were *Argonauts*, sailing forth into the unknown, in search of honour and glory.

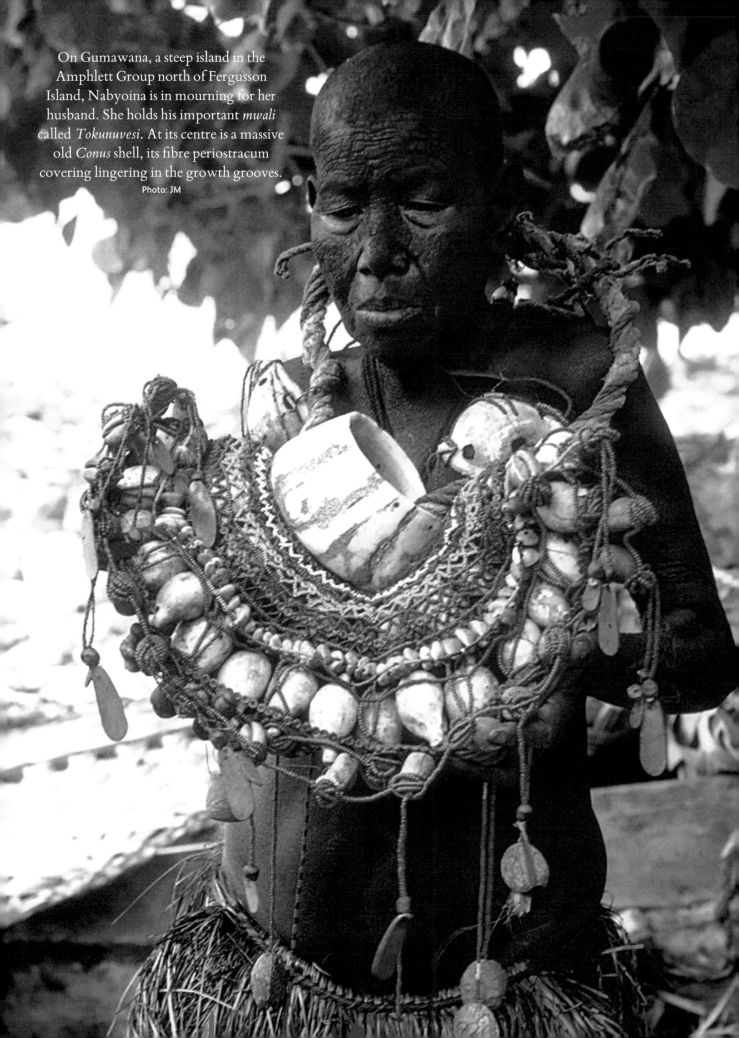

On Gumawana, a steep island in the Amphlett Group north of Fergusson Island, Nabyoina is in mourning for her husband. She holds his important *mwali* called *Tokunuvesi*. At its centre is a massive old *Conus* shell, its fibre periostracum covering lingering in the growth grooves.
Photo: JM

The *Kula* Objects

Mwali

Describing these as arm-shells, bracelets or bangles hardly does them justice!

Mwali are cut from a cross section of cone shells and then adorned with trade beads, shells and seeds to make them rattle when moving. A *mwali* typically starts off modestly, as just a cone shell armband with a few adornments attached, such as those top right.

Then, they are constantly added to, improved in value, as they move from one owner to the next – constantly gaining in importance. *Mwali* are classed and ranked by size, quality, polish, age and history – until finally they become legendary objects and are given their own name.

The history of an important *mwali* would handed down orally. It might become far too elaborate to wear and may be displayed only for important ceremonies or occasions.

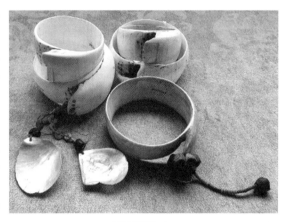

WG T0543 etc

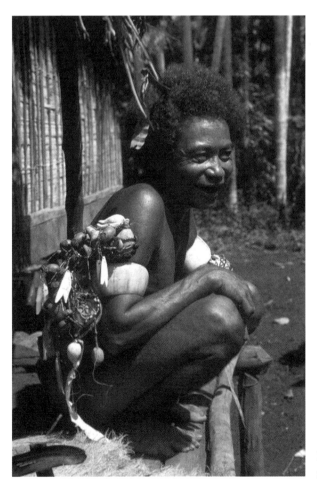

Kitava woman wearing a *mwali*. **Photo: JM**

"Soulava *and* mwali *must travel. At certain places, the big name* mwalis *come together and get paired. There is great credit to the one who has the strategy to achieve this. Then they can continue to travel again."*

Gerald 1979

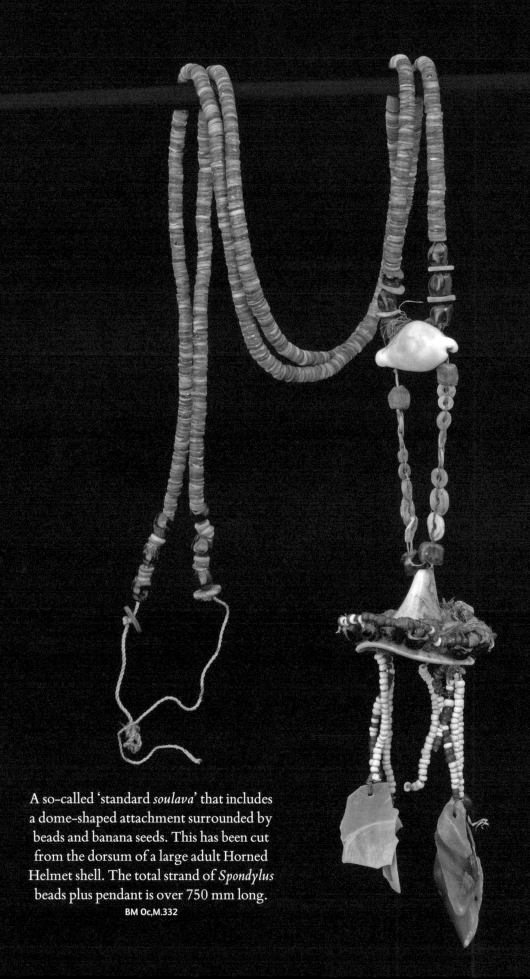

A so-called 'standard *soulava*' that includes a dome-shaped attachment surrounded by beads and banana seeds. This has been cut from the dorsum of a large adult Horned Helmet shell. The total strand of *Spondylus* beads plus pendant is over 750 mm long.

BM Oc,M.332

The *Kula* Objects

Soulava

These are long necklaces, some 2–5 m long, usually strung with valuable shell-money beads cut from *Spondylus* shells. Early *soulavas* seem to be simple shell strings, but over time they became to be more and more adorned with a plethora of attachments.

Soulavas are used and worn in different ways across the Massim area. On Rossel island they are worn as back adornments, and on Sudest Island they are trade items, mainly used for purchasing canoes from the Deboyne Islands.

The two *soulavas* illustrated on this page spread were both collected in the Trobriand Islands by Bronisław Malinowski between 1900 and 1918. The one at right shows the chaotic assemblage of shell and beads attached to the basic *Spondylus* shell and banana seed strand.

The *soulava* on the facing page shows what has come to be seen as 'the standard *soulava*' since the publication of Malinowski's *Argonauts of the Western Pacific* in 1922. It includes a dome-shaped attachment surrounded by beads and banana seeds. This has been cut from the dorsum of a large adult Horned Helmet shell *Cassis cornuta*. Adults usually have tall dorsal spines in the final growth stage: The photo at right shows clearly how these domes were made from the impressive 'horns' of these giant shells.

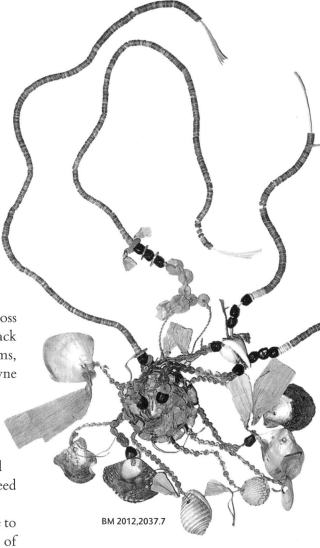

BM 2012,2037.7

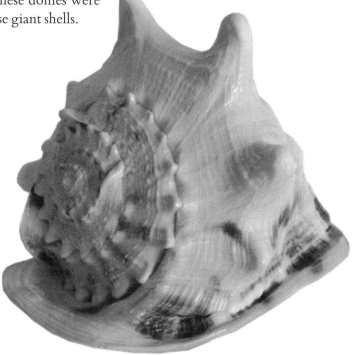

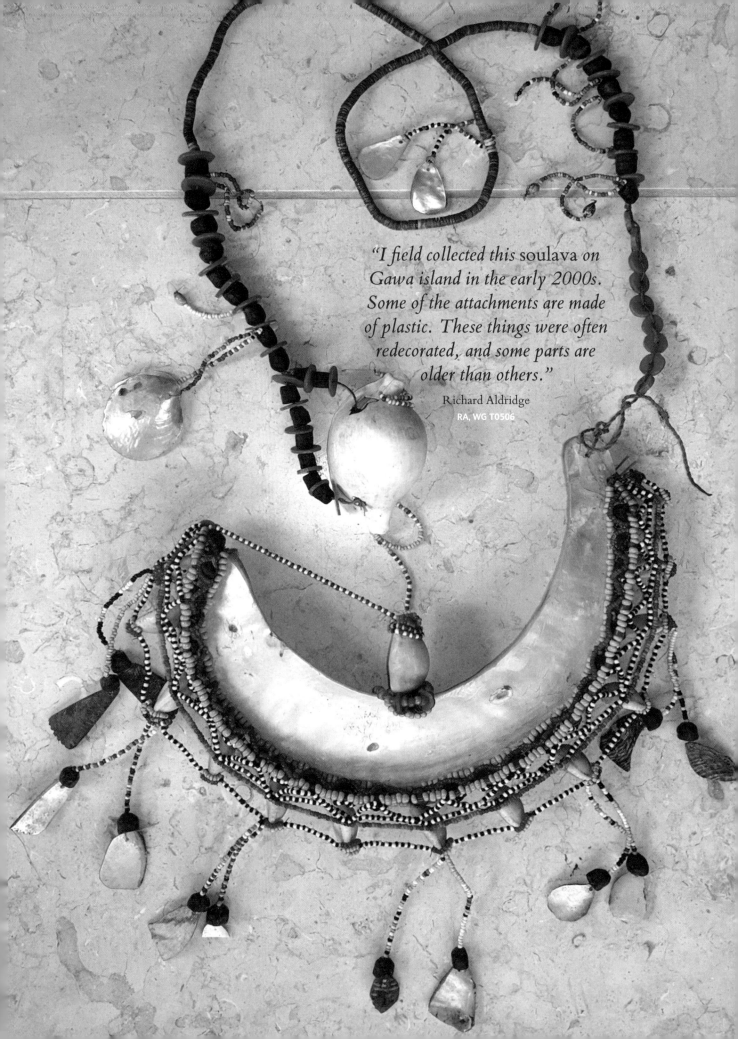

"I field collected this soulava on Gawa island in the early 2000s. Some of the attachments are made of plastic. These things were often redecorated, and some parts are older than others."

Richard Aldridge

RA, WG T0506

Over the years, *soulavas* became even more elaborate, with many having a large crescent-cut pearl shell added as a focal point – and these were further adorned with elaborate glass beads, shells and yet more banana seeds.

On this page are some examples of *soulavas* made between the 1950s and 1980s.

Each *soulava* would have been ranked according to the fineness of the work, the colour of the *Spondylus* shells (salmon red being seen as the best), age and its history of travel and use around the *Kula* Ring.

A Duau woman at Sewai on Normanby Island wearing a precious *soulava* over her shoulder. Photo: JM

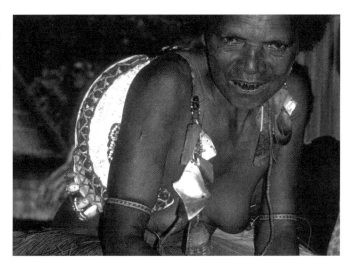

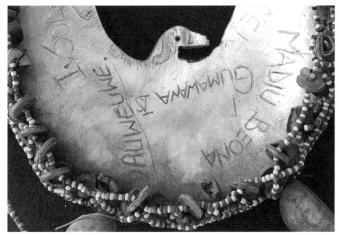

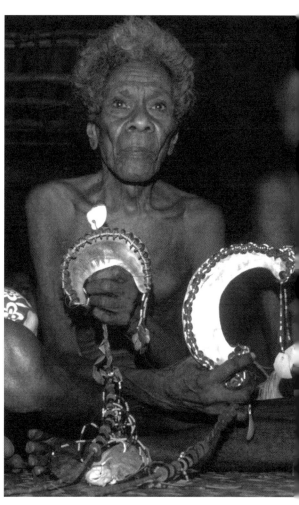

On some important *soulavas*, the back of the pearl shell has the names of previous owners carved into the shell surface. **RA, WG T0658**

Above is a renowned *Kula* Master on Fergusson Island holding two important *soulavas*, one named Dalumeyama. Photo: JM

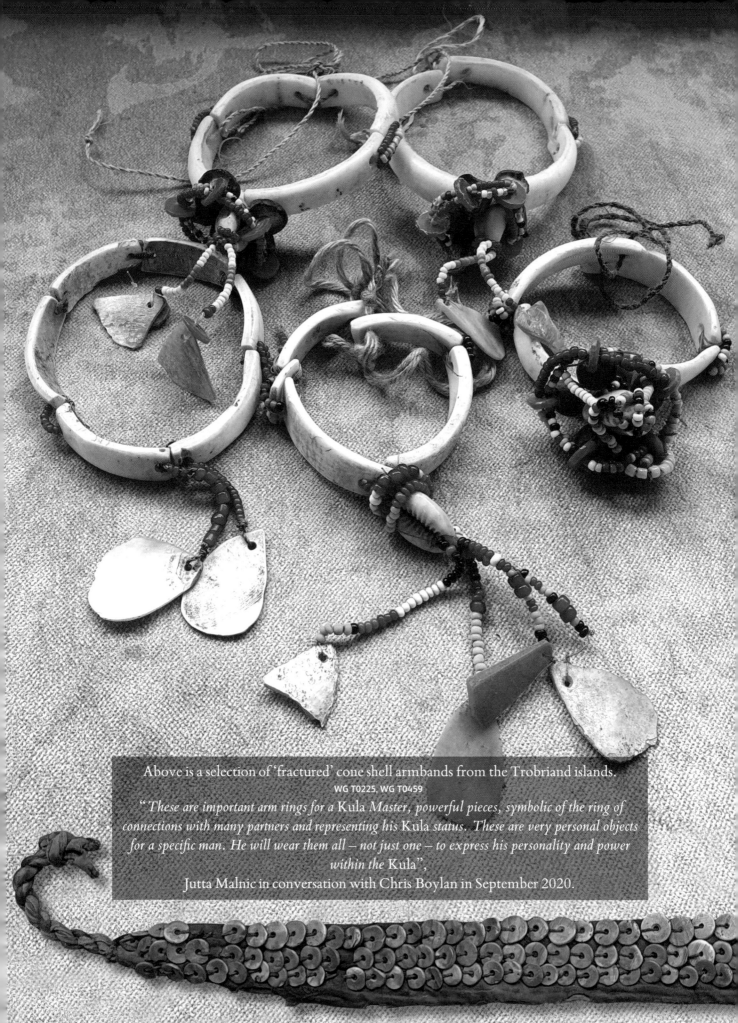

Above is a selection of 'fractured' cone shell armbands from the Trobriand islands.

WG T0225, WG T0459

"*These are important arm rings for a Kula Master, powerful pieces, symbolic of the ring of connections with many partners and representing his Kula status. These are very personal objects for a specific man. He will wear them all – not just one – to express his personality and power within the Kula*",

Jutta Malnic in conversation with Chris Boylan in September 2020.

A *Kula* Master's regalia

The red *Spondylus* shell discs, in the form of *bagi* shell currency, were amongst a Massim family's most precious things. Any object that contained these discs showed prestige and status.

The *doga* necklaces such as these at right were populated with *bagi* currency and had a complete circle pig tusk as the centre-piece. The *doga* previously accompanied *mwali* armbands on the *Kula* voyages but more recently have become pure prestige and heirloom items.

The chief's wealth belt *katudababila* (shown across the bottom of this page spread) leaves the wearer's status in no doubt – it is covered in four lines of *Spondylus* shell discs indicating a senior rank. The maximum would be a 'five-line' belt worn by only the highest of chiefs. This highly prestigious and well-used object is from Kiriwina in the Trobriand Islands.

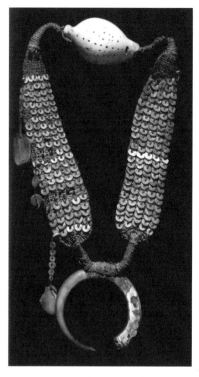

Doga pig tusk necklace, heavy with precious *Spondylus* shell beads.
MH/RA 108A

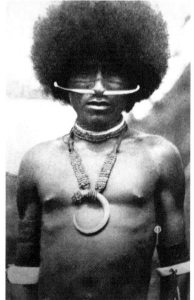

Doga worn by a man in the D'Entrecosteaux Islands. **Photo: Jeness & Ballantyne 1920**

This carved wooden comb in the Massim style, would be worn as an adornment placed into the hair. **GR, WG T0455**

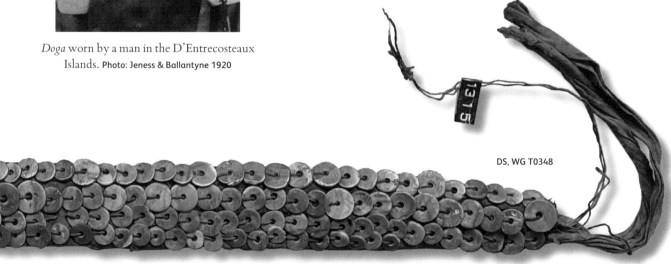

DS, WG T0348

Central to these value networks have always been canoes – the essential mode of transport on the ocean highways connecting a multiplicity of island groups. The quality and diversity of their construction, the rituals before, during and after the voyages and the complex designs with which the canoes were adorned are a fascinating subject all on their own and can only be hinted at here. Certainly, they have never just been the marine equivalent of planes, trains or trucks.

Drawing of a Vakutan canoe from
The Art of Kula by Shirley Campbell, 2002

The *Kula* canoes

The making of a *nagega* canoe used in the *Kula* voyages involves superb craftmanship plus a spiritual myth called *mwasila* (the word implies magic, and a good feeling). *Kula* Masters say it is *the way to translate a dream into physical reality*.

The entire canoe is cut from one tree up to eleven metres long and is a wonderful example of Massim material culture. It is made for a specific purpose, it is a means to an end, but the elaborate carvings of the splashboards attached to both ends of the canoe, the prows and filials, are far more than functional. Their installation is accompanied by important ceremonies that will protect the voyagers.

"Beyond their practical value these boards also have a spiritual/magical function to increase the owner's personal beauty, essential for a successful Kula voyage."

Douglas Newton

"The tree knew it was going to become a canoe. Not an ordinary canoe, but a Kula canoe. Before cutting down the tree, you give it your inner vision of the canoe. The tree holds this image."

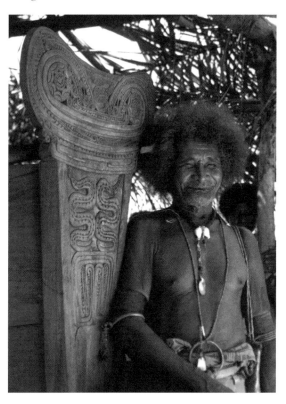

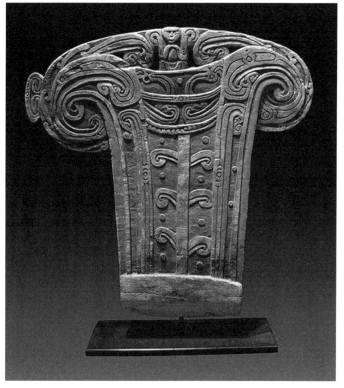

A Master Carver with his recently made canoe splash board finely carved with stylised eyes and bird designs, the repeating pattern of curved bird necks back-to-back. Panaeati, a flat-topped island in the Deboyne Islands atoll, Louisiade Archipelago. Photo: JM

An old splashboard with traces of the original paints. The abstract human figure at the top of many splashboards represents a god *guwaya* who is believed to live at the bottom of the sea. According to Malinowski in 1922 *Guwaya* would 'eat' a drowning man if not magically protected. TB, WG T0674

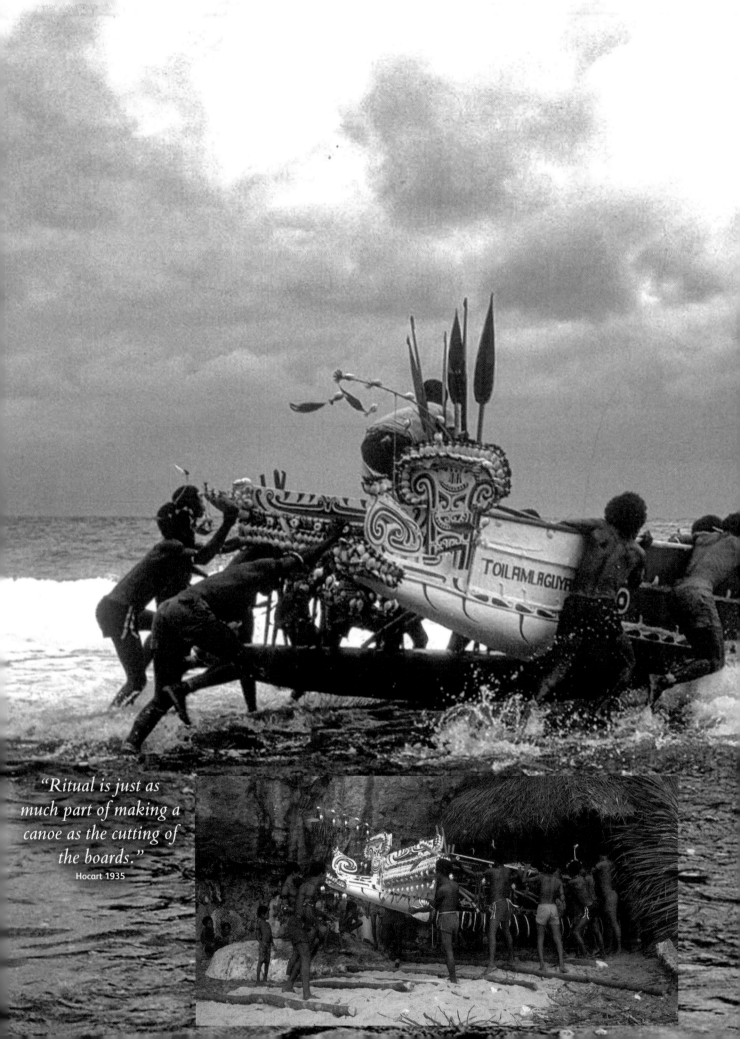

> "Ritual is just as much part of making a canoe as the cutting of the boards."
>
> Hocart 1935

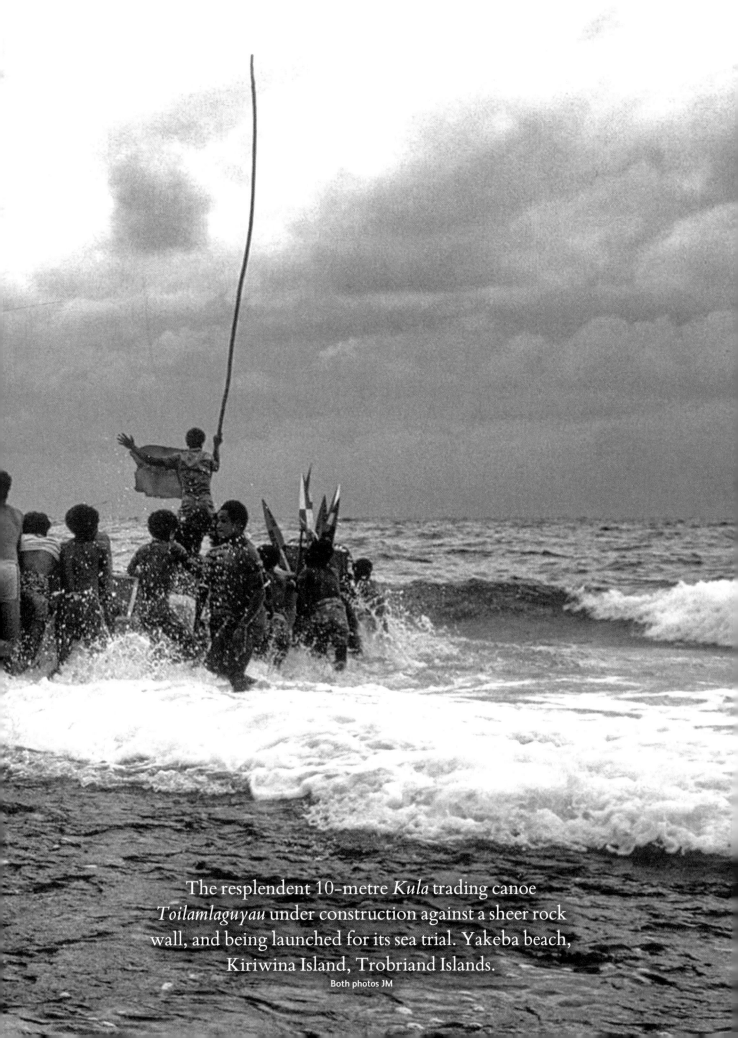

The resplendent 10-metre *Kula* trading canoe
Toilamlaguyau under construction against a sheer rock
wall, and being launched for its sea trial. Yakeba beach,
Kiriwina Island, Trobriand Islands.

Both photos JM

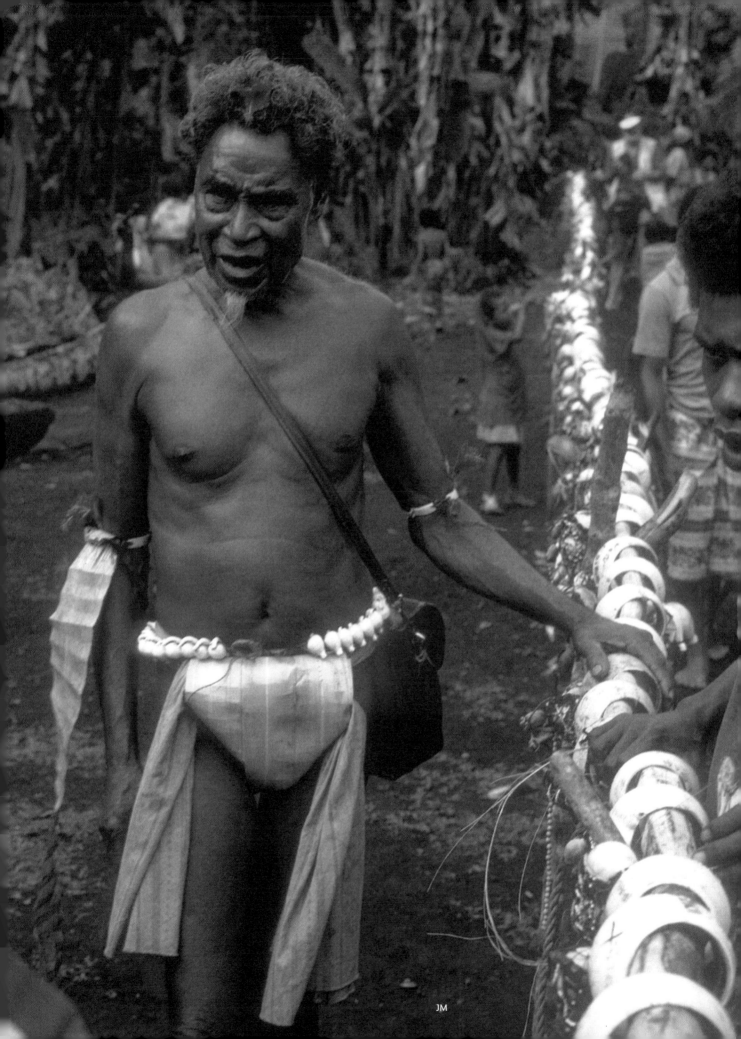

Home after a *Kula* voyage

At Yalumgwa village, on Kiriwina Island in the Trobriand Islands, the men have returned from a *Kula* voyage to a tumultuous welcome by the whole village. The *mwali* gathered during the voyage are proudly displayed, counted and admired.

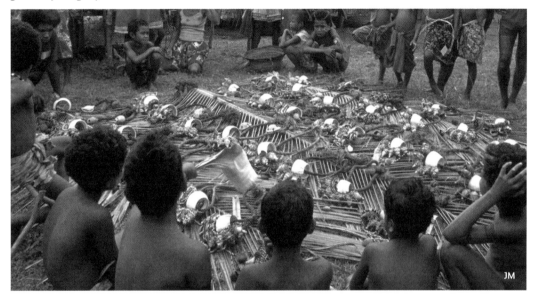

On the facing page, in a similar ceremony at Okububura village on Kitava Island, one of the other three large islands in the Trobriand Islands, after return from another *Kula* trading voyage, *mwali* are assembled for the count.

You may note that there are no *soulava* in the booty in either of these examples – that is because of the counter-clockwise direction that these particular voyages took. Remember that the two ceremonial gifts always circulate in opposite directions: *soulava* necklaces move clockwise and *mwali* armbands move counter-clockwise within the *Kula* Ring.

These are times for great rejoicing. The mwalis *represent new and renewed relationships across the islands and bode for a prosperous, and peaceful, future.*

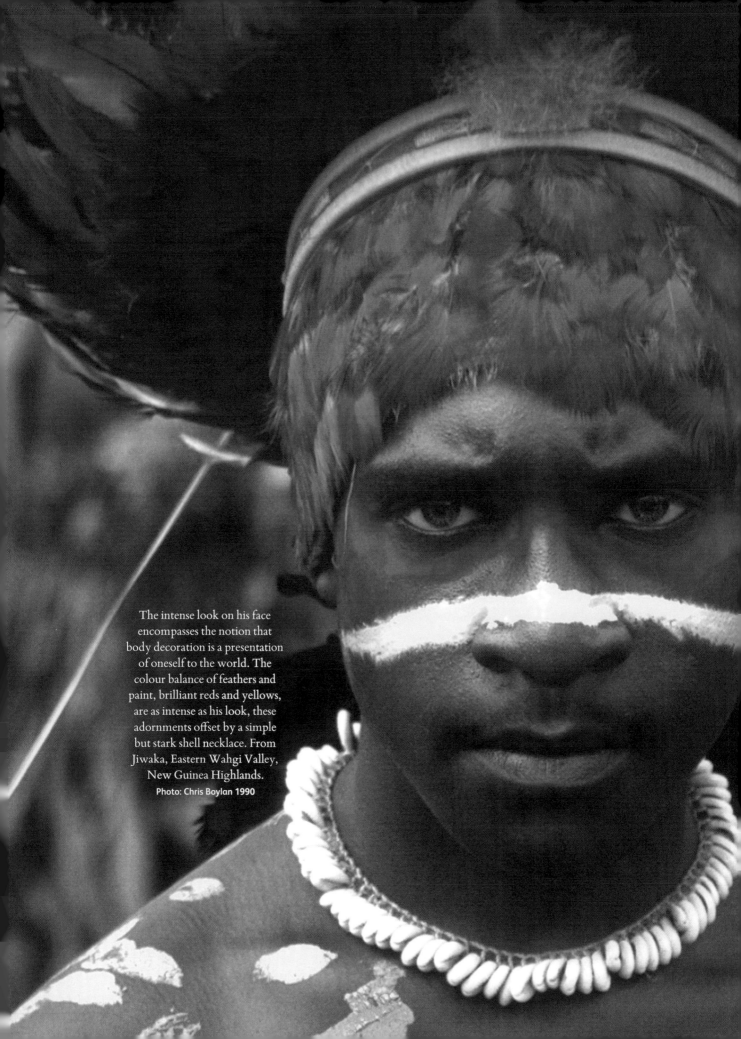

The intense look on his face
encompasses the notion that
body decoration is a presentation
of oneself to the world. The
colour balance of feathers and
paint, brilliant reds and yellows,
are as intense as his look, these
adornments offset by a simple
but stark shell necklace. From
Jiwaka, Eastern Wahgi Valley,
New Guinea Highlands.
Photo: Chris Boylan 1990

POSTSCRIPT

How dare you?!

I recognise that this book is an outside-in perspective. I have travelled widely amongst the South Sea Islands but have not actually lived immersed in any of the many cultures. In response to early drafts of my book, some locals asked how I dare appropriate their culture for my own ends. Perhaps I am being as much of a voyeur as the long line of European researchers who have lived amongst you and written about their vivid and compelling encounters. Neither am I an expert from decades of research or generations of dealing in tribal arts. I'm an interloper amongst your vast knowledge and personal experiences of the culture and its objects.

This book is a product of my personal passion for the South Seas, as a traveller amongst its people, a diver on its reefs and as a collector.

This is a not-for-profit project and all the many expert contributors have given their time, images and creative input pro bono. I am deeply indebted to each and every one.

In that spirit, I hope that we can also give something back to the people whose material culture we are celebrating. Together with the sponsors and subscribers listed on the following page, plus many other individual donors, we plan to donate at least 100 copies of this book to local community groups in the South Seas. It is our hope that this will help inspire young artists

This book is a celebration of the South Seas, of magic cultures that love a good celebration – and take adornment seriously.

and crafters in some specific new projects. A reminder that a simple act of showcasing the culture can lead to its appreciation, and even preservation, by future generations.

I started with a plan for a 200-page book based on my collection. You hold the result in your hands, double the planned scope, and a 'cutting room floor' of similar size. Much is missing in this volume – you may well miss Solomon Islands combs, New Guinea phallocrypts and much more. How naive I was in estimating the scope of my ambition – and the depth of the South Seas story.

I fear there may be scope for a second volume of the book, and a journey from the past into the future.

Sponsors & Subscribers

These people and organisations supported the *Adorned by Nature* project by pre-ordering and/or donating copies of this book to be used in art projects within the South Seas communities starting in 2022. These are the generous 'angels' who made this possible, Thank you for your faith and confidence.

Adrian M. Feisel
Albert Sheean
Alex Arthur, Tribal Art Magazine
Amelia Ann Dick
Andreas Grünemeyer
Anne Joffe
Annie & Roger Boehm
Annie Boehm
Anselm Guise
Anthony Meyer
Antoine Bril
António Monteiro
Audrey Pearl Urbach
Barbara Kusnetzky
Berry de Bruijn
Black Hills Institute
British Museum
Caroline Klarr
Charles Lovely
Charles Lovely
Charlotte Dakin
Charlotte Dakin-Norris
Charlotte Gilbert
Chris Boylan
Chris, Cheryl & Russell Browne
Christian Klug
Christine & Trevor Winer
Christine Robinson
Clive Loveless
Colleen Westaway
David Beardsmore
Dr Jeff Kinch
Dr. Daniel Pfalzgraf
Drury & Sandra Tallant
Felix S. D. Feisel
Finette Lemaire
Franck Marcelin
Gabriella Roy
Garrett Tyler Urbach
Geoff Elvy

Geoffrey Sparkes
Georges Geeraerts
Guido Poppe
Guillaume Fesq
Günter Feisel
Hank Ebes
Hugues Bienaymé
Ian J. McNiven
Isabelle Gaillard-MP & Joao Monteiro Paes
Jerome Edler
John Gaye
Joseph Robert Villari
Joseph Zadrozny
Josette Dufour
Julian Joseph
Karl-Heinz & Bronwen Töpfer
Kate & Isabelle
Ken & Karenza Mathews
Kevin Sharpe
Kim Hahn
Klaas Schoof
Kyama
Lina Lo
Lucinda Formyduval
Mara Fizdale
Marc Assayag African & Oceanic Art, Montreal
Maria Dolores San Millán Vergé
Mark & Linda Barron
Mark & Nellie Nizette
Maurice Knight
Miguel Ibáñez Artica
Morten J. Wannek
Olga Fontanellaz
PANONYME
Patricia & Ian Robb
Patrick Branger
Patrick Vincent
Paul Southgate
Peter Coldicott

Peter Thomas
Philip R James, Southampton
Philip Rae-Scott
Philippe Vandenberghe
Phillip Shugar
Prairie Rouge
Professor Christopher Bartlett
Qi Cui
Rachel Vanatta
Rad Joura
Richard Bizley
Rita Okrent Collection
Rita Uechtritz
Sabine Feisel
Sam Horses
Samson Dean
Sandrine & Curt von Boguslawski
Sarah Corbett
Scott Semans
Simon the Delusional
Sue Hobbs
Susan Bienkowski
Sylvia Gottwald
Tess Axson Johnson
The Girl Adorned
The Gross Family
Thomas S. Wannek
Thomas Schäfer
Tim Freeman
Tom Corbett
Tom Kapitany
Trefor & Sheila Harries
Truus & Joost Daalder
Ulrich Kortmann
Waile Simona Buscarons
Warwick S. Majcher
Watze Kamstra
William & Gigi Salomon
Wylda Bayrón

References & further reading

In tune with today's digital realities, we have provided a complete set of references and suggestions for further reading at the book website www.AdornedByNature.AtOne.org, click on Content +++. You can also participate in the discussion on issues raised by the book on our Facebook group *Adorned by Nature – The Book*.

Image/Object Credits & Provenance

Photographs, maps, drawings and charts are primarily by Wolfgang Grulke unless indicated otherwise. Objects illustrated are from the author's collection or as indicated with each object with the following credits, from earliest to most recent collection and, where known, includes the collection number used in that collection.

For example: *DA, UK D123, WG T0236* means the object was collected by David Akin, then was acquired by Ulrich Kortmann (D123 was his collection number) and is currently in Wolfgang Grulke's collection with collection number T0236.

AB: Arthur Beau Palmer, Brisbane, Australia
AM: Anthony Meyer, Paris, France
AW: Arthur Whall, Sydney & New York
BB: Ben Burt, British Museum, London, UK
BL: Bernhard Lehmkuhl, Cologne, Germany
BM: British Museum, London, UK
BR: Bernhard Rabus, Munich, Germany
BS: Bruce Saunders, Brisbane, Australia
CB: Chris Boylan, Sydney, Australia
CD: Col Davidson, Orange, NSW, Australia
CH: Charterhouse School Museum, Godalming, UK
CR: Charles Ratton, Paris, France
CU: Cambridge University Museum, Cambridge, UK
CW: Christopher Worrall Wilson, Sydney, Australia
DA: David Akin, Ann Arbor, Michigan, USA
DE: Dieter Alfons Eichhorn, Herne, Germany
DI: Dietmar Ebbers, EUCOPRIMO, Germany
DS: David Said, Sydney, Australia
EL: Eric Lancrenon, Nouméa, New Caledonia
EU: EUCOPRIMO magazine *Der Primitivgeldsamm*ler
FH: Frank Hurley, Australia
FM: Franck Marcelin, Aix en Provence, France
FR: Frank & Amu Reiter, Berlin, Germany
GL: Galerie Lemaire, Amsterdam
GP: Guido Poppe, Cebu, Philippines
GR: Gabriella Roy, Sydney, Australia
HB: Hugues Bienaymé, Paris, France
HD: Helen Dennett, Sydney, Australia
HK: Prof. Hartmut Kraft, Cologne, Germany
JF: John Friede, Rye, New York
JM: Jutta Malnic, Sydney, Australia
JO; John Magers, Sydney, Australia
KK: Kurt Koschatzky, Regensburg, Germany
KL: Kunsthaus Lempertz, Germany

KS: Klaas Schoof, Amsterdam, Netherlands
LL: Prof. Lowell Lane, Texas, USA
MA: Marc Assayag, Montreal, Canada
MB: Museum of Cultures Basel, Switzerland
MC: Marion Clark, Honiara, Solomon Islands
MH: Michael Hamson, California, USA
MI: Michael Kremerskothen, Germany
MK: Michael Kaura, Malaita, Solomon Islands
ML: Neil McLeod, xxx, Australia
MM: Macleay Museum, Sydney, Australia
MV: Museum Victoria, Melbourne, Australia
NL: Nationaal Museum van Wereldculturen, Netherlands
NM: Nicolai Michoutouchkine, Vanuatu
OF: Olga Fontanellaz, Geneva, Switzerland
PB: Peter McCabe, Adelaide, Australia
PC: Private Collection
PG: Paul Gardissat, Vanuatu
PH: Peter Hallinan, Brisbane, Australia
PM: Pitt-Rivers Museum, Oxford, UK
PS: Peter Selz, Berkeley, California, USA
RA: Richard Aldridge, Shelley, Western Australia
RD: Richard Dorrell, Poulsbo, Washington, USA
RP: Barbara & Ron Perry, Tucson, Arizona.
SE: Seward Kennedy, London, UK
SI: Solomon Islands National Museum, Honiara
SK: Sir Mariano Kelesi, Honiara, Solomon Islands
SM: SGM 'Meyers' Adams, Yorkshire, UK
SP: Stichting Papoea Erfgoed / Papua Heritage Foundation"
TB: Todd Barlin, Sydney, Australia
TM: Traditional Money Association Journals (TMA 1980-1998), Orange, Australia
UG: University of Glasgow, Scotland, UK
UK: Ulrich Kortmann, Dortmund, Germany
VK: Museum für Voelkerkunde, Berlin, Germany
WG: Wolfgang Grulke, Dorset, UK
WW: Woolley & Wallis Auctions, Salisbury, UK

Some of the material used in this publication is in the public domain, from Wikipedia, Wikimedia and Google Earth Pro. We claim Fair Use for use of some copyrighted materials for research, criticism, commentary, and reporting. We have made every effort to track down copyright owners and do not wish to violate the rights of any person or entity. If you feel we have inadvertently failed to accredit or reference anyone appropriately, please contact Service@AtOne.org and we will add any updates to the www.AdornedByNature.AtOne.org website.

Index

New Guinea
Sepik River
Major Cultural Groups

Schouten Islands

Torricelli Mountains

Lumi

Prince Alexander Mountains

Boiken

Abelam

Coastal Sepik/Ramu River

Murik Lakes

Manam Island

Washkuk
Hills

Iatmul

*Chambri
Lakes*

Sepik River

epik

Middle Sepik

Lower Sepik

Ramu River

Papua New Guinea (PNG)

Papua

West Sepik

Ramu River

Mountain Ok

Waghi River

Kalam

Enga

Western Highlands

Indonesia. Papua Province.

Papua New Guinea.

Huli

Melpa

Asaro

Mount Hagen

Kuman

Benabena

Mendi

Goroka

Eastern Highlands

Chimbu

Komano

Southern Highlands

Wiru

Kewa

Fore

New Guinea
Highlands
Major Cultural Groups

Anga

Towns

Fly River